THE COMPLETE
PAINTING COURSE

THE COMPLETE PAINTING COURSE

Wendon Blake

Macdonald

A Macdonald BOOK

© Billboard Ltd 1984

First published in Great Britain in 1985
by Macdonald & Co (Publishers) Ltd
London & Sydney

A member of BPCC plc

This volume was compiled from four separate
books published under the titles: *The Acrylic
Painting Book* (1978), *The Oil Painting Book* (1979),
The Watercolour Painting Book (1978), and *The
Portrait and Figure Painting Book* (1980).

British Library Cataloguing in Publication Data

Blake, Wendon
 The complete painting course
 1. Painting — Technique
 I. Title
 751.4 ND1500

 ISBN 0-356-10961-5

Printed and bound in Japan

Macdonald & Co (Publishers) Ltd
Maxwell House
74 Worship Street
London EC2A 2EN

CONTENTS

INTRODUCTION

Complete Painting Course. In the 400 pages of this book, you'll find the most comprehensive survey of painting techniques available in any single volume. In nearly 700 illustrations, including 50 step-by-step painting demonstrations in full color, the book teaches you how to paint in the three most popular media—oil, watercolor, and acrylic—and also shows you how to paint the five most popular subjects: landscapes, seascapes, portraits, figures, and still life.

Four Books in One. The book is actually four books in one, distilling the essential pages of four art instruction books that have won a worldwide audience in eight languages: *The Oil Painting Book, The Watercolor Painting Book, The Acrylic Painting Book,* and *The Portrait and Figure Painting Book*. (In their original format, these four books came to a total of more than 1000 pages.) Thus, the book you're now reading is organized in the following four parts that correspond to the original books: "Oil Painting," "Watercolor Painting," "Acrylic Painting," and "Portrait and Figure Painting."

How to Use This Book. The basic principle of this book is "learning by doing." You'll see every painting operation demonstrated step-by-step. You'll watch over the artist's shoulder as George Cherepov paints landscapes, seascapes, and still life in oil; Claude Croney paints landscapes, seascapes, and still life in watercolor; Rudy De Reyna paints landscapes, seascapes, and still life in acrylic; and George Passantino paints portraits and figures in oil. Each of these noted artists begins by demonstrating simple subjects and then goes on to show you how to paint more complex ones, building on the techniques you've learned from the earlier demonstrations. In these demonstrations, each illustration shows a stage in the progress of the painting, while the accompanying text describes the exact painting procedure, equipment, and color mixtures. Having seen the artist do it, you're then encouraged to try the process yourself. Of course, this doesn't mean that you have to copy the painting in the book. But do try to find a similar subject and then attempt a similar painting, using the same methods you've seen in the demonstration.

Oil Painting. Part One on "Oil Painting" introduces the fundamental tools and techniques, showing you how to paint with bristle and softhair brushes, painting knives, and combinations of all three. The color demonstrations begin with indoor and outdoor still lifes—vegetables, fruit, flowers, rocks in a meadow—and then show you how to paint such outdoor subjects as summer, autumn, and winter landscapes; trees in a grassy field; a cloudy sky; a sunset over mountains; a rocky beach; and a pond surrounded by woods. Part One concludes with instructions for correcting oil paintings, stretching a canvas, framing, and executing a variety of special effects.

Watercolor Painting. Part Two on "Watercolor Painting" begins by recommending brushes, colors, and watercolor papers, and then shows you the basic methods of applying and controlling liquid color: flat and graded washes, drybrush, and the wet paper technique. As in Part One, the color demonstrations begin with simple still lifes of vegetables, fruit, and flowers indoors, followed by outdoor still lifes of wildflowers and a tree stump. Then you learn how to paint spring, summer, autumn, and winter landscapes; a lake, a cloudy sky, and a sunset. And Part Two concludes with a fascinating survey of special effects with knives, brushes, and other tools; various ways to correct and repaint watercolors; and instructions for matting and framing.

Acrylic Painting. Part Three on "Acrylic Painting" also begins with the basic equipment, and then explains the fundamental techniques of painting in this versatile medium: opaque and transparent painting, scumbling, and drybrush. The color demonstrations follow a familiar and time-tested teaching method, starting with still lifes of fruits, vegetables, flowers, and household objects; moving on to landscapes of the seasons—summer, autumn, and winter; and concluding with such challenging outdoor subjects as mountains, desert, a rocky beach, and a sunset. Like the preceding section, Part Three finishes with a survey of special effects, ways of correcting and repainting, and suggestions for framing.

Portrait and Figure Painting. The fourth and final part deals with the most demanding subject of all: portraits and figures in oil. This comprehensive section analyzes head and figure proportions, then shows how to paint male and female heads (including children), facial features (the eye, nose, mouth, and ear) and every part of the figure (torso, arm and hand, leg and foot). The portrait demonstrations in color show how to paint adult and child models of varied skin and hair colors: blond, brown-haired, dark-haired, black, and oriental. And the figure demonstrations show how to paint the female nude in four different seated and standing poses. You'll also find guidance on lighting portraits and figures, posing and composing, and sketching portraits and figures in pencil and in oil.

PART ONE

OIL PAINTING

Color Selection. When you walk into an art supply store, you'll probably be dazzled by the number of different colors you can buy. There are far more tube colors than any artist can use. In reality, the oil paintings in this book were done with just a dozen colors, about the average number used by most professionals. The colors listed below are really enough for a lifetime of painting. You'll notice that most colors are in pairs: two blues, two reds, two yellows, two browns. One member of each pair is bright, the other is subdued, giving you the greatest possible range of color mixtures.

Blues. Ultramarine blue is a dark, subdued hue with a faint hint of violet. Phthalocyanine blue is much more brilliant and has surprising tinting strength—which means that just a little goes a long way when you mix it with another color. So add phthalocyanine blue very gradually. These two blues will do almost every job. But George Cherepov likes to keep a tube of cobalt blue handy for painting skies and flesh tones; this is a beautiful, very delicate blue, which you can consider an "optional" color.

Reds. Cadmium red light is a fiery red with a hint of orange. All cadmium colors have tremendous tinting strength, so remember to add them to mixtures just a bit at a time. Alizarin crimson is a darker red and has a slightly violet cast.

Yellows. Cadmium yellow light is a dazzling, sunny yellow with tremendous tinting strength, like all the cadmiums. Yellow ochre is a soft, tannish tone. If your art supply store carries two shades of yellow ochre, buy the lighter one.

Browns. Burnt umber is a dark, somber brown. Burnt sienna is a coppery brown with a suggestion of orange.

Greens. Although nature is full of greens—and so is your art supply store—you can mix an extraordinary variety of greens with the colors on your palette. But it *is* convenient to have just one green available in a tube. The most useful green is a bright, clear hue called viridian.

Black and White. The standard black, used by almost every oil painter, is ivory black. Buy either zinc white or titanium white; there's very little difference between them except for their chemical content. Be sure to buy the biggest tube of white sold in the store; you'll use lots of it.

Linseed Oil. Although the color in the tubes already contains linseed oil, the manufacturer adds only enough oil to produce a thick paste that you squeeze out in little mounds around the edge of your palette. When you start to paint, you'll probably prefer more fluid color. So buy a bottle of linseed oil and pour some into that little metal cup (or "dipper") clipped to the edge of your palette. You can then dip your brush into the oil, pick up some paint on the tip of the brush, and blend oil and paint together on your palette to produce the consistency you want.

Turpentine. Buy a big bottle of turpentine for two purposes. You'll want to fill that second metal cup, clipped to the edge of your palette, so that you can add a few drops of turpentine to the mixture of paint and linseed oil. This will make the paint even more fluid. The more turpentine you add, the more liquid the paint will become. Some oil painters like to premix linseed oil and turpentine, 50-50, in a bottle to make a thinner *painting medium*, as it's called. They keep the medium in one palette cup and pure turpentine in the other. For cleaning your brushes as you paint, pour some more turpentine into a jar about the size of your hand and keep this jar near the palette. Then, when you want to rinse out the color on your brush and pick up a fresh color, you simply swirl the brush around in the turpentine and wipe the bristles on a newspaper.

Painting Mediums. The simplest painting medium is the traditional 50-50 blend of linseed oil and turpentine. Many painters are satisfied to thin their paint with that medium for the rest of their lives. On the other hand, art supply stores do sell other mediums that you might like to try. Three of the most popular are damar, copal, and mastic painting mediums. These are usually a blend of a natural resin—called damar, copal, or mastic, as you might expect—plus some linseed oil and some turpentine. The resin is really a kind of varnish that adds luminosity to the paint and makes it dry more quickly. Once you've tried the traditional linseed oil-turpentine combination, you might like to experiment with one of the resinous mediums.

Other Solvents. If you can't get turpentine, you'll find that mineral spirits (the British call it white spirit) is a good alternative. You can use it to thin your colors and also to rinse your brushes as you work. Some painters use kerosene (called paraffin in Britain) for cleaning their brushes, but it's flammable and has a foul odor. Avoid it.

Buying Brushes. There are three rules for buying brushes. First, buy the best you can afford—even if you can afford only a few. Second, buy big brushes, not little ones; big brushes encourage you to work in bold strokes. Third, buy brushes in pairs, roughly the same size. For example, if you're painting a sky, you can probably use one big brush for the patches of blue and the gray shadows on the clouds, but you'll want another brush, unsullied by blue or gray, to paint the white areas of the clouds.

Recommended Brushes. Begin with a couple of really big bristle brushes, around 1″ (25 mm) wide for painting your largest color areas. You might want to try two different shapes: one can be a flat, while the other might be a filbert. And one might be just a bit smaller than the other. The numbering systems of manufacturers vary, but you'll probably come reasonably close if you buy a number 11 and a number 12. Then you'll need two or three bristle brushes about half this size, numbers 7 and 8 in the catalogs of most brush manufacturers. Again, try a flat, a filbert, and perhaps a bright. For painting smoother passages, details, and lines, three softhair brushes are useful: one that's about 1/2″ (25 mm) wide; one that's about half this wide; and a pointed, round brush that's about 1/8″ or 3/16″ (3-5 mm) thick at the widest point.

Knives. For mixing colors on the palette and for scraping a wet canvas when you want to make a correction, a palette knife is essential. Many oil painters prefer to mix colors with a knife. If you'd like to *paint* with a knife, don't use the palette knife. Instead, buy a painting knife, with a short, flexible, diamond-shaped blade.

Painting Surfaces. When you're starting to paint in oil, you can buy inexpensive canvas boards at any art supply store. These are made of canvas coated with white paint and glued to sturdy cardboard in standard sizes that will fit into your paintbox. Later, you can buy stretched canvas—sheets of canvas precoated with white paint and nailed to a rectangular frame made of wooden stretcher bars. You can save money by stretching your own canvas. You buy the stretcher bars and canvas and then assemble them yourself. If you like to paint on a smooth surface, buy sheets of hardboard and coat them with acrylic gesso, a thick, white paint that you buy in cans or jars and then thin with water.

Easel. An easel is helpful, but not essential. It's just a wooden framework with two "grippers" that hold the canvas upright while you paint. The "grippers" slide up and down to fit larger or smaller paintings—and to match your height. If you'd rather not invest in an easel, there's nothing wrong with hammering a few nails partway into the wall and resting your painting on them; if the heads of the nails overlap the edges of the painting, they'll hold it securely. Most paintboxes have lids with grooves to hold canvas boards. When you flip the lid upright, the lid becomes your easel.

Paintbox. To store your painting equipment and to carry your gear outdoors, a wooden paintbox is a great convenience. The box has compartments for brushes, knives, tubes, small bottles of oil and turpentine, and other accessories. It usually holds a palette—plus some canvas boards inside the lid.

Palette. A wooden paintbox often comes with a wooden palette. Rub the palette with several coats of linseed oil to make the surface smooth, shiny, and nonabsorbent. When the oil is dry, the palette won't soak up your tube colors, and the surface will be easy to clean at the end of the painting day. Even more convenient is a paper palette. This looks like a sketchpad, but the pages are nonabsorbent paper. At the beginning of the painting day, you squeeze out your colors on the top sheet. When you're finished, you just tear off and discard the top sheet. Paper palettes come in standard sizes that fit into paintboxes.

Odds and Ends. To hold your turpentine and your painting medium—which might be plain linseed oil or one of the mixtures you read about earlier—buy two metal palette cups (or "dippers"). To sketch the composition on your canvas before you start to paint, buy a few sticks of natural charcoal—not charcoal pencils or compressed charcoal. Keep a clean rag handy to dust off the charcoal and make the lines paler before you start to paint. Some smooth, absorbent, lint-free rags are good for wiping mistakes off your painting surface. Paper towels or a stack of old newspapers (a lot cheaper than paper towels) are essential for wiping your brush when you've rinsed it in turpentine. For stretching your own canvas, buy a hammer (preferably with a magnetic head), some nails or carpet tacks about 3/8″ (9-10 mm) long, scissors, and a ruler.

Work Layout. Before you start to paint, lay out your equipment in a consistent way so that everything is always in its place when you reach for it. If you're right-handed, place the palette on a tabletop to your right, along with a jar of turpentine, your rags and newspapers or paper towels, and a clean jar in which you store your brushes, hair end up. Establish a fixed location for each color on your palette. One good way is to place your *cool* colors (black, blue, green) along one edge and the *warm* colors (yellow, orange, red, brown) along another edge. Put a big dab of white in one corner, where it won't be fouled by other colors.

Bristle Brushes. The brushes most commonly used for oil painting are made of stiff, white hog bristles. The filbert (top) is long and springy, comes to a slightly rounded tip, and makes a soft stroke. The flat (center) is also long and springy, but it has a squarish tip and makes a more precise, rectangular stroke. The bright (bottom) also has a squarish tip and makes a rectangular stroke, but it's short and stiff, digging deeper into the paint and leaving a strongly textured stroke.

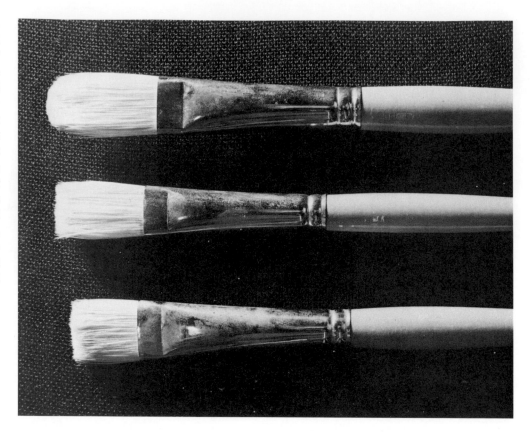

Softhair Brushes. Although bristle brushes do most of the work in oil painting, it's helpful to have some softhair brushes for smoother, more precise brushwork. The top two brushes here are sables: a small, flat brush that makes smooth, rectangular strokes; and a round, pointed brush that makes fluent lines for sketching in the picture and adding linear details such as leaves, branches, or eyebrows. At the bottom is an oxhair brush, and just above it is a soft, white nylon brush; both make broad, smooth, squarish strokes.

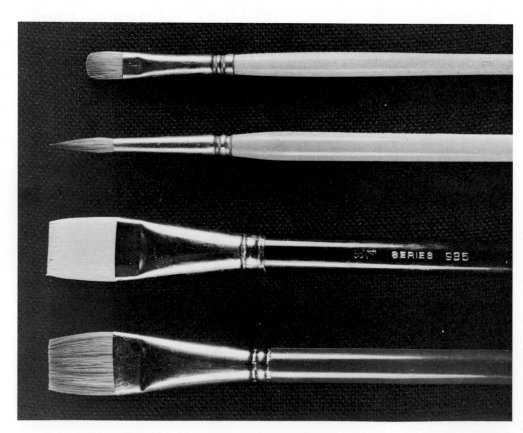

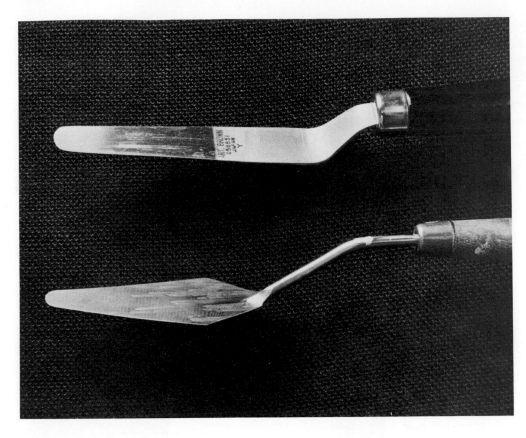

Knives. A palette knife (top) is useful for mixing color on the palette, for scraping color off the palette at the end of a painting session, and for scraping color off the canvas when you're dissatisfied with what you've done and want to make a fresh start. A painting knife (bottom) has a very thin, flexible blade that's specially designed for spreading color on the canvas.

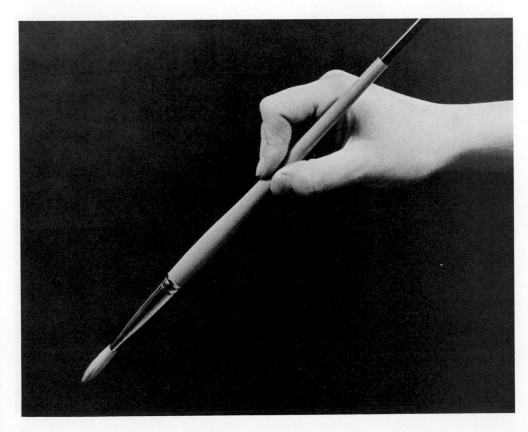

Holding the Brush. Your brushwork will be bold, free, and relaxed if you hold the brush at least halfway up the handle. As you become more confident, your strokes may become bolder still, and you'll want to hold the brush still farther back. There *may* be times when you'll want to hold the brush closer to the bristles in order to paint precise details; but don't get into the habit, or your strokes will become small and constrained.

EQUIPMENT

Easel. For working indoors, a wooden studio easel is convenient. Your canvas board, stretched canvas, or gesso panel is held upright by wooden "grippers" that slide up and down to fit the size of the painting. They also adjust to match your own height. A studio easel should be the heaviest and sturdiest you can afford so that it won't wobble when you attack the painting with vigorous strokes.

Paintbox. A paintbox usually contains a wooden palette that you can lift out and hold as you paint. Beneath the palette, the lower half of the box contains compartments for tubes, brushes, knives, bottles of oil and turpentine, and other accessories. The lid of the palette often has grooves into which you can slide two or three canvas boards. The open lid will stand upright—with the help of a supporting metal strip which you see at the right—and can serve as an easel when you paint outdoors. You can also buy a lightweight, folding outdoor easel if you prefer.

Palette. The wooden palette that comes inside your paintbox is the traditional mixing surface that artists have used for centuries. A convenient alternative is the paper tear-off palette: sheets of oilproof paper that are bound together like a sketchpad. You mix your colors on the top sheet, which you then tear off and discard at the end of the painting day, leaving a fresh sheet for the next painting session. This takes a lot less time than cleaning a wooden palette at the end of the painting day. Many artists also find it easier to mix colors on the white surface of the paper palette than on the brown surface of the wooden palette, since the paper is the same color as the white canvas.

Brush Washer. To clean your brush as you paint, rinse it in a jar of turpentine or mineral spirits (called white spirit in Britain). To create a convenient brush washer, save an empty food tin after you've removed the top; turn the tin over so that the bottom faces up; then punch holes in the bottom with a pointed metal tool. Drop the tin into a wide-mouthed jar—with the perforated bottom of the tin facing up. Then fill the jar with solvent. When you rinse your brush, the discarded paint will sink through the holes to the bottom of the jar, and the solvent above the tin will remain fairly clean.

Paint Tube. When you squeeze color out of a tube, squeeze the tube at the far end and roll up the empty portion. In this way you'll get the maximum amount of color out of the tube—and the maximum amount of paint for your money.

Palette Cups (Dippers). These two metal cups have gripping devices along the bottom so that you can clamp the cups over the edges of your palette. One cup is for turpentine or mineral spirits to thin your paint as you work. (Don't use this cup for rinsing your brush; that's what the brush washer is for.) The other cup is for your painting medium. This can be pure linseed oil; a 50-50 blend of linseed oil and turpentine that you mix yourself; or a painting medium that you buy in the art supply store—usually a blend of linseed oil, turpentine, and a natural resin such as damar, copal, or mastic. Be sure to clean your palette cups at the end of the painting day, or they'll get gummy.

Canvas. The most popular surface for oil painting is cotton or linen canvas. Canvas boards—inexpensive fabric that's covered with white paint and glued to stiff cardboard—are sold in every art supply store. Beginners usually start by painting on canvas boards and then switch to stretched canvas later on. You'll find instructions for stretching your own canvas—which means nailing the fabric to a rectangular wooden framework—later in this book. The weave of the canvas softens your brushstrokes and makes it easy to blend the paint, as you can see in the soft forms of these clouds. The texture of the canvas generally shows through unless you apply the paint very thickly.

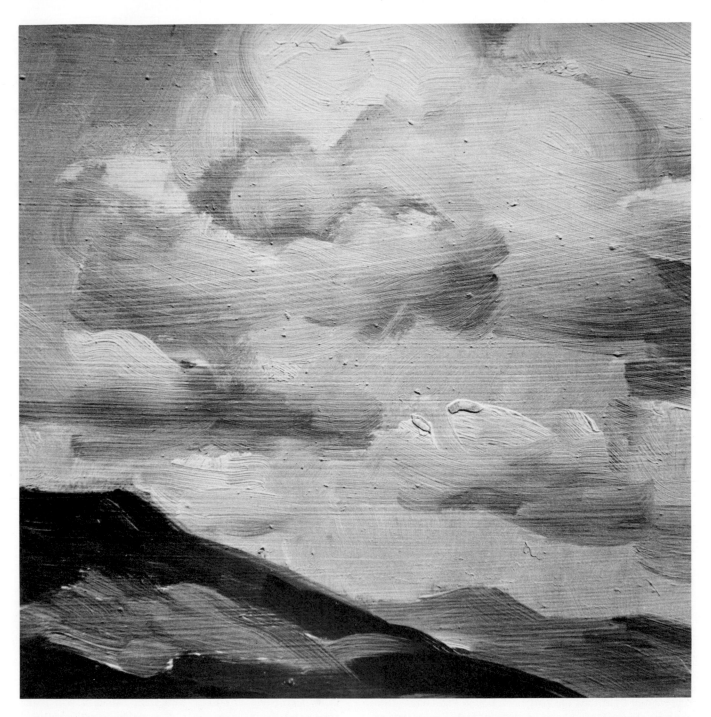

Panel. Some painters prefer to work on the smoother surface of a panel. Today, this is usually a sheet of hardboard that's the modern replacement for the wood panels used by the old masters. Like canvas boards and stretched canvas, the panel is coated by the manufacturer with a layer of white oil paint or white gesso. It's easy and inexpensive to prepare your own panels. Most art supply stores stock acrylic gesso, a thick, white paint which you brush onto the hardboard with a nylon housepainter's brush. As it comes out of the jar or the can, the gesso is thick. For a smooth painting surface, thin the gesso with water to a milky consistency and then apply several coats. If you like a rougher painting surface, apply the gesso undiluted or add just a little water; your nylon brush will leave delicate grooves in the gesso, as you see here. Even when the gesso has a slight texture, the brush glides more smoothly over a panel than over canvas. Thus, brushwork on a panel has a smoother, more fluent look, as you can see in these clouds.

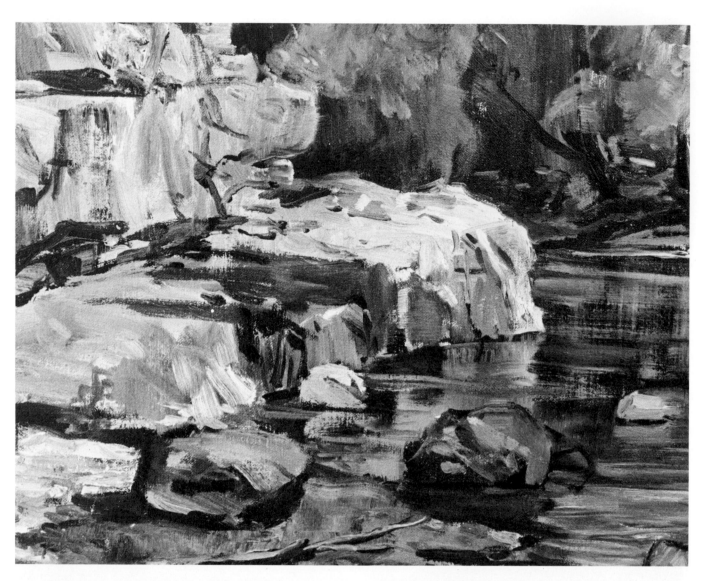

Thick Color. As it comes from the tube, oil paint is a thick paste. The manufacturer adds just enough linseed oil to the powdered pigment to produce a rich, buttery consistency that comes easily out of the tube—but the paint is far from fluid. If you like to paint with thick color, you can dip your bristle brushes into the mounds of color on your palette and go right to work. But most painters like to work with color that's more fluid than the pasty compound that comes from the tube. Even if you like to work with thick, rough strokes, it usually helps to add just a bit of painting medium to make the paint more brushable. How much medium you add will depend on the subject and the kind of brushwork you have in mind. The rough surfaces of these rocks are painted with heavy strokes of color that's only a bit more fluid than the paint that comes from the tube. For this kind of rugged brushwork, add just a touch of painting medium, whether it's pure linseed oil, a 50-50 blend of linseed oil and turpentine, or one of the resin mediums you buy in the art supply store. Don't add any extra turpentine, since it will make your paint much more fluid. For thick, heavily textured strokes that show the marks of the brush, it also helps to work with your shortest, stiffest bristle brushes.

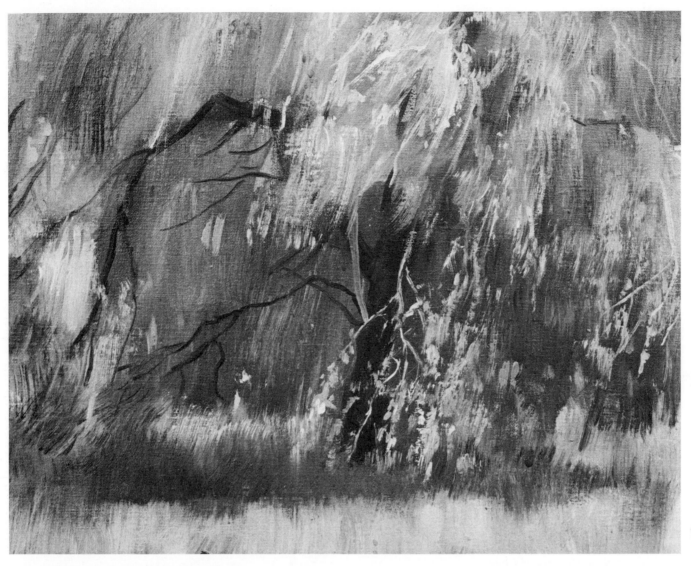

Thin Color. The soft, blurry forms of this willow tree are painted with thin color that's diluted with a lot of painting medium. Here's where it really helps to add some extra turpentine to make the paint more fluid. However, just turpentine isn't enough. You'll find that pure turpentine not only makes the paint thinner but also reduces the rich, oily consistency of the paint. For soft, subtle brushwork, you want paint that's both thin *and* oily. So you've got to add some more linseed oil or resin medium, along with the turpentine. This blend of turpentine and oil produces just the right consistency for these big blurry strokes, as well as the more precise linear strokes of the branches and leaves. You also have to choose the right brush to match the consistency of the paint. Here, the broad, soft strokes are made by a large filbert. The slender, precise strokes are made by a round sable.

Step 1. To try out your bristle brushes, find some roughly textured subject like this tree. For the first sketchy lines on the canvas, thin your tube color with lots of turpentine and work with the tip of the brush. Keep the paint as thin as watercolor so that the brush sweeps quickly over the canvas—you can wipe off the strokes with a rag if you want to make any changes. Don't be too careful with these first strokes; most of them will be obliterated by the heavier strokes that come next.

Step 2. Now, working with slightly thicker color—add some linseed oil along with the turpentine—start to brush in the clusters of leaves with broad, free strokes. Notice that many of the strokes in Step 1 have already disappeared under the leaves. Working with the tip of the brush, you can add some darks for the shadows on the trunks. Don't worry about details at this early stage. The idea is to cover the canvas with broad masses of color.

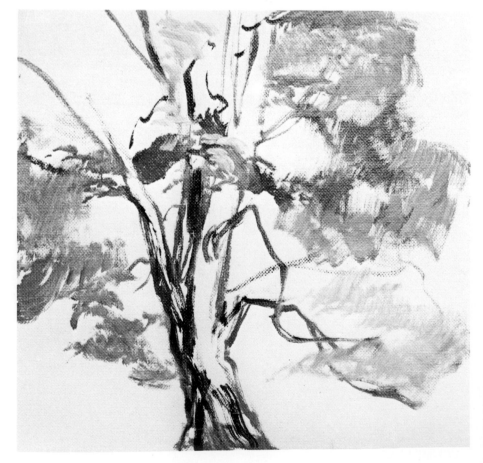

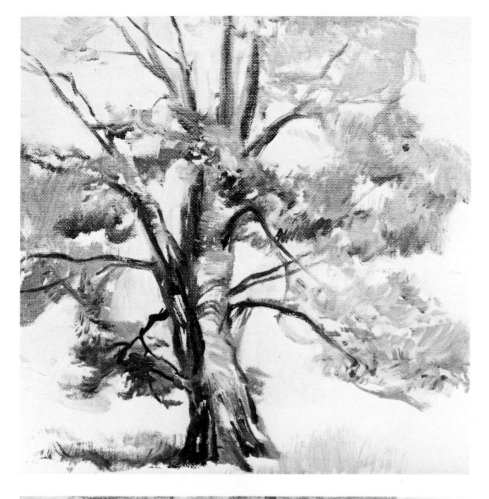

Step 3. By the time you're finished with Step 2, all the clusters of leaves should be covered with rough strokes of color. These are what painters call the middletones—tones that are darker than the lightest parts of the picture, but lighter than the darkest parts. When you have enough middletones on the canvas, you can start to add some darks: the shadows under the clusters of leaves; some more shadows on the trunk and branches; and the shadow cast by the trunk on the grass to your left. Now you're working with the tip of the brush and the strokes are smaller. But don't make your strokes too precise. Work with free movements.

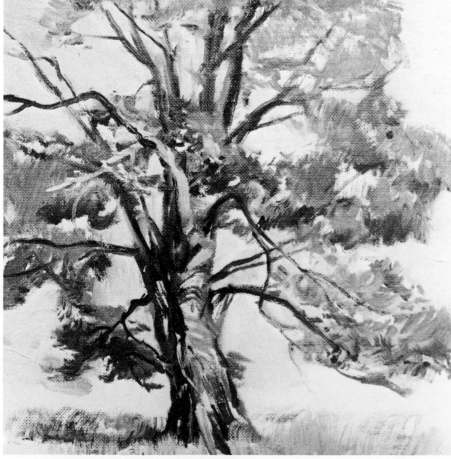

Step 4. Save the brightest touches of light and the details for the very end. Use the tip of the brush to indicate the sunstruck branches and leaves. You can also use the tip of the brush to add darks to the branches—and to add some more branches. Just use the tip to suggest a few leaves. Now you have some idea of the different kinds of strokes you can make with bristle brushes: broad, scrubby strokes for the clusters of foliage; linear, rhythmic strokes for the branches; and mere touches for a few leaves.

Step 1. To learn what your softhair brushes can do, find some subject— like these birches—that lends itself to smooth, linear brushwork. Once again, start out by thinning your tube color with plenty of turpentine so that you can draw the main lines of the composition with the tip of the brush. These trunks are drawn with the tip of a round sable. In fact, this whole demonstration is done with sables, but it's worth noting that exactly the same job could be done with white nylon brushes, which are a lot less expensive!

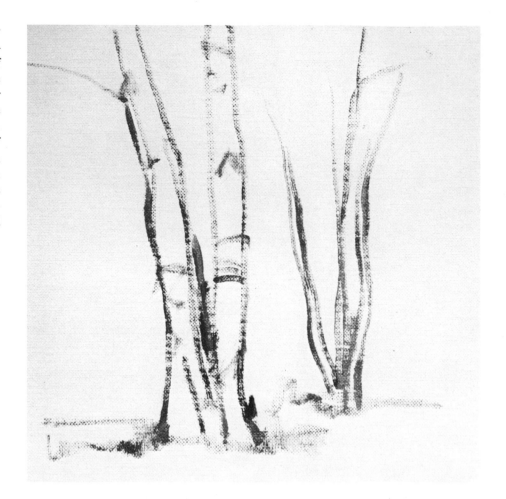

Step 2. In the early stages of a painting, the most important thing is to cover the canvas with broad strokes of wet color. The sky is painted with horizontal and vertical strokes made by a flat softhair brush, leaving bare canvas for the trunks. The darks at the bottoms of the trunks and along the ground are painted with a round softhair brush. Note that the sky is painted right over the smaller tree, which is almost obliterated. This is no problem; the tree will be repainted right over the sky. You can see the marks of the brush in the sky, but they're much smoother and less distinct than the strokes made by the bristle brush in the preceding demonstration.

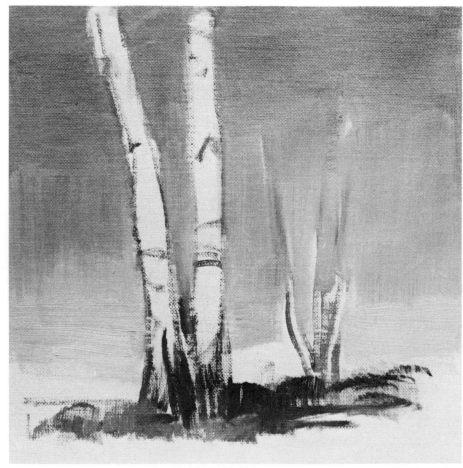

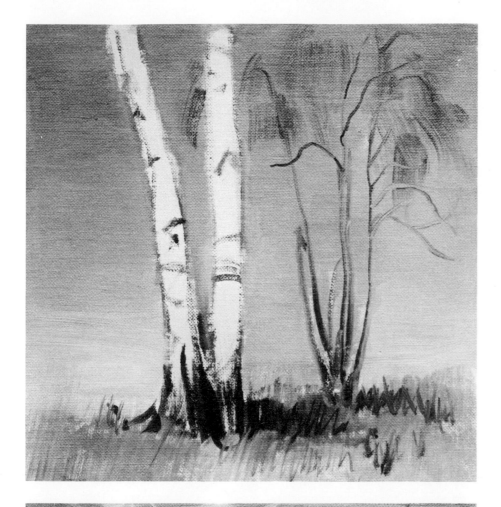

Step 3. Here's where you can see the unique character of softhair brushwork. The sky is blended with the overlapping, horizontal strokes of a flat softhair brush, producing a lovely gradation from dark to light and almost eliminating the marks of the brush. Then the tip of a round softhair brush reestablishes the slender trunks of the smaller tree and indicates the texture of the grass. For such smooth brushwork, you need fluid paint that contains a lot of medium.

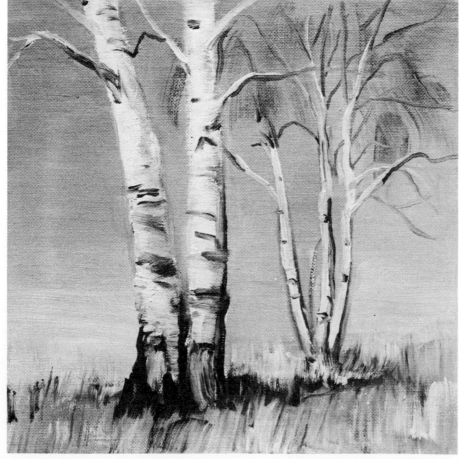

Step 4. The trunks are completed with strokes that are just a bit thicker than the sky and grass but still contain enough medium to make the paint flow smoothly. The tip of a round softhair brush adds the dark details in the bark and also adds some more blades of grass. The wispy foliage is painted with a flat softhair brush carrying just a bit of color so that you can see the tracks left by the hairs of the brush.

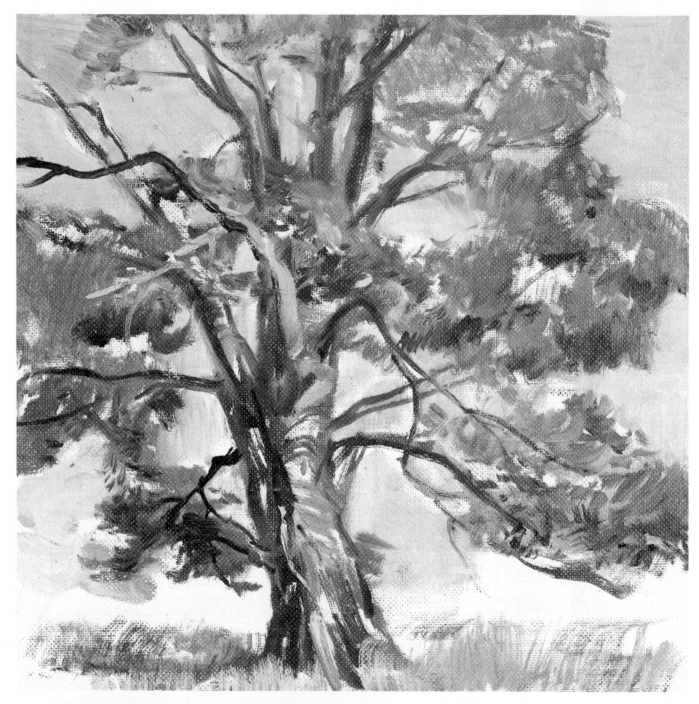

Tree in Full Leaf. The sturdy hoghairs of a bristle brush normally leave a distinct mark in the paint. Strokes made by a bristle brush usually have a slightly rough, irregular quality, which is part of their beauty. These big, stiff brushes are actually capable of far more precision than you might think. If you work with the whole body of the brush, you can produce broad strokes like those in the masses of leaves. If you work with the very tip of the brush, moving it sideways so that only the edge touches the canvas, you can produce slender strokes, like these branches and twigs. A quick touch of the tip or the corner of the brush can suggest such details as the individual leaves among the lower foliage.

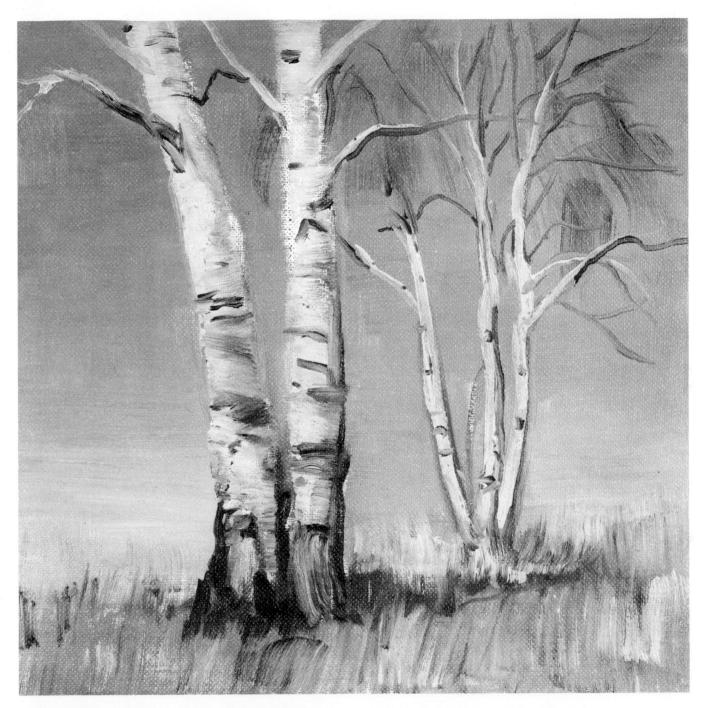

Clump of Bare Trees. A sable, oxhair, or white nylon brush is made of much softer hairs that apply the paint more smoothly and leave very little impression on the painting surface. If you work with thin paint and move the brush back and forth to blend the strokes, you can practically eliminate the mark of the brush—as you see in the sky behind these birches. When you apply the paint more thickly, you can see the strokes, but they're not nearly as rough as strokes made by a bristle brush. Compare the smooth trunks of these birches with the rougher trunk of the tree on the facing page. The rough strokes in the grass do look something like bristle brushstrokes, even though they're made with a softhair brush; the brush carries very little paint and is applied with quick, scrubby strokes, with spaces left between them. The thicker trunks and the smooth sky tone are painted with a flat softhair brush. The thinner trunks and branches are painted with a round softhair brush. Bristle brushes can carry lots of thick color, containing very little medium. But to work effectively with softhair brushes, add enough medium to make the paint more fluid.

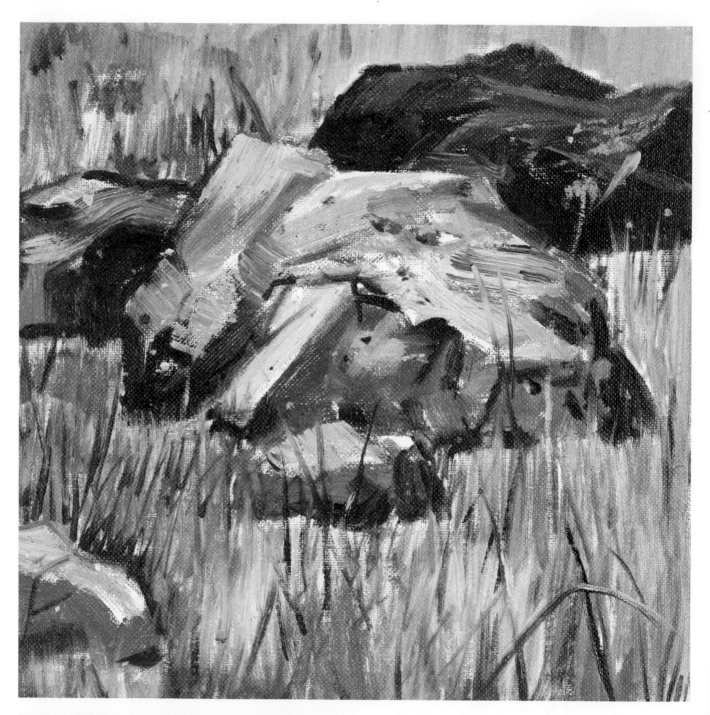

Rocks and Grass. Using both bristle and softhair brushes will give you a rich vocabulary of brushstrokes. In the sunlit tops and shadowy sides of these rocks, you can see the thickly textured strokes made by bristle brushes carrying a heavy load of color, diluted with only a touch of medium. The thinner, smoother color of the grass is made by softhair brushes carrying fluid paint that contains much more medium. The rocks are painted with broad strokes made by a flat bristle brush, while the grasses and weeds are painted with the tip of a round softhair brush.

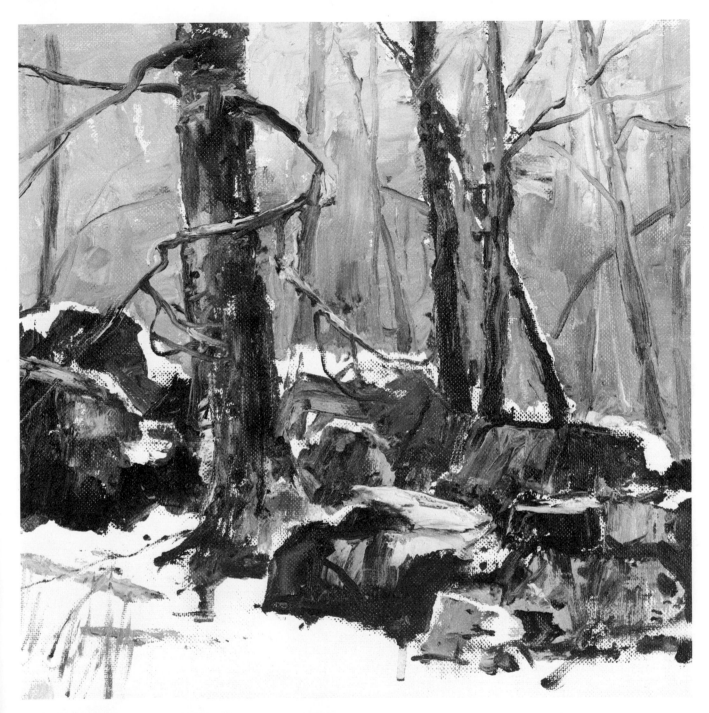

Trees and Rocks. A bristle brush and a painting knife can both carry thick color and make bold, heavy strokes. These two painting tools work well together. The knife applies the broad, irregular planes of color that don't require much precision, such as the tones between the trunk and the distant trees, the broader strokes on the trunks, and the light and shadow planes on the rocks. The bristle brush is used to paint the more precise forms of the trunks, the branches, and the details of the rocks. Look closely and you can see the imprint of the bristles in contrast with the smoother paint left by the knife blade.

Step 1. Now try combining bristle and softhair brushes to see how many different kinds of strokes you can produce. Try to find some subject that combines big, rough forms and soft, delicate forms, like these rocks and weeds. Once again, begin by brushing in the main forms with fluid color thinned with lots of turpentine. A round softhair brush is usually best for this job.

Step 2. It's always best to begin by covering the broadest areas of the picture with big strokes. The rocks are quickly covered with flat strokes made by a big bristle brush. The stiff bristles leave distinct grooves in the paint, accentuating the rough character of the rocks. Such thick strokes contain only a little medium—or no medium at all—so that the paint remains a heavy paste.

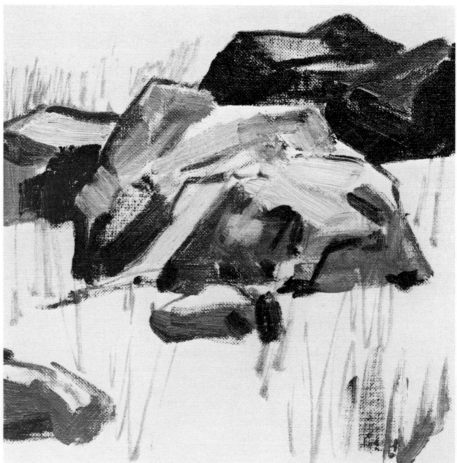

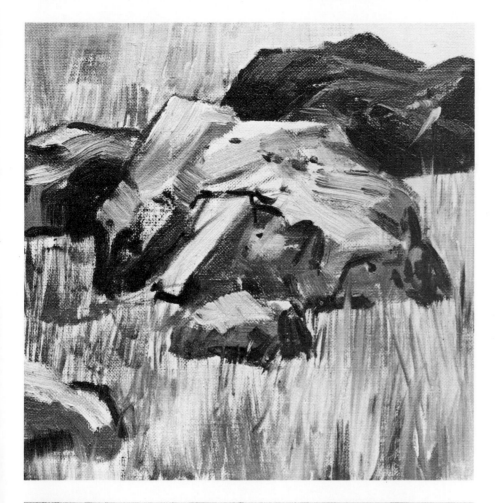

Step 3. Now the round softhair brush comes into play. Because the softhair brush can't handle thick, pasty color, the paint is thinned with medium to a more fluid consistency. Then the rocks are surrounded with thin, fluid strokes for the grass. Some strokes are dark, while others are light, and the softhair brush easily blends them together. The bristle brush returns to complete the rocks with thick strokes.

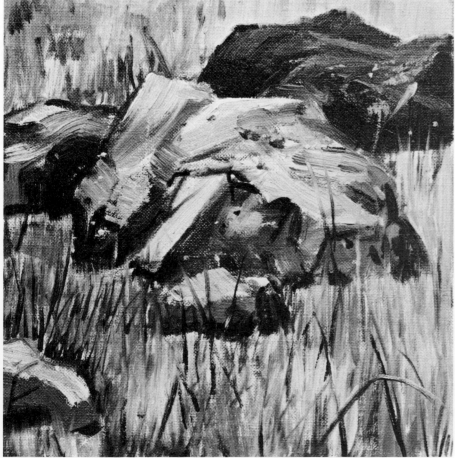

Step 4. By the end of Step 3, the entire canvas is covered with broad masses of color, with very little attention to detail. The details are saved for the final step, when the tip of the round softhair brush adds more blades of grass and weeds, a few lighter flecks for wildflowers, and a crack to the rock in the lower left area.

Step 1. A bristle brush and a painting knife are an ideal combination for painting big, rugged forms with rough textures such as a landscape with treetrunks and rocks. When you try out this combination of painting tools, work with thick color. You may be surprised to discover that you can draw the composition on the canvas with the edge of the knife, as you see here. Pick up some color on the underside of the knife. To make the slender lines of the trunks, just touch the side of the knife to the canvas and pull the blade downward, as if you're slicing bread. For thicker lines, such as those on the rocks or at the bases of the trees, press the edge of the blade against the canvas and pull slightly sideways to spread the paint.

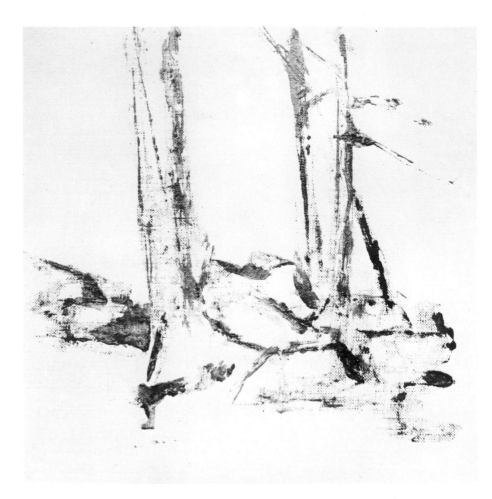

Step 2. Now working with the underside of the blade covered with thick color, you can spread broad strokes on the canvas very much as you'd spread butter on a slice of bread. The rocks are painted with broad, squarish strokes made by the flat underside of the blade. For the slender trunks at the right, you pick up color under the tip of the blade and use it like a brush, pulling the knife downward over the canvas. The broader trunk is painted partly with the tip and partly with the entire underside of the blade, not carrying too much paint, so some patches of bare canvas show through.

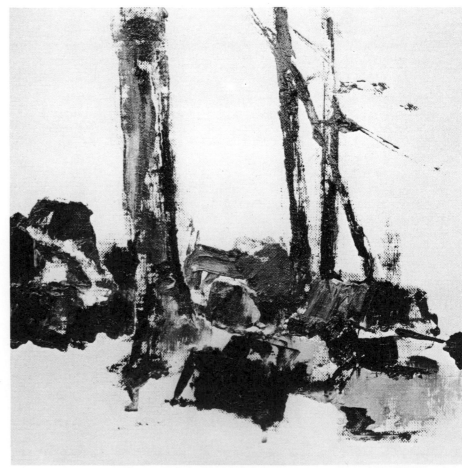

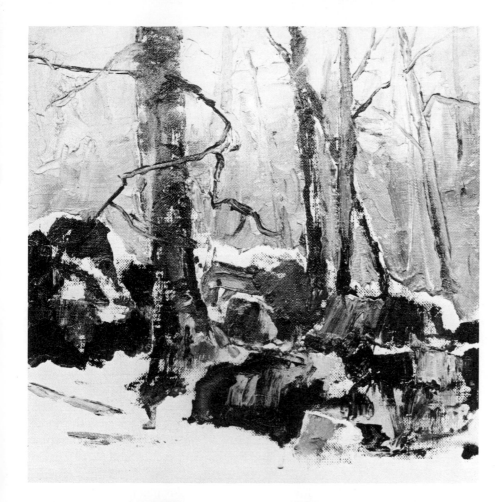

Step 3. The pale tones of the misty woods behind the trees are painted with broad strokes of the underside of the blade. More trunks are added with the tip of the blade. The curving branches on the thicker trunk are painted with curving strokes of the tip. More squarish strokes are added to the rocks in the lower right.

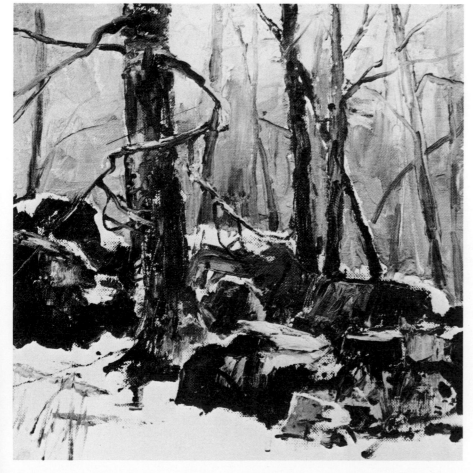

Step 4. Now the bristle brush comes into play to strengthen certain forms and add final details. Brushstrokes are carried right over the knifestrokes to strengthen the trunks and the branches. More branches are added by the brush—a job which is too precise for the knife. On the rocks and on the big trunk, the knife blends the lights and darks just a bit and roughens the smooth knifestrokes to create a more ragged texture. When you've painted most of the picture with a knife, don't overdo the brushwork. Use the brush selectively and then stop.

Setting the Palette. Obviously, you start the painting day by squeezing out your dozen colors on the palette. Squeeze the collapsible tube from the end, replace the cap, and then roll up the empty portion of the tube. You'll get more paint out of the tube this way—which means that you'll save money on expensive artists' colors. It's usually best to place these colors along the top edge of the palette and along the left side if you're right handed, or along the right side if you're left handed. Keep the center and the lower edge of the palette clear for mixing color. Keep the paint in the mixing area away from the edges of the palette where the fresh color is stored. Don't let the mixtures foul the mounds of pure color.

Mixing Colors. Above all, think before you mix. Decide on the hue you're hoping to mix and then decide exactly which colors you're going to move from the edges of the palette to that central mixing surface. Don't wander around the palette, poking your brush into various colors at random, then scrubbing them together "to see what happens." Plan your color mixtures in advance: pick up a generous amount of each color with the tip of your brush or your palette knife; then blend them in the center of the palette with decisive movements. If you prefer to mix with the brush, scrub the colors together with a circular or back-and-forth movement, but don't spread the color too far—try to keep it in one place. Many professionals prefer to mix with the palette knife, claiming that they get brighter, cleaner mixtures because they can wipe the knife blade absolutely clean before they dip the blade into fresh color. Use a circular movement when you mix with the knife, spreading the paint out, then heaping it together and spreading it out again until the color blends smoothly.

Avoiding Mud. Two or three colors, plus white, should give you just about any color mixture you need. One of the unwritten "laws" of color mixing seems to be that more than three colors—not including white—will produce mud. If you know what each color on your palette can do, you should never really *need* more than three colors in a mixture. And just two colors will often do the job. It's also important to keep your knives and brushes as clean as you possibly can. Before you pick up a fresh color, rinse your brush in turpentine and make sure to wipe away most of the turpentine on a sheet of newspaper or a paper towel. You can keep your knife blade clean and shiny by wiping it frequently with a paper towel.

Diluting Color. Pure tube color is generally too thick for lively, fluent brushwork. That's why you've got those palette cups (or "dippers") full of linseed oil and turpentine—or perhaps one of those resin painting mediums you read about awhile back. In the earliest stages of painting, when you're making your preliminary brush drawing, you can thin your color to a very fluid consistency with pure turpentine. But once you begin to cover the canvas with color, then it's important to dilute your color with a 50-50 mixture of linseed oil and turpentine, or with a resin medium. This preserves the creamy consistency of the paint, which pure turpentine tends to break down. It's important to keep those cups of medium and solvent as clean as possible. Before you dip a brush into the cup, wipe the hairs with a paper towel or rag, or rinse the brush in turpentine and dry it on a piece of newspaper.

Testing Color Mixtures. One of the most productive ways to spend an afternoon is to run a simple series of tests that reveal how all the colors on your palette behave when they're mixed with one another. Be methodical about it. Take a dozen sheets of canvas-textured paper and mark each sheet with the name of just one color on your palette. Then mix that color with every single hue on your palette and paint a patch of that mixture on the paper, about 1″ (25 mm) square. At the lower edge of each color patch, scrub in a little white to record how the mixture changes when you lighten it. If you have the time and the patience, it's particularly interesting to try each mixture two or three times, varying the proportions of the colors. For instance, if you're mixing cadmium red and cadmium yellow, first try a mixture in which the red and yellow are added in equal quantities; then try more red and less yellow; finally, try more yellow and less red.

Color Charts. Be sure to label each color patch with the names (or perhaps just the initials) of the colors in the mixture. Now you've got a series of color charts which you can tack on your wall and study when you're planning the color mixtures in a painting. The whole job of making these charts won't take more than a few hours and will save you countless days of frustration when you're actually mixing the colors for a picture. After awhile, all these color mixtures will be stored in your memory, and you'll no longer need the charts. But while you're learning, they're a great convenience. Making these charts is the fastest way to learn how to mix colors—and they're fun to do.

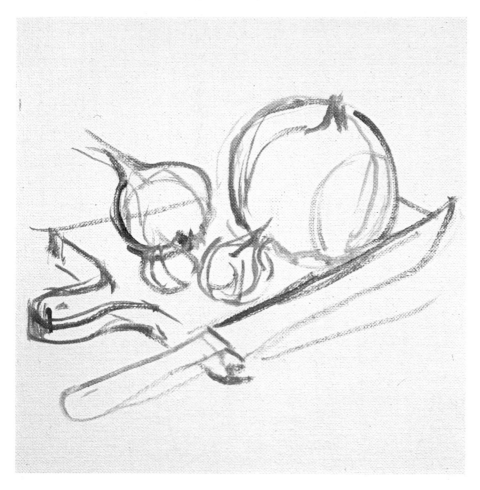

Step 1. When you're learning how to handle oil paint, it's best to begin by painting a few simple, familiar household objects such as these vegetables and kitchen utensils. Just group them casually on a table-top and go to work. Sketch the forms on the canvas with a few charcoal lines. Use a clean rag to dust off most of the charcoal, leaving the lines very faint. Then rein-force the lines with the tip of a round softhair brush dipped in some quiet color such as burnt umber and diluted with plenty of turpentine.

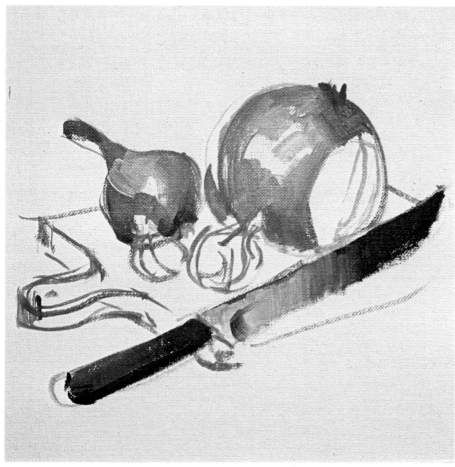

Step 2. The next step is to cover the most important shapes in the picture with broad strokes of color. Use your biggest bristle brushes and don't worry about details. In the early stages, the paint shouldn't be too thick, so add enough medium to give you a creamy consistency. The big onion is painted with cadmium yellow, ultramarine blue, and burnt sienna. The smaller onion is burnt sienna, yellow ochre, and white with some ultramarine blue added in the darks. The darks of the knife are also burnt sienna and ultra-marine blue, with the yellow onion mixtures reflected in the lighter part of the blade.

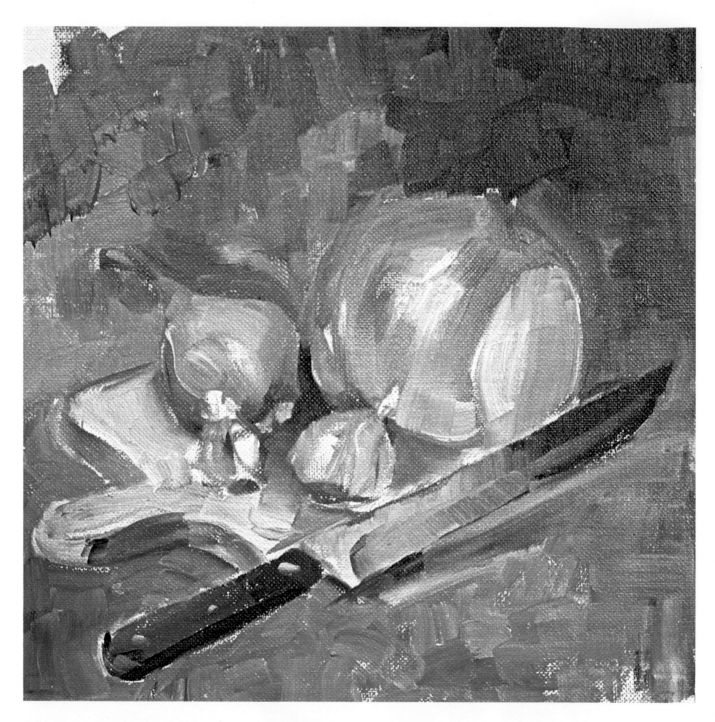

Step 3. Having covered the main shapes with color, your next goal is to cover the entire painting surface. Once again, work with your biggest bristle brushes and use bold, free strokes, paying no attention to details. Don't worry if the painting looks rough and perhaps a bit sloppy; you'll fix that in the final stage. Right now just think about broad areas of color. The dark tone above and behind the onions is a mixture of burnt umber, ultramarine blue, yellow ochre, and white. You can see the broad, squarish strokes of the big bristle brush—there's no attempt to blend them or smooth them out. This same mixture is carried down over the tabletop, switching from burnt umber to burnt sienna, then adding more yellow ochre and white. The rounded forms of the two onions are shaped with strokes of the shadowy background mixture plus more white; notice how the strokes curve around the forms. The cut side of the big onion is painted with vertical strokes of this mixture plus a lot of white. The smaller shapes of the garlic are painted with free, curving strokes of ultramarine blue, burnt umber, and white. The top of the wooden breadboard is painted with this mixture, with less white in the shadow between the onions and the garlic. This same shadow tone appears on the side of the handle of the breadboard, along with some strokes of the yellowish tone used on the big onion. More of this yellowish tone is blended into the knife blade to suggest a reflection in the shiny metal. Part of the knife handle is lightened with a mixture of burnt sienna, yellow ochre, ultramarine blue, and white.

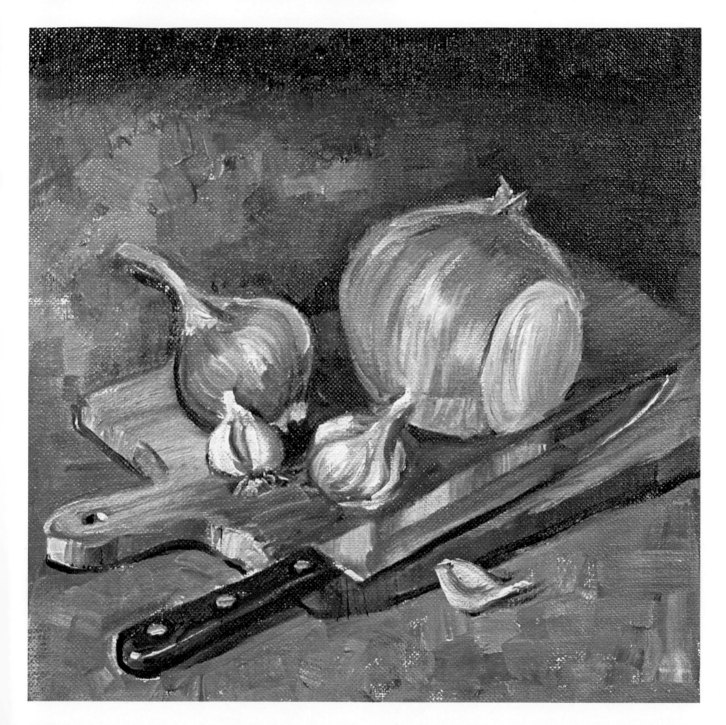

Step 4. By the end of Step 3, the entire picture is covered with wet, juicy color. So far, all the work is done with big bristle brushes. Only in the final stage do smaller bristle brushes and a softhair brush come into play. The tip of a small bristle brush is used to draw curving strokes over the rounded forms of the onions and garlic: mixtures of ultramarine blue, yellow ochre, burnt umber or burnt sienna, and white for the darker strokes; burnt umber, yellow ochre, and lots of white for the paler strokes. The same brush carries the same mixtures across the top of the breadboard to suggest the grain of the wood. The edge of the breadboard is darkened with ultramarine blue, burnt sienna, and a little white. Then the tip of a round softhair brush draws lines of this same mixture over the garlic and into the knife blade. The softhair brush then draws darker lines of the same mixture (containing less white) along the undersides of the vegetables, breadboard, and knife, to suggest shadows. This same brush adds touches of detail such as the rivets in the knife handle and the hole in the breadboard handle, plus a stroke of pure white toward the tip of the knife blade. A flat softhair brush blends and smoothes the background tone in the upper right area, adding some strokes of ultramarine blue, burnt sienna, and white to suggest the edge of the tabletop disappearing into the darkness. But the blending isn't carried too far—most of the original brushwork remains, still rough and spontaneous.

Step 1. Fruit is another common subject which is easy and delightful to paint. Rather than sketching your preliminary lines in charcoal, you might like to try working directly with a round softhair brush, burnt umber, and plenty of turpentine so that the lines won't be too dark. Then you can reinforce and correct these first lines with a darker mixture containing less turpentine. Here, you can see where the dark lines are drawn right over and around the lighter ones.

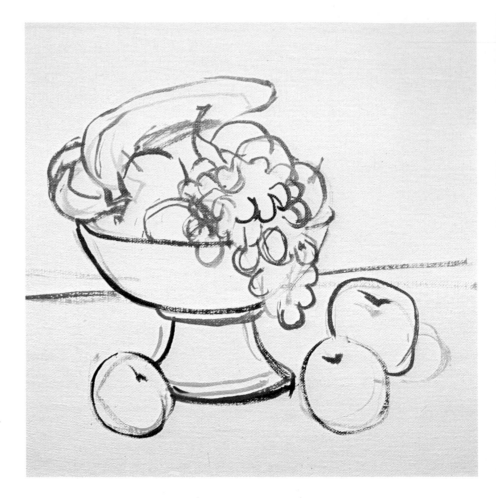

Step 2. Following the same basic method, start out once again by covering some of the important shapes with broad strokes of creamy color diluted with just enough medium to make the paint flow easily. The apples are painted with curving strokes of alizarin crimson, cadmium red, cadmium yellow, and a little white. The oranges in the bowl are quickly covered with cadmium red, cadmium yellow, and white. The bananas and the lemon on the tabletop are painted with cadmium yellow and white, softened with a touch of burnt umber and ultramarine blue.

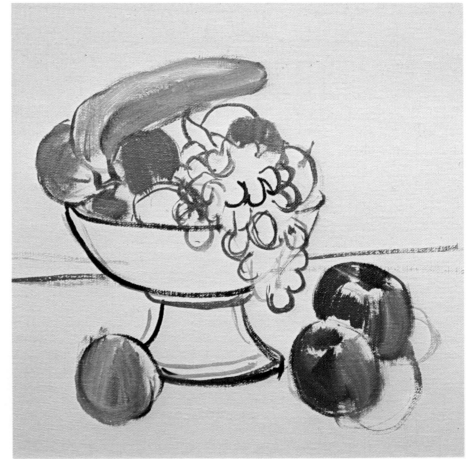

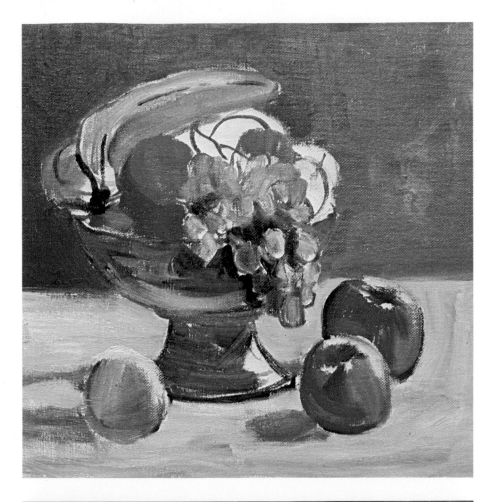

Step 3. At this stage, the goal is still to cover the entire canvas with wet color, working with big bristle brushes and not worrying about detail. The background is covered with a mixture of alizarin crimson, cadmium red, a little ultramarine blue, and white. The tabletop is brushed with horizontal strokes of burnt umber, ultramarine blue, and white—with a darker version of this mixture in the shadows. More of the apple mixture is brushed over the fruit in the bowl. The grapes are covered with dark and light strokes of ultramarine blue, cadmium yellow, burnt sienna, and white. The bowl is painted with curving strokes of ultramarine blue, alizarin crimson, and white.

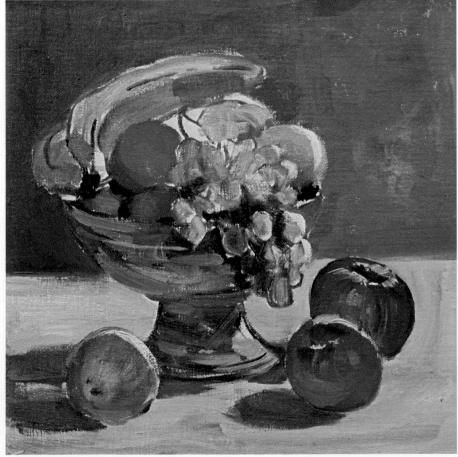

Step 4. Now smaller bristle brushes add some darks and lights to make the forms look more three-dimensional. Some burnt sienna and ultramarine blue are added to the apple mixture for the shadow sides of the apples. Some burnt umber and ultramarine blue darken the lemon on the table top. The shadows on the table are extended with this same mixture. Touches of dark are added among the fruit in the bowl with burnt sienna and ultramarine blue. The bowl is brightened with strokes of cobalt blue and white. And some strokes of almost pure white—with just a hint of cobalt blue—are drawn over the tops of the fruit to make them look shiny.

Step 5. When the canvas is completely covered with wet color, you're ready to start refining the forms. Shadows are added to the bananas with curving strokes of cadmium yellow, burnt umber, ultramarine blue, and white. A bit more white is added to the apple and lemon mixtures to soften the tones of the fruit in the bowl. Light and dark strokes of ultramarine blue, cadmium yellow, and white are drawn around the grapes with the tip of a round brush. The same brush is used to strengthen the shape of the bowl with dark lines of burnt sienna and ultramarine blue.

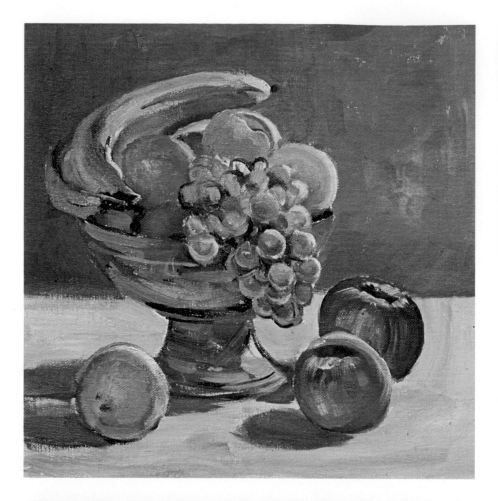

Step 6. The painting is now approaching its final stages, and it's time to begin thinking about details. So far, nearly all the work has been done with flat bristle brushes. Now a small round brush draws dark lines of burnt umber and ultramarine blue to indicate the stems of the grapes and apples, the dark patches on the banana skins, and the shadows among the grapes. This same brush is rinsed in turpentine, wiped on newspaper, and picks up a bit of pure white to suggest flashes of light on the edges of the banana, grapes, apples, and vase.

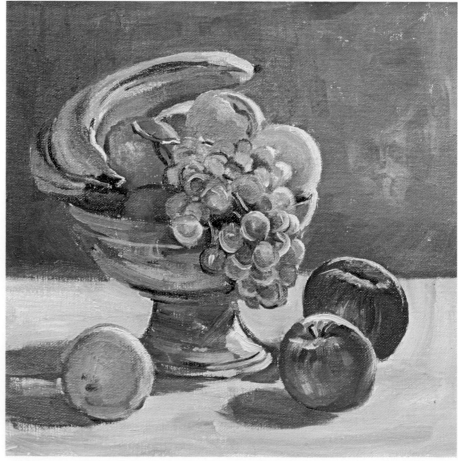

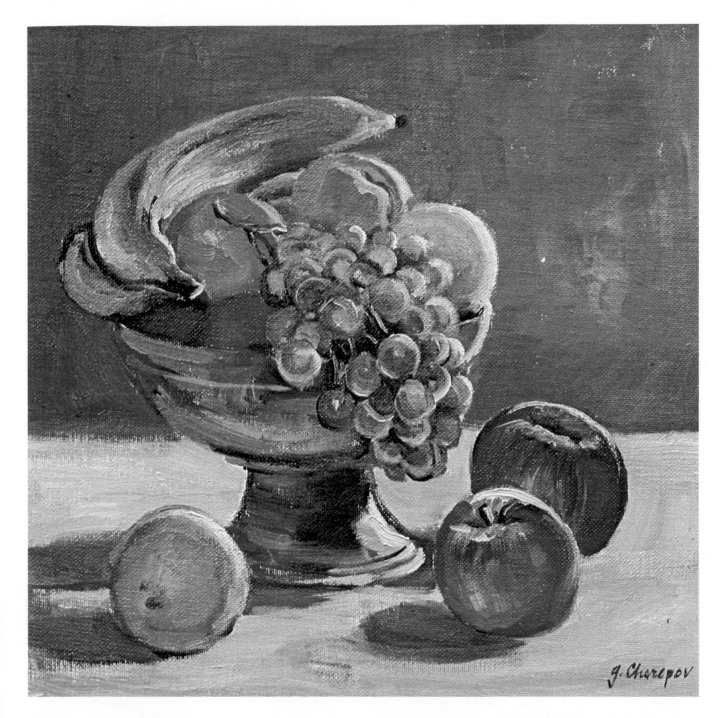

Step 7. You might think that the picture is finished at the end of Step 6—but not quite. There's still room for a few refinements. A small bristle brush adds some cadmium yellow and white to the inside of the banana and blends this bright tone into the shadow. The shadow on the base of the bowl is darkened with burnt umber and ultramarine blue. A small, flat softhair brush blends the lights and shadows on the grapes to make them more luminous—and then the round brush adds some shiny strokes of white slightly tinted with the original greenish mixture. Some of the warm background tones are blended into the light areas of the tablecloth and also into the shadows cast by the fruit and the bowl. Notice that the only touches of really thick paint are saved for these final stages: the bright tone inside the curve of the banana, the flash of light on the base of the bowl, and the lighted top of the nearest apple are painted with thick strokes that literally stand up from the canvas.

Step 1. Flowers are certainly the most popular of all still life subjects. Don't waste too much time arranging them neatly in the vase. Just arrange them casually and go to work on the preliminary drawing on the canvas. Here you can see the first pale lines of the composition, followed by darker lines drawn right over them. Notice that most of the flowers are drawn as simple, round forms, with only a few strokes to indicate petals. After all, these strokes will soon be covered with opaque color—which already begins to appear in rough strokes at the top of the bouquet.

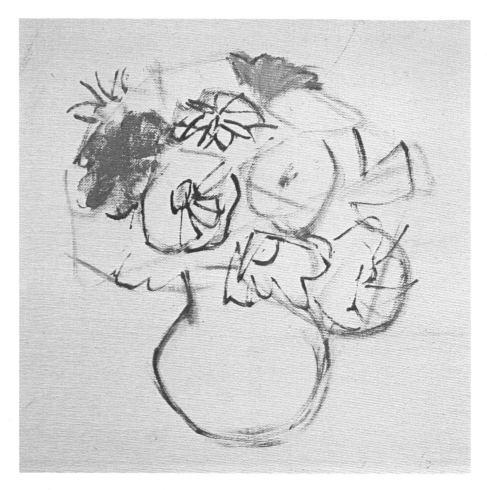

Step 2. Now begin to scrub in the colors of the flowers with your biggest bristle brushes. Just paint them as patches of bright color and don't worry about their precise forms. The red flowers are cadmium red, alizarin crimson, and a bit of ultramarine blue in the darks. The pink flowers are the same mixture, plus a lot of white. The orange flower is cadmium red and cadmium yellow, plus some white. The yellow flower at the top is cadmium yellow, white, and a touch of ultramarine blue. The darkest flower at the right is ultramarine blue, alizarin crimson, and white.

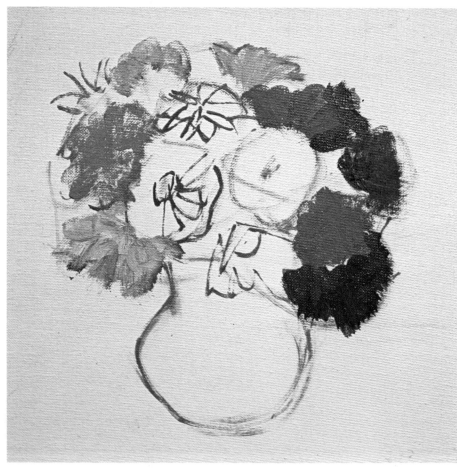

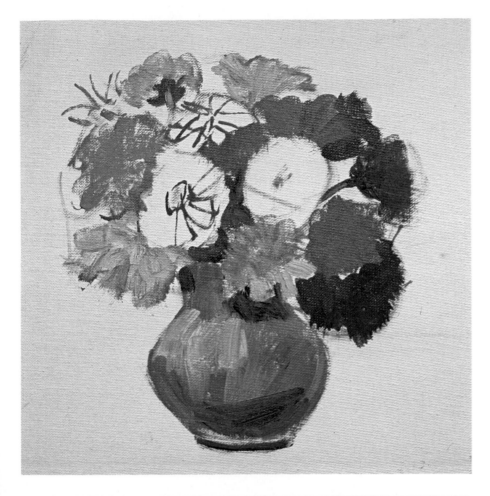

Step 3. The bristle brush now blocks in the shape of the vase with phthalocyanine blue, burnt sienna, and white. The tip of a small bristle brush adds a few stems and some other notes of green among the flowers with viridian and burnt sienna. Another yellow flower is painted with cadmium yellow and white, with a little burnt umber in the shadow area. You still can't see any petals, but the brushstrokes seem to follow the direction of the petals, and those rough dabs of color begin to look like flowers.

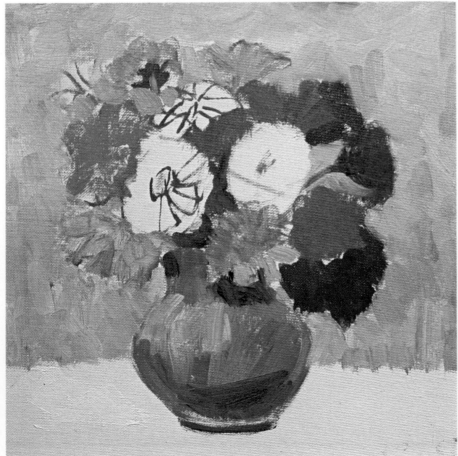

Step 4. The wall behind the flowers is painted with short, quick strokes of ultramarine blue, cadmium red, yellow ochre, and white, with a bit more yellow ochre in the upper left area. Don't worry if the background tone works its way over the edge of the flowers, which will be sharpened up in later stages.

Step 5. The tablecloth is painted with cadmium yellow, white, and a bit of burnt umber in the shadow, The flat shape of an orange flower is added to the bouquet with cadmium red, cadmium yellow, and some white. At this point, the entire canvas is covered with rough strokes of color, leaving bare canvas for just two white flowers. Not a single flower is painted in precise detail, and the entire job is done with bristle brushes.

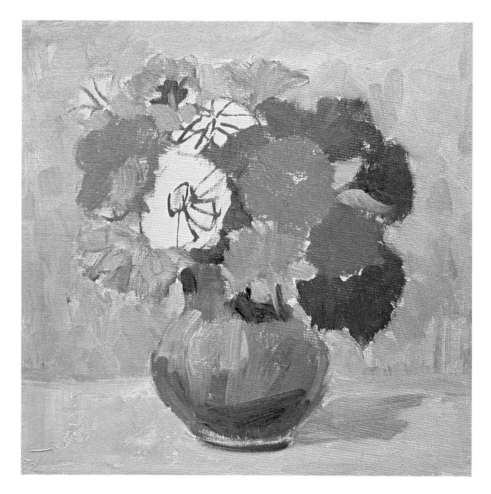

Step 6. Now the smaller bristle brushes and the round softhair brush go into action. The larger white flower is painted with white and yellow ochre in the lights, ultramarine blue, burnt sienna, yellow ochre and white in the shadows. Some burnt sienna and ultramarine blue are stroked across the tabletop to suggest folds in the cloth. The round brush picks up a fluid mixture of burnt sienna and ultramarine blue, then dashes in a few quick, casual lines to suggest the center of the flowers and some petals. The side of the vase is darkened with the original mixture used in Step 3, but which now contains less white.

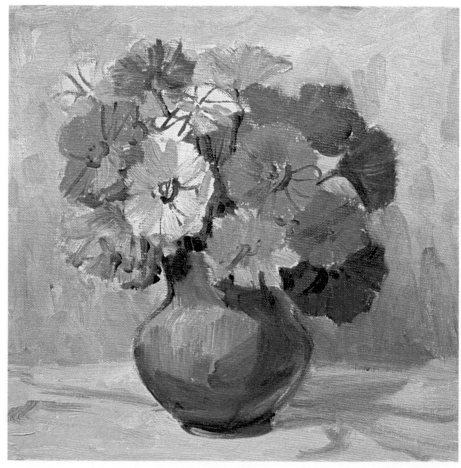

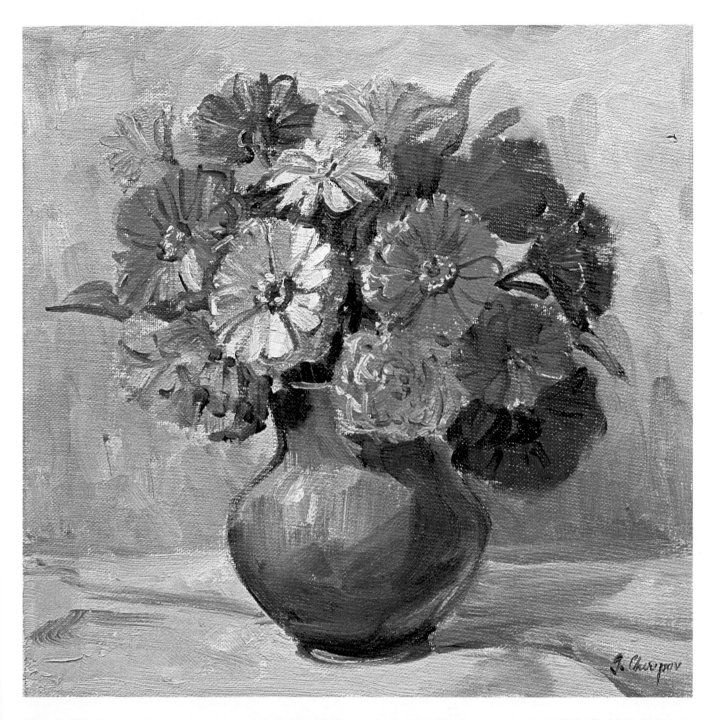

Step 7. The last precise touches are saved for the final stage. The smaller white flower is completed with the round brush, using the same mixtures used for the bigger white flower. The tip of the round brush adds more dark lines to the flowers—but doesn't paint every petal! Only a few petals are picked out in each flower. Then the round brush picks up a bright mixture of white tinted with just a little yellow ochre and adds some quick strokes to the flowers in the center of the bouquet to suggest light flashing on the petals. More leaves and other notes of green are added with viridian, cadmium yellow, and ultramarine blue. The shadow on the table to the right of the vase is darkened with this same mixture. The brushwork is worth studying carefully: the flowers look surprisingly complete, although they're nothing more than scrubby patches of color with a few light and dark lines drawn over them.

Step 1. Having painted several still lifes indoors, the logical next step is to find what might be called an outdoor still life. Try painting some big, solid objects such as a rock formation, perhaps surrounded by wildflowers. In this preliminary drawing, you can see that the pale lines of the rocks are drawn first, then corrected and reinforced by darker lines. These strokes are all burnt umber diluted with plenty of turpentine.

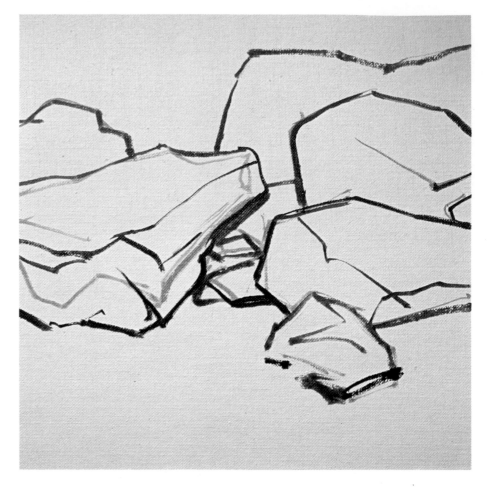

Step 2. The rocks are begun with broad, squarish strokes of a bristle brush to suggest their blocky shapes. The lighter tones are mixtures of ultramarine blue, burnt sienna, yellow ochre, and white. The darker strokes are ultramarine blue and burnt sienna. Each stroke is a slightly different combination of these colors so that some strokes are dominated by blue, others by reddish brown, and still others by yellow.

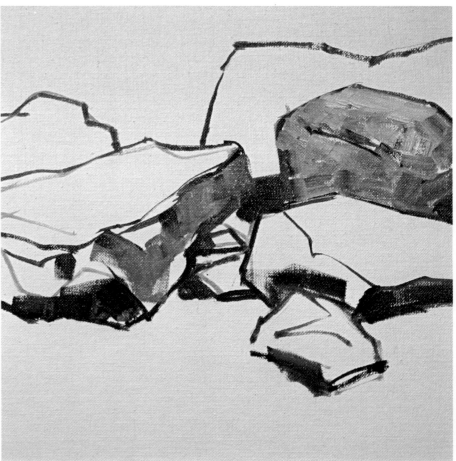

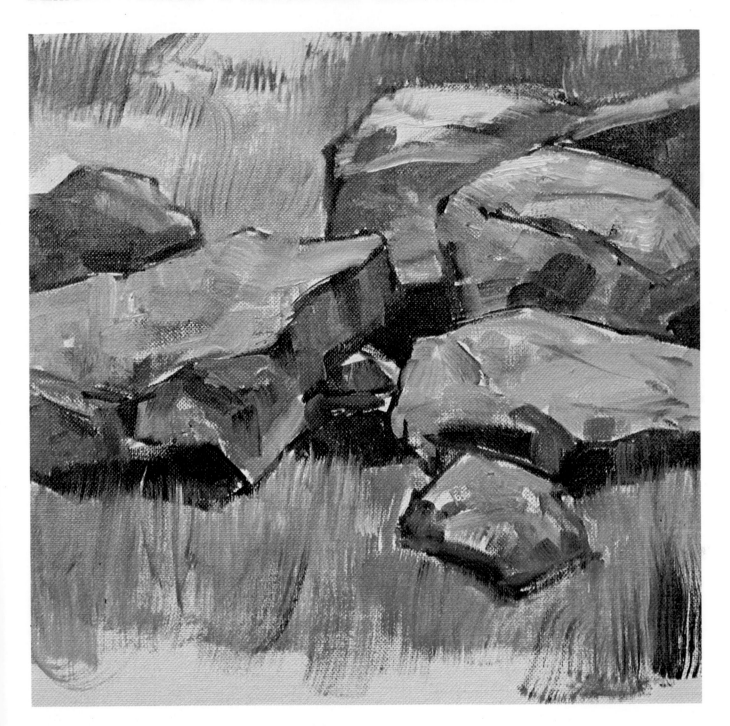

Step 3. The rocks are completely covered with broad strokes of the mixtures introduced in Step 2. The strokes aren't blended, but each stroke stands out with its own texture and color. Notice the stroke of almost pure white that suggests a flash of sunlight on the topmost rock. The meadow above and below the rocks starts out as a broad, very scrubby tone of cadmium yellow, viridian, a little burnt sienna, and a lot of turpentine, simply to cover the canvas. Then the tip of a round brush works over this mixture with rapid strokes of viridian and burnt sienna blended partly into the wet undertone and suggesting weeds and grasses. Notice how these slender strokes move up over the shadowy undersides of the rocks.

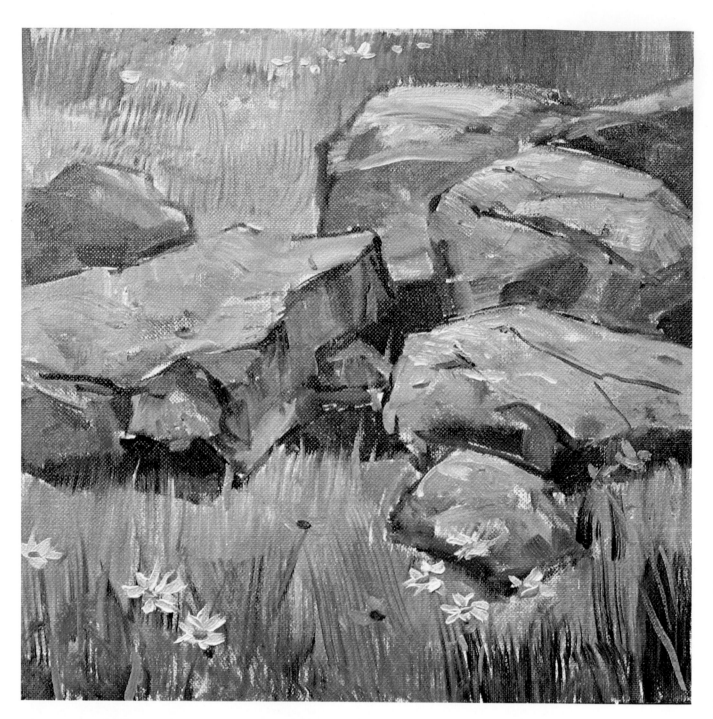

Step 4. The strokes of the meadow are carried to the top and bottom of the canvas with the same round softhair brush. Dark blades of grass are suggested in the left foreground with a mixture of cadmium yellow, viridian, and burnt sienna. Paler strokes of this mixture are carried upward to the base of the rock where the mixture is now mainly cadmium yellow. Light and dark strokes of this mixture are continued above the rock and over the distant meadow. Then a much darker blend—mainly burnt sienna and viridian—suggests the grasses and weeds in the lower right area. Now a bristle brush picks up a pale version of the original rock mixture of ultramarine blue, burnt sienna, yellow ochre, and lots of white. This blend is carried over the tops of the rocks with rough, thick strokes that emphasize the rocky texture. The tip of the round softhair brush draws some cracks in the rocks with burnt sienna and ultramarine blue diluted to a fluid consistency. This same brush adds some wildflowers with strokes of pure white for the petals and a dab of cadmium yellow and burnt sienna at the center. The orange flowers are cadmium red and cadmium yellow, with burnt umber in the center.

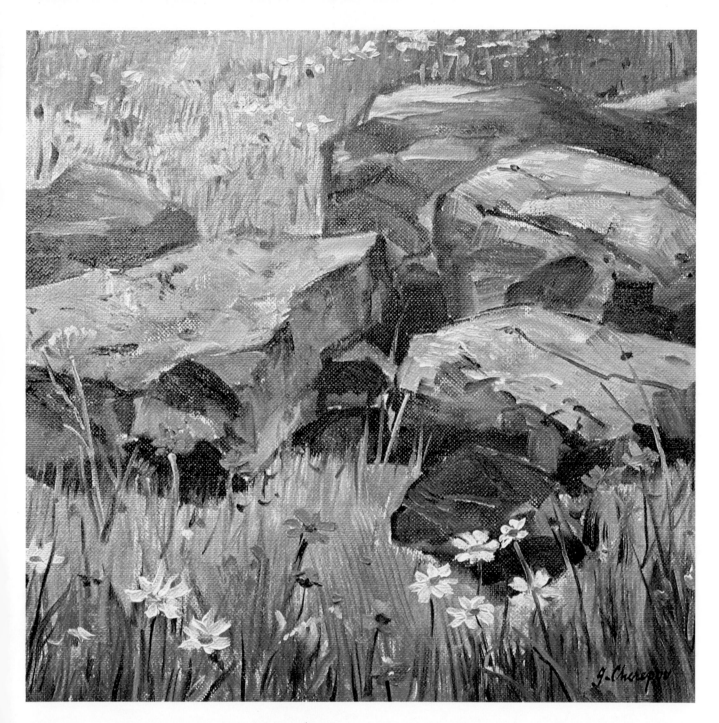

Step 5. The rocks need more contrast between their sunlit tops and shadowy sides. So the sides are darkened with bristle brushstrokes of burnt sienna, ultramarine blue, yellow ochre, and just a little white. Notice that the dark strokes are thin—containing a lot of medium—while the lighter strokes at the tops of the rocks are thicker paint, containing much less medium. The white flower strokes, begun in Step 4, are now carried over the distant meadow at the top of the picture, interspersed with a few touches of the orange mixture. Although the strokes are pure white, they blend slightly with the underlying color; thus, the white becomes cooler or warmer, depending upon the tone underneath. More orange flowers are added in the foreground. Their dark and light stems are the same dark and light mixtures used to paint the grass and weeds. Some scattered purple flowers are a blend of ultramarine blue, alizarin crimson, and white. The picture is completed with crisp dark and light strokes of viridian, burnt sienna, and cadmium yellow—applied with the round brush—to indicate more detail in the foreground.

Step 1. Summer is a fine time to go outdoors and paint your first landscape. It's usually best to make your first brush lines in some color that will harmonize with the colors of the finished picture. The preliminary brush drawing is cobalt blue plus plenty of turpentine. Then the distant hills are painted with mixtures of cobalt blue, alizarin crimson, yellow ochre, and white. You can see that some strokes contain more blue, others contain more crimson, and still others contain a lot of white.

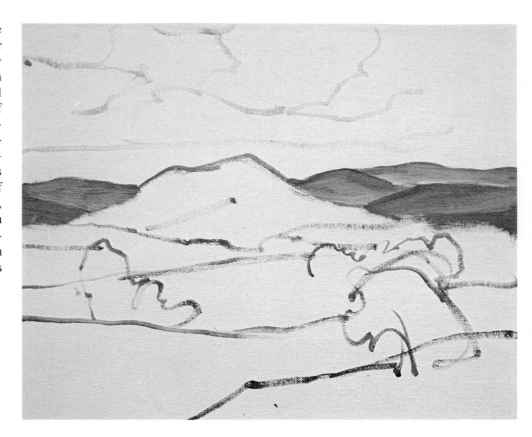

Step 2. The big, dark hill is painted with the same blend of colors—although you can see that the proportions of blue, red, yellow, and white vary from stroke to stroke. The darker strokes contain more blue or red. The light patch is mostly yellow ochre and white. The dark mass at the base of the hill is mostly blue and red, with almost no white. Everything is done with bristle brushes. The strokes are all broad and rough.

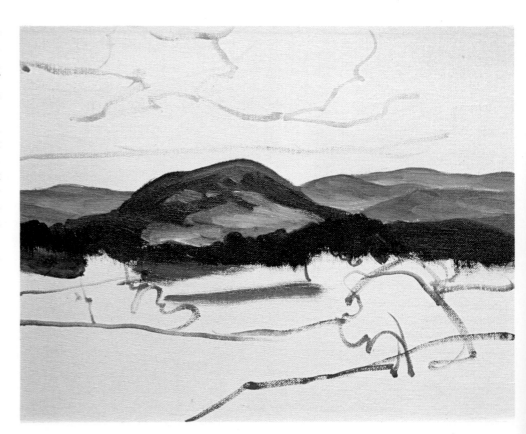

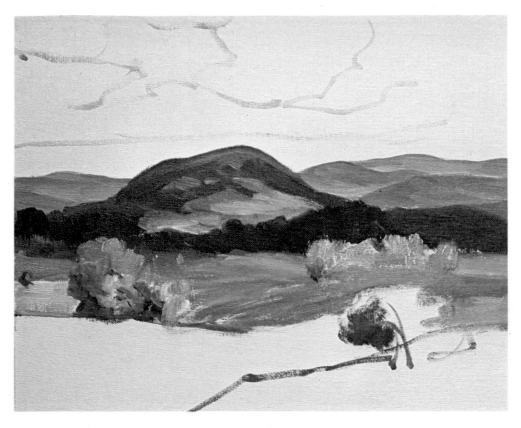

Step 3. The sunny colors of the meadow are painted with essentially the same combination of blue, red, yellow, and white—but cadmium yellow is substituted for the more muted yellow ochre, while the delicate cobalt blue is replaced by the deeper ultramarine. The combination of cadmium yellow and ultramarine blue produces these lovely yellow-greens, warmed here and there by a stroke of crimson or cooled by a stroke of blue. Notice that the meadow is painted with smooth, horizontal strokes, while the trees are executed with short, scrubby, vertical and diagonal strokes that suggest clusters of foliage.

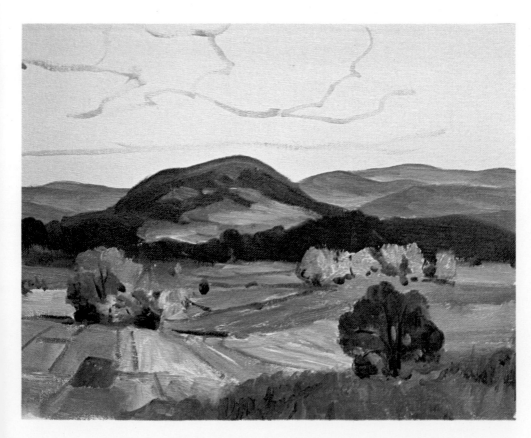

Step 4. More strokes of the meadow mixtures are carried into the foreground, which is even sunnier and contains more cadmium yellow and white in the brightest patches. The meadow is divided into the geometric forms of cultivated fields, each with its own color—containing more blue, red, or yellow. The dark tree and the patch of shadow in the right foreground are a blend of cadmium yellow, ultramarine blue, and burnt sienna instead of alizarin crimson. This same mixture is used for the shadows on the more distant trees. The tip of a round brush picks up this mixture and draws the lines of the fields as well as the trunks and branches of the trees.

Step 5. Until now, no work has been done on the sky. Here you can see that the sky tones are brushed around the shapes of the clouds, which remain bare canvas. The mixtures are the same ones used for the hills: cobalt blue, alizarin crimson, yellow ochre, and white. The lower sky is mostly yellow ochre and white, with just a hint of blue and red. The upper sky is dominated by blue with a good deal of white but just a hint of red and yellow in the mixture. At the midpoint of the sky, these two tones are softly blended together by a flat softhair brush.

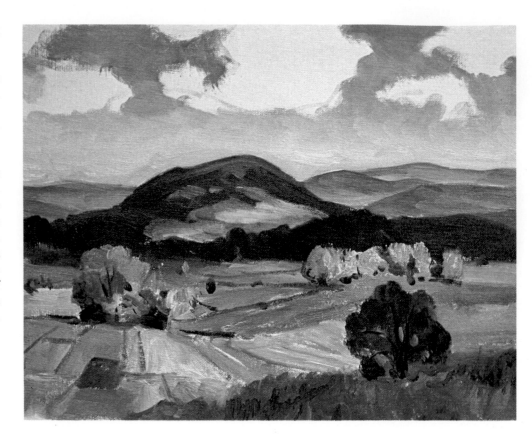

Step 6. The shadowy undersides of the clouds are also painted with a flat softhair brush. The colors are the same as the sky, but with more alizarin crimson and a lot of white. For the sunlit edges of the clouds, the bristle brush comes into play again, carrying a thick blend of white with just a speck of sky tone. You can see that the sunny edges are thicker and more ragged than the soft, smooth shadow strokes. A small, flat softhair brush picks up the dark sky tone and adds some dark notes to the undersides of the clouds—then adds some wisps of dark clouds in the lower sky at the left.

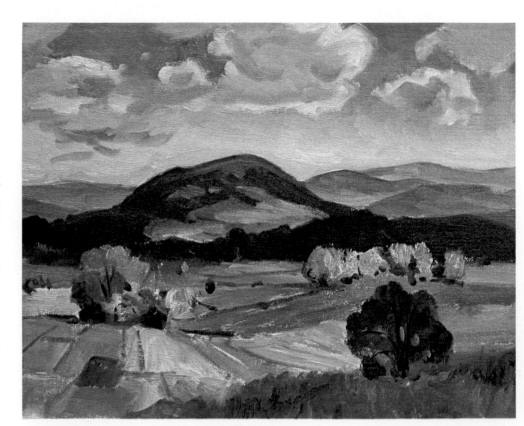

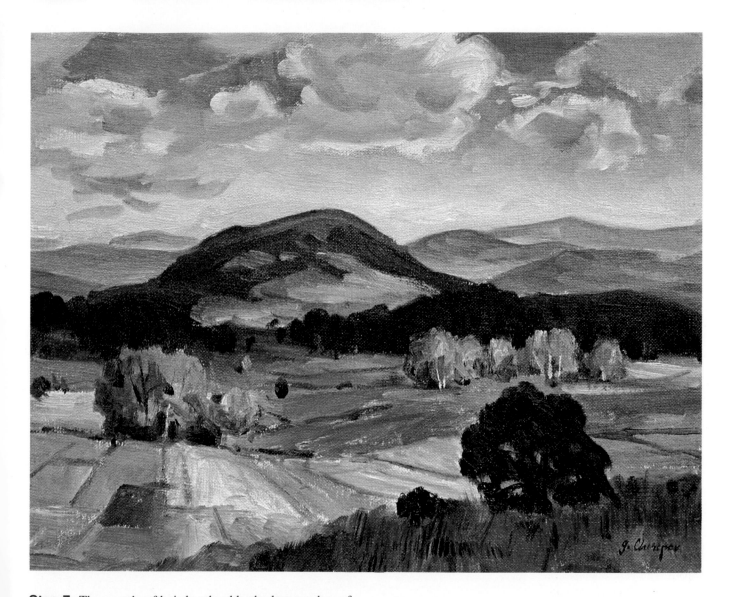

Step 7. The round softhair brush adds the last touches of detail—often so subtle that you must look closely to find them. The dark tree in the foreground is adjusted with strokes of ultramarine blue, burnt sienna, and yellow ochre, making the tree darker still and pitching it slightly to the side. Notice how several gaps are left in the foliage for the sun to shine through. A dark bush is added to the foreground with the same mixture, and dark blades of grass are added. Touches of the same mixture are added within the darkness of the woods at the base of the big hill, suggesting individual trees. Then a bristle brush repaints the sunlit trees—just above the dark tree in the lower right—with rougher, heavier strokes of the original mixture, but with a little more red. The center of the meadow is darkened and warmed in exactly the same way to accentuate the sunny fields in the foreground. These fields are made even sunnier with strokes of cadmium yellow, white and just a little ultramarine blue. The round brush finally comes back to add a few white wisps of clouds in the upper right area, some white trunks among the distant trees, a few touches of darkness among the trees, and more lines between the fields.

Step 1. When you paint a group of trees, start out by drawing the trunks with some care, but don't try to draw the precise shapes of the clusters of leaves. Try to visualize each cluster as a big, simple shape, then draw a quick line around the shape—bearing in mind that this line will soon disappear. This autumn landscape begins with a brush drawing in burnt umber that defines the main treetrunks and the edge of the shore but merely suggests a few other trunks, branches, and leafy masses. The leaves are begun as a flat, scrubby tone of cadmium yellow and a little burnt umber.

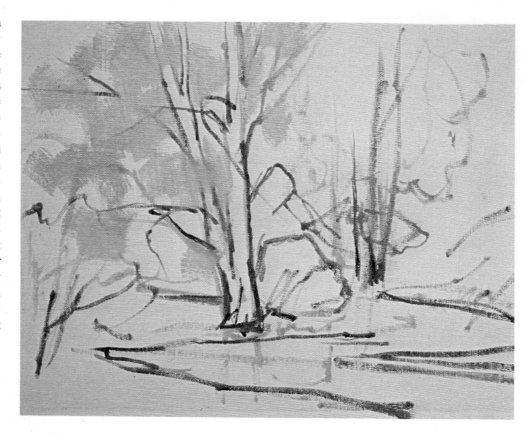

Step 2. The yellow shapes of the leaves of the main tree are extended outward with more of the same mixture. Then some shadows are suggested with cadmium yellow, yellow ochre, and burnt umber. These mixtures are carried downward into the water, which will reflect the colors of the surrounding foliage.

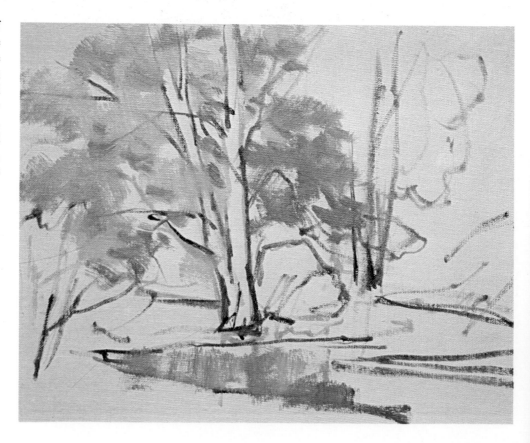

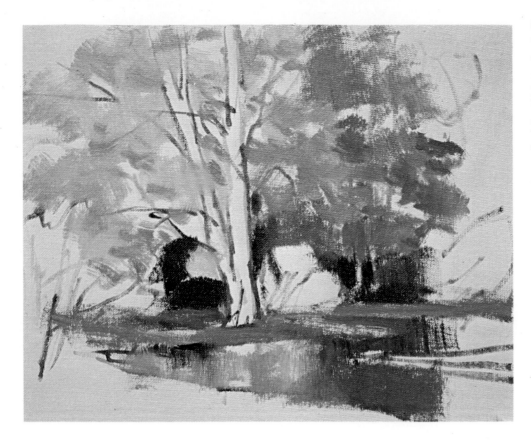

Step 3. To paint the coppery tone of the distant trees, some cadmium red and burnt sienna are added to the cadmium yellow. This same mixture is brushed along the shoreline. Some darks are added with burnt sienna and ultramarine blue, and some dark reflections are added to the water with these mixtures.

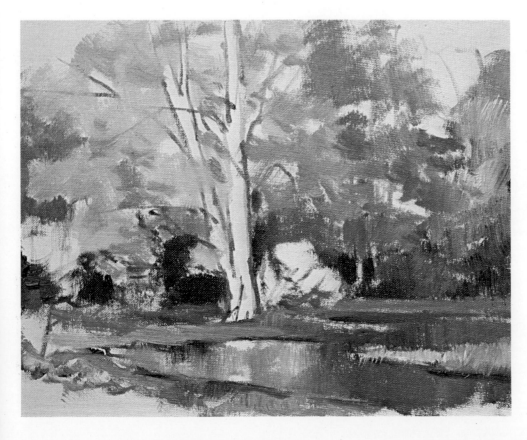

Step 4. Green foliage is added at the right with viridian, burnt sienna, and a slight touch of phthalocyanine blue—which must be added in tiny quantities, or it will dominate the mixture. This same mixture is carried down into the water to reflect the trees above. Some viridian, burnt sienna, and white are added to the near shore and along the left side of the picture.

Step 5. The bright color of the bush at the bottom of the central tree is painted with alizarin crimson, white, and a hint of ultramarine blue. The copper tone of the foliage at the left is burnt sienna, cadmium yellow, and ultramarine blue. The near shoreline is covered with the same mixture that first appeared in Step 4. And the sky is covered with free strokes of cobalt blue, alizarin crimson, yellow ochre, and white. Notice how spots of sky tone appear through the foliage.

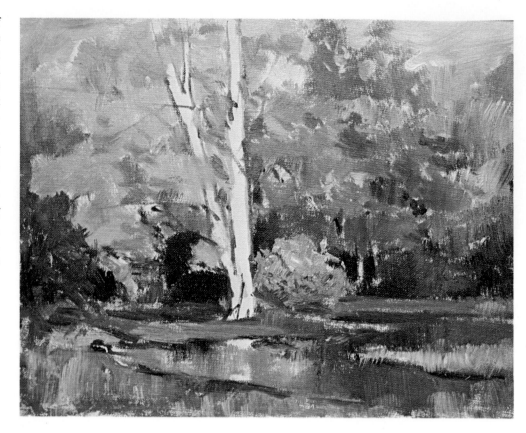

Step 6. So far, the entire canvas is covered with color—expect for the two trunks of the central tree—and it's time to start adding details. The central trunks are painted with short, thick strokes of the same mixture as appears in the sky, but with more white. Then the round brush picks up a fluid mixture of burnt umber and ultramarine blue to add dark trunks and branches. As soon as these dark lines are added, the scrubby strokes in Step 5 are transformed into clusters of leaves. Notice how the colors of the trunks are reflected in the water—a little softer and less distinct.

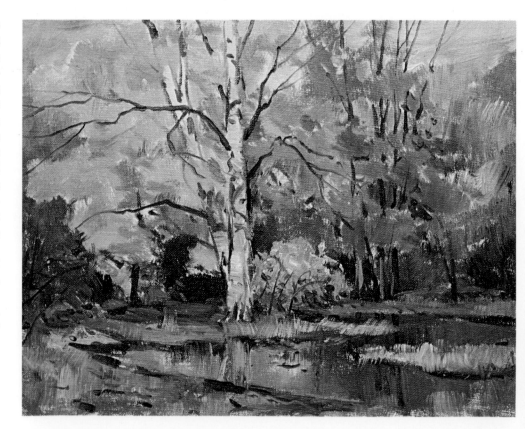

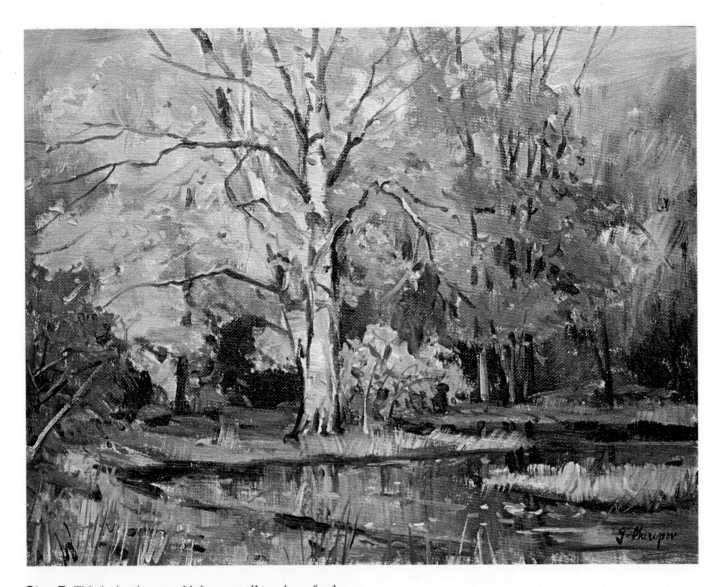

Step 7. This is the time to add those small touches of color that *suggest* so much more detail than you actually see if you look closely at the picture. The tip of a small bristle brush adds thick dabs of cadmium yellow and white here and there among the foliage of the central tree, making you think that you see individual leaves—although you really don't. In the same way, flecks of cadmium red and cadmium yellow are added to the orange trees at the right and among the coppery foliage at the extreme left. Flecks of white and yellow are added to the pond to suggest floating leaves. Dried grasses and weeds are suggested with the tip of a round brush carrying a pale mixture of white, yellow ochre, and burnt umber. More foliage tones are added to the pond. Notice how the brushstrokes express the forms: those last bits of foliage are painted with short, choppy strokes; the branches are painted with wandering, rhythmic strokes; while the reflections in the pond are painted with vertical strokes.

Step 1. Because a winter landscape has a generally cool tone, it's best to use a cool color for your preliminary brush drawing. You can use cobalt or ultramarine blue diluted with a lot of turpentine, or you can use a mixture of blue and burnt umber, as you see here. This brush drawing indicates the shapes of the trunks, the edges of the stream, the tops of the snowdrifts, and the horizon line. When you paint a landscape, it's often a good idea to work from the top down. The sky is begun with cobalt blue and white.

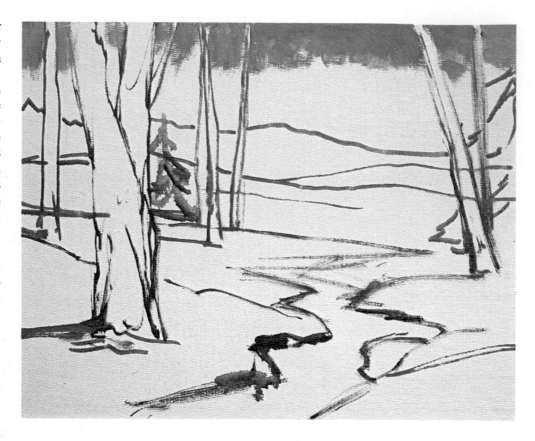

Step 2. To suggest a glow of warm light in the lower sky, a mixture of yellow ochre, alizarin crimson, and white is brushed upward from the horizon. When you're painting a snow scene, it's particularly important to get the sky tone right. After all, snow is just crystallized water; like water, the snow will reflect the colors of the sky.

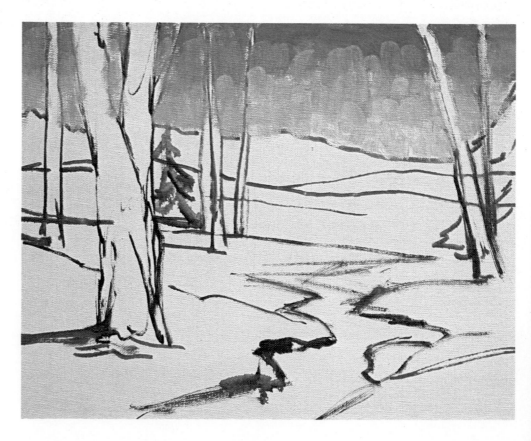

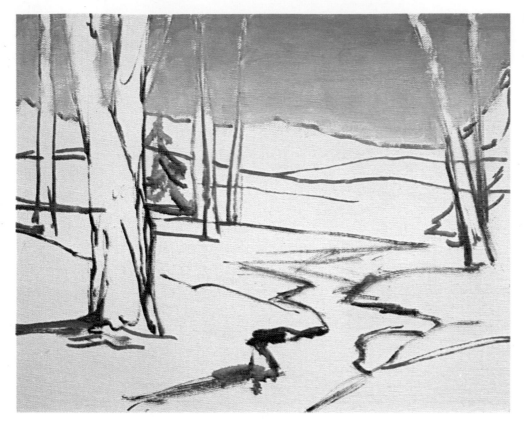

Step 3. The strokes of the sky are blended with a flat softhair brush. Now the warm tone at the horizon merges softly with the cooler tone at the top of the picture. Look carefully at skies and you'll see that the color is often darkest and coolest at the top, gradually growing warmer and paler toward the horizon.

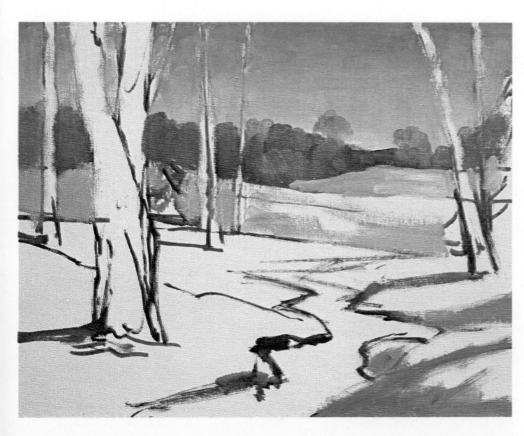

Step 4. The shadows of the snow reflect the color of the sky, so they're painted with the same mixture of cobalt blue, alizarin crimson, and yellow ochre, plus white. The lighted areas of the snow are still left bare canvas. The same three colors are used to paint the distant woods along the horizon, but with more alizarin crimson and yellow ochre added to produce a warmer tone.

Step 5. The sunlit tops of the snowbanks are painted with white that's tinted with just a touch of yellow ochre and cadmium red to add a hint of warmth. The lights and shadows of the snowbanks are blended together to produce a soft transition. The distant treetrunks are painted with the mixture that was used for the trees along the horizon. The big tree to the left is begun with a rough stroke of this mixture to indicate a shadow.

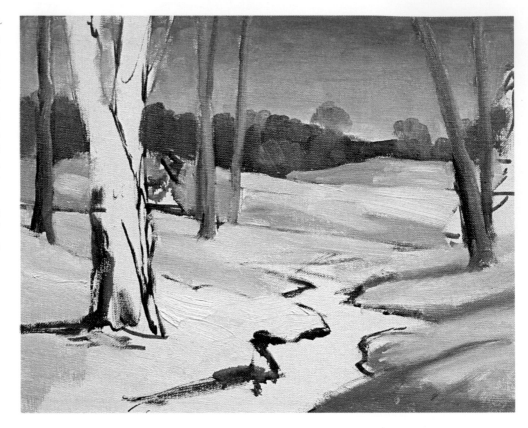

Step 6. The big tree is now covered with rough, thick strokes of burnt sienna, yellow ochre, viridian, and white—with more white in the sunlit patches. The roughness of the brushwork matches the roughness of the bark. The dark tone of the brook is painted with fluid strokes of viridian, ultramarine blue, and yellow ochre; a few white lines are added with the tip of a round brush. The same greenish mixture is used to suggest an evergreen in the upper left area. Two more distant trees are added with the same mixture used for those at the horizon.

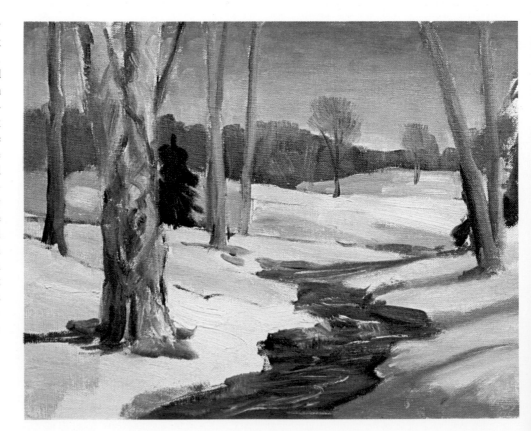

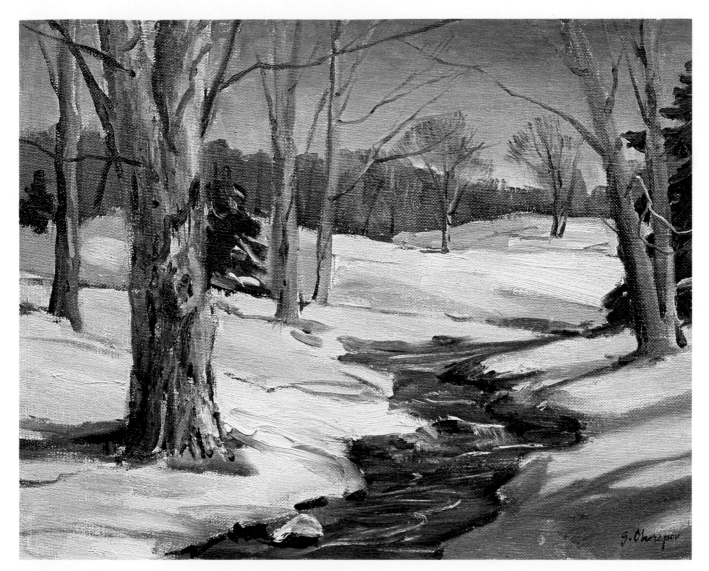

Step 7. Another evergreen is added at the right with the mixture used in Step 6. A bristle brush strengthens the shadows on the snow with the mixture introduced in Step 4. Then another bristle brush builds up the lighted areas of the snow with the mixture used in Step 5. Around the big tree, you can see that much thicker paint is used for the lights than for the shadows—a good rule to follow. Then a small round brush uses the original tree mixtures to draw branches, twigs, and shadows along the trunks. The curve of the snow is accentuated by slender lines that suggest shadows cast by the branches. The dark lines along the edges of the stream and on the big trunk are drawn by the tip of the round brush carrying a mixture of viridian and burnt umber. A few strokes of pure white are added to suggest snow on the branches, on the distant evergreen, and on the rock in the stream.

Step 1. The preliminary brush drawing defines the trees as two big, simple shapes. A round softhair brush swiftly glides around the edges of the foliage with a mixture of burnt umber, viridian, and lots of turpentine to make the color flow as smoothly as watercolor. The shapes of the foliage aren't defined *too* precisely. These strokes will soon be covered by thicker color—and that will be the time to render the masses of foliage more exactly.

Step 2. A small bristle brush is used to paint the dark strokes of the trunk and branches with a mixture of viridian, burnt sienna, and white. The strokes are still very loose and casual—the forms will be more precisely painted in the final stages. Then a bristle brush begins to paint the foliage with a mixture of viridian, yellow ochre, and the slightest hint of cadmium red to add a touch of warmth. The strokes already begin to reflect the character of the subject: long, rhythmic strokes for the trunk and branches; short, ragged strokes of thicker color (diluted with less medium) to suggest the texture of the leaves.

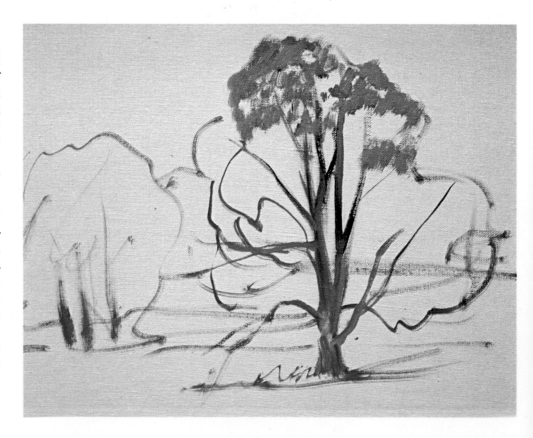

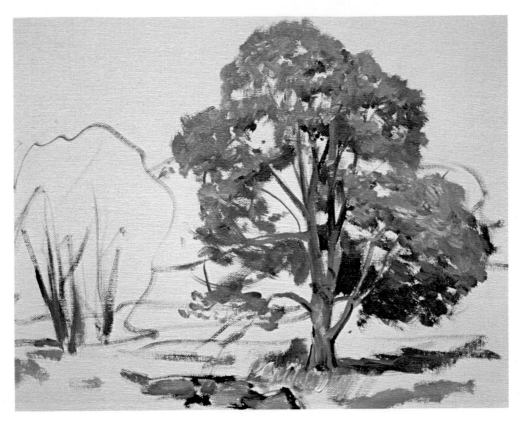

Step 3. A bristle brush works its way down to cover the foliage area with short, ragged strokes of viridian, yellow ochre, a hint of cadmium red, and white in the sunlit areas. Then the shadows among the foliage are painted with viridian and burnt sienna, a mixture which also appears in the shadow at the base of the tree. A softhair brush defines the trunk more precisely, using the same mixture as first appeared in Step 2, then adds some shadow strokes with phthalocyanine blue and burnt sienna. A bristle brush begins to suggest the rocks at the bottom of the picture with this same phthalocyanine blue/burnt sienna mixture, adding white for the sunlit planes of the rocks.

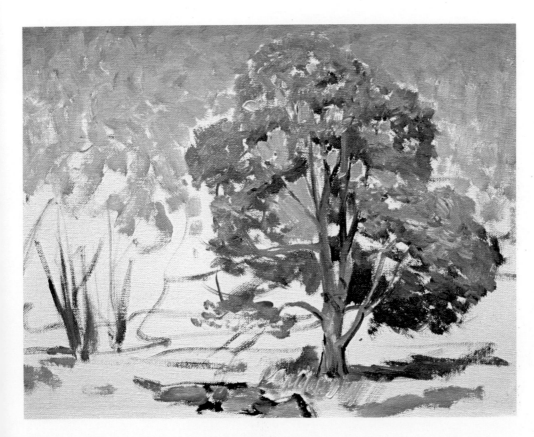

Step 4. The sky is painted around the trees with short strokes that overlap one another. The first strokes are cobalt blue and white. These are overlaid with strokes of alizarin crimson and white, and strokes of yellow ochre and white. The action of the brush blends these three tones—but there's no attempt to fuse the strokes into one smooth, continuous tone. Notice how the strokes at the top of the sky are darkest and bluest, growing warmer and paler toward the horizon. Also observe how patches of sky break through the foliage of the big tree.

Step 5. The sky strokes have obscured the brush lines that defined the smaller tree at the left, so now this tree is rebuilt with strokes of the same foliage mixture as was used on the big tree. A bristle brush goes over the sky with short strokes, partially blending the colors that were applied in Step 4, but still allowing each stroke to show. Then the sky mixture—with more blue—is used to paint a darker tone along the horizon. This tone will eventually become the distant hills. The grassy meadow is begun with scrubby, casual strokes of viridian, cadmium yellow, burnt sienna, and white.

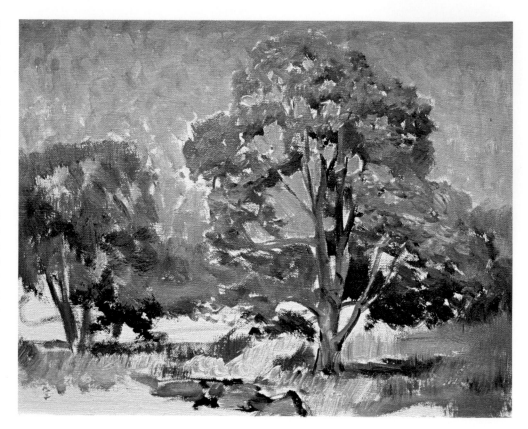

Step 6. The sky is completed with short, diagonal strokes that eliminate the patches of bare canvas. Then the foliage of the big tree is enriched with thick strokes of viridian, cadmium yellow, white, and the slightest touch of burnt sienna—emphasizing the brilliant sunlight. This same mixture brightens the meadow. Between the two trees, broad strokes of sky mixture sharpen the top of the distant hill. All this work has been done with bristle brushes. Now a round, soft-hair brush paints the lights and shadows on the trunks and branches with the original mixtures used in Step 2 and 3, adding more white for the strokes of sunlight. This same brush begins to add dark touches to suggest leaves.

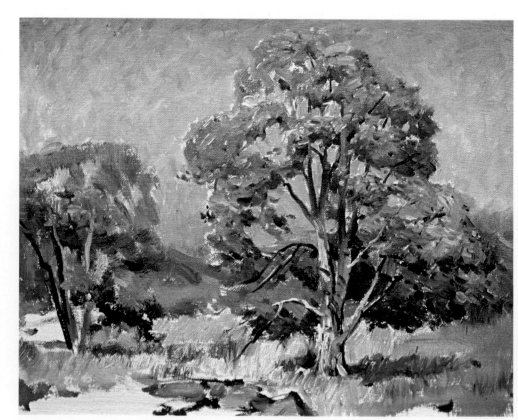

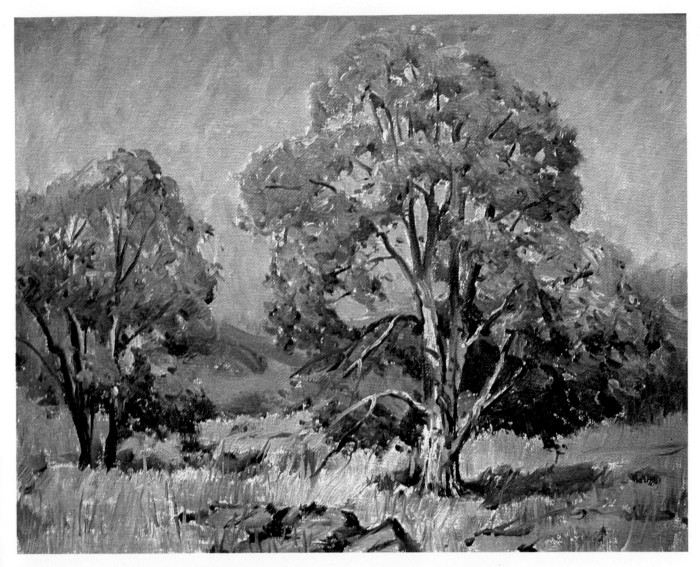

Step 7. It's always important to paint with broad, free strokes until the very end of the picture—when the last few details are added with smaller, more precise strokes. In this final stage, a bristle brush completes the foliage of the smaller tree with broad strokes of viridian and yellow ochre warmed with a speck of burnt sienna and lightened with white. This same tone covers the rest of the meadow. Then the tip of a round, softhair brush goes to work on those last details that give the painting a sense of completeness. The dark trunks of the smaller tree are flowing, rhythmic strokes of phthalocyanine blue and burnt sienna diluted with painting medium to fluid consistency that's just right for linear brushwork. The same brush adds more dark strokes to the trunk and branches of the bigger tree. Then the brush is rinsed out in turpentine, quickly dried on a sheet of newspaper, and dipped into a mixture of burnt umber, yellow, and white to strengthen the lighted patches on the bark. The point of the brush adds a few more dark touches among the trees to suggest individual leaves—but not too many. The round brush sharpens the shapes of the rocks with the shadow mixture that was used on the trunks. Then the tip of the brush scribbles vertical and diagonal strokes over the meadow to suggest grasses and weeds—pale strokes of white faintly tinted with cadmium yellow, plus darker strokes of viridian, burnt sienna, and yellow ochre. The finished painting contains just enough of these details to seem "real," but not enough detail to become distracting. The painting is still dominated by bold, free, broad brushwork.

Step 1. This demonstration is painted on a panel rather than on canvas. The panel is a sheet of hardboard covered with acrylic gesso. You can buy gesso panels in some art supply stores, but it's just as easy to make them yourself. Buy a tin or a jar of this thick, white liquid; add enough water to produce a milky consistency; then brush one or more coats onto the hardboard with a nylon housepainter's brush. You can see that this panel is covered with one very thin coat that shows the streaky marks of the brush. The preliminary line drawing is made with cobalt blue, burnt umber, and lots of turpentine.

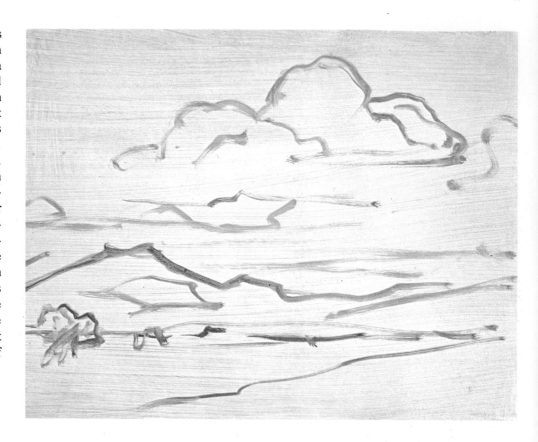

Step 2. A sunny sky isn't just a smooth, uniform blue like a coat of paint on a wall, but contains lots of subtle color variations. Here's a method for capturing the subtleties of a blue, sunny sky. A bristle brush covers the sky with short, distinct strokes of cobalt blue and white. At the very top, the strokes are darker and closer together. Lower down, the strokes contain more white, and there are bigger spaces between them.

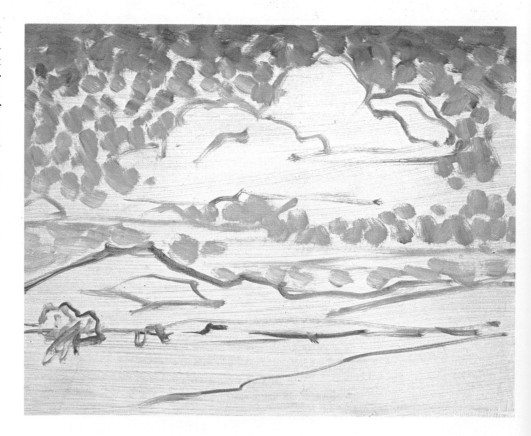

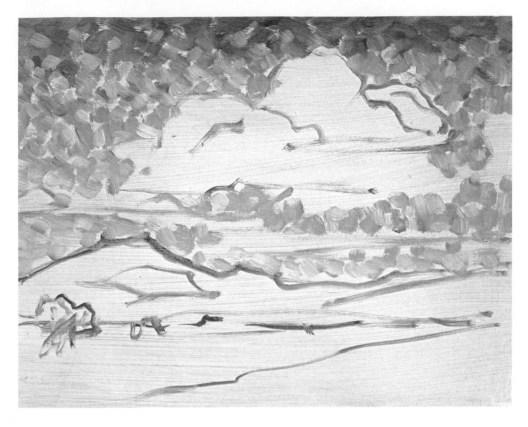

Step 3. Now another bristle brush picks up a mixture of yellow ochre and white. Like the blue tone applied in Step 2, this mixture is added to the sky in short, distinct strokes. These strokes of yellow sometimes overlap blue strokes and sometimes fill the spaces between them. Only a few yellow strokes are added toward the very top; the yellow strokes become denser further down.

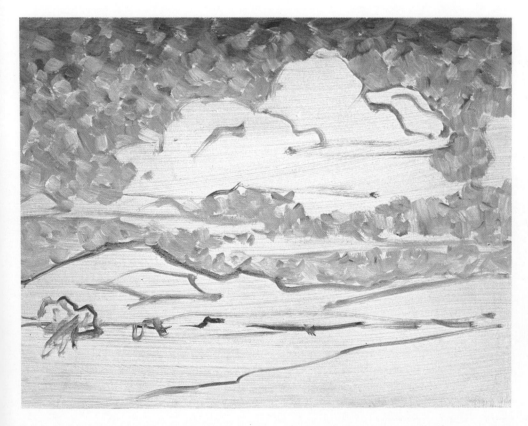

Step 4. Alizarin crimson and white are blended on the palette to a pinkish mixture. Like the yellow strokes in Step 3, a few strokes of this pink are scattered across the top of the sky. More pink strokes appear on either side of the big cloud. But the greatest number of pink strokes appear toward the horizon. Now half-close your eyes and look carefully at Step 4. You can see how these three colors are beginning to blend to create a sky that's darkest and bluest at the top, gradually growing paler and warmer toward the horizon. So far, no attempt is made to blend these strokes together. That comes next.

Step 5. With short, slightly diagonal strokes, a clean brush works its way across the sky from left to right and from top to bottom, gently fusing the blue, yellow, and pink strokes. It's possible, of course, to sweep the brush across the sky with long strokes that would blend all the colors smoothly together. But that would destroy all the subtle color variations. The short, diagonal blending strokes preserve all those subtle suggestions of blue, yellow, and pink which make this sky tone so luminous and vibrant. Now the shadowy undersides of the clouds are painted with a mixture of the same three colors (plus white) as in the sky. Notice that some shadow strokes contain more blue, pink, or yellow.

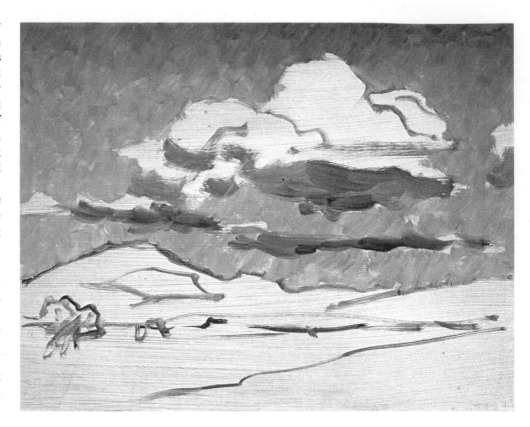

Step 6. The sunlit areas of the clouds are completed with curving strokes of white tinted with slight touches of the shadow mixture. The lights and shadows are blended softly together, but not too smoothly; you can still see the brushstrokes. The pale, distant mountains are painted with exactly the same mixture that's used for the sky—with a little more alizarin crimson in the light tones and more cobalt blue in the shadow. And the darker, nearer mountains are painted with a darker version of this mixture— more cobalt blue in the darks and more yellow ochre in the patch of sunlight at left of center. A few trees are begun with short strokes of cobalt blue and cadmium yellow.

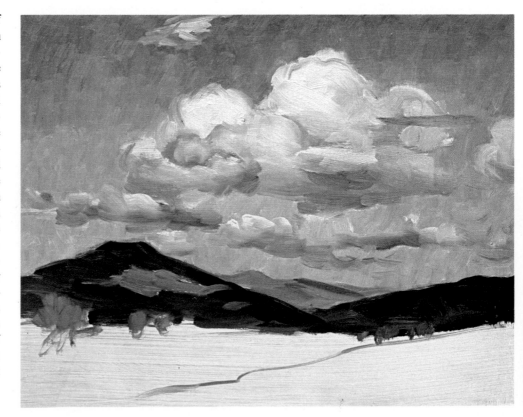

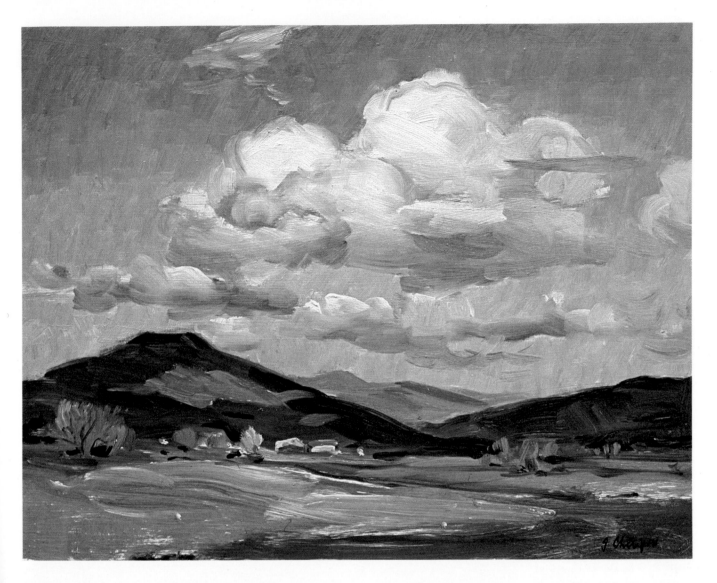

Step 7. The sunny foreground is completed with broad, rapid strokes of viridian, cadmium yellow, burnt sienna, and white. The patch of shadow that travels across the foreground to the right is mainly viridian and burnt sienna. The brilliant sunlight at the center of the foreground is almost pure white, tinted with the grassy mixture. Notice that the foreground strokes aren't smoothly blended: some contain more viridian; others contain more cadmium yellow or burnt sienna. The last few touches are the trees and houses at the lower edges of the mountains. A small bristle brush adds more dabs of cobalt blue, cadmium yellow, and a little burnt sienna to suggest additional trees as well as some white tinted with a little yellow ochre to suggest the sunlit walls of houses and the sunlit tops of the trees. The job is completed with the tip of a round, softhair brush that picks up a mixture of ultramarine blue and burnt sienna to add some shadow lines under the trees, a few dark strokes to the mountains, and a dark line along the road just beneath the houses. The same brush adds a few strokes to suggest a trunk and branches within the tree at the extreme left—this is the mixture used to paint the shadow in the foreground. This brush adds some final warm touches: a line of burnt sienna for the road, some more lines of burnt sienna at the bases of the mountains, and a single stroke of burnt sienna for the top of one house. The brushwork deserves close study. The blue sky consists almost entirely of short, slightly diagonal strokes. In contrast, the clouds are painted with horizontal and arc-like strokes that match the curves of the forms. Most of the strokes in the landscape are long horizontals and diagonals that follow the contours of the terrain. Since this is primarily a sky picture, the clouds are painted with the greatest sense of detail, while the landscape is painted with an absolute minimum of strokes. On the smooth gesso panel, it's *possible* to use a flat softhair brush to blend all the strokes together and create uniform tones that eliminate the marks of the brush—but this would produce a lifeless picture! Instead, each stroke is allowed to show clearly. The smooth panel actually emphasizes the vitality of the brushwork.

Step 1. A sunset usually displays a particularly dramatic pattern of dark and light shapes. The dark landscape and dark clouds are silhouetted against the pale tones of the sky. These dark and light shapes, in turn, are reflected in the water. It's important to define these shapes carefully in the preliminary brush drawing, which outlines the silhouettes of the mountains, the clouds, and the shoreline. The combination of cobalt blue, alizarin crimson, and yellow ochre is particularly effective for sky pictures, as you've already seen. So this mixture is diluted with turpentine for the initial brush drawing.

Step 2. The darkest, most sharply defined shape is painted first. The mountains at the horizon are brushed in with a rich, dark mixture that's mostly cobalt blue, plus a little alizarin crimson, yellow ochre, and white. Just below the shoreline, the reflection of these mountains is added to the water. With this dark note clearly defined, it's easier to determine just how light to make the sky and water. It's also easier to paint the dark clouds, which must be slightly lighter than the dark landscape.

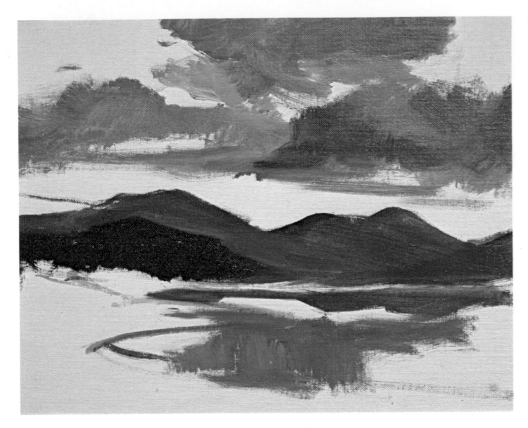

Step 3. Still working with this same color combination—cobalt blue, alizarin crimson, yellow ochre, and white—a bristle brush scrubs in the shapes of the clouds. As you can see, this color combination is amazingly versatile. The cool, dark tones contain all of these colors, but the mixture is dominated by cobalt blue. The warm tone at the center contains less cobalt blue and is dominated by alizarin crimson and yellow ochre. Strokes of these mixtures are carried down into the water, which always reflects the sky. And this same mixture, containing more cobalt blue and less white, defines the murky shape of a hill just below the mountain at the left.

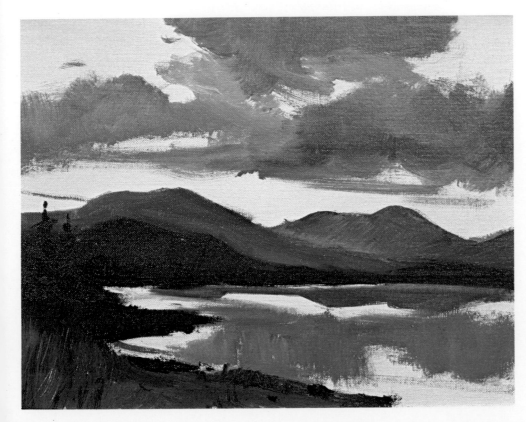

Step 4. Leaving bare canvas for the pale patches of sky and water, a bristle brush continues to define the shapes of the shoreline. The dark mixture of the hill—mainly cobalt blue, with just a little yellow ochre and alizarin crimson—is carried downward at the left to create a spur of land that juts out into the water. The edge of the shoreline in the immediate foreground is completed with this mixture. A round, soft-hair brush adds a few small strokes of this dark tone to suggest the tips of evergreens rising above the dark hill at the extreme left. Then more yellow ochre is added to complete the warmer tone of the grassy beach. The brush handle scratches weeds into the beach at the lower left.

Step 5. Work begins on the bright patch of sky just above the horizon. A bristle brush paints thick, horizontal strokes of white, cadmium yellow, and just a little cadmium red beneath the clouds. Just above the peaks, a little more cadmium red is added. More strokes of this mixture fill the breaks within the lower edges of the clouds. And this same mixture, with just a little more cadmium red, is repeated in the water, which now reflects the forms of the peaks, sky and clouds.

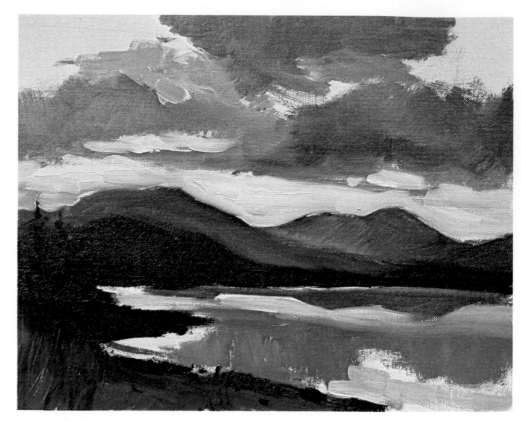

Step 6. Work continues simultaneously on the sky and water, since the same colors must appear in both. The upper sky—above and between the clouds—begins with smooth strokes of cobalt blue and white at the very top. Then, as the brush works downward toward the clouds, yellow ochre and more white are added to this mixture. This process is reversed in the water: cobalt blue and white appear at the lower edge, with more white and yellow ochre added as the brush moves upward. Bright touches of sunlight are added to the lower edge of the topmost cloud with thick strokes of cadmium yellow, cadmium red, and white. And streaks of this mixture are added to the center of the bright sky.

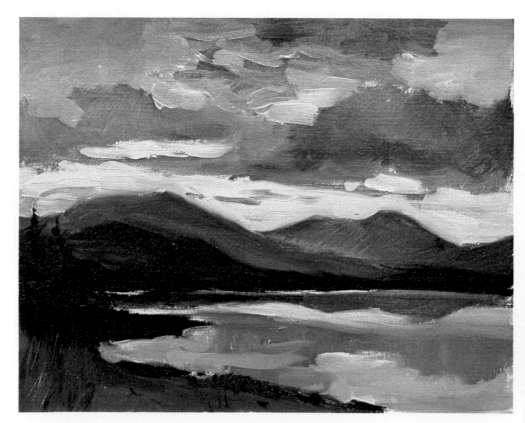

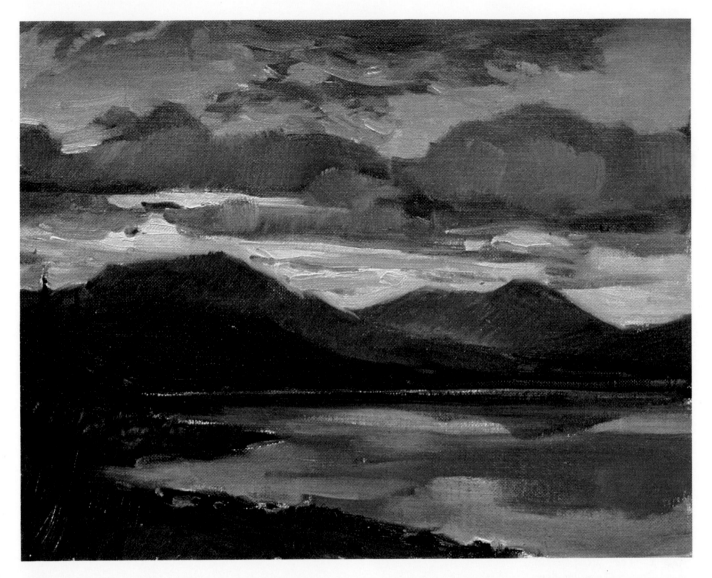

Step 7. At the end of Step 6, the canvas is completely covered with color. The main shapes and colors are established. But now it's time to refine these shapes and colors in the final stage. A large bristle brush moves up and down over the central band of clouds, sharpening their shapes with vertical strokes of the original mixture, sometimes lighter and sometimes darker, to create a distinct sense of light and shadow. A few horizontal strokes of this tone are added to suggest streaky clouds within the sunlit strip above the peaks. And the topmost cloud is darkened with this tone. Just as the dark clouds are redefined, so are the sunlit areas of the sky. A small bristle brush adds thick strokes of cadmium yellow, cadmium red, and white at the break between the peaks, where the sun is brightest. Then a round softhair brush adds curving strokes of this mixture to brighten the lower edges of the two top clouds. Notice how a few wisps of this mixture are added at the upper left to suggest windblown strips of cloud. Having defined the dark clouds more clearly, the bristle brush also solidifies the dark reflections of these clouds in the water. Moving horizontally, the bristle brush blends the tones of the water at the left and in the foreground to soften the shapes so that they won't distract attention from the more dramatic shapes in the sky. The tip of a small bristle brush adds a few scrubs of the cloud mixture beneath the evergreens at the extreme left to suggest the last few rays of the light falling on the grassy shore. No more details are added. The picture consists almost entirely of broad, simple shapes. It's particularly interesting to note that this sunset consists mainly of cool, subdued colors that frame a few areas of brighter color. Sunrises and sunsets are rarely as brilliant as most beginners paint them. At this time of day, most of the landscape is already in shadow, and most of the clouds are dark silhouettes. So the key to painting a successful sunrise or sunset is to surround your bright colors with these somber tones.

Step 1. Rocks are hard and they should *look* hard. Thus, the preliminary brush drawing renders these rock formations with straight, hard lines. The foreground rocks are simply drawn as silhouettes enclosing jagged shape of a tidepool. The big rock formation—the focal point of the picture—is drawn in greater detail. The round, softhair brush defines its silhouette with ultramarine blue and burnt sienna diluted with turpentine, then goes on to define the shapes of the shadows within the rock.

Step 2. The dark, warm tones of the rocks in the center are painted with straight, diagonal and horizontal strokes of burnt umber, yellow ochre, ultramarine blue, and white—with more ultramarine blue in the shadows. The paler, cooler tone of the rocks in the immediate foreground is a mixture of ultramarine blue, burnt umber, and white, applied with a big bristle brush that pulls the strokes downward to emphasize the blocky character of the shapes. The thick color contains almost no painting medium so that the heavily loaded brush drags the paint over the textured surface of the canvas; the weave of the canvas comes through to enhance the roughness of the rocks.

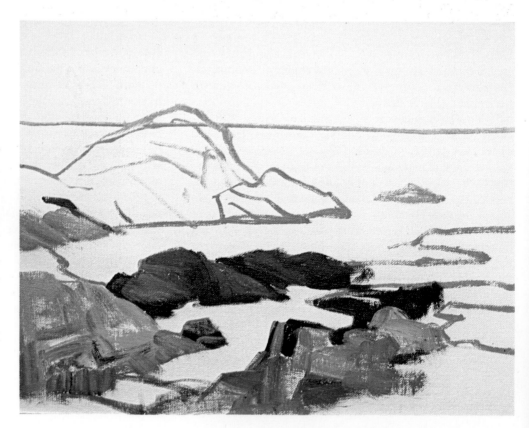

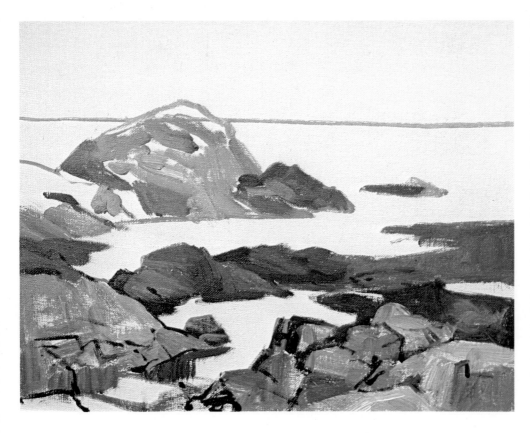

Step 3. The big rock that dominates the picture is painted with thick, straight strokes of ultramarine blue, burnt umber, and white, with more blue in the shadows. Work continues on the foreground rocks with this same mixture; the sides of the rocks are painted with vertical and diagonal strokes, while the tops are often painted with horizontal strokes. A small bristle brush picks up a dark mixture of ultramarine blue and burnt sienna to strike in the dark lines of the shadows and the cracks. A bristle brush goes back over dark, seaweed-covered rocks with burnt sienna, viridian, yellow ochre, and white, and then carries this mixture along the shoreline.

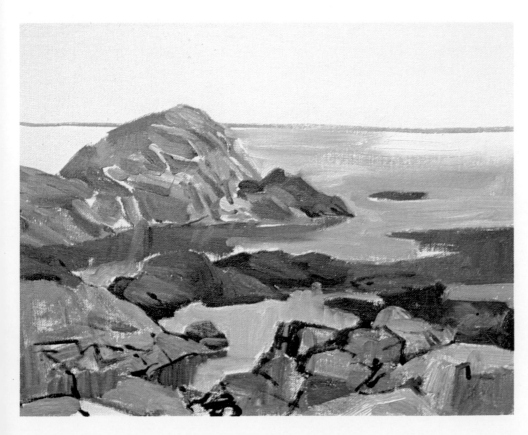

Step 4. A large bristle brush begins to cover the sea with horizontal strokes of ultramarine blue, burnt umber, and white. With a darker version of this same mixture (containing less white) a small bristle brush places more shadow strokes on the big rock formation. The dark slope of the big rock formation and the dark reflection in the water are both painted with ultramarine blue and white, softened with a touch of burnt umber. The tidepool in the foreground is painted with the same mixture that's used for the distant water, but a hint of yellow ochre and more white are added.

Step 5. The sea is now covered with long, horizontal strokes of ultramarine blue, burnt umber, and lots of white—with more white near the horizon, where the sun shines on the water. The sky is painted by the method you've already seen, starting with separate strokes of ultramarine blue and white. A touch of viridian is added to the original mixture of ultramarine blue, burnt umber, and white to suggest the grassy slopes of the big rock formation. Small touches of viridian, burnt sienna, yellow ochre, and white accentuate the weedy texture of the seaweed-covered rocks and shore.

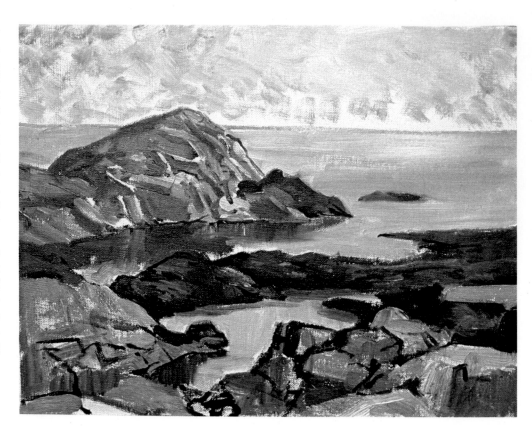

Step 6. Work continues on the sky with strokes of alizarin crimson and white, and yellow ochre and white, which the brush has already begun to blend. Notice how additional white has been brushed into the section of the overcast sky where the sun begins to break through. A strip of distant shore is placed at the horizon with ultramarine blue, alizarin crimson, yellow ochre, and lots of white to make this coastline seem far away.

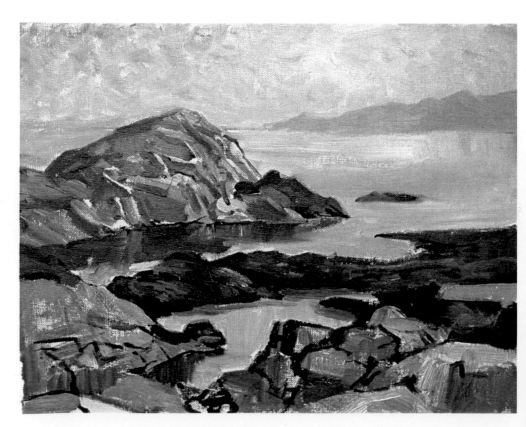

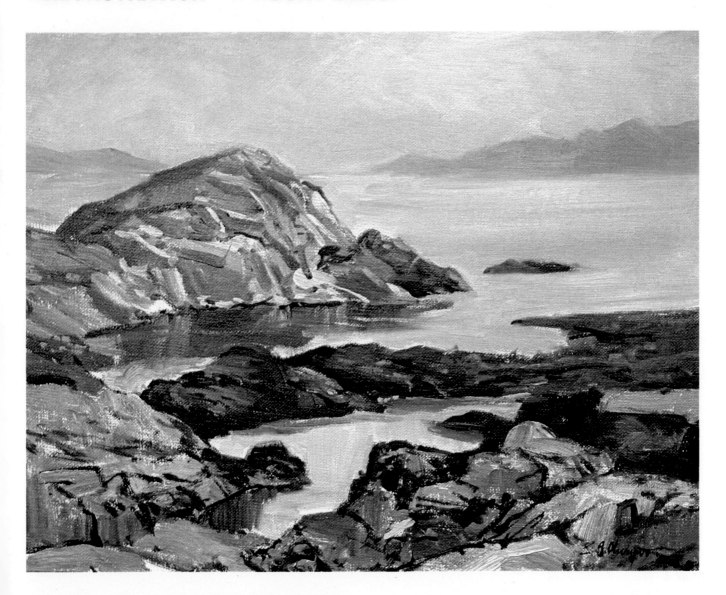

Step 7. In this final stage, the sky is completely blended, but you can still see traces of the original brushwork. In the process of blending the sky, the brush softens the edge of the distant shoreline at the right, then adds another piece of shoreline along the horizon at the left. The tip of a small bristle brush accentuates the lighted planes of the biggest rock formation with straight strokes of thick color—ultramarine blue, burnt umber, yellow ochre, and lots of white. The tip of a round brush carries horizontal lines of this mixture across the dark reflection in the water to suggest a few ripples. The tone of the seaweed is enriched with short, thick strokes of viridian, burnt sienna, yellow ochre, and white. A round, softhair brush wanders over the rocks in the foreground, placing scattered touches of warm color among the cool tones: the small strokes on the rock at the extreme left are yellow ochre, cadmium yellow, burnt sienna, and white, while the warm touches in the central rocks are burnt sienna with a little ultramarine blue and white. Then the tip of the round brush picks up a rich, dark mixture of ultramarine blue and burnt sienna to add more cracks to the foreground rocks and redefine their dark edges.

Step 1. A round softhair brush draws the major shapes of the composition with ultramarine blue, burnt umber, yellow ochre, and white, diluted with turpentine. The shapes of the trees are reflected in the pond, so they're repeated in the water, upsidedown. The brush defines the trees rather casually, but carefully traces the outline of the pond—particularly the zigzag contour of the far shore. This zigzag line is important because it leads the eye back into the picture.

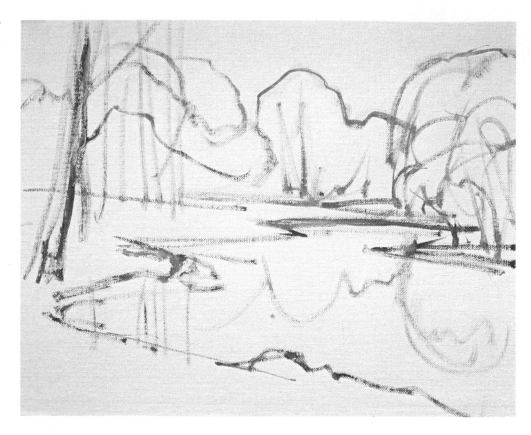

Step 2. This is one of those slightly overcast days when the sunlight shines through and lends a soft, golden glow to the sky and the water. Because the water reflects the color of the sky, these two areas are painted first. A big bristle brush covers the sky with broad strokes of yellow ochre, ultramarine blue, burnt umber, and lots of white. You can see that the sky is slightly darker at the right, where it contains just a bit more ultramarine blue and burnt umber. The water is painted with these same colors—becoming distinctly darker at lower right. Notice that the water is first painted with vertical strokes, followed by a few horizontal strokes to suggest glints of light in the foreground.

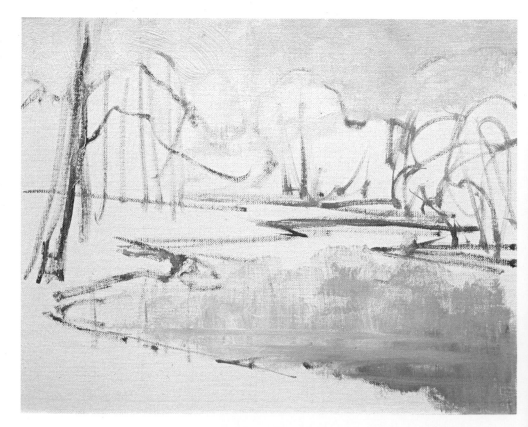

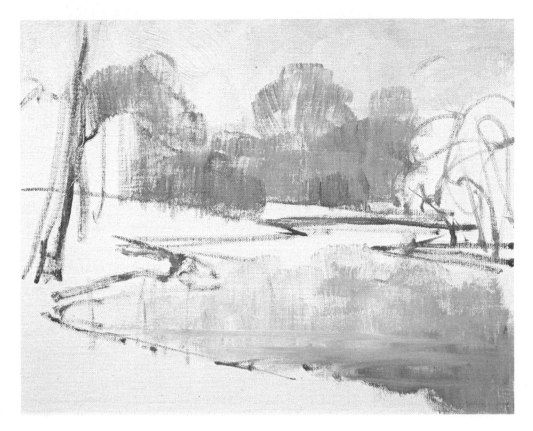

Step 3. The distant trees at the center of the picture are painted with broad, rough strokes that suggest masses of foliage. A bristle brush applies ultramarine blue, alizarin crimson, burnt umber, and white. These colors aren't mixed too smoothly on the palette, so you can see touches of blue, crimson, or umber within the individual strokes. Notice how some gaps are left between the strokes for the sky to shine through the foliage. The warmer mass of trees to the left is begun with strokes of ultramarine blue, burnt umber, yellow ochre, and white.

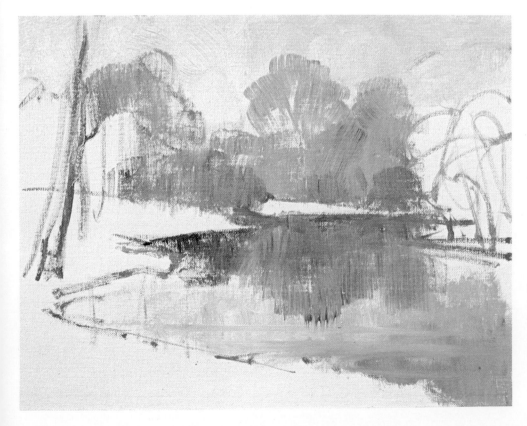

Step 4. The colors of the trees are now carried down into the water with vertical strokes. First the central tree color is darkened and cooled with a bit more ultramarine blue then stroked downward to merge softly with the wet color that already covers the pond. The strokes remain blurred and streaky—very much like reflections. Then the warmer tone of the foliage at left is darkened with a bit more burnt umber and blended into the water with rough, vertical strokes. Notice that a small tree is added to the shore at right with the same colors used for the warm foliage at left.

Step 5. The green willow at the right is first painted as a rough mass of color—a loose mixture of ultramarine blue, cadmium yellow, burnt umber, and white. This is done with a bristle brush, which carries the colors downward into the water. Then the tip of a round soft-hair brush picks up some white, faintly tinted with the green foliage mixture, to strike in some slender strokes of sunlight on the foliage. Finally, the round brush adds dark strokes of ultramarine blue and burnt umber, suggesting a trunk and shadows among the foliage. Notice how most of the brushstrokes curve downward, following the movement of the foliage of the willow.

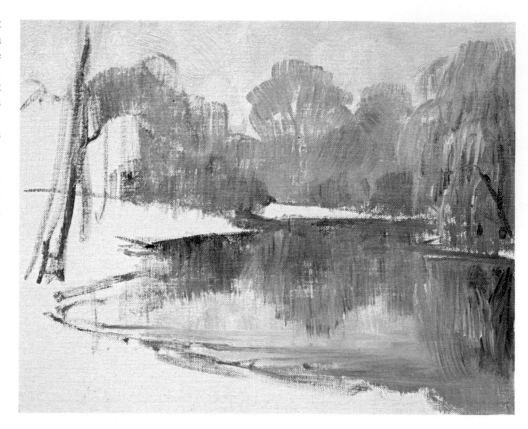

Step 6. At the left, the dark foliage is extended upward and out to the edge of the picture. The ragged brushstrokes do a particularly good job of suggesting the texture of the foliage. The brush doesn't carry too much paint and is dragged lightly over the canvas, allowing the texture of the weave to break up the strokes. The strokes combine several different color mixtures: the cool colors of the most distant trees; the green of the willow; and the warmer tone that first appears in Step 3. The dark reflection in the water is painted with vertical strokes of ultramarine blue, burnt umber, yellow ochre, and white. A round softhair brush picks up this dark mixture to add a few slender tree-trunks among the foliage.

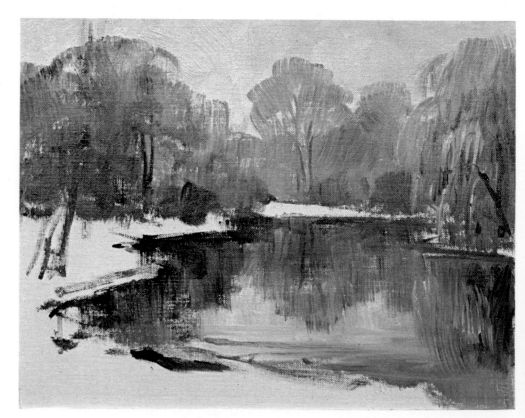

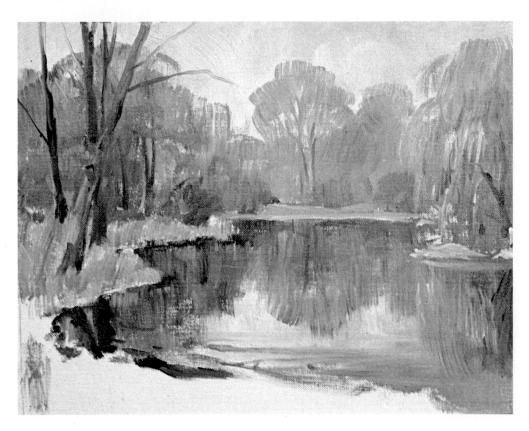

Step 7. Work begins on the shore at the left. The soft, warm tone of the dry grass is scrubbed in with vertical and diagonal strokes of ultramarine blue, burnt umber, yellow ochre, and plenty of white. A round brush paints the treetrunks and branches with this same mixture, darkened with more ultramarine blue, and burnt umber. The dark reflections of these trees are carried down into the water with thick, irregular strokes. The soft tone of the grassy mixture is carried across the distant shoreline and beneath the willow. Here and there along the shoreline a warm touch is added with a quick stroke of cadmium yellow, cadmium red, and white to suggest some bright autumn foliage.

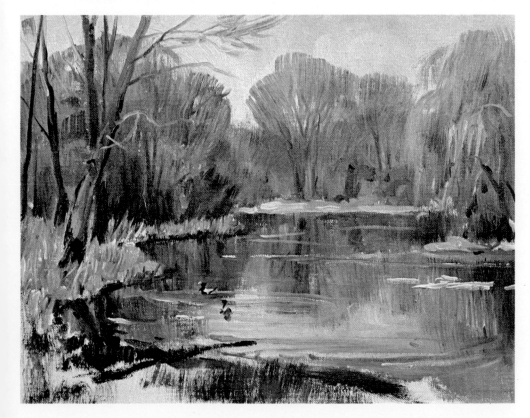

Step 8. A small bristle brush and a round softhair brush alternate, adding shadows, more trunks, and more branches to the distant foliage. These dark reflections are pulled downward into the water with vertical strokes. A bristle brush begins to scrub in the dark tone of the immediate foreground with viridian and burnt sienna. The tip of a round brush picks up some white, tinted with the original sky mixture, to add pale strokes that suggest sunlit weeds on the shore, sunlit branches on the trees, and streaks of light and ripples on the water. Quick dark and light strokes indicate two ducks swimming on the surface of the pond. In the lower left area, a single dark stroke becomes a fallen log.

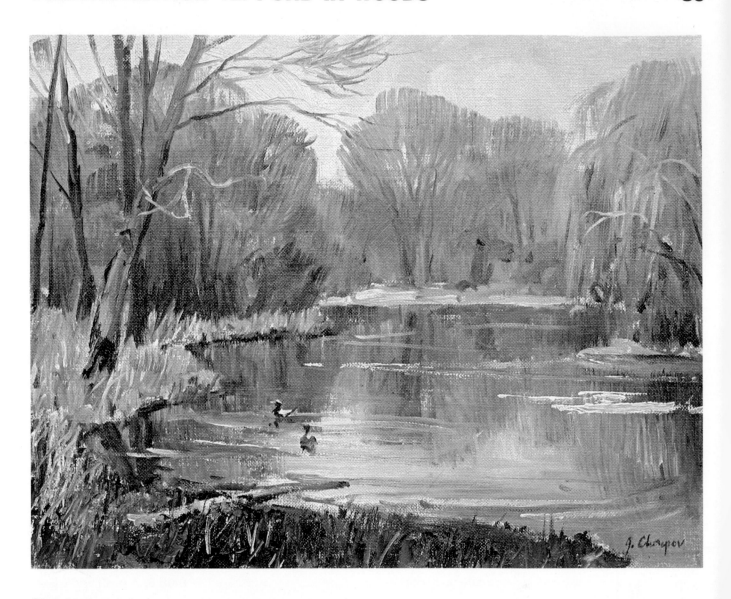

Step 9. The weedy foreground is painted first with rough strokes of yellow ochre, burnt sienna, ultramarine blue, and a touch of white. The paint is thick and rough, applied with a stiff bristle brush. Then the point of a softhair brush goes back into this thick color to pick out individual, sunlit weeds with scribbly strokes of white tinted with yellow ochre. A single stroke of this mixture renders the sunlit top of the fallen log at lower left. Now a small bristle brush and a round softhair brush wander over the surface of the painting, adding touches of darkness and stronger color to heighten the contrasts in the finished painting. Look carefully and you can see where dark notes are added to the foliage and branches with ultramarine blue and burnt sienna. Warm tones are added to the foliage and to the reflections in the water with various mixtures of burnt sienna, yellow ochre, and occasional touches of cadmium yellow or cad-mium red, darkened here and there with ultramarine blue. These subtle changes are particularly evident in the willow at the right, where the shadows are darkened, more dark branches are added, and a hint of warmth is blended into the reflection. Among the foliage of the willow, the round brush adds a few strokes of ultramarine blue softened with a hint of burnt umber and white. The completed painting has stronger darks, sharper contrasts, and greater warmth. The sequence of painting operations is worth remembering. First, the sky is painted—with its reflection in the lake. This is followed by the painting of the foliage—and its reflection in the lake. At this point, the canvas is almost entirely covered with soft color. In the final stages, the painting is completed with stronger darks, warm notes, and the usual touches of texture and detail.

Correcting as You Work. While you're working on a painting, there will certainly be times when you want to change your mind. You may want to move a couple of trees closer together, simplify the shape of a cloud, paint the grass a brighter color, or simply eliminate a distracting rock. If you want to make these changes while the painting is still wet, don't try to cover up your "mistake" by just painting over it. The underlying paint is apt to work its way up into the new strokes and make the repainting job a lot harder. Furthermore, when you pile wet paint on top of wet paint, the surface of the picture starts to get wet and gummy, making the fresh paint hard to push around. Before you repaint any part of a picture, it's always best to remove as much wet color as you can. Scrape that first layer of paint with the side of your palette knife and wipe the blade of the knife on a rag, a paper towel, or a sheet of newspaper. Don't try to reuse the paint you've taken off.

Scraping and Repainting. When you scrape off some unsatisfactory section of the painting, you won't get down to bare, white canvas. The knife doesn't take off every trace of wet paint, but leaves a "ghost" of that tree you wanted to move or that rock you wanted to delete. This is no problem. A fresh layer of color will easily cover what's left of the underlying paint. In fact, that "ghost" has two advantages. Just a faint trace of wet color on the canvas will actually make your brush move more easily over the painting—it can be a very pleasant surface to work on. And that pale image can serve as a helpful guide for your brush to follow.

Wiping out and Repainting. Of course, many artists find that "ghost" image distracting. When they want to make a change, they prefer to eliminate as much of the underlying image as they can. Then the solution is to take a tough, lint-free rag, dip it in turpentine or mineral spirits (white spirit in Britain), and scrub away the wet color. If the paint is fairly thick, it's a good idea to scrape it first with a palette knife. This takes off all the paint that sticks up from the surface. After the scraping, you can use the rag and solvent to dig further into the fibers of the canvas and get rid of the "ghost" that's left by the scraping.

Repainting a Dry Canvas. What if the picture has sat around the studio for a week or more—which probably means that it's now dry to the touch? You can't remove the image easily, but it *is* easy to paint over the dry surface. Start by working over the surface gently with fine sandpaper or steel wool; this will take off some of the paint and roughen the surface slightly so that it becomes more receptive to new brushwork. Then it's a good idea to moisten the surface with just a bit of medium. Dip a clean, lint-free rag in your mixture of linseed oil and turpentine—or one of the more exotic mediums you read about earlier—and wipe the rag over the area you expect to repaint. The canvas should be slightly moist, giving you the pleasant sensation that you're working on a wet painting after all. But the canvas shouldn't be so wet and shiny that the brush slithers over the surface and the bristles don't dig in; if the canvas seems too wet, wipe it gently with a dry rag, leaving the surface just faintly moist.

Maintaining Spontaneity. When you repaint some part of a picture, one of the hardest jobs is to make the repainted portion look as spontaneous as the rest of the picture. The most important advice is: don't be too careful! When you scrape out or wipe out some section of a wet painting, don't be too neat. Scrape or scrub vigorously. Don't remove the offending section so carefully that you leave a neat, sharp edge looking as if you've done the job with a scissors. Leave the edge a bit rough and blurry. Don't worry if you scrape or scrub a bit beyond the area you expect to repaint. For example, if you're scraping out the cheek of a portrait head, don't try to preserve every stroke of the background tone that appears next to the cheek. It's better to take out the cheek and a little of the background tone as well. Then, when you repaint the cheek, you'll have to repaint some of the background too. And you'll feel free to paint both cheek and background with bold strokes.

Be Ruthless. Nothing is more painful than trying to remove and repaint some section of a picture that does contain some good parts. What do you do when the foliage of the tree seems wrong, but you've done a particularly good job with the branches buried among the foliage? Can you scrape away the foliage and manage, somehow, to preserve the brushwork of the branches? Probably not. If you try to scrape or wipe too neatly around those branches, they'll never look like they're part of the same tree when you repaint fresh foliage around them. It's better to be ruthless and scrape off the leaves and branches together. Repaint them both with bold strokes. After all, if you got the branches right the first time, you can do it again!

Step 1. This bouquet of flowers looks too neat and lacks variety because all the blooms are roughly the same size. The blooms need to be distributed in a more casual way and painted with more gusto. The vase is also dull because it lacks strong light-and-dark contrast. The floral decoration on the side of the vase lends nothing to the picture.

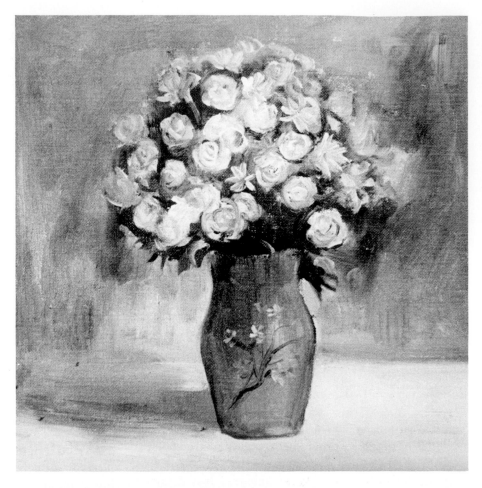

Step 2. The flowers and vase are scraped with the side of the palette knife. This scraping operation doesn't remove all the color. Most of the paint is removed, but you can still see a "ghost" image of the flowers. The general shape of the vase remains intact, making it easier to repaint. However, enough paint has been removed to reveal the texture of the canvas—which will *feel* like bare canvas when the brush goes back to work.

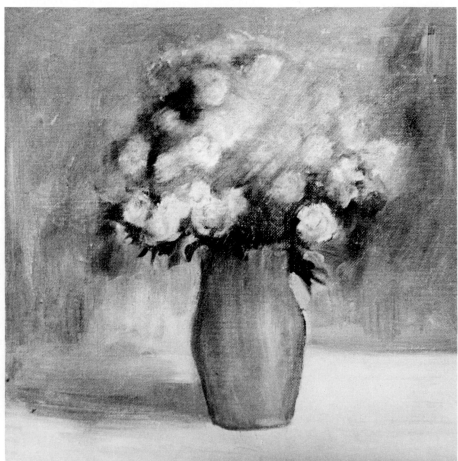

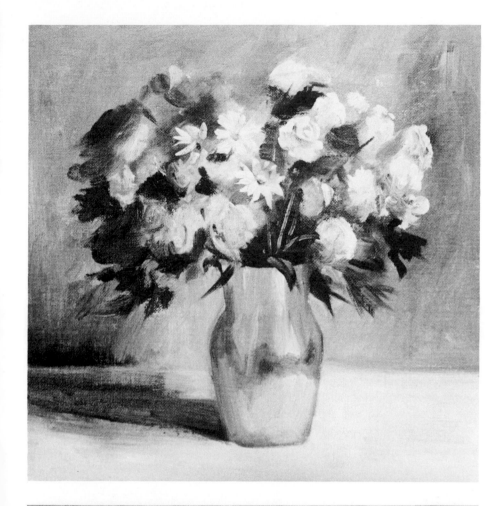

Step 3. The flowers are rearranged in a looser, more "accidental" design. The lighting is changed so that there are stronger contrasts of light and shade within the bouquet and on the vase, plus shadows on the tabletop and wall. The new bouquet is begun with rough, free strokes that quickly cover the "ghost" image in Step 2. The bold strokes of light and shadow on the vase rapidly cover the pale tone that remained in Step 2.

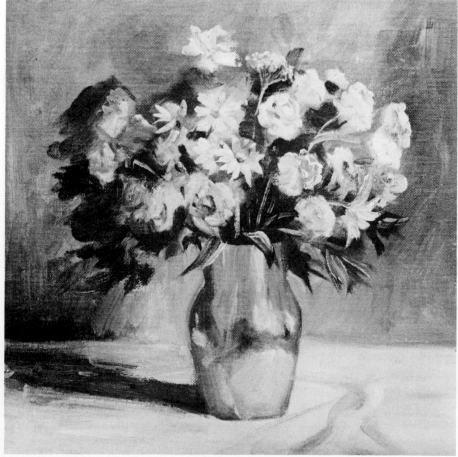

Step 4. Smaller strokes are added to the flowers to suggest petals and stems. But most of the brushwork remains loose and suggestive, unlike the tighter brushwork in the original painting shown in Step 1. Highlights are added to the vase, and the contours are sharpened. The shadows on the tabletop and wall are strengthened. The "ghost" image in Step 2 has served as a guide, particularly in the repainting of the vase, but now the original painting has disappeared totally under the new, more vigorous brushwork.

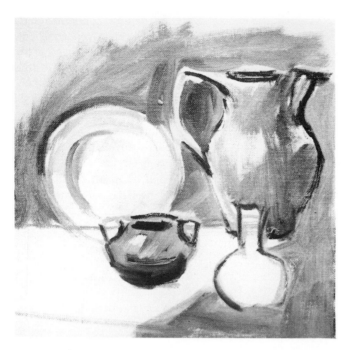

Step 1. The entire composition of this still life is wrong. The pitcher faces outward and leads the eye away from the center of the painting. The two smaller vessels need to be relocated. Only the dish seems to be in the right place.

Step 2. Scraping the painting won't work—the knife won't take off enough paint to remove the pitcher and the two smaller vessels that need to be relocated. A clean, lint-free rag is dipped in turpentine or mineral spirits. The canvas is scrubbed until the three forms disappear entirely. A faint tone remains, but this will be covered easily when the picture is repainted.

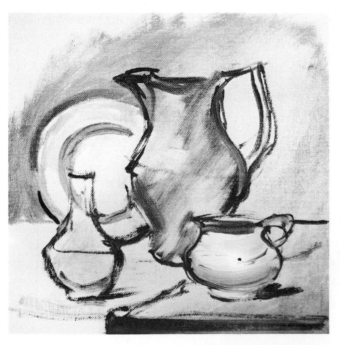

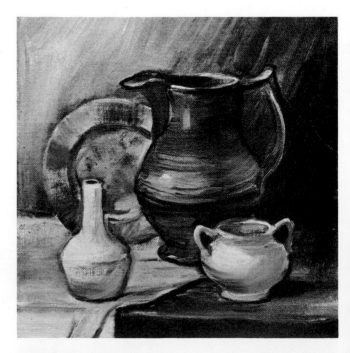

Step 3. With fluid color diluted with plenty of solvent, the pitcher is turned around and relocated so that it occupies the focal point of the painting. The small vase and pot are transposed. The four objects are now regrouped so that they overlap and join forces to make a more unified pictorial design.

Step 4. The still life is now completed with strokes of heavier color. The pale tone that remains in Step 2 is now completely covered with fresh color. There's no trace of the original location of the still life objects that appeared in Step 1.

Step 1. This portrait head is much too pale and the shapes are too vague. The painting is dry, however, which means that it's too late to scrape off the original color with a knife or scrub it off with a rag.

Step 2. The solution is to remove the more prominent brushstrokes with fine sandpaper or steel wool, which also roughens the surface of the canvas and makes it more receptive to fresh brushwork. Then the surface is moistened with a clean rag dipped into just a bit of medium. When fresh paint is applied to this moist surface, the brush feels as if it's moving over a wet painting.

Step 3. The hair, the shadows on the face and neck, and the dark tones of the features are repainted with bold strokes and darker color. As the brush moves over the damp surface, the strokes seem to melt softly into the canvas.

Step 4. In the completed painting, the two layers of color—dry below and wet above—look like one continuous layer of wet paint. Working on a moist surface makes all the difference. The new strokes would look harsh if they were painted on dry canvas.

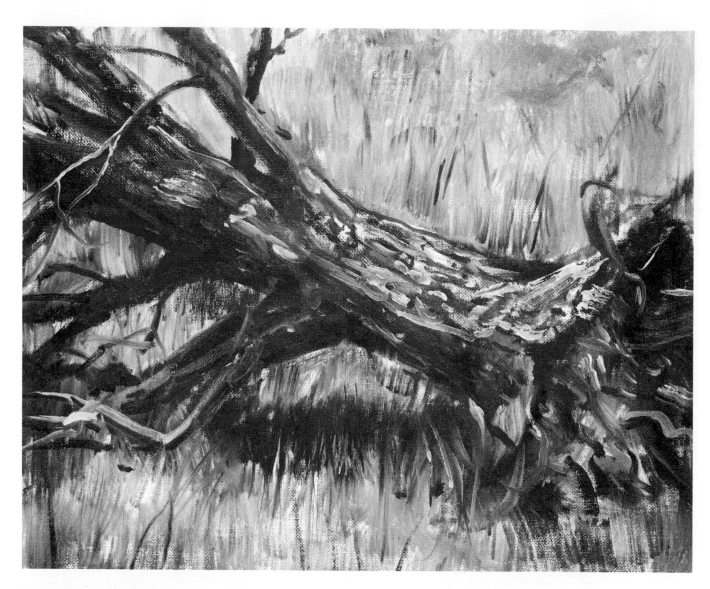

Fallen Tree and Grass. The traditional term for thick paint is the Italian word *impasto*. Strokes of thick, pasty color are a simple way to render rough, irregular textures such as this fallen tree with its rough bark, broken branches, and twisted network of roots. The thick strokes of the bark literally stick up from the canvas. Some of the foreground weeds are also painted with thick color that makes them seem closer than the weeds in the distance. For *impasto* brushwork, use color straight from the tube or add just a touch of painting medium—but not enough to make the paint too fluid.

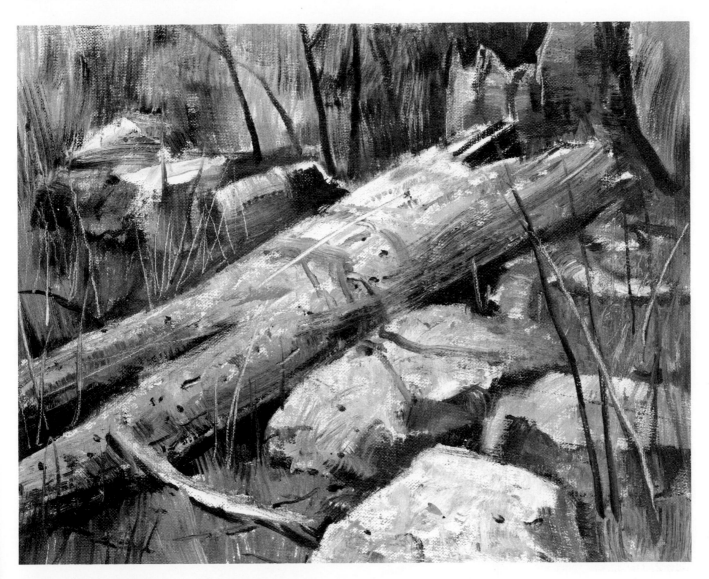

Treetrunk and Rocks. But thick paint isn't the *only* way to create rough textures. You can do just the opposite. Instead of building the paint up from the surface of the canvas with *impasto* brushwork, you can scrape down into the wet paint, making grooves and deep scratches with the tip of the palette knife or the point of the brush handle. You can see such scratches running along this fallen treetrunk, giving the impression of dried, cracked bark. On the facing page, some of the sunlit weeds are painted with strokes of thick color that stand up from the canvas. But in the example on this page, the light-struck weeds are scratched out of the dark paint, revealing the paler tone of the canvas beneath.

Step 1. Like any other subject, the fallen tree begins as a brush drawing in thin color diluted with plenty of turpentine. There's no hint of the thick paint and rough brushwork that will come later. It's always best to begin with thin paint so that you can wipe away the lines with a cloth if you change your mind about the composition or the accuracy of the drawing.

Step 2. The darkest tones are painted first: the shadowy areas of the trunk and branches, the patch of shadow beneath the roots, and the jagged shadow cast by the trunk on the grass. At this stage, the paint is still quite thin and fluid, diluted with a good deal of medium.

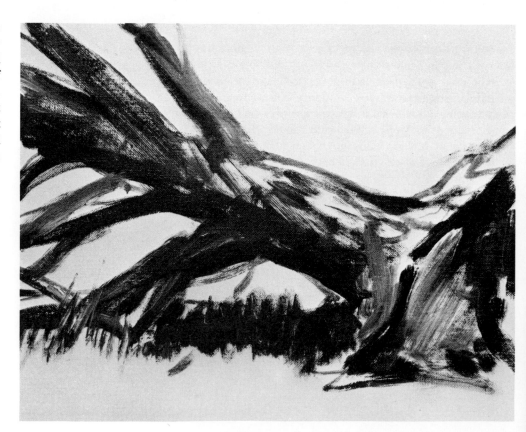

Step 3. Lighter tones are added to the trunk. The lighted areas of the grass are painted beneath the tree, between the branches, and in the meadow beyond. A few light patches appear on the bark, and some lightstruck roots are brushed over the shadow at the base of the tree. The entire canvas is covered with wet color, which is still fluid and creamy. The impasto strokes are saved for the very end.

Step 4. Now the lightest tones of the bark, branches, weeds, and roots are painted with rough, quick strokes of thick color. Each impasto stroke is made with a firm, decisive movement of the brush—and the stroke is left unchanged. The rough texture of the stroke would be ironed out if the brush moved back and forth. In the finished painting, the darks remain thin and fluid; only the lights are thickly painted. In fact, most of the canvas is thinly painted, and the impasto appears only in certain areas. It's best to use impasto brushwork selectively—thick strokes will look more important if they're surrounded by thinner color.

SCRAPING TECHNIQUE

Step 1. This outdoor "still-life"—a heavy log, rock, and weeds—begins with a simple brush drawing that defines the major shapes. There's no attempt to draw details such as the crack in the log or the weeds that will be scratched into the wet paint in the final stage.

Step 2. The trunk and rock are begun with broad strokes of a bristle brush, roughly painted so that the marks of the bristles show and express the texture of the subject. The paint on the log is thick and pasty, and many of the strokes are made with a painting knife.

Step 3. Now the entire canvas is covered with wet color. The paint on the fallen trunk is particularly thick. When scratches are made into this thick color, they'll stand out more clearly than they would if the color were thinly applied.

Step 4. The tip of the palette knife and the pointed end of the brush handle travel up the side of the trunk, leaving grooves and scratches that suggest the texture of the bark. More scratches become the slender strands of weeds that spring up around the sides of the trunk and among the rocks. The lighted tops of the rocks are scraped here and there with the side of the knife blade. The tip of a round brush adds some dark weeds and twigs that contrast nicely with the light scratches.

Step 1. If you want to stretch your own canvas, buy wooden stretcher bars at your art supply store. These are wooden strips with slotted ends that fit together to make a rectangular frame. You'll need four bars, one for each side of the frame. The best nails for stretching canvas are 3/8″ or 1/2″ (9-12 mm) carpet tacks.

Step 2. When you assemble the slotted stretcher bars, they should fit together tightly without the aid of nails or glue. Check them with a carpenter's square to make sure that each corner is a right angle. If the corners aren't exactly right, it's easy to adjust the bars by pushing them around a bit.

Step 3. Cut a rectangle of canvas that's roughly 2″ (50mm) larger than the stretcher frame on all four sides. As it comes from the store, one side of the canvas will be coated with white paint, and the other side will be raw fabric. Place the sheet of canvas with the white side down on a clean surface. Then center the stretcher frame on the fabric.

Step 4. Fold one side of the canvas over the stretcher bar and hammer a single nail through the canvas into the edge of the bar—at the very center. Do exactly the same thing on the opposite stretcher bar, pulling the canvas tight as a drum and hammering a nail through the canvas into the edge of the bar. Then repeat this process on the other two bars so you've got a single nail holding the canvas to the centers of all four bars.

Step 5. Add two more nails to each bar—one on either side of the original nail, about 2″ (50 mm) apart. Working with the back of the canvas facing you, pull the canvas tight with one hand while you hammer with the other. Repeat this process on all four sides. Keep adding pairs of nails to each side, gradually working toward the corners. Pull the canvas as tight as you can while you hammer. At first you may have trouble getting the canvas tight and smooth. Don't hammer the nails all the way in; let the heads stick up so you can yank the nails out and try again.

Step 6. When you get to the corners, you'll find that a flap of canvas sticks out at each corner. Fold it over and tack it to the stretcher as you see here.

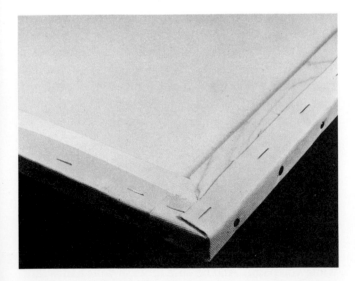

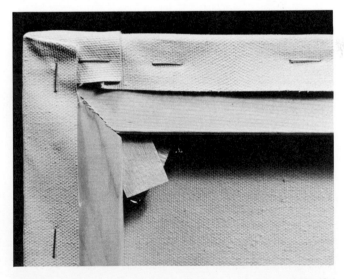

Step 7. Then fold the remaining canvas over the backs of the stretcher bars and staple it down to make a neat job. Speaking of staples, you might like to try using a staple gun for the whole job—instead of tacks or nails.

Step 8. Here's a close-up of the corner, seen from the back, showing the canvas all neatly folded and stapled down. Inside the corners of the stretcher bars you can see the ends of triangular wooden keys, which you hammer into slots to stretch the canvas tighter if it's not absolutely smooth. Your art supply store will give you the keys when you buy the stretcher bars. Hold the keys in place by hammering small tacks behind them. If the canvas starts to loosen and get wavy later on, just hammer in the keys a little further.

Cleaning Your Palette. When you're finished painting, the center of your palette will be covered with smears and dabs of wet color. Along the edges of your palette, there will probably be little mounds of half-used tube color. If you're working on a wooden palette, it's easy enough to wipe off the central mixing area with a rag or a paper towel and a little turpentine or mineral spirits (called white spirit in Britain). Wipe the surface until it's clean and shiny. If you leave a muddy film of color on the mixing area, those traces of old mixtures may work their way into fresh mixtures the next time you paint. And that film of color will develop gradually into a crust that impedes the action of your brush or knife.

Saving Color. As long as you clean the central mixing area, there's nothing wrong with leaving the little mounds of wet color around the edges. Just wipe away any mixtures that may have accumulated around the mounds—leaving bright, fresh color for your next session. If you're planning to paint the next day—or within the next few days—the little piles of color on your palette will stay wet for your next painting session. If they start to dry out, they tend to form a leathery skin on the surface but contain moist color within. You can just puncture the leathery skin, peel it away, and work with the fresh color inside. If you're using a tear-off paper palette, you can simply peel away the top sheet; scoop off the mounds of moist color with your knife; transfer them to the next fresh sheet; then toss away the soiled sheet. If you're not planning to paint again for a week or more, discard the unused color and begin with a clean surface next time.

Care of Tube Colors. By the time you're finished painting, many of your tubes will be smeared with wet color. Wipe them clean with a rag or a paper towel so that you can read the labels and identify the colors the next time you paint. It's terribly frustrating to scramble around among paint-encrusted tubes trying to figure out which is which. Be particularly careful to clean the necks of the tubes and the insides of the caps so that they'll screw on and off easily. You'll also get more paint out of the tube if you roll the tubes up from the end instead of squashing them flat.

Care of Brushes. Don't just rinse the brushes in turpentine or mineral spirits, then wipe them on a newspaper, and assume that they're clean. No matter how clean the brushes may look, these solvents always leave a slight residue on the bristles. Eventually the residue builds up and stiffens the bristles so that they're no longer lively and responsive to your touch. After rinsing the brushes in a solvent and wiping them on newspaper, you *must* take the time to lather each brush in the palm of your hand. Use a very mild soap

with lukewarm water. Keep lathering and rinsing in water until there's no trace of color in the suds. Be sure to work the lather up the bristles to the ferrule—the metal tube that holds the bristles. Then rinse away every bit of soap. Don't be discouraged if the bristles still look a bit discolored after repeated latherings. A very slight hint of color usually remains. But if you've lathered the brushes until the *suds* are snow white, you've removed all the color that will come out.

Care of Knives. The top and bottom surfaces of your palette knife and painting knife blades should be wiped clean and shiny. Use a rag or a paper towel. Don't overlook the edges and tips of the blades—wipe them too. With repeated use, these edges tend to become sharper, so wipe them with care. If they get too sharp, you can blunt them with the same kind of abrasive stone that's normally used for sharpening knives.

Care of Fluids. In the same way that you wipe your tubes clean after a painting session, wipe your bottles of oil, turpentine, and painting medium so that you can read the labels. Before you screw on the caps, wipe the necks of the bottles and the insides of the caps so that they won't stick. Screw on all caps very tightly so that your turpentine or mineral spirit won't evaporate, and your oil won't dry out.

Rags, Newspapers, and Paper Towels. By the end of the painting session, you'll probably have quite a collection of paint-stained rags, paper towels, and newspapers. Don't let this debris accumulate. Get it immediately into a tightly sealed metal container. Then get it out of the house! Remember that if oily rags and papers are left long enough, they gradually absorb oxygen and ignite by spontaneous combustion.

Safety Precautions. None of the painting materials recommended in this book are serious health hazards, but several can be mildly toxic. Oil paints in general—and the cadmium colors in particular—ought to be kept out of your digestive system. While you're painting, some color will always end up on your hands. For this reason, it's important to avoid eating or smoking while you paint. And be sure to wash your hands thoroughly with mild soap and water at the end of the painting session. Turpentine and mineral spirits produce fumes, so it's a good idea to work in a ventilated room: an open window or skylight will send those fumes out into the open air, rather than through the house. Although other solvents such as gasoline (petrol in Britain), kerosene (paraffin in Britain), and other industrial compounds are sometimes recommended for use in the studio, they're usually flammable or toxic or both. So stick to turpentine or mineral spirits.

Washing. Rinse your brush in turpentine or mineral spirits, dry it on newspaper, then lather it with mild soap and lukewarm water in your palm.

Shaping. Keep lathering and rinsing until the suds are snow white. Wash out the bristles with clear water. Press the damp bristles into a neat shape.

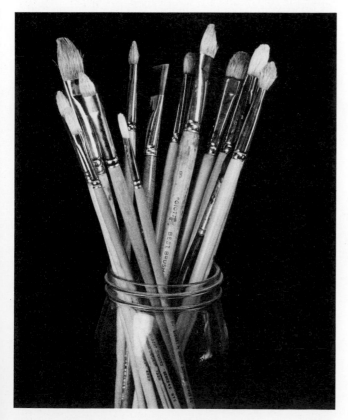

Drying. While they're drying, store brushes in a jar, bristle end up. If you use your brushes often, store them in the jar between painting sessions.

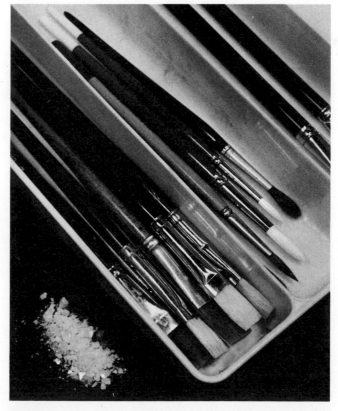

Storing. If you don't use brushes regularly, store them in a shallow box (or a silverware tray like this one) and put them in a drawer with moth-killing crystals.

Permanent Colors. Looking at the dates on the oil paintings in the world's great art museums, you know that an oil painting can last for centuries. But a picture is only as durable as the materials used to paint it. To begin with, not all colors are equally permanent—some will crack or change color over the years. There are also some colors that form unstable chemical combinations: that is, they deteriorate when they're mixed with certain other colors. So the lesson is: stick to permanent colors. All the colors recommended in this book are extremely durable when used by themselves or in combination with other colors. There's just one exception. Ivory black has a tendency to crack when it's used straight from the tube, although it's fine when you use it in mixtures with other colors. So make a point of blending ivory black with at least one other tube color. If you'd like to experiment with other colors, always check the manufacturer's literature to find out how permanent that color will be.

Permanent Painting Surfaces. A painting is only as durable as the surface it's painted on. Professional oil painters normally work on stretched canvas: high-quality linen or cotton nailed to a rectangular framework of well-seasoned wood. Or they work on the hardboard panels that have replaced the wood panels used by the old masters. In either case, the canvas or hardboard is coated with white oil paint or gesso, applied either by the manufacturer or by the artist himself. Yes, canvas boards are the most popular surface among Sunday painters and students. They're durable enough for you and your family to enjoy for many years. But the canvas is inexpensive, and the cardboard backing will eventually start to crumble. So when you start thinking about posterity, switch to stretched canvas or hardboard panels.

Varnish. Oil paintings—unlike watercolors—aren't exhibited under glass. The leathery surface of a dried oil painting is a lot tougher than a sheet of paper. However, an oil painting is normally protected by a coat of varnish that serves the same purpose as a sheet of glass. When you go shopping for varnish, you'll probably see some bottles labeled *retouching varnish* and others labeled *picture varnish*. They have different functions.

Retouching Varnish. Most oil paintings are dry to the touch in a week or so, but it takes at last six months for the paint to dry all the way through. As soon as the surface feels dry, you can protect it with *retouching varnish*. This is a thin mixture of solvent and a little resin such as damar or mastic. The solvent evaporates, leaving behind just enough resin to preserve the freshness of the colors—and perhaps brighten the colors a bit—while the paint film continues to dry. Apply retouching varnish with a soft nylon housepainter's brush. Work with parallel strokes. Don't scrub back and forth or you'll disturb the paint, which isn't as dry as it looks.

Final Varnish. The bottle that's labeled *picture varnish* is a thicker version of the same formula used to make the retouching varnish. The main difference is that the picture varnish contains a lot more resin. This is the final varnish that protects the surface of the picture like a sheet of glass that protects a watercolor. Most oil paintings are ready for a coat of picture varnish after about six months. But if you paint with very thick strokes, they'll take longer to dry all the way through, and it's best to wait as long as a year. Again, use a soft nylon housepainter's brush and work with parallel strokes. Move the brush in one direction only—from top to bottom or from one side to the other. Work on a clean, dust-free, horizontal surface and leave the painting there until the varnish dries to a smooth, glassy film. Don't scrub the brush back and forth, or you'll disturb the smooth surface of the varnish.

Framing. The design of a frame is a matter of taste. It's up to you to decide whether you like a frame that's ornate or simple, colorful or subdued. But remember that the frame also preserves the picture. If you choose a wooden frame, make sure that it's thick and sturdy enough to protect the edges of the canvas from damage. The frame should also be rigid enough to keep the canvas from warping. If you prefer to frame the picture in slender strips—rather than the thicker, more traditional kind of frame—rigid metal strips will provide better protection than wood. If the painting is on stretched canvas, it's a good idea to protect the back by tacking or stapling a sheet of cardboard to the wooden stretcher bars.

Storing Oil Paintings. If you're not going to hang paintings, store them vertically, not horizontally. Don't stack one on top of the other like a pile of magazines. Find some closet where the canvases or panels can be stored upright, standing on their edges. The front of one painting should face the back of another; that way, they don't stick together if the paint is still slightly soft. Remember that stretched canvases are particularly fragile; handle them so that the corner of one canvas won't poke a hole in the face of another.

PART TWO

WATERCOLOR PAINTING

Tubes and Pans. Watercolors are normally sold in collapsible metal tubes about as long as your thumb and in metal or plastic pans about the size of the first joint of your thumb. The tube color is a moist paste that you squeeze out onto the surface of your palette. The color in the pan is dry to the touch but dissolves as soon as you touch it with a wet brush. The pans, which lock neatly into a small metal box made to fit them, are convenient for rapid painting on location. But the pans are useful mainly for small pictures—no more than twice the size of this page—because the dry paint in the pans is best for mixing small quantities of color. The tubes are more versatile and more popular. The moist color in the tubes will quickly yield small washes for small pictures and big washes for big pictures. If you must choose between tubes and pans, buy the tubes. Later, if you want a special kit for painting small pictures outdoors, buy the pans.

Color Selection. The watercolors in this book were painted with just eleven tube colors. True, the colors of nature are infinite, but most professional watercolorists find that they can cope with the colors of nature with a dozen tube colors—or even less. Once you learn to mix the various colors on your palette, you'll be astonished at the range of colors you can produce. Six of these eleven colors are *primaries*—two blues, two reds, two yellows—which means colors that you cannot create by mixing other colors. Just two are *secondaries*—orange and green—which means colors that you *can* create by mixing two primaries. You can mix a rich variety of greens by combining various blues and yellows, plus many different oranges by combining reds and yellows. So you could really do without the secondaries. But it does save time to have them. The last three colors on your palette are what painters call neutrals: two shades of brown and a gray.

Blues. Ultramarine is a dark, soft blue that produces a rich variety of greens when blended with the yellows, and a wide range of grays, browns, and brown-grays when mixed with the neutrals. Cerulean blue is a light, bright blue that is popular for skies and atmospheric effects. At some point in the future, you might like to try substituting phthalocyanine blue for cerulean; phthalocyanine is more brilliant, but must be used in small quantities because it tends to dominate any mixture.

Reds. Alizarin crimson is a bright red with a hint of purple; it produces lovely oranges when mixed with the yellows, subtle violets when mixed with the blues, and rich darks when mixed with green. Cadmium red light is a dazzling red with a hint of orange, producing rich oranges when mixed with the yellows, coppery tones when mixed with the browns, and surprising darks (not violets) when mixed with the blues.

Yellows. Cadmium yellow light is bright and sunny, producing luminous oranges when mixed with the reds and rich greens when mixed with the blues. Yellow ochre is a much more subdued, tannish yellow that produces subtle greens when mixed with the blues and muted oranges when mixed with the reds. You'll find that both cadmiums tend to dominate mixtures, so add them just a bit at a time.

Orange. Cadmium orange is a color you really could create by mixing cadmium yellow light and cadmium red light. But it's a beautiful, sunny orange and convenient to have ready-made.

Green. Hooker's green is optional—you can mix lots of greens—but convenient, like cadmium orange. Just don't become dependent on this one green. Learn how many other greens you can mix by combining your various blues and yellows. And see how many other greens you can make by modifying Hooker's green with the other colors on your palette.

Browns. Burnt umber is a dark, subdued brown that produces lovely brown-grays and blue-grays when blended with the blues, subtle foliage colors when mixed with green, and warm autumn colors when mixed with reds, yellows, and oranges. Burnt sienna is a bright orange-brown that produces a very different range of blue-grays and brown-grays when mixed with the blues, plus rich coppery tones when blended with reds and yellows.

Gray. Payne's gray has a distinctly bluish tone, which makes it popular for painting skies, clouds, and atmospheric effects.

No Black, No White. You may be surprised to discover that this color list contains no black or white. Once you begin to experiment with color mixing, you'll find that you don't really need black. You can mix much more interesting darks—containing a fascinating hint of color—by blending such colors as blue and brown, red and green, orange and blue. And blue-brown mixtures make far more interesting grays than you can create with black. Your sheet of watercolor paper provides the only white you need. You lighten a color mixture with water, not with white paint; the white paper shines through the transparent color, "mixing" with the color to produce the exact shade you want. If some area is meant to be *pure* white, you simply leave the paper bare.

Studio Setup. Whether you work in a special room you've set aside as a studio or just in a corner of a bedroom or a kitchen, it's important to be methodical about setting up your painting equipment. Let's review the basic equipment you'll need and see how this equipment should be arranged.

Brushes. It's best to buy just a few brushes—and buy the best you can afford. You can perform every significant painting operation with just four softhair brushes, whether they're expensive sable, less costly oxhair or squirrel, soft white nylon, or some blend of inexpensive animal hairs. All you really need are a big number 12 round and a smaller number 7 round plus a big 1″ (25 mm) flat and a second flat about half that size.

Paper. The best all-purpose watercolor paper is mouldmade 140 pound stock in the cold pressed surface (called a "not" surface in Britain), which you ought to buy in the largest available sheets and cut into halves or quarters. The most common sheet size is 22″ × 30″ (55 cm × 75 cm). Later, you may want to try the same paper in a rough surface.

Drawing Board. The simplest way to support your paper while you work is to tack or tape the sheet to a piece of hardboard, cut just a little bigger than a full sheet or half sheet of watercolor paper. You can rest this board on a tabletop, perhaps propped up by a book at the back edge, so the board slants toward you. You can also rest the board in your lap or even on the ground. Art supply stores carry more expensive wooden drawing boards to which you tape your paper. At some point, you may want to invest in a professional drawing table, with a top that tilts to whatever angle you find convenient. But you can easily get by with an inexpensive piece of hardboard, a handful of thumbtacks or pushpins, and a role of masking tape, 1″ (25 mm) wide to hold down the edges of your paper.

Palette or Paintbox. Some professionals just squeeze out and mix their colors on a white enamel tray—which you can probably find in a shop that sells kitchen supplies. The palette made *specifically* for watercolor is white metal or plastic, with compartments into which you squeeze tube colors, plus a mixing surface for producing quantities of liquid color. For working on location, it's convenient to have a metal watercolor box with compartments for your gear. But a toolbox or a fishing tackle box—with lots of compartments—will do just as well. If you decide to work outdoors with pans of color, buy an empty metal box equipped to hold pans, then buy the selection of colors listed in this book: don't buy a box that contains pans of color preselected by the manufacturer.

Odds and Ends. You'll need some single-edge razor blades or a knife with a retractable blade (for safety) to cut paper. Paper towels and cleansing tissues are useful, not only for cleaning up, but for lifting wet color from a painting in progress. A sponge is excellent for wetting paper, lifting wet color, and cleaning up spills. You'll obviously need a pencil for sketching your composition on the watercolor paper before you paint: buy an HB drawing pencil in an art supply store or just use an ordinary office pencil. To erase the pencil lines when the watercolor is dry, get a kneaded rubber (or "putty rubber") eraser, so soft that you can shape it like clay and erase a pencil line without abrading the delicate surface of the paper. Find three wide-mouthed glass jars big enough to hold a quart or a liter of water; you'll find out why in a moment. If you're working outdoors, a folding stool is a convenience—and insect repellent is a *must*!

Work Layout. Lay out your supplies and equipment in a consistent way, so everything is always in its place when you reach for it. Directly in front of you is your drawing board with your paper tacked or taped to it. If you're right-handed, place your palette and those three wide-mouthed jars to the right of the drawing board. In one jar, store your brushes, hair end up; don't let them roll around on the table and get squashed. Fill the other two jars with clear water. Use one jar of water as a "well" from which you draw water to mix with your colors; use the other for washing your brushes. Keep the sponge in a corner of your palette and the paper towels nearby, ready for emergencies. Line up your tubes of color someplace where you can get at them quickly—possibly along the other side of your drawing board—when you need to refill your palette. Naturally, you'd reverse these arrangements if you're left-handed.

Palette Layout. In the excitement of painting, it's essential to dart your brush at the right color instinctively. So establish a fixed location for each color on your palette. There's no one standard arrangement. One good way is to line up your colors in a row with the *cool* colors at one end and the *warm* colors at the other. The cool colors would be gray, two blues, and green, followed by the warm yellows, orange, reds, and browns. The main thing is to be consistent, so you can find your colors when you want them.

Round Brushes. When wet, a round brush should have a neat bullet shape and come to a sharp point. Here are five typical good round brushes. The two at left are expensive sables. The center brush is a less expensive ox-hair. At right are two inexpensive oriental brushes with bamboo handles—worth trying if you're on a tight budget. A good substitute for sable is soft white nylon.

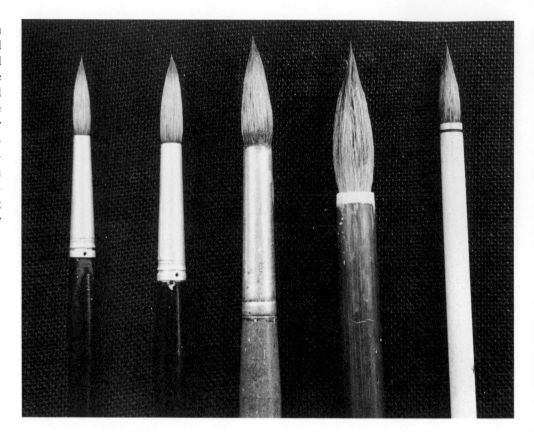

Flat Brushes. A good flat brush, when wet, should taper to a squarish shape that curves inward toward the working end. Here, from left to right, are a large oxhair, good for big washes; a small bristle brush like those used for oil painting, helpful for scrubbing out areas to be corrected; a large white nylon brush, a good substitute for the more expensive sable; and a nylon housepainter's brush, which you might like to try for painting or wetting big areas.

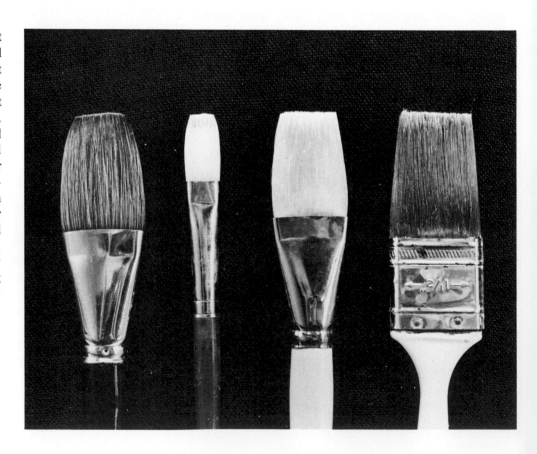

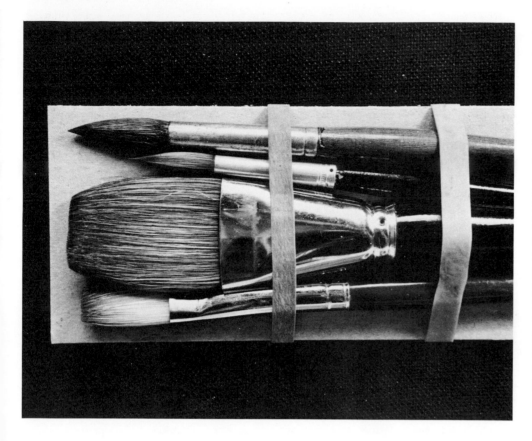

Carrying Your Brushes.
When you're working on location and carrying your brushes from place to place, it's important to protect the delicate hairs from being squashed in your paintbox. One good way to do this is to cut a piece of stiff cardboard just a bit longer than the longest brush. Then arrange the brushes carefully on the board, making sure that they don't squash one another, then strap them down with a few rubber bands. For further protection, you can then slip the board into a sturdy envelope or wrap it in something flexible, like a cloth or bamboo placemat, secured with a couple of rubber bands.

Sponges and Towels. For wetting your paper, sponging off areas you want to repaint, and cleaning up spills, it's worthwhile to buy an inexpensive synthetic sponge (left) or the more expensive natural sponge (lower right). The natural sponge has a silkier texture and will treat the surface of the paper more gently. Paper towels (upper right) are also good for cleaning up—and are handy for blotting up wet color from the surface of the painting when you want to lighten some passage that seems too dark.

Watercolor Palette. The most versatile type of watercolor palette is made of white molded plastic or lightweight metal coated with tough white enamel paint. Along the edges of this white plastic palette are compartments into which you squeeze your tube colors. The center of the palette is a large, flat mixing area. A "lip" prevents the tube colors from running out of the compartments into the central mixing area. At the end of the painting session, you can simply mop up the mixing area with a sponge or paper towel, leaving the color in the compartments for the next painting session.

Studio Palette. Designed primarily for use indoors, this palette has circular "wells" into which you squeeze your tube colors, plus rectangular compartments for individual mixtures. The compartments slant down at one end so that the mixtures will run downward and form pools into which you can dip your brush.

Box for Pans. For painting small watercolors outdoors, many artists prefer to carry a metal box that holds little rectangular pans of dry color, rather than tubes. The dry colors liquefy as soon as you touch them with a wet brush. Buy an empty box and then buy separate pans of color, which you insert into the box. Notice that the box has two lids that open to give you four "wells" and one flat mixing surface.

Fiberboard and Tacks. A simple way to support your watercolor paper when you're painting is to tack the sheet to a stiff piece of fiberboard. This particular piece of fiberboard is 3/4″ (about 18 mm) thick and soft enough to accept thumbtacks (drawing pins) or pushpins. Be sure to cut the board just a bit larger than the size of your watercolor paper.

Plywood and Tape. Another solution is to tape your watercolor paper to a sheet of wood—preferably plywood, which will resist warping when it gets wet. The wood will be too hard to take tacks, so use masking tape that's at least 1″ (25 mm) wide, or even wider if you can find it. A sheet of smooth hardboard will also do the job. If available, buy hardboard or plywood that's made for outdoor use; it's more resistant to moisture.

Pencil and Knife. To sketch your composition on the watercolor paper, carry a sharp pencil with a lead that's not too dark. HB is a good grade. A mechanical pencil with retractable lead is least apt to break. For cutting paper and tape, as well as for scratching lines into your painting, a sharp knife is handy. This knife is convenient and safe because it has a retractable blade, which you can replace when it gets dull.

Round Brushes. The basic tool for watercolor painting is a round softhair brush. A cluster of carefully selected animal hairs is cemented into a metal cylinder (called a ferrule) which, in turn, is clamped onto the end of a cylindrical wooden brush handle. The cluster of hairs is shaped something like a bullet: thick and round at the ferrule, then gradually tapering to a sharp point. It's important to have the biggest round brush you can afford. In most art supply catalogs, this is usually a number 12 sable, which is about 5/16″ (roughly 8 mm) in diameter at the point where the hairs enter the ferrule. Some dealers stock a number 14 sable, which is even bigger: roughly 3/8″ (about 10 mm) in diameter at the end of the ferrule. For detailed work, you should have another round sable that's about half the diameter of the big one—usually a number 7 in most art supply catalogs.

Saving Money. You'll probably be shocked by the price of a top-quality sable brush. The animal hairs are rare and costly; the brushes are made by hand; and the price seems to go up every year! For these reasons, the most expensive sables are generally bought by professionals. However, there are other softhair brushes which will do the job. First of all, there *are* less expensive grades of sable, which your art supply store may carry. Second, there are oxhair and squirrel hair brushes that are *far* less expensive; they're less springy than sable, but lots of artists like them just as well. And several manufacturers have now come up with soft, white nylon brushes—a kind of synthetic sable—that behave very much like natural sable, but cost a lot less.

Flat Brushes. For large areas of color such as skies and expanses of water, a large, flat brush is extremely useful. This is a flat, squarish body of soft hairs set into a broad metal ferrule at the end of a thick, cylindrical wooden handle. The most useful flat brush is at least 1″ (25 mm) wide where the hairs enter the ferrule; and if you're going to paint really big pictures, try to find a flat brush that's even bigger. For bold brushwork on a smaller scale, get a 1/2″ (12 or 13 mm) flat brush. Once again, don't be discouraged by the price of top-quality sable. Cheaper sable, oxhair, squirrel hair, or white nylon will do just as well.

Other Brushes. Many watercolorists carry one or two oil painting brushes—the kind made of white hog bristles—in their kits. Because these bristles are stiffer than the sables, oxhairs, and white nylons, the oil brushes make a bolder, rougher stroke. But bristle brushes are most commonly used for scrubbing out a passage that needs to be lightened or corrected. You might like to try working with a 1″ (25 mm) bristle brush, later adding another one that's half that size. For delicate line work, many watercolorists like a very slender sable called a rigger, originally developed for sign painters. And for wetting large areas with clear water, it's sometimes helpful to have a 2″ (50 mm) nylon housepainter's brush.

Testing Softhair Brushes. When you buy a softhair brush, it's important to test the brush before you walk out of the store. A good art supply store generally has a jar of water near the brush rack for just this purpose. A knowledgeable customer will test out several brushes before he makes his final choice. Dip the brush into the water and swirl the brush around carefully with a gentle circular motion. Make sure that you don't squash the hairs against the bottom of the jar. Then remove the wet brush from the jar, hold the handle at the far end, and make a quick whipping motion with a snap of your wrist. A good round brush should prove its worth by automatically assuming a smooth bullet shape, sharply pointed at the tip. A good flat brush should form a neat, squarish shape, tapering in slightly toward the forward edge. If the round brush assumes an irregular tip, rather than coming to a neat point, try another brush. If the hairs of the flat brush don't come neatly together after this test, but retain a ragged shape, don't buy the brush. Keep testing brushes until you find one that behaves properly.

How Many Brushes? Although a professional watercolorist often has a drawer full of brushes, accumulated over the years, you really need very few. You can paint watercolors for the rest of your life with just four brushes: the two round ones and the two flat ones described above. Others may be fun to have, but they're certainly optional. If you want to compare the handling qualities of the expensive, highly resilient brushes with the less expensive, softer brushes, there's a way to do this without spending too much money. When you buy your two biggest brushes—the large round and the large flat—these can be inexpensive oxhair or squirrel hair. After all, when you're working with big brushes, you're making bold, free strokes, so the brush doesn't need to have an absolutely perfect shape. Then, when you buy your two smaller brushes—one round and one flat—you might invest in top-quality sables, which are less expensive in this size. If you prefer, the small round brush can be sable and the small flat one might be white nylon. After a year of painting, you'll know whether you like a soft brush or a resilient one.

Watercolor Paper. You *can* paint a watercolor on any thick white drawing paper, but most artists work on paper made specifically for watercolor painting. The best watercolor papers have a texture—the professionals call it a *tooth*—that responds to the stroke of the brush as no ordinary paper can. Good watercolor paper also has just the right degree of absorbency to hold the liquid color, which is more apt to wander off in some unpredictable direction when you work on ordinary drawing paper. So stick to watercolor paper and buy the best you can afford.

Textures. Watercolor papers are manufactured in three surfaces: rough, cold pressed, and hot pressed. The rough surface has a very pronounced tooth, best for large pictures and bold brushwork. The cold pressed variety—which the British call a "not" surface—still has a distinct tooth, but a far more subtle texture, which most watercolorists prefer. The cold pressed surface is a lot easier to work on, particularly for beginners. Hot pressed paper is almost as smooth as the paper on which this book is printed. The surface has very little tooth, and the liquid color tends to run away from you. Hot pressed paper is mainly for experienced painters who've learned how to control it.

Paper Weights. When it gets wet, watercolor paper swells and tends to buckle—or cockle, as the British say. That is, the paper tends to develop bulges or waves. The thicker the paper, the less pronounced (and the less irritating) these waves or bulges will be. The *thinnest* paper that's convenient to paint on is designated as 140 pound. This is the weight of a very heavy drawing paper. The *thickest* paper you're likely to use is 300 pound, which is as stiff as cardboard. No, a single sheet of paper won't weigh 140 pounds or 300 pounds. That's the weight of a *ream* of paper, which means 500 sheets. In other words, a 140 pound sheet comes from a stack of 500 sheets weighing 140 pounds altogether.

Buying Paper. It's most economical to buy watercolor paper in individual sheets, which are most often 22″ × 30″ (55 cm × 75 cm). When a watercolorist talks about a "full sheet," this is usually the size he means. You can then cut this sheet into halves or quarters, which are all convenient sizes for painting. For small practice pictures and rapid sketches, you can even cut the sheet into eighths. You can also buy a small stack of watercolor paper in a pad, bound on one edge like a book. And you can buy a stack of paper in a block, which is bound along all four edges to keep the paper from curling up as you paint. But you pay a lot extra for the binding. You save a lot of money by buying sheets, cutting them up, and then tacking or taping them to your own drawing board.

Handmade Versus Machinemade. At one time, watercolor papers were normally made by hand. Such paper was called "100% rag" because it was made entirely of shredded rags. Today, all but a few of the great handmade paper mills have disappeared. Some art supply dealers stock rare, expensive handmade papers, which are still the best—if you can afford them. But most watercolorists now paint on machinemade papers that are chemically pure cellulose fiber, actually as permanent as the all-rag stock. The best machinemade papers are called *mouldmade*, a slow, careful process that produces a painting surface that comes reasonably close to the handmade stock. Mouldmade paper is still expensive, though not as costly as the handmade variety.

Testing Watercolor Paper. Assuming that you're not ready to invest in handmade paper—most people don't—it's best to work with mouldmade paper, which is still far better than the *ordinary* machinemade papers. If you look carefully at the surface, you'll see that the less expensive machinemade papers have a mechanical, repetitive texture that has much less "personality" than the more random texture of the mouldmade. But a good art supply store may have several brands of mouldmade paper, differing in absorbency, texture, and toughness. Buy one or two sheets of each (perhaps one cold pressed and one rough), cut them into quarters, label them so you know which is which, and paint pictures on them all. After a few months of experimentation, you'll know which sheet you like best.

What to Look for. See how absorbent the paper is. One sheet soaks up the liquid color, while another seems to resist it—the color seems to stay on the surface and need more stroking to force it into the hills and valleys of the sheet. At first glance, the more absorbent paper may look better, but some artists do like the less absorbent kind. (You can also make it a bit more absorbent by sponging the surface with clear water.) Speaking of toughness, you'll also find that some papers will take more punishment than others. The more absorbent papers are usually softer, which means that you can't scrub out and repaint easily. The tougher surfaces will take more vigorous brushwork and are easier to scrub out and correct. Watch the texture too. If you like to work on a large scale with big, ragged strokes, you may like the rough surface better than the cold pressed, which lends itself to smoother washes and more controlled brushwork.

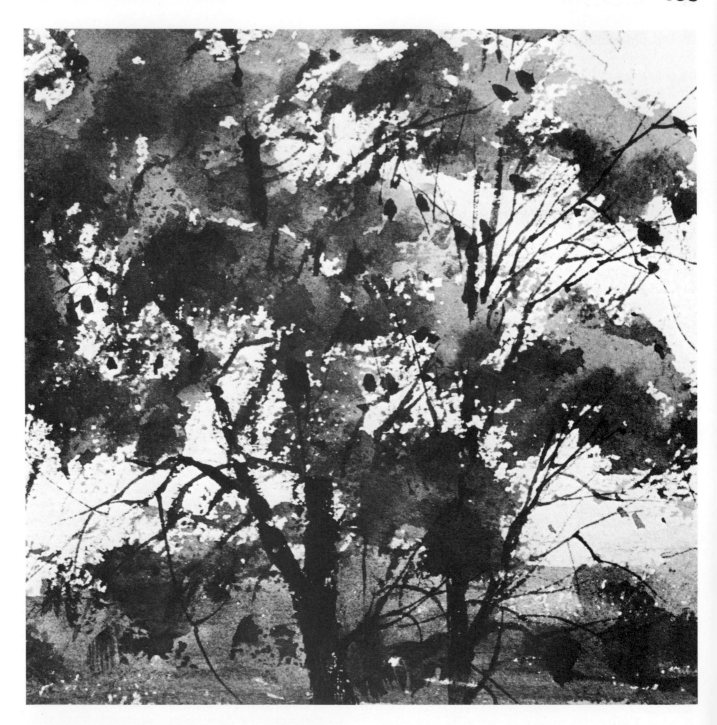

Rough Paper. The surface of your watercolor paper will have a strong influence on the character of your brushwork. On rough paper, the brushstrokes have a ragged, irregular quality that's just right for suggesting the rough texture of treetrunks and branches and the flickering effect of leaves against a light sky. In this life-size closeup of a section of a landscape, you can see how the texture of the paper literally breaks up the brushstrokes. If you like to work with bold, free strokes, you'll enjoy working on rough paper.

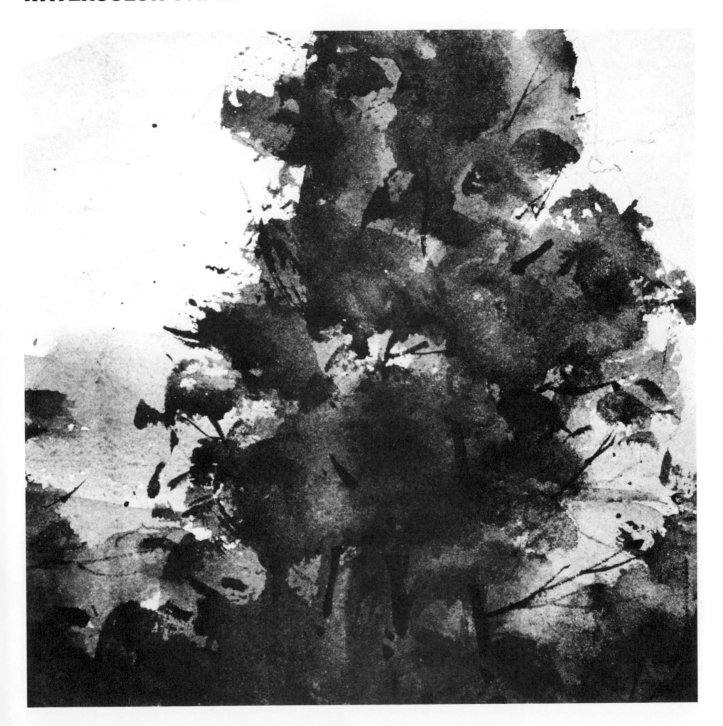

Cold Pressed Paper. The most popular surface is cold pressed—called "not" in Britain—which still has a distinct texture, but not nearly as irregular as the rough sheet. In this close-up of a tree from another painting, you can see that the liquid color goes on smoothly, and the brushstrokes don't look nearly as ragged. Cold pressed stock is the "all-purpose" paper that most watercolorists prefer because it's most versatile. It takes everything from big, smooth masses of color to tiny details. And you can still work with big, free strokes, if that's your style.

Step 1. Mountains are a good subject for practicing flat washes. The big shapes are blocked in with a series of strokes, slightly overlapping one another so that they fuse together at the edges. The tone doesn't have to be smooth and even; mountains are craggy, after all, and the individual strokes can show a bit.

Step 2. For the shadow sides of the mountain, a darker wash is applied with free, irregular strokes. These big planes of light and shadow can be painted very effectively with a flat brush.

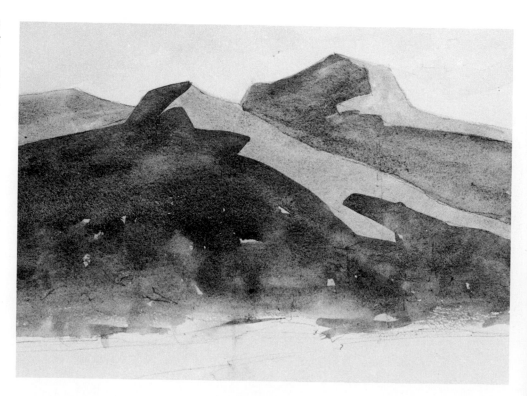

Step 3. When that shadow plane is dry, a darker shadow tone is applied to strengthen and vary that area. The shadow tone that was painted in Step 2 isn't completely covered here, but peeks through the darker tone to suggest a variety of lights and shadows.

Step 4. With the light and shadow planes of the mountains completed, a still darker tone is mixed for the trees in the foreground. These are brushed in with quick, irregular strokes made by the tip of a small, round brush. To suggest snow beneath the trees, some pale strokes are added—about as dark as the wash in Step 1. The whole picture is painted in four flat tones.

Step 1. Here's how hills are done in graded washes. Once again, it's best to start from the top. The sky begins with one or two long strokes of dark color, followed by several strokes of paler color containing more water. The pale strokes are added while the dark strokes are still wet so that they blur together. When the sky is dry, the distant hills are done in exactly the same way. In the foreground and along the edge of the near hill, you can see traces of the very pale pencil drawing with which the picture began. So far, the near hill and the foreground are just bare paper.

Step 2. Now the nearest, biggest hill is done in the same way as the sky and the far hill. The topmost strokes are quite dark; thus the more distant hill at the horizon seems farther away. The immediate foreground is still bare paper.

Step 3. At this point, work begins on the immediate foreground. You can see that it's a rather streaky, graded wash. The strokes are applied very freely so that they don't quite blend, and the strokes in the immediate foreground are only a little darker than those beyond. As you'll see in the next step, the entire foreground will have an irregular texture.

Step 4. As in the previous demonstration, the darks and the details are saved for the very end. Now the tip of the brush suggests the dark trees at the foot of the hill plus the grasses and weeds at the very bottom of the picture.

Step 1. This atmospheric study of a lake begins with a wash that goes from dark to light to dark again. The sky at the top begins with some dark strokes, followed by paler strokes that blend with the dark ones and work down to the midpoint of the sheet. Then these pale strokes begin to fuse with darker strokes once again, coming down to the edge of the lake.

Step 2. The land mass below the sky is also a kind of graded wash, starting with dark strokes at the horizon and then gradually giving way to paler strokes in the wedge of shore at the left. The foreground grasses are roughly indicated with pale vertical strokes.

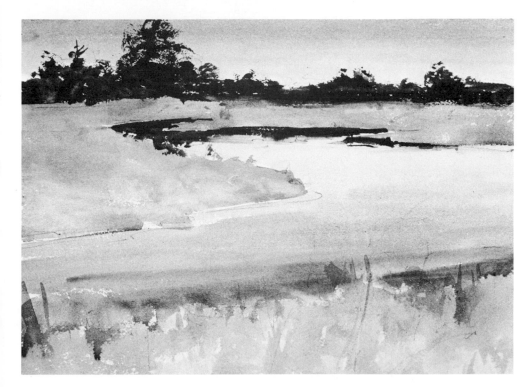

Step 3. When the darks of the trees are blocked in at the horizon, the graded wash in the sky suddenly creates a feeling of glowing light. And when the dark reflection of the trees is added just below the distant shore, the graded wash of the lake gives the impression of reflected light on the distant water.

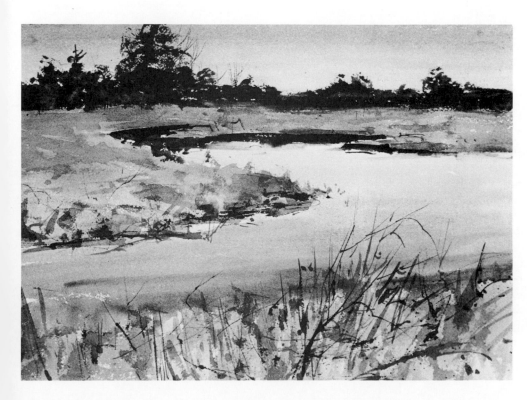

Step 4. Now the picture is completed by adding some darks along the edge of the near shoreline and adding some strokes for weeds in the immediate foreground. The graded wash in Step 1 doesn't make much sense all by itself; but with these details added, the sky and water glow with light.

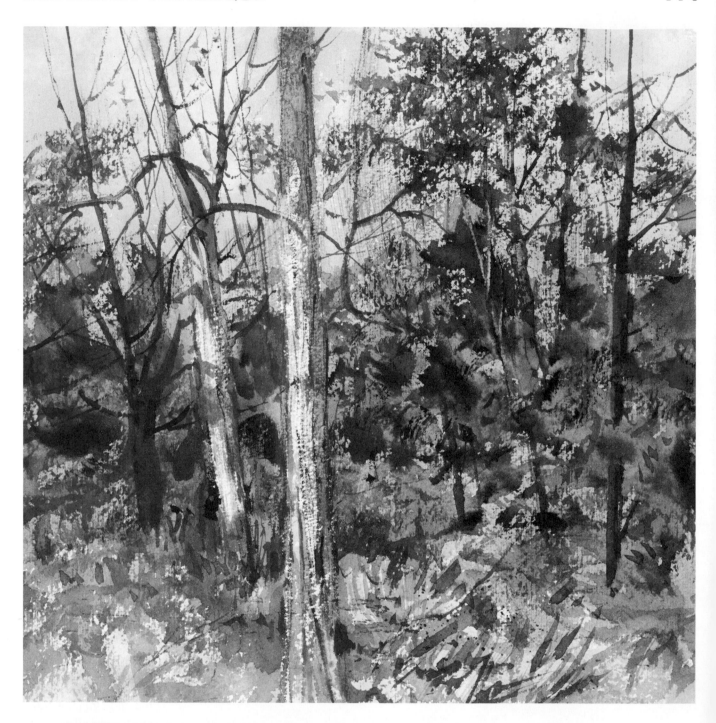

Woods Painted with Drybrush. Drybrush is a method of exploiting the texture of the paper to create rough-textured brushstrokes. The brush isn't literally dry, but just damp. You can dip the brush in liquid color and then wipe the hairs on a paper towel to remove some of the color, or you can just pick up a bit of color on the brush, not letting the hairs get too wet. You then skim the damp brush over the paper, hitting the ridges and skipping over the valleys. The color tends to be deposited on those ridges, leaving the valleys bare. The harder you press, the more color you deposit, but some paper always peeks through, and the strokes have a fascinating, ragged quality that is ideal for suggesting textures such as treetrunks, masses of leaves, and the flicker of sunlight on the ground below.

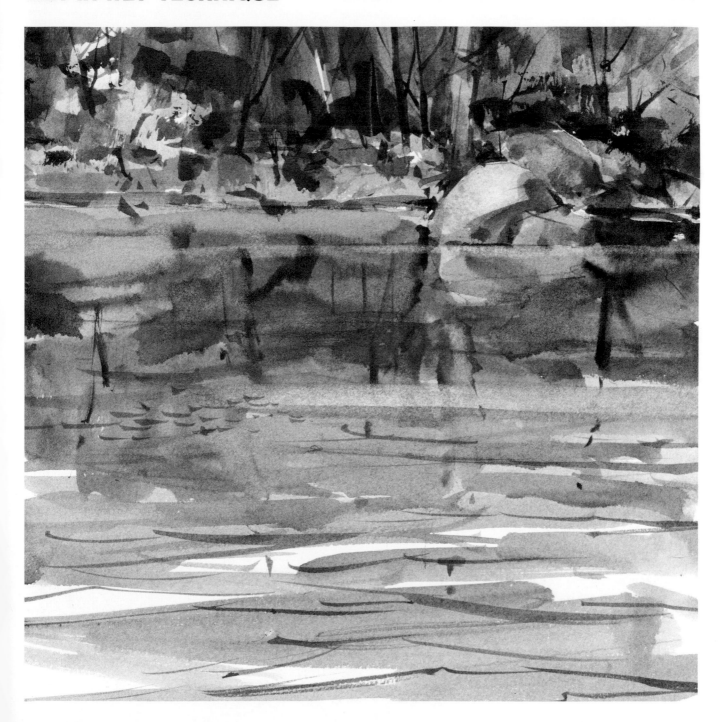

Reflections Painted Wet-in-Wet. As you discovered when you painted a series of overlapping strokes to create flat and graded washes, a stroke of watercolor blurs when it hits a wet area of the paper. The technique called wet-in-wet takes advantage of this phenomenon. If you wet the paper first—either with pure water or with liquid color—and then apply fresh strokes of color to this wet surface, those strokes will blur. You can see this happening in the reflections of the dark woods in the water just above the midpoint of this picture. The dark strokes blur into a paler undertone to suggest the mysterious shapes of the reflections.

Step 1. Now you'll see how drybrush is used to paint the rough texture of a forest scene. Over a simple pencil drawing of the main shapes, a pale tone is quickly brushed in for the distant sky, leaving bare paper for the two light treetrunks just left of center. While the sky wash is still wet, a few darker strokes are added to suggest the distant woods. These darker strokes blur into the wet sky wash.

Step 2. The tip of the brush adds a few fast, decisive strokes for the darker treetrunks and also for some branches. It's a good idea to place these darks early so that you don't lose track of them among the mass of drybrush strokes that will come next.

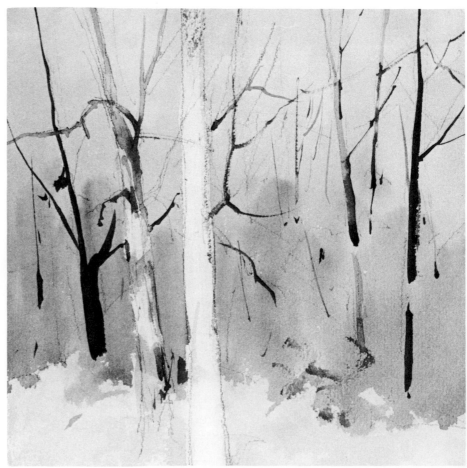

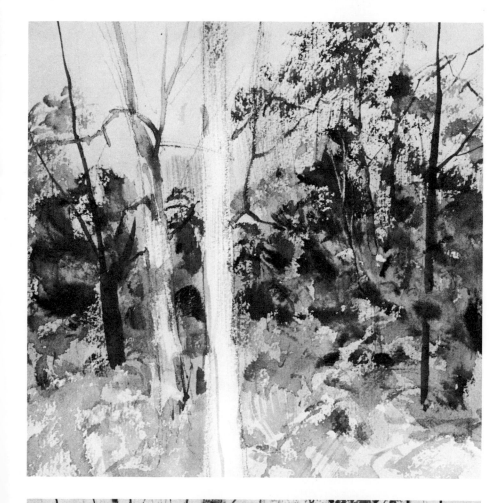

Step 3. Now the drybrush work begins. The brush is damp, not wet—lots of color, but not too much water. If the brush is too wet, wipe it on a paper towel. Now the brush is skimmed over the paper, leaving color on the ridges and skipping over the valleys. If you press harder, you'll deposit more color, but the strokes will still have a broken, irregular look, with flecks of paper showing through. The darks in the center are placed with quick, rough strokes. If some strokes look too dark and ragged, they can be softened with some strokes of liquid color, as you see in the center. Notice the pale drybrush strokes in the immediate foreground.

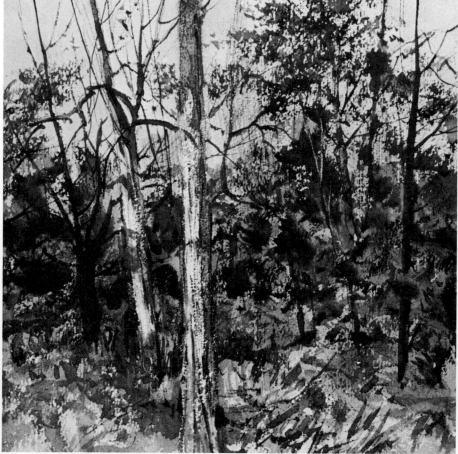

Step 4. Drybrush strokes gradually build up the darks of the woods, the foliage against the sky, and the grasses and weeds in the foreground. Finally, the tip of the brush suggests the texture of the central treetrunk with slender strokes—and adds details such as more branches, twigs, and foreground weeds.

Step 1. Now let's see how a rock formation is painted in drybrush. The distant landscape is painted in several flat washes. The sky is one irregular flat wash with some darker strokes added wet-in-wet. The scrubby tree is painted by pressing down a damp brush and pulling it away. Now the drybrush work begins.

Step 2. The shadows on the rocks are painted with the quick strokes of a damp, flat brush held at an angle so the flat side hits the paper. The lighted tops of the rocks are textured by very light strokes of the brush, applied with very little pressure and pulled along rapidly, just skimming the surface of the paper.

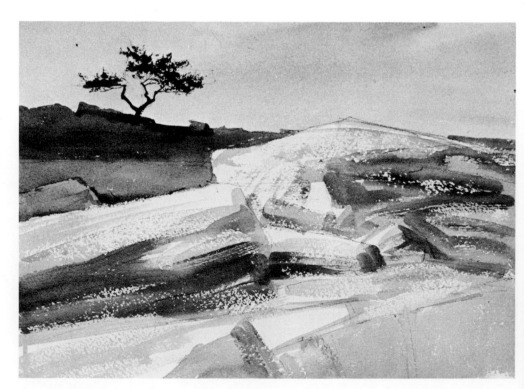

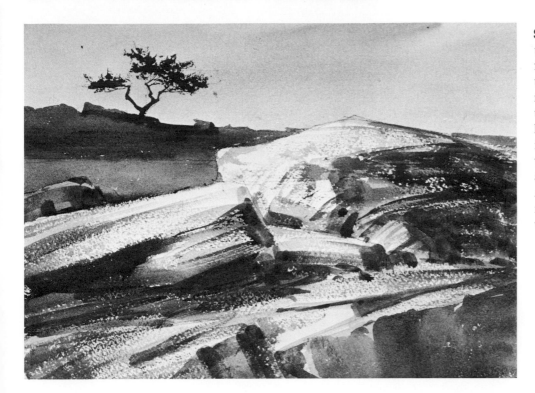

Step 3. The shadow sides of the rocks are darkened with further drybrush strokes. This time, the color on the brush is not only darker, but a bit wetter. And the brush is pressed harder against the paper, forcing the color further into the valleys. The slender strokes are made with a round brush. And the shadow in the lower right corner is a fluid flat wash.

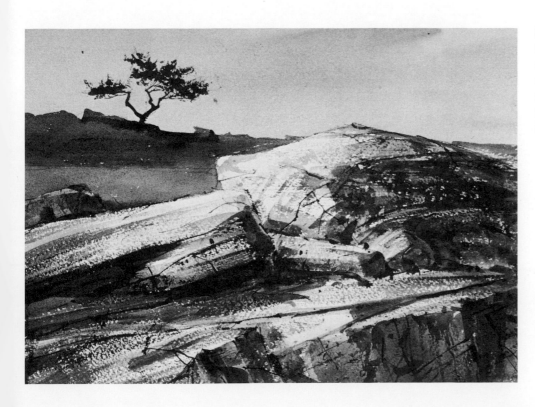

Step 4. More drybrush textures are added to the shadow on the lower right. Then the tip of a small, round brush is used to strike in slender lines for the cracks and flecks that complete the rocks.

Step 1. A wet-in-wet passage looks most effective when contrasted with more precise washes. So this picture begins with a series of flat washes for the woods at the top. This section is painted flat wash over flat wash, like the rock study you've already seen. Just a few big strokes suggest lights and shadows.

Step 2. Now the woods are completed with more precise, slender strokes to suggest treetrunks and more shadows. For precise work like this, you can either use a small brush or the very tip of a large brush. The water area is still bare paper.

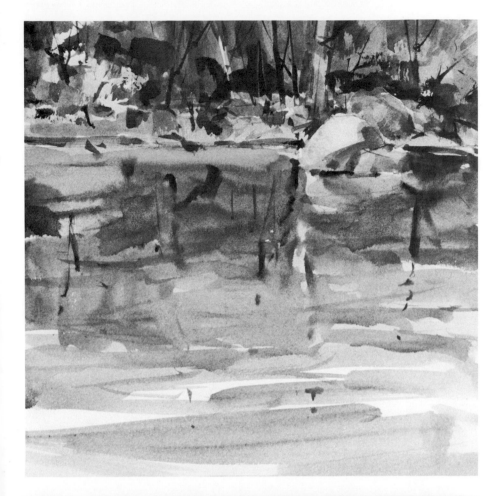

Step 3. At this point, the reflections are painted wet-in-wet. A series of pale horizontal strokes suggests the water. It's important to wait a moment to let that wash settle into the paper. Then, while the underlying wash is still wet and shiny, the brush goes back in with much darker strokes that blur and suggest the reflections just below the shoreline. Since a wet-in-wet passage always dries *much* lighter than you expect, the color on your brush should be quite dark.

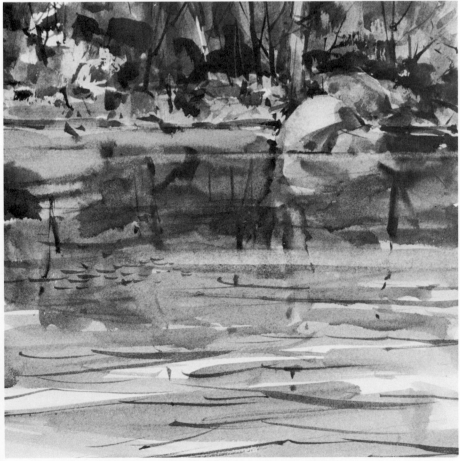

Step 4. When the water and reflections are dry, a few ripples and streaks are added with a small brush. Now you'll see that the dried color of the water is a lot paler than the wet wash.

Step 1. It's usually best to *begin* with a wet-in-wet effect and then complete the painting with strokes and washes on dry paper. In this first stage, the entire sheet is brushed with clear water. Then the distant shore, the island, and the ripples in the water are all painted into this wet surface and allowed to dry. The dark strokes are thicker color, diluted with less water.

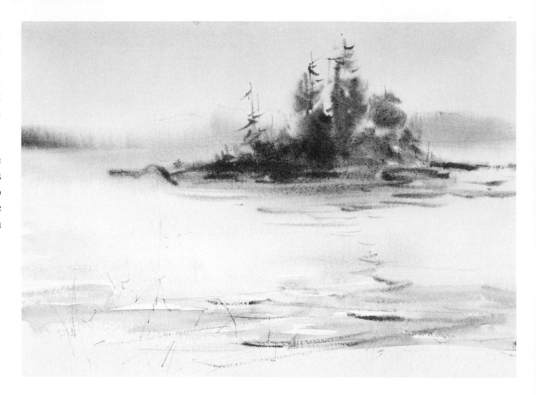

Step 2. The entire sheet is allowed to dry. Then the foreground is begun with free strokes, scraped here and there with the tip of the brush handle to suggest weeds struck by the light.

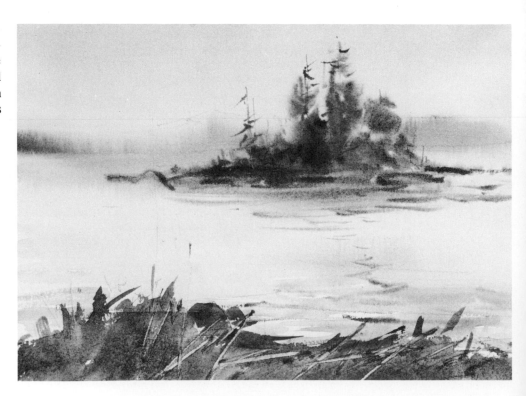

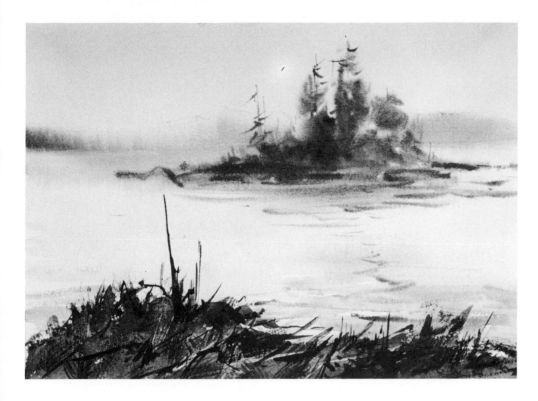

Step 3. The foreground is gradually built up with more and more crisp, dark strokes working their way across the misty blur of the lake. The contrast of the sharp-focus foreground and the blurry distance is the key to the picture—the foreground makes the wet-in-wet island look more distant and mysterious.

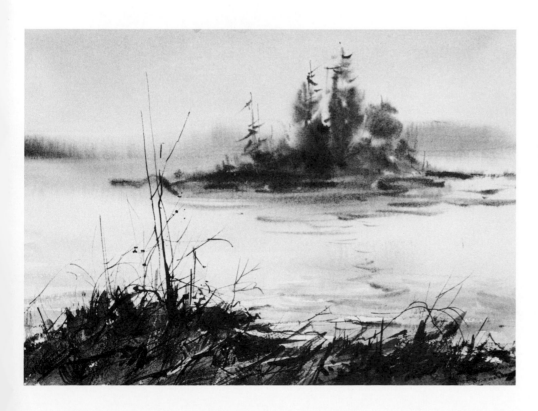

Step 4. The weeds of the foreground are completed with long, slender strokes that cut across the blurred, wet-in-wet distance, further accentuating the contrast between sharp focus and soft focus. At this point, it's possible to rewet certain areas of the island with clear water and drop in additional dark touches, which are almost invisible because they blur away into the surrounding darkness. But do this very selectively and with great care—don't rewet the whole painting.

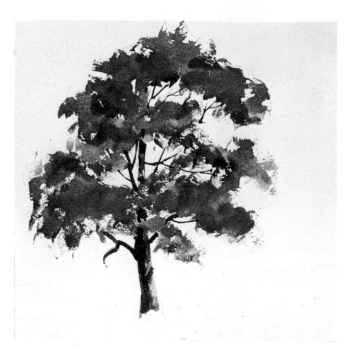

Step 1. A round brush tends to leave a more jagged, irregular stroke than a flat brush. A good way to tell the difference between the ways these two brushes work is to try painting the same tree with both. In this first stage, the broad masses of foliage are blocked in with the round brush held at an angle, so both the tip and the side press against the paper.

Step 2. Now, working with the tip of the brush, add the trunk and the branches. If it's a good one, even a very large brush comes to quite a sharp point, so you can make precise strokes.

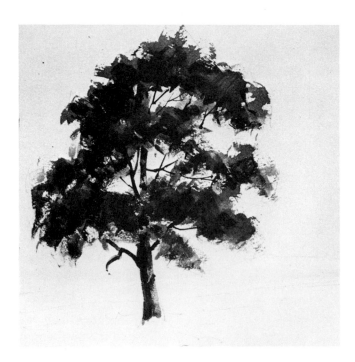

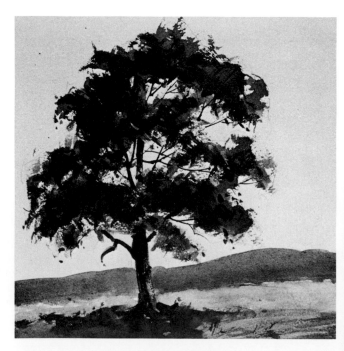

Step 3. Working with the side of the brush once again, you can block in the dark of the foliage. When you work with the side of the brush, the stroke tends to be broken up by the texture of the paper, giving you an effect called drybrush.

Step 4. Now you can add the final touches with the tip of the brush once again, adding more branches and a few flecks for leaves. And you can complete the picture by brushing in a strip of tone for the distant hill, plus some darks in the foreground to suggest a shadow under the tree.

Step 1. A flat brush tends to make broad, squarish strokes. You ought to bear this in mind when you make your preliminary pencil drawing, which should visualize the tree in big, blocky masses.

Step 2. Following the drawing rather freely, the flat brush quickly places large color areas. These have a much broader, flatter character than the foliage in the preceding demonstration, which was painted with a round brush. Because the flat brush covers so much territory, you can work very quickly.

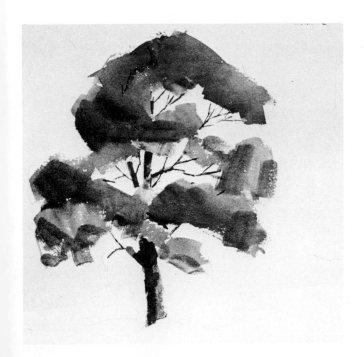

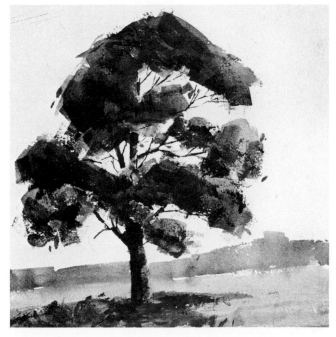

Step 3. You might not think that such a big brush would be capable of precise work, but it is. Just a touch of the forward edge of the brush will make a very crisp line, as in the branches of the tree. If you press down and give the brush a slight pull, you can make a thicker line, as in the trunk.

Step 4. Working with the side of the flat brush, you can produce rough-textured darks for the shadows of the foliage. The distant hills are just one sweeping stroke. And you can make the ragged shadow at the bottom of the tree by patting the brush against the paper.

Linear Strokes. A watercolor brush can make many different kinds of lines, depending upon which part of the brush you use—and how you hold it. If you work with just the tip of the brush, you can make rhythmic, slender lines. If you press down a bit harder, more of the brush will spread out onto the paper, and you'll produce thicker lines. That's how these treetrunks and branches are painted. The thick strokes of the branches are made by pressing down firmly so that not only the tip of the brush, but also a fair amount of the body, travels across the surface. For the thinner trunks, the brush isn't pressed down quite so hard. And just the tip of the brush is used for the slender branches and twigs. The brush carries lots of very fluid color. This group of trees is essentially a series of thick and thin lines.

Broad Strokes. If you work with the side of the brush, holding the wooden handle at an angle or almost parallel with the surface of the paper, you can make broad, ragged strokes like the brushwork used to paint these evergreens. The strokes will be particularly broad and ragged if you pull the brush sideways. That's how the thicker strokes in this picture were made. You can also press the brush firmly against the paper, pull it away to one side, and gradually lift the brush off the surface—making a stroke that starts out thick and ends up thin, like the brushwork toward the tops of these trees. Working with the side of the brush also gives you the broken drybrush textures you see along the edges of the branches.

Planning Your Colors. Watercolor, unlike oil paint, doesn't allow you to mix a batch of color, brush it over the painting surface, wipe it off, and try again. Once that mixture is on the watercolor paper, it's there to stay. As you'll see later, there *are* ways of washing off an unsuccessful color mixture, but these are strictly emergency measures. That first wash of color should be the right one. The only way to make sure it's the right one is to know what each color on your palette can do, so you can plan every color mixture in advance.

Testing Your Colors. The best way to find out what your colors will do is to plan a simple series of tests. If you use the color selection recommended in this book, you'll have eleven colors on your palette. Make a "test sheet" for each of these colors. Take three full-size sheets of watercolor paper and cut them into quarters, which will give you a dozen small sheets, one for each color on your palette—plus an extra sheet which you can put aside for a small painting later on. At the top of each sheet, write the name of one of the colors on your palette. Then, using one of your big brushes—either the large round or the large flat—paint a series of color patches about 1″ (25 mm) square in several rows across the sheet.

Mixtures. Start with the color whose name is written at the top of the sheet. Mix it with a little water for the first patch, with more water for the second, and with a lot of water for the third. Then mix that color with each color on your palette. Label each mixture so you can go back to the "test sheet" later on and see how you got all those fascinating colors. It's particularly interesting to try each mixture two or three times, varying the proportions of the colors. In other words, if you're mixing ultramarine blue and cadmium yellow light, first try a mixture in which the blue and yellow are added in equal quantities; then try more blue and less yellow; finally, try more yellow and less blue. Painting these "test sheets" is the quickest way to learn about your colors. The whole job won't take you more than a few hours and will save you countless days of frustration when you're actually painting.

Color Charts. It's worthwhile to do these "test sheets" methodically. Label each mixture with some code that you'll be able to decipher months later. For example, if the mixture is ultramarine blue and cadmium yellow light, you might just use the initials UB-CYL. Now these are more than just "test sheets"; they're color charts that you can use for years, tacking them on your studio wall and referring to them when you're planning the color mixtures in a painting. Eventually, all these color mixtures will be stored in your memory, and you can put the charts away in a drawer. But while you're learning, the charts are a great convenience. They also look very professional and will impress your friends!

Color Mixing. When the time comes to mix colors for a painting, here are a few tips to bear in mind. Dip your brush into the water first, then pick up a bit of moist color from the palette with the *tip* of the brush and stir the brush around on the palette until you get an even blend of color and water. Then pick up a bit of your second color on the tip of your brush and stir this into the mixture. If you need a third color, stir this into the mixture *after* you've blended the first two colors. The point is to add the colors to the mixture one at a time so you can judge how much you're adding and see the mixture change gradually. Try to stick with mixtures of just two or three colors. Mixtures of four or more colors tend to turn muddy.

Mixing on the Paper. Because watercolor is fluid and transparent, you'll discover interesting ways of mixing color right on the paper. One method is the wet-in-wet technique. You can wet the surface of the paper with clear water and quickly brush two or three colors onto the shiny surface; allow them to flow and merge by themselves, with just a little help from the brush. This produces lovely, irregular color mixtures, with one hue blurring into another like the interlocking blues and grays of a cloudy sky. Another way to mix directly on the paper is to put down one color, allow it to dry, then paint a second veil of color over the first. The underlying color will shine through the second wash, and the two will "mix" in the eye of the viewer. A wash of blue over a dry patch of yellow will produce green, but this will be quite a different green from a mixture of the same two colors on your palette. One transparent color over another produces an *optical* mixture.

Testing Optical Mixtures. Just as you've made "test sheets" to see what happens when you mix one color with another, it's worthwhile to make some more "test sheets" to see what kinds of *optical* mixtures you can create. The quickest way to do this is to take one of your flat brushes and make a long, straight stroke of one color. Let it dry. Then cross this long stroke with a short stroke of each color on your palette. Make each short stroke just long enough so that you can see how it looks on the bare white paper and then how it changes as it crosses the underlying stripe of color. Make one of these "stripe charts" for each color on your palette, and you'll discover a great variety of optical mixtures that you'd never find any other way.

Step 1. To learn how to model forms—to get a sense of three-dimensional roundness—it's best to start out with some still-life objects from the kitchen, such as this arrangement of an eggplant, an onion, and some radishes. Begin with a simple drawing. You needn't be too precise in drawing your lines, since you're going to erase them with kneaded rubber (or putty rubber) after the complete painting is dry.

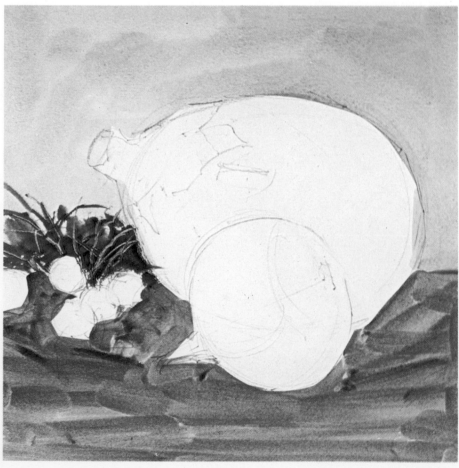

Step 2. The background and the tabletop are painted with big, free strokes. The background is ultramarine blue mixed with a touch of burnt sienna. The tabletop is mostly burnt umber, plus a bit of cerulean blue. The greens behind the radishes are Hooker's green and burnt sienna, painted with a small, round brush. The stems are scraped out with the tip of the brush handle while the color is still wet.

Step 3. The rounded form of the eggplant is brushed in with curving strokes—a blend of alizarin crimson, ultramarine blue, and burnt umber. Some strokes are darker than others and they all blur together, leaving a piece of bare paper for the highlight. The onion is painted with a mixture of yellow ochre, cadmium orange, and a touch of cerulean blue, with all the strokes blurring together, wet-in-wet. The dark spots on the onion are burnt umber, brushed in while the underlying color is still wet. The green on the eggplant is cadmium yellow, cerulean blue, and yellow ochre.

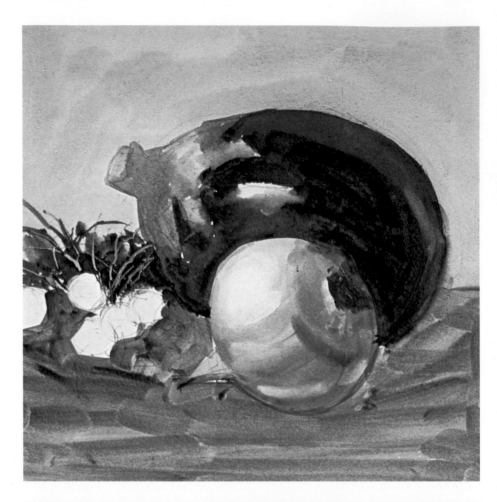

Step 4. The radishes are modeled with the short, curving strokes of a small, round brush—a blend of cadmium yellow, cadmium red, and alizarin crimson for the bright tones, then Hooker's green for the dark touches. The dark greens on the tip of the eggplant are also Hooker's green darkened with a touch of cadmium red.

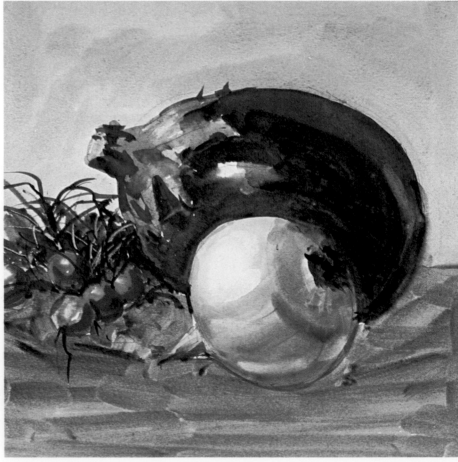

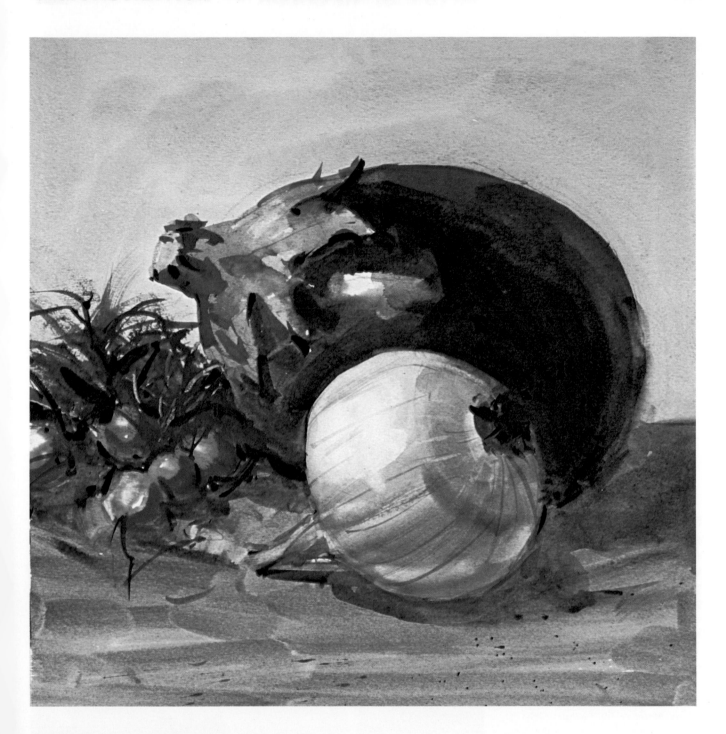

Step 5. Finally, cast shadows are added beneath the eggplant, onion, and radishes in a dark mixture of burnt umber and ultramarine blue. Some dark touches are added to the green tip of the eggplant, at both ends of the onion, and behind the radishes with a mixture of Hooker's green and alizarin crimson. Some lines of burnt umber are added to the onion, and some light lines are scratched out with the corner of a sharp blade. Going back to the green mixture in Step 2, some drybrush strokes are added behind the radishes. As you can see, the main point is to follow the forms. The brushstrokes on the vegetables are rounded, like the shapes of the vegetables themselves. And the strokes of the table are horizontal, like the surface of the table.

Step 1. Some rough-textured object like this old, dead treestump is ideal for developing your skill with drybrush. This may also be a good opportunity to try out rough paper, in contrast to the cold pressed (or "not") paper used in the previous demonstration. The preliminary pencil drawing defines the general shape of the treestump, indicates some of the bigger cracks, and suggests some roots that will be painted out later because they're distracting.

Step 2. In a landscape, it's usually best to start with the sky, painting it with a large flat or round brush. The sky mixture here is ultramarine blue, alizarin crimson, and yellow ochre. Then you can work on the shapes along the horizon, which happen to be trees in this case—a mixture of Hooker's green and burnt umber, with a bit of Payne's gray. The grass is Hooker's green, yellow ochre, and burnt sienna. This completes the background for the treestump. The lines in the distant trees are scratched with the tip of a brush handle while the color is wet.

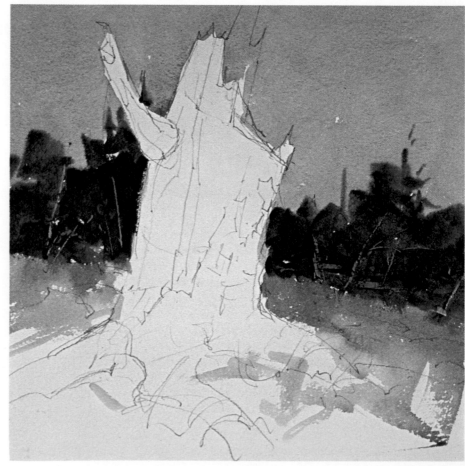

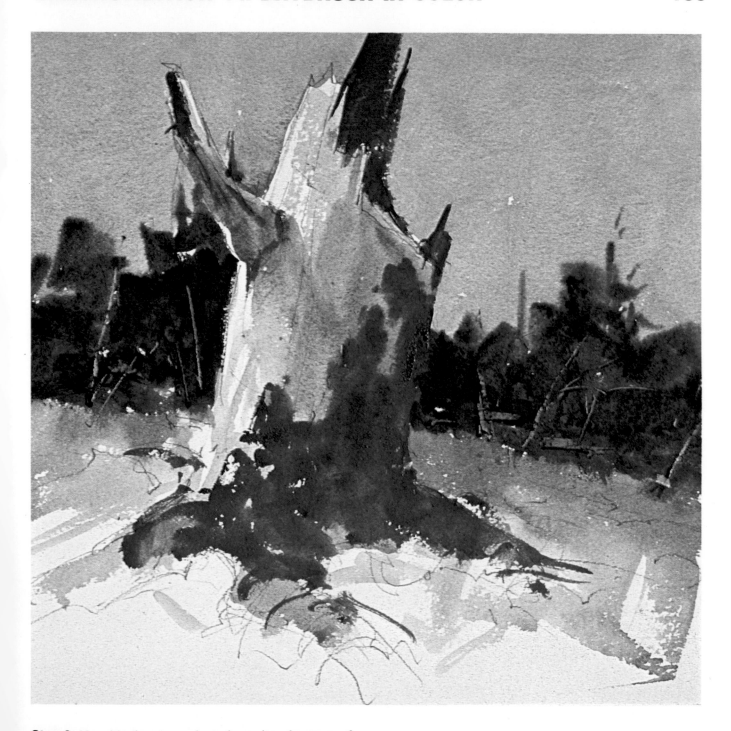

Step 3. Now it's time to work on the main color areas of the treestump itself. It's usually best to work from light to dark. The lighter tones of the wood are burnt sienna and ultramarine blue, leaving some bare paper on the left side of the stump for the lights. This same mixture is used for the shadow side of the broken branch. While the light tone is still damp, a dark mixture of Hooker's green and burnt umber is added to the right side of the stump, so the dark and light tones fuse slightly. This mixture is also used for the other darks on the stump. At this point, the brush carries a lot of color, but it's not too wet; thus the strokes have a drybrush feeling—particularly the darks at the top of the stump.

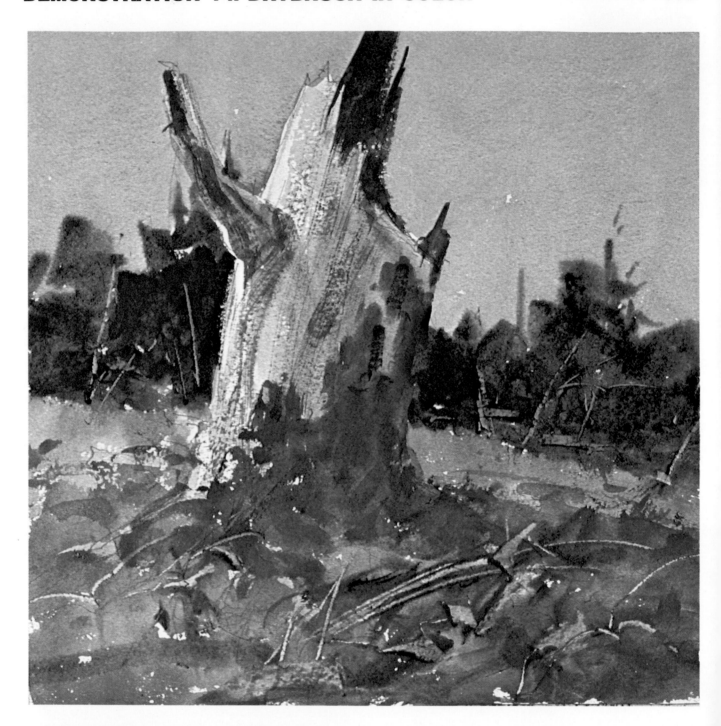

Step 4. Now drybrush strokes are added to the stump, following the upward direction of the form and suggesting the roughness of the dead, weathered wood. These strokes are a mixture of cerulean blue and burnt sienna. The dead weeds in the foreground are painted roughly with a big brush—a mixture of yellow ochre, burnt sienna, and burnt umber—with one wet stroke blurring into the next. While the foreground color is still wet, it's fun to scrape into the color with the tip of a brush handle to suggest individual weeds. If you look closely, you can see some drybrush strokes suggesting the rough texture of the ground.

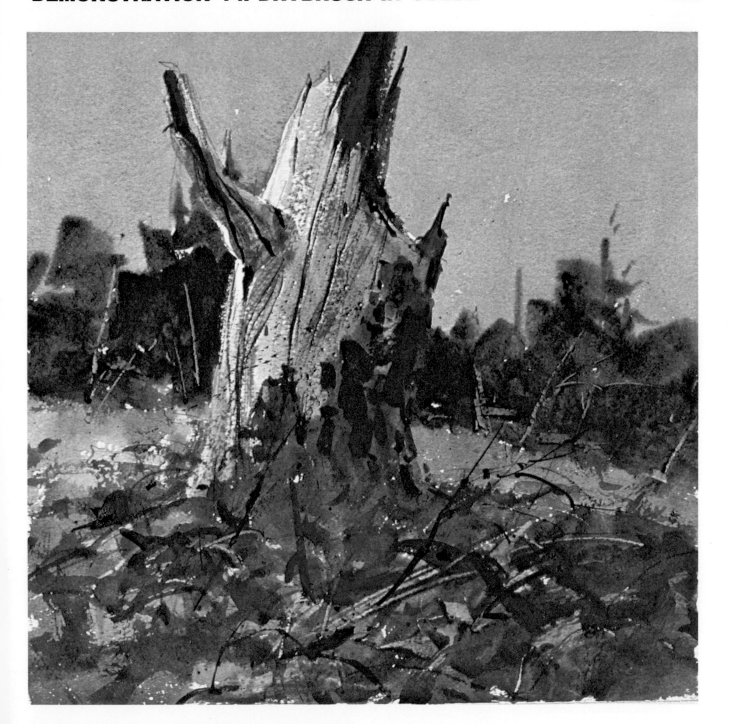

Step 5. Drybrush strokes of burnt umber are added to the foreground. More darks are added to the stump with a mixture of alizarin crimson and Hooker's green. This mixture is used for the very slender strokes and additional drybrush textures on the light part of the stump. The sharp corner of a blade is used to scrape out some light lines next to the dark ones, strongly emphasizing the texture of the wood. Finally, a few touches of cadmium red are added at the base of the stump, within the dark shadows at the top of the stump, and inside the cracked branch. The finished painting is actually a combination of many different effects. The sky is a flat wash. The distant trees are painted wet-in-wet into the sky. Drybrush is used selectively, mainly on the stump and in the foreground.

Step 1. The rounded forms of fruit always make an excellent subject for a still life— good practice for developing your skills with the brush. This casual arrangement of grapefruit, apples, and plums begins with a simple pencil drawing that indicates the rounded shapes of the fruit, plus the bowl and the dividing line between the tabletop and the background wall. The background is painted with a mixture of cerulean blue, yellow ochre, and burnt sienna, with more blue in some places and more brown or yellow in others. The same colors are used on the underside of the bowl, with more yellow ochre.

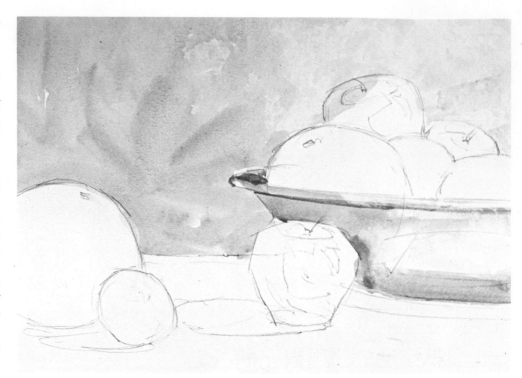

Step 2. The light side of the grapefruit is painted with cadmium yellow, plus some yellow ochre and a touch of cerulean blue on the shadow side. While the light washes are still wet, the dark strokes are added so that the dark and light strokes blur together a bit. Notice how the strokes curve to follow the rounded forms.

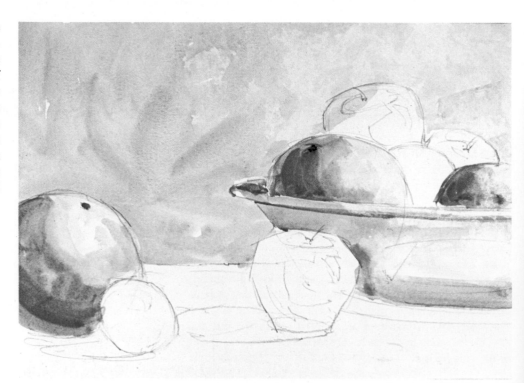

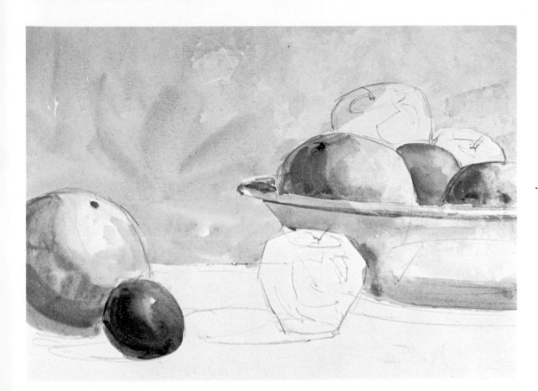

Step 3. The orange in the bowl, just behind the two grapefruit, starts with a mixture of cadmium yellow and cadmium orange. An extra dash of cadmium orange is added to the top while the first wash is still wet, and a little Hooker's green is brushed into the wet wash to suggest a ·shadow farther down. The plum is mainly ultramarine blue and alizarin crimson, with a hint of yellow ochre. A bit of bare paper is left for the highlight. The lighter side of the plum is painted with more water in the mixture, the shadow side with less. The two tones blend together, wet-in-wet.

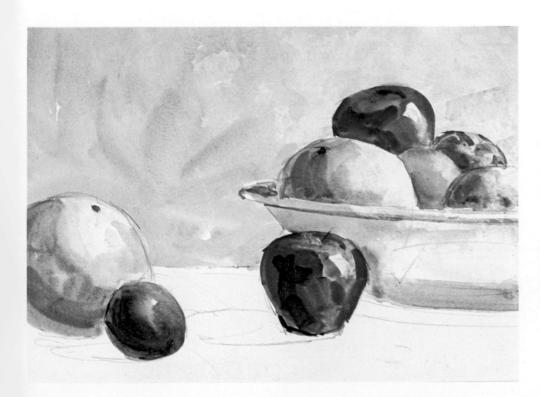

Step 4. The lighter sides of the apples are painted with cadmium red and a little cadmium yellow, adding more cadmium red and alizarin crimson to the shadow side. The darkest touches of shadow include a little Hooker's green. The dark touches are added while the lighter strokes are still slightly wet. The green at the top of the apple is Hooker's green plus a little cadmium yellow. The paler apple at the back of the bowl is painted with the same mixtures, but with more water.

Step 5. Now it's time to "anchor" the fruit to the horizontal surface of the table, which is painted with a large, flat brush carrying a fluid mixture of Hooker's green and burnt sienna. You can see that the brushstrokes are rather irregular, some containing more green and some containing more brown. More strokes are added to the background wall with the same big brush; the free, erratic strokes carry mixtures of cerulean blue, yellow ochre, and burnt sienna, some strokes bluer and some browner than others.

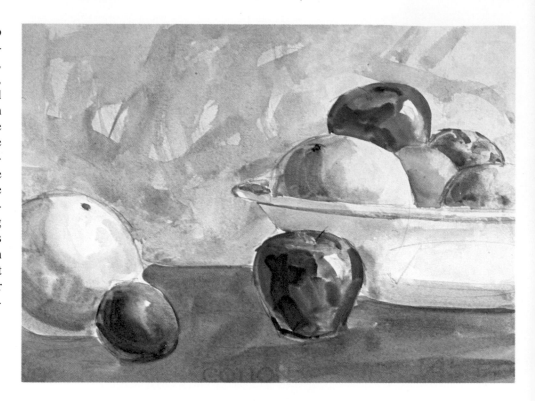

Step 6. Shadows on the table are added with a dark mixture of burnt umber and Hooker's green, carefully painted with a small, round sable. A few strokes are added to the tabletop to suggest the wood texture. Then more texture is added to the wall and the tabletop by a technique called spattering: the brush is dipped into wet color, which is then thrown onto the painting surface with a whipping motion of the wrist, spattering small droplets of paint. Stems are added to the apples—a blackish blend of Hooker's green and alizarin crimson.

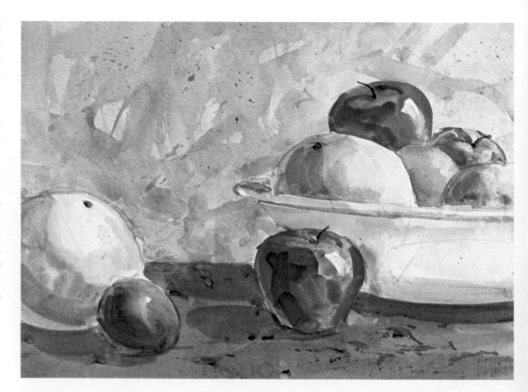

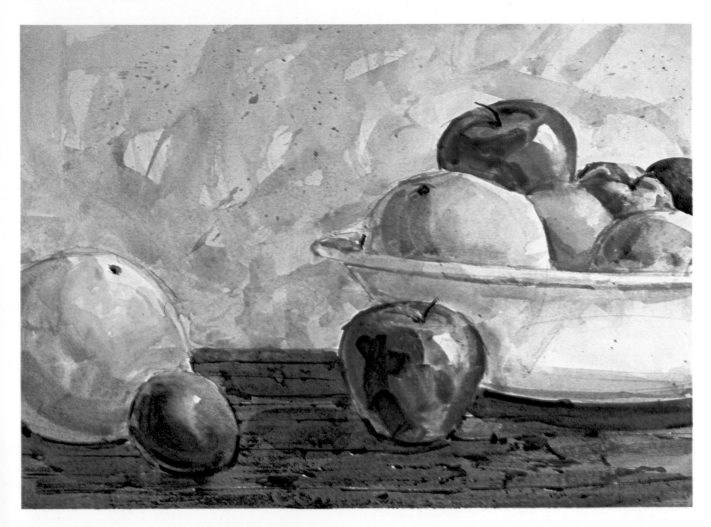

Step 7. The picture seems to need another dark note, so a second plum is added to the bowl, using the same mixtures as the plum painted in Step 3. Finally, details are added with the tip of a small, round brush. Lines are painted on the tabletop to suggest cracks. The same brush is used for the drybrush textures on the table. The corner of a sharp blade scratches some light lines next to the dark ones. Dark lines are added to sharpen the edges of the fruit in the bowl, beneath the bowl, and beneath the fruit on the table—to make them "sit" more securely. These darks aren't black, but a mixture of Hooker's green and alizarin crimson, like the apple stems. Finally, the shadow on the side of the bowl is darkened slightly with cerulean blue, yellow ochre, and burnt sienna. Notice the warm reflection of the apple in the shiny side of the bowl—painted all the way back in Step 1!

Step 1. Perhaps the most delightful indoor subject is a vase of flowers, preferably in some casual arrangement like this one. Here, the background tone is a mixture of ultramarine blue, yellow ochre, and a touch of alizarin crimson. When the background is dry, the general shapes of the flowers are painted in various mixtures of cadmium orange, cadmium red, and alizarin crimson, with the shapes blurring into one another, wet-in-wet. With the flowers just partially dry, the leaves are quickly added, sometimes blurring into the edges of the flowers. The leaves are Hooker's green and burnt umber.

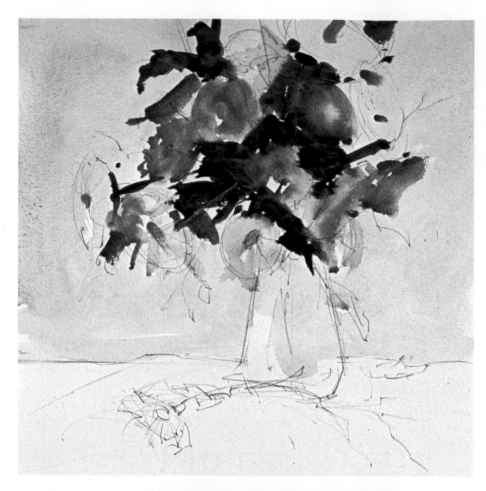

Step 2. Cooler flowers are added with a mixture of cerulean blue and alizarin crimson. The yellow centers of the flowers are yellow ochre and cadmium yellow. So far, the brushwork is broad and free, with no attention to detail—the flowers and leaves are just colored shapes.

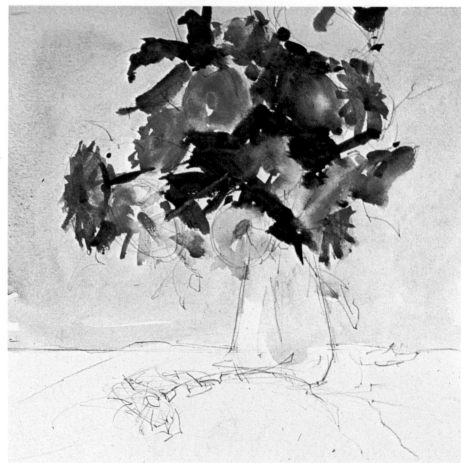

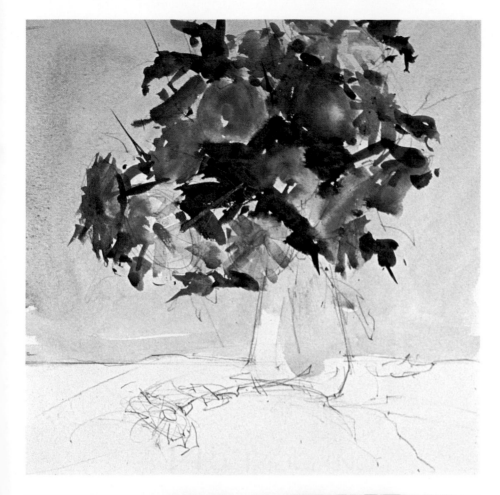

Step 3. With the main shapes of the flowers and leaves blocked in, less important shapes are added around the edges—more flowers at the top and bottom, more leaves at the bottom and the right. The leaves are the same mixture of Hooker's green and burnt umber. The new, pale flowers are yellow ochre and cerulean blue in the light areas, Hooker's green, yellow ochre, and ultramarine blue in the darker areas.

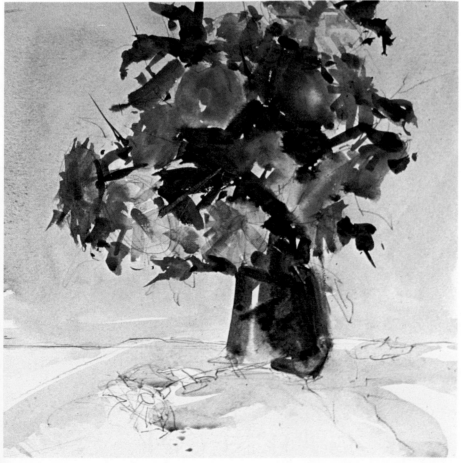

Step 4. Now it's time to begin work on the glass vase. The glass and the water within it have no color of their own, but simply reflect the color of their surroundings. Thus, the vase takes on the color of the dark stems in the water and the dark leaves above. The strokes on the vase are various mixtures of cerulean blue and burnt sienna, with a hint of Hooker's green, all painted into one another while they're still wet. A patch of light paper is left for a highlight, and a softer light is created by blotting up some wet color with a paper towel. The folds on the tabletop are suggested with a mixture of cerulean blue and burnt sienna.

Step 5. A flower and a leaf are added to the tabletop. The petals are a mixture of cadmium orange, cadmium red, and alizarin crimson, painted with a small, round brush. The light green is cadmium yellow, yellow ochre, and Hooker's green, while the dark green is Hooker's green and a touch of alizarin crimson. Cool shadows are added beneath the flower and under the leaves with cerulean blue and a little burnt sienna.

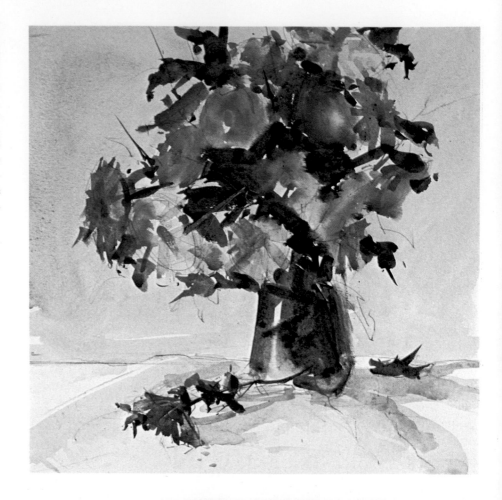

Step 6. The main colored shapes are completed. Now come the details. Alizarin crimson and Hooker's green make a good dark tone for painting the slender lines that suggest the petals of the flowers and the vase. The same mixture is used for adding more stems and a few more leaves.

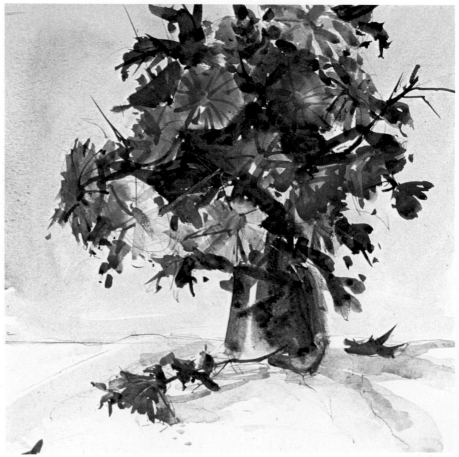

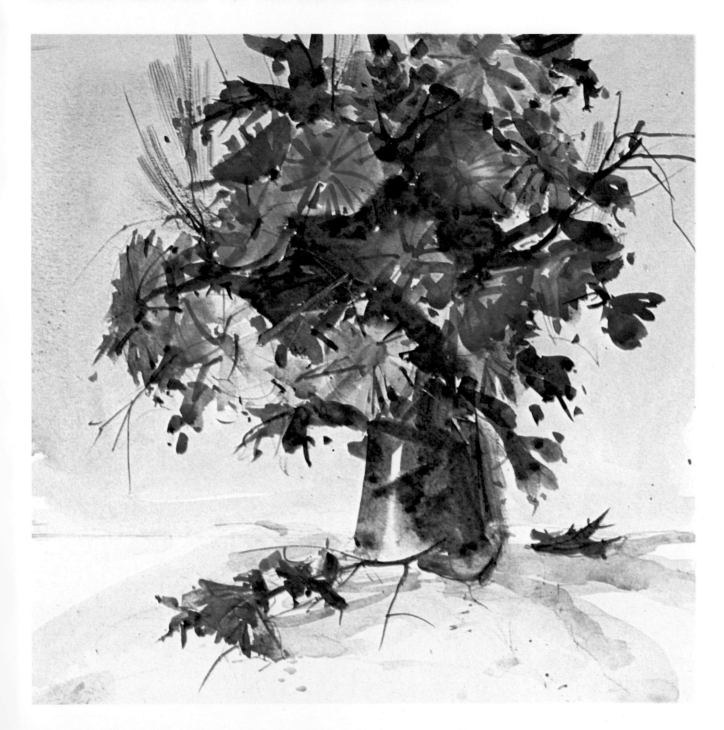

Step 7. In the final stage, you look carefully at the picture and add just a few more details, very selectively. Here you can see even more twigs at the right and left sides of the bouquet. More twigs are also added to the stem of the flower on the tabletop, and a fernlike shape is added at the upper left. All these dark notes are mixtures of Hooker's green and burnt umber or Hooker's green and alizarin crimson. Just a bit of spatter in the immediate foreground suggests some fallen petals or bits of bark from the twigs. In painting the delicate, graceful forms of flowers, it's important not to be *too* careful. Paint them as freely and broadly as you paint trees. And don't get carried away with too much detail. A little detail goes a long way.

Step 1. Having painted a bouquet of flowers indoors, why not try painting flowers in their natural outdoor setting? This demonstration begins with a fairly precise drawing of the main flower shapes, plus a few simple lines for the rocks and the lighter mass of flowers in the distance. The rock forms are painted in a series of flat washes—a mixture of alizarin crimson, ultramarine blue, and yellow ochre, with each successive wash getting a bit darker. The warm tone on the flowers is a liquid "mask" that repels paint and keeps the paper pure white. You'll see why later.

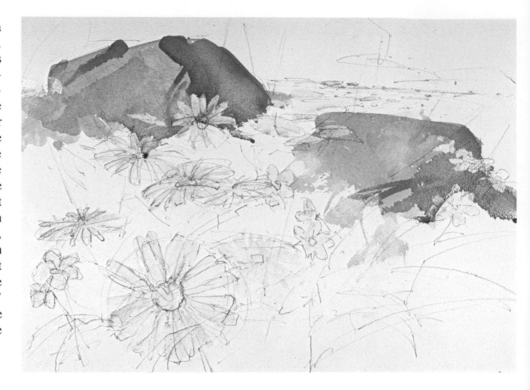

Step 2. Now the whole picture is covered with big, splashy strokes to indicate the large color areas. The lighter greens are mixtures of cadmium yellow, Hooker's green, and burnt sienna. The darker greens are Hooker's green and burnt umber. The splashes of hot color are mixtures of cadmium orange, cadmium red, and alizarin crimson. Some color overlaps the pale shapes of the flowers but doesn't soak into the paper because these areas are protected by the dried masking liquid—or frisket—which you can buy in an art supply store that specializes in materials for graphic designers.

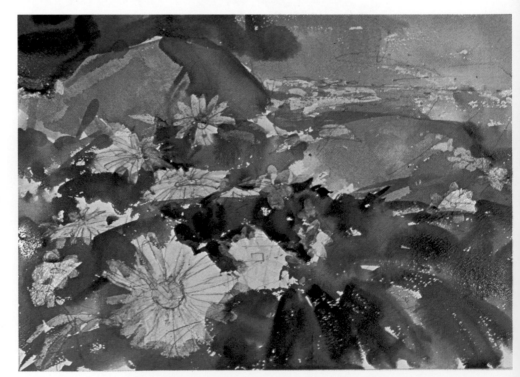

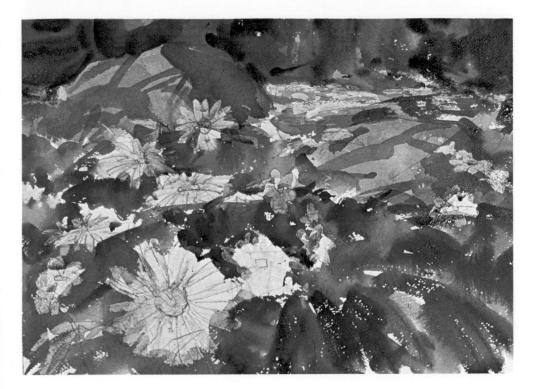

Step 3. The background at the top of the painting is darkened with strokes of Hooker's green blended with burnt umber and ultramarine blue. Notice how the various dark strokes overlap and blur together, wet-in-wet. The shadows on the rocks are painted with the same mixture used in Step 1. So far, everything has been done with a big, round brush.

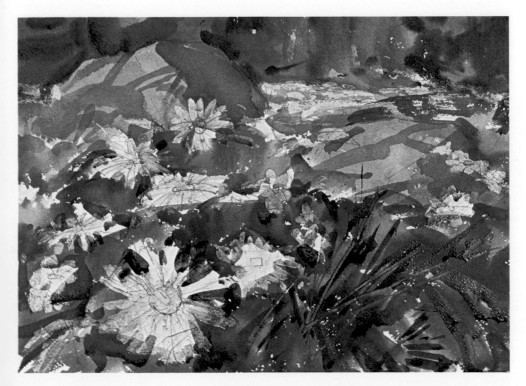

Step 4. Now more work is done in the foreground, where slender, dark strokes are added with a small, round brush to suggest grasses and weeds. You can see these in the lower right, where the dark strokes are a mixture of Hooker's green, burnt umber, and ultramarine blue. While the paint is still damp, the lighter lines in the lower right are scraped in with the tip of the brush handle.

Step 5. The time has come to remove the masking liquid from the flowers in the foreground and from the mass of flowers beyond the rocks. You can peel away the frisket with your fingers; it comes off like a thin sheet of rubber. The flowers are now ready for you to paint.

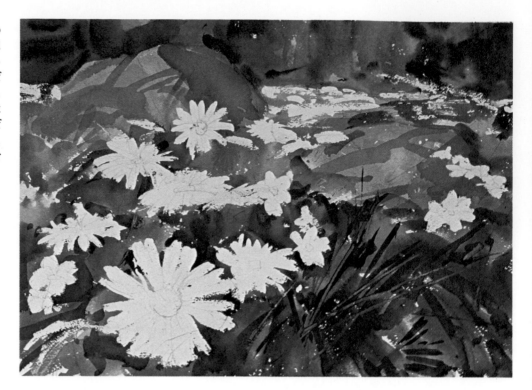

Step 6. The violet flowers are painted with a mixture of ultramarine blue and alizarin crimson. The shadows on the white flowers are a very pale mixture of yellow ochre and cerulean blue. The centers of the white flowers are yellow ochre with a touch of cadmium orange and cerulean blue. The brilliant reddish flower just left of center is cadmium red and alizarin crimson. Touches of these mixtures are added to the mass of flowers beyond the rocks.

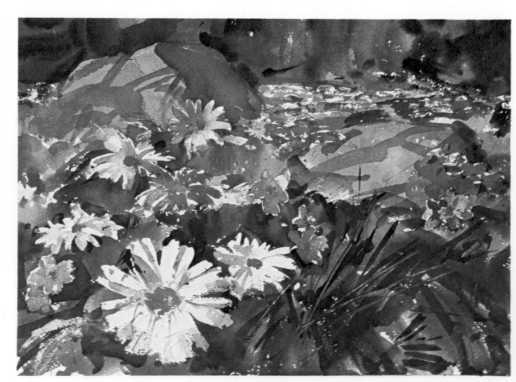

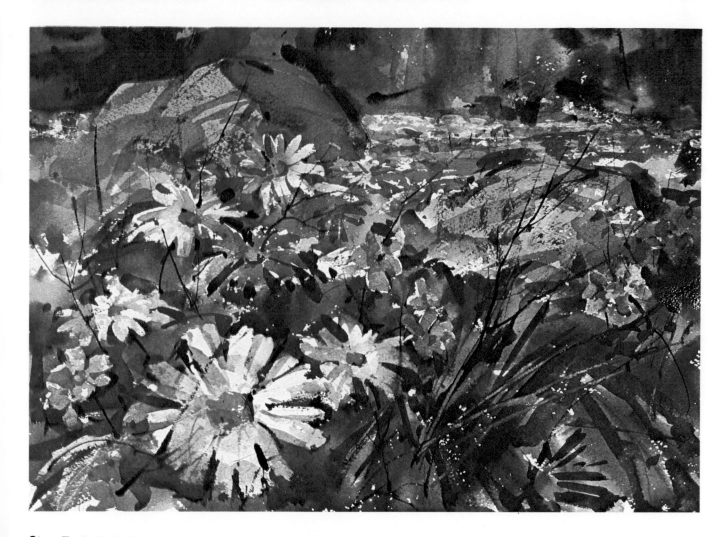

Step 7. Cool shadows are washed over the flowers in the foreground—a mixture of ultramarine blue, burnt sienna, and yellow ochre. The edges of some of the white flowers are softened and blurred by scrubbing them with a wet bristle brush, then blotting them with a paper towel. You can see this clearly in the smaller white flower at the center of the picture. With a small, round brush, dark strokes are added around the nearby flowers to sharpen their shapes—the darks are a mixture of Hooker's green and alizarin crimson. The same mixture is used to add crisp, slender strokes for blades of grass that stick up through the masses of flowers, particularly in the left side of the painting. The same dark mixture is used to add a few dark strokes to the rocks, and the brush is skimmed lightly over the rocks to add some drybrush textures. For these very slender lines, it's helpful to have a skinny brush used by signpainters—called a rigger. If you squint at the finished painting, you'll make an interesting discovery: the painting consists mostly of dark, rather subdued tones, and there are really very few bright colors. These bright colors have so much impact precisely because they're surrounded by more somber hues.

Step 1. In spring, when leaves first appear on the trees, foliage is a delicate green, often with a hint of yellow—and the masses of leaves aren't as thick as they will be later on in midsummer. This spring landscape begins with a very simple pencil drawing that just indicates the general direction of the treetrunks and the overall shapes of the leafy masses. The sky is covered with a wash of yellow ochre. While this wash is still wet, ultramarine blue is painted in with a large, round brush.

Step 2. The same brush is used to paint the distant hills with a mixture of ultramarine blue and alizarin crimson. You can see that the individual strokes vary in color: some have more blue and some more crimson. The brushwork is rough because the hills will be partially covered by a mass of trees in the next step.

Step 3. Now the foliage in the middle distance is added with a big, round brush. The strokes are mixtures of cadmium yellow, Hooker's green, and cerulean blue. In many of the strokes, the yellow is allowed to dominate. And the strokes are applied over and into one another, fusing wet-in-wet.

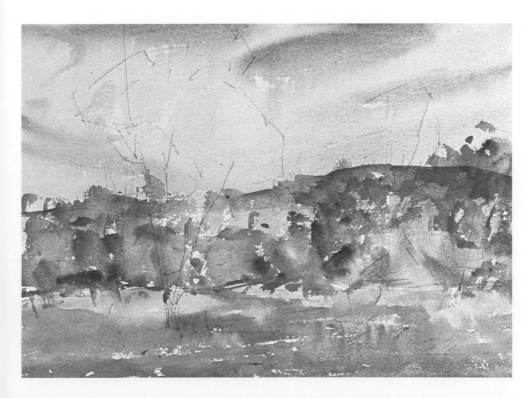

Step 4. The grass in the foreground is added with a big, round brush—the strokes are again mixtures of cadmium yellow, Hooker's green, and cerulean blue. Notice that a dark shadow has been added beneath the pencil lines of the tree on the left. In contrast with the short vertical and diagonal strokes used to suggest the trees in Step 3, the meadow is suggested mainly with long horizontal strokes.

Step 5. Now the small, round brush is used to indicate some treetrunks and branches with a dark mixture of alizarin crimson and Hooker's green. Never try to render every branch and twig. Just pick out a few. This dark tone could also be a mixture of burnt sienna and ultramarine blue, if you'd like to try a different combination.

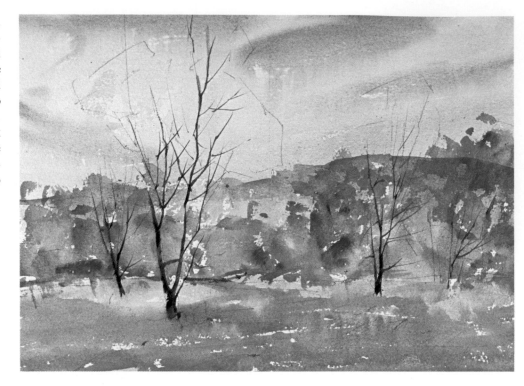

Step 6. Now, using the side of the same brush, the first foliage is drybrushed into the picture with a mixture of Hooker's green and cerulean blue, with just a hint of cadmium yellow. Working with the side of the brush, rather than the tip, you can make short, ragged strokes that are broken up by the texture of the paper, suggesting masses of leaves with patches of sky breaking through. The same method is used to drybrush a shadow under the larger tree.

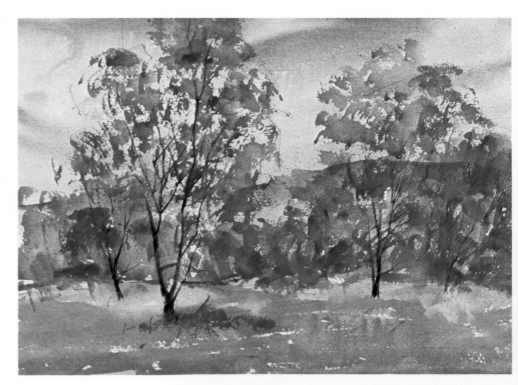

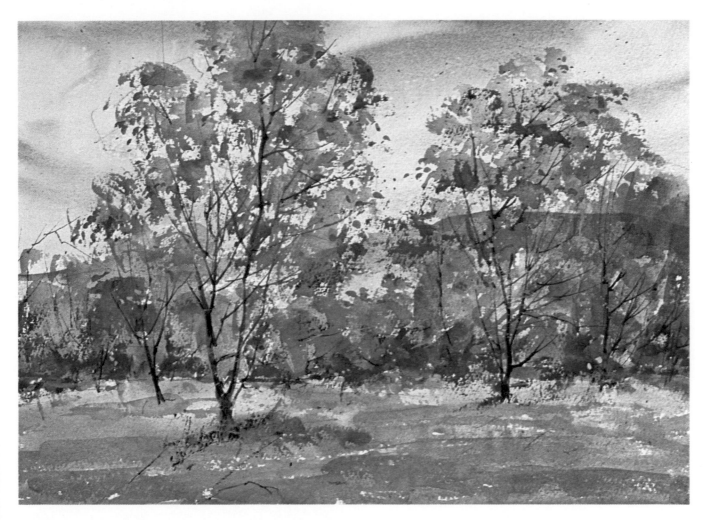

Step 7. Now, going back to a big, round brush, the picture is completed mainly with drybrush strokes—mixtures of ultramarine blue, cadmium yellow, and Hooker's green. Some darker patches are added to the trees in the foreground, suggesting shadow areas on the masses of leaves. Shadows are also suggested on the mass of trees in the middle distance, particularly along the lower edge. A shadow is suggested at the base of the tree on the right, and the shadow is darkened beneath the tree on the left. Darker horizontal strokes are added to the meadow, so there's now a gradation from dark green in the foreground to a lighter tone in the middle distance. Notice how bits of paper are allowed to show through the strokes on the ground, suggesting patches of sunlight. Some of the dark green mixture and a bit of cadmium yellow are spattered among the trees. And a rigger is used to add some more branches.

Step 1. In midsummer, trees are in full leaf and foliage tends to be darker and denser. Once again, this landscape begins with a very simple drawing, just suggesting the placement of the treetrunks, the leafy masses, some foreground shadows, and the shapes of the hills. The sky begins with a few strokes of a very pale yellow ochre, quickly followed by strokes of cerulean blue that fuse softly into the yellow. The strokes of the distant hills are mixtures of cerulean blue and cadmium orange.

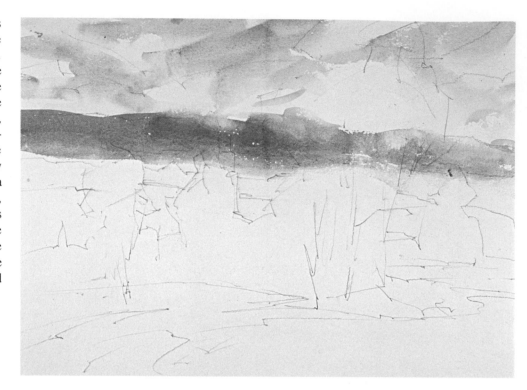

Step 2. The foreground is painted with a mixture of cadmium yellow, Hooker's green, cerulean blue, and an occasional hint of cadmium orange. The same mixtures are used for the green patches between the trees in the middle distance, but with a bit more blue and green in the strokes. The patches of color between the trees are brushed in very freely, paying little attention to their exact shapes, since a great deal of the middle distance will be covered by the bigger, darker shapes of the trees.

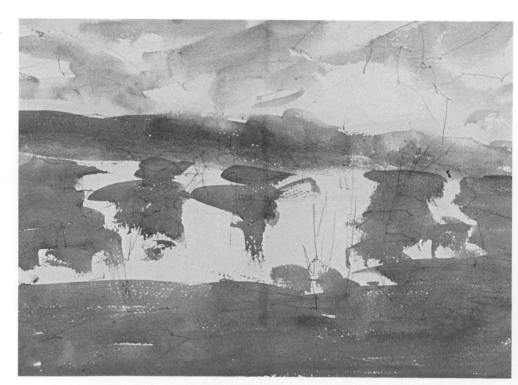

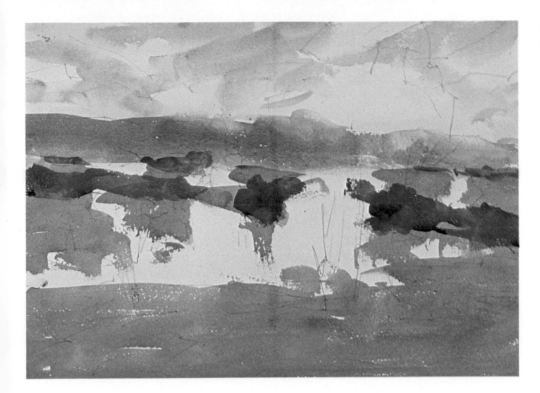

Step 3. Still working with a big, round brush, the darker patches in the middle distance are now painted with a mixture of Hooker's green and cerulean blue. You could actually use a small round brush at this point, but it's always best to use the biggest brush you can handle, since this forces you to work boldly.

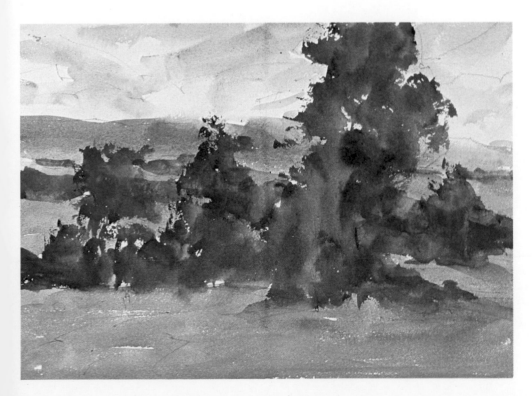

Step 4. The big masses of the foreground trees are now brushed in with a blend of Hooker's green, cadmium yellow, and burnt sienna. The darkest strokes contain more burnt sienna. The strokes are brushed over and into one another, so they tend to fuse wet-in-wet. Along the edges of the trees, the side of the brush is used so that the dry-brush effect suggests leafy edges. Where the leafy masses touch the ground, a damp brush (just water) is used to soften the transition.

Step 5. The foliage is darkened with a mixture of Hooker's green and burnt umber. Many of the leafy masses now appear to be in shadow. You can see a trunk beginning to show in the largest tree, beneath which a shadow has begun to appear. With a small, round brush, a few dark flecks are added around the edges of the trees to suggest some more leaves.

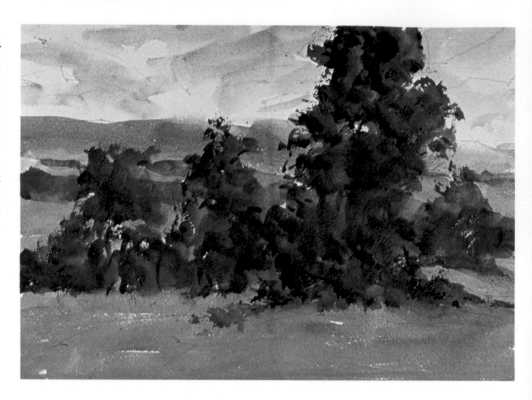

Step 6. The tree shadows in the foreground are painted with a mixture of Hooker's green and burnt sienna. The strokes curve slightly, suggesting the curve of the meadow. The sunlit patches are the wash that was applied in Step 2, which is allowed to break through the darker shadow strokes.

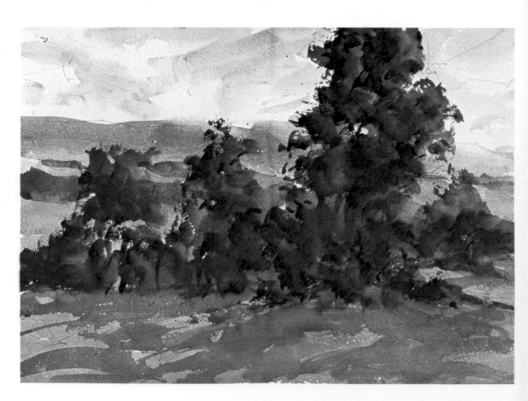

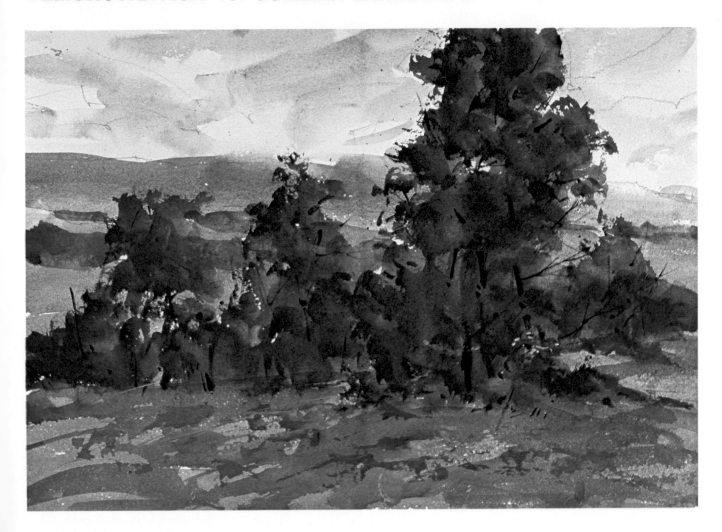

Step 7. As always, details are saved for the very end. A small, round brush is used to indicate trunks and branches among the trees. More dark strokes are added to the foreground, while the shadow under the largest tree is reinforced with some dark strokes too. Some tiny flecks of cadmium yellow are added to the grass and around the base of the largest tree. They're very unobtrusive, but they do make the painting look just a bit sunnier. This painting is a particularly good example of how few strokes you need to paint a convincing landscape. The trees consist almost entirely of large masses of color with just a few touches of a small brush to suggest trunk and branches. By the way, did you notice that the pencil lines in the sky haven't been erased? You can leave them there if you like. Or you can take them out with a kneaded (putty rubber) eraser. But wait until the painting is absolutely dry, or even this very soft eraser will abrade the surface.

Step 1. The hot colors of autumn trees look even richer if they're placed against a very subdued background such as a gray or overcast sky. So this autumn scene begins with a sky of Payne's gray, warmed with a bit of yellow ochre. The sky tone is brushed right over the pencil drawing, which will later disappear under masses of color. The distant hills are cerulean blue and a bit of cadmium red. A big sky like this can be painted quickly with a large, flat brush or a large, round brush.

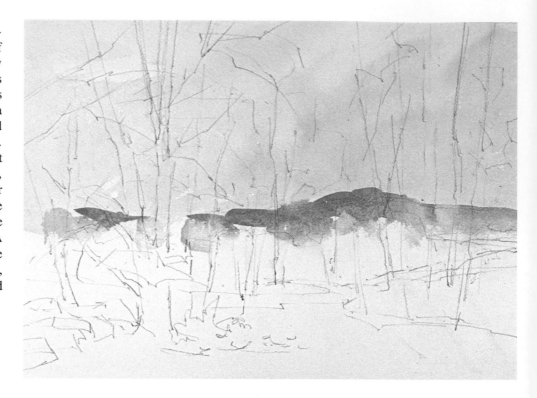

Step 2. The mass of foliage in the middle distance is painted with short strokes of a big round brush. The strokes are mixtures of cadmium orange, Hooker's green, and burnt sienna. The darker strokes contain more burnt sienna, and the hotter colors contain more cadmium orange.

Step 3. Now the colorful masses of foliage are roughly painted with short strokes of a big, round brush. The strokes are various mixtures of cadmium yellow, yellow ochre, cadmium orange, Hooker's green, and burnt umber— never more than two or three colors in any mixture. The wet strokes tend to blur into one another. The side of the brush is often used for a dry-brush effect that suggests leaves. Notice how patches of sky break through among the strokes.

Step 4. The darks of the tree-trunks and the rocks at the left are added with a small, round brush, carrying a blend of alizarin crimson, Hooker's green, and just a touch of cadmium red. Observe how the trunks of the larger trees to the left are painted with short strokes so that the trunks are often concealed by the masses of leaves. The color on the rocks is rather thick—not too much water—so the strokes have a drybrush feeling that suggests the rough texture of the rocks.

Step 5. Going back to a big round brush, the foreground is painted with various mixtures of cadmium orange, cadmium red, alizarin crimson, and Hooker's green—never more than two or three colors to a given mixture. The darks, suggesting shadows on the ground, contain more Hooker's green. The strokes blend into one another, wet-in-wet, and curve slightly to suggest the contour of the ground.

Step 6. To suggest individual leaves—some of them blowing in the autumn wind—a mixture of cadmium orange, cadmium red, and Hooker's green is spattered over the upper part of the picture with a small round brush. More trunks and branches are added with the tip of a small brush and a mixture of alizarin crimson, cadmium red, and Hooker's green, which makes a very rich dark. The tiniest branches can be done with a rigger.

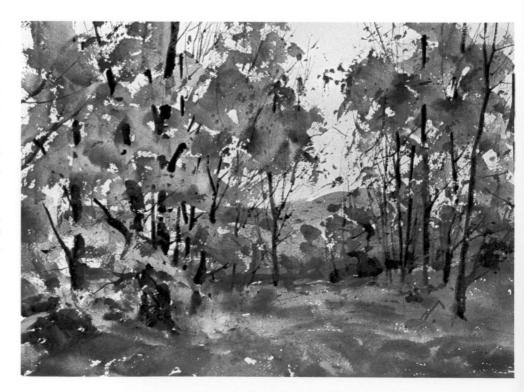

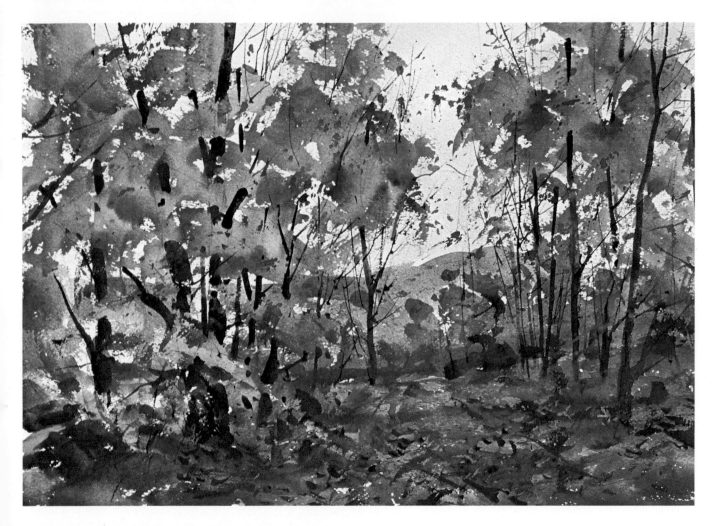

Step 7. The lively texture of the fallen leaves on the ground is suggested by drybrush strokes, made with the side of a small round brush and a mixture of alizarin crimson and Hooker's green. More touches of this mixture are added with the tip of the small brush. While the paint on the ground is still damp, some lighter areas are scratched in with the tip of the brush handle or a slender, blunt knife. If you look carefully at the ground area, all you'll see is a mass of rough brushwork and a few tiny strokes made with the tip of the brush. You don't really see any fallen leaves, but the brushwork makes you *think* you see them. Detail is suggested, never painted methodically. And look carefully at those hot autumn colors. They're not nearly as red and orange as you might think. If the whole painting were just red and orange, you'd find it terribly monotonous. You need that gray sky and those cool hints of green for relief. Besides, they make the warm colors look warmer by contrast.

Step 1. The pencil drawing defines the main masses of the trees, but not too precisely—so there's plenty of freedom for impulsive brushwork later on. The sky begins with a very wet wash of yellow ochre, applied with a big, flat brush, followed by broad strokes of Payne's gray and ultramarine blue while the underlying wash is still wet. Just before the sky loses its shine, the distant trees are painted into the wetness with Hooker's green, Payne's gray, and cerulean blue, applied with a small brush.

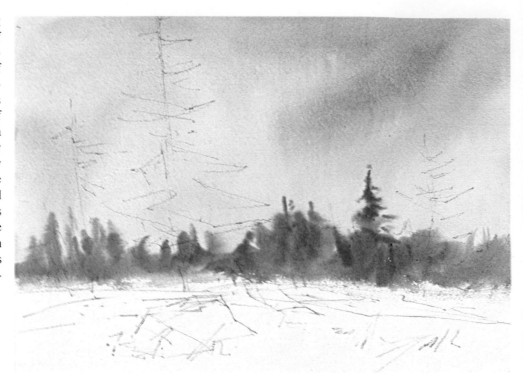

Step 2. When the sky and the distant trees are dry, two more trees are brushed in with a darker mixture of Hooker's green, Payne's gray, and cerulean blue, applied with a small, round brush. These trees strokes have a special character that reflects the way the brush is handled. The wet brush is pressed down hard at the center of the tree and then pulled quickly away to the side. Thus, the stroke is thick and dark at one end, but then tapers down to a thinner, more irregular shape as the brush moves outward.

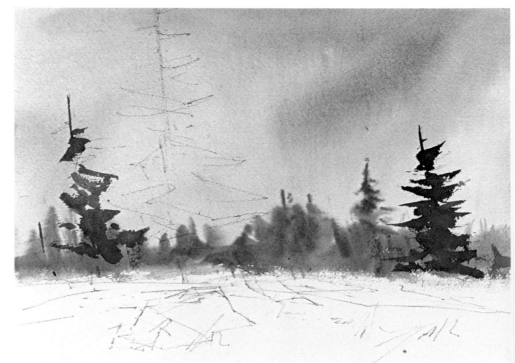

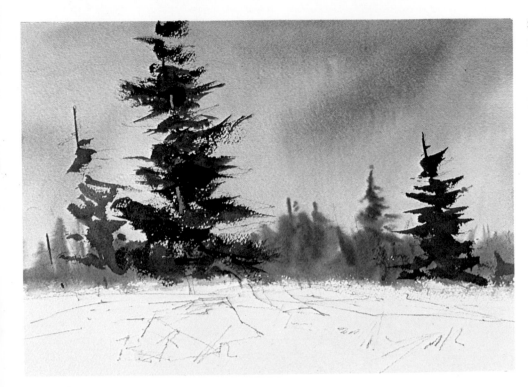

Step 3. The largest tree is now painted with a big, round brush, using the same kind of strokes as in Step 2. The lighter foliage is painted with Hooker's green, ultramarine blue, and burnt umber, then allowed to dry. The darks are painted with the same mixture, but contain more ultramarine blue. While the color is still damp, a blunt knife is used to scrape away some pale lines for the trunk.

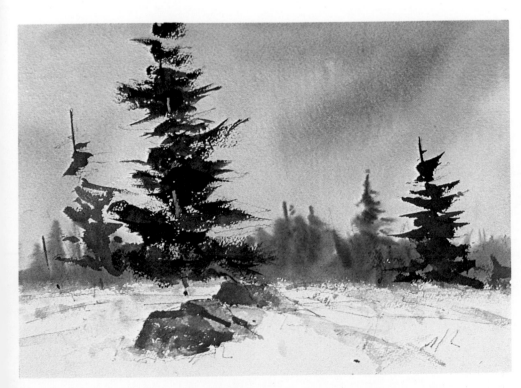

Step 4. The light and shadow planes of the rocks are both painted with Payne's gray and yellow ochre—with less water for the shadows. To suggest a few tones on the snow, a small brush glides quickly over the paper with pale strokes of ultramarine blue and burnt umber. Notice how flecks of paper are allowed to show through the shadows of the rocks, suggesting a rough texture.

Step 5. The dry grass breaking through the snow adds some warm notes to enliven a picture that is generally cool. The tip of a small, round brush is used to add drybrush strokes of cadmium orange, burnt sienna, and burnt umber. The same tone appears in the very slender strokes that suggest a few weeds—and is spattered across the foreground. These very thin strokes are a good opportunity to use the signpainter's brush called a rigger.

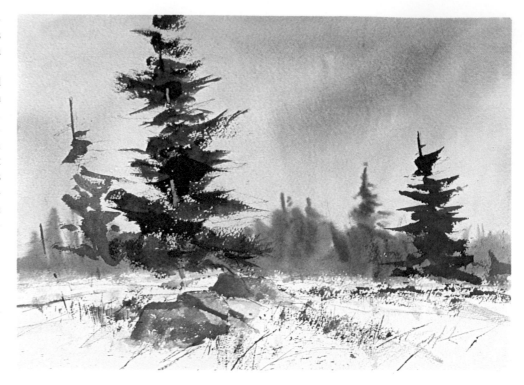

Step 6. The picture needs an additional tree to add "weight" at the center of interest. The tree is added with a dark mixture of Hooker's green, ultramarine blue, and burnt umber—using the same press-and-pull strokes that worked so well for the other trees.

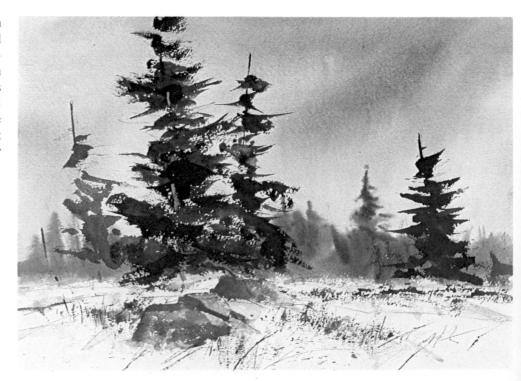

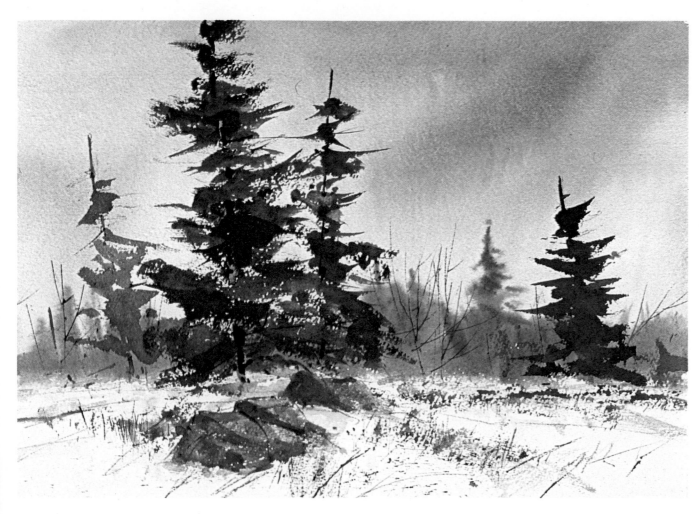

Step 7. Here's where you add those final touches that seem invisible at first glance, but do make a great difference when you look closely. A small, round brush is loaded with a dark mixture of alizarin crimson and Hooker's green. The very tip is used to add darks such as the trunks of the central trees, the cracks and additional touches of shadow on the rocks, and the skeletons of more trees along the horizon. A pale mixture of ultramarine blue and burnt umber is added just under the central tree to suggest a shadow that "anchors" the tree more firmly to the ground. Compare the finished trees and rocks with those in Step 6 and you'll see how much the picture gains by these slight touches. The big central tree is placed more firmly on the ground by its dark trunk and shadow. A few cracks and additional darks make the rocks much more solid and realistic.

Step 1. Your pencil drawing can't possibly indicate every wave and ripple in the surface of the lake, so all you can do is draw a few lines to separate the dark areas from the light ones. And a few pencil lines can define the shapes along the shoreline. This sky starts with a wash of yellow ochre, which is allowed to dry. This is followed by some strokes of cerulean blue, modified by a hint of yellow ochre.

Step 2. The distant hills are painted with a wash of yellow ochre, Payne's gray, and cerulean blue. While the wash is still wet, it's blotted with a paper towel, which lightens the tone and fades it out in the right-hand side. Thus, the distant shore seems farther away and has a more atmospheric quality.

Step 3. As you can see, the whole idea is to work from top to bottom and from distance to middle distance to foreground. Now the tree-covered island is painted with strokes of Hooker's green and burnt umber. The strokes are short and rough, some darker and some lighter, some containing more Hooker's green and others containing more burnt umber. The color does not contain too much water, so the brush is damp, rather than wet, giving a ragged drybrush character to the strokes.

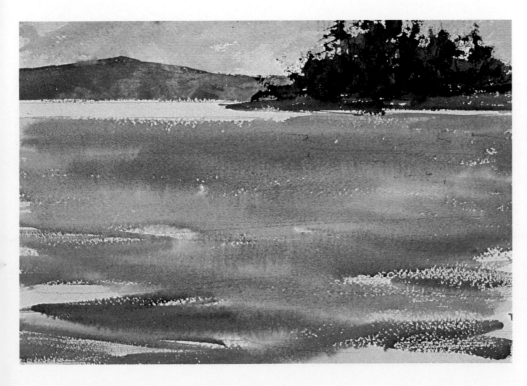

Step 4. The water is painted with a very wet wash that mingles yellow ochre, cerulean blue, ultramarine blue, and Hooker's green, all applied with a big, round brush. A pale wash of yellow ochre and cerulean blue goes onto the paper first, followed by darker mixtures that quickly spread and blur. In the foreground, you can see that the color isn't quite as fluid and the brush isn't nearly as wet, so the strokes at the very bottom of the picture are drybrush. The paint really looks wet—just like the water.

Step 5. When the colors of the water are dry, a small brush goes to work on the dark reflections under the island. These dark, horizontal drybrush strokes are a mixture of ultramarine blue, Hooker's green, and burnt umber. A few ripples and horizontal lines are drawn into the water with the tip of the brush. The dark patch in the upper left section is the same mixture, but with more water. Notice how the drybrush strokes in this section create the feeling that light is flashing on the ripples.

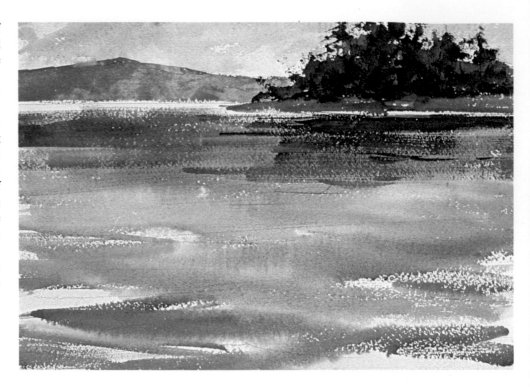

Step 6. Working downward, a small, round brush adds short, choppy, slightly curved strokes to suggest ripples. The strokes vary in length and thickness; thus they're never monotonous. The mixture is Hooker's green and ultramarine blue.

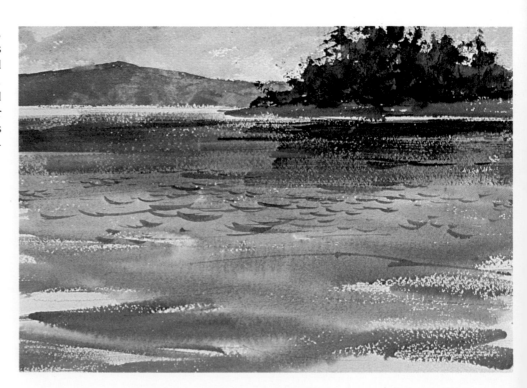

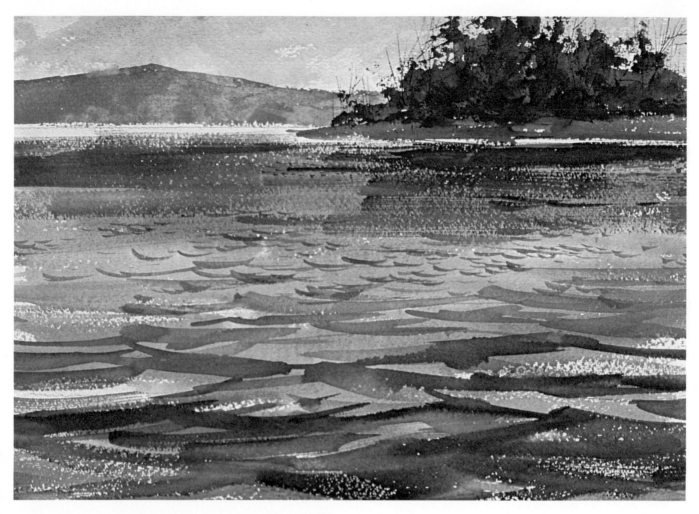

Step 7. The brushstrokes for the ripples grow longer, thicker, and darker as they approach the immediate foreground. The blend of Hooker's green and ultramarine blue is darkened by burnt umber. The smaller strokes are done with a small, round brush. Now the bigger strokes are executed by a large brush. Specks of white paper continue to peek through like sparkles of light on the water. Finally, a few branches and other details are added to the island with a mixture of burnt umber and Hooker's green.

Step 1. It's usually best to begin a sunny sky by painting in the blue patches between the clouds. The big blue shape in the upper left section comes first—a mixture of ultramarine blue, cerulean blue, and a little yellow ochre, touched with clear water to blur a few edges. The right side of the sky is brushed with clear water. Then more strokes of the same mixture are carried from left to right above the horizon, blurring as they strike the wet paper. The strip of blue at the horizon is also painted on wet paper, which produces very soft edges.

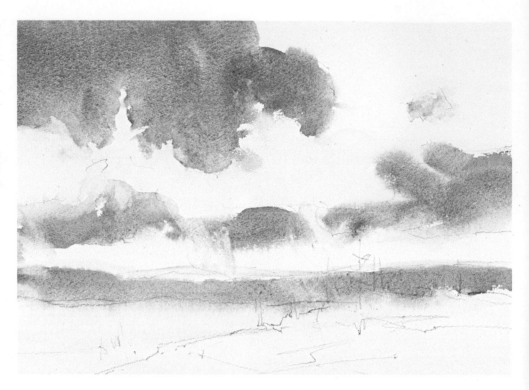

Step 2. When the blue areas are dry, the shadow sides of the clouds are brushed in with a pale wash of Payne's gray and yellow ochre. Once again, a brush carrying clear water is used to blur the edges of some of these strokes so that the shadows seem to melt away into the lighted areas of the clouds.

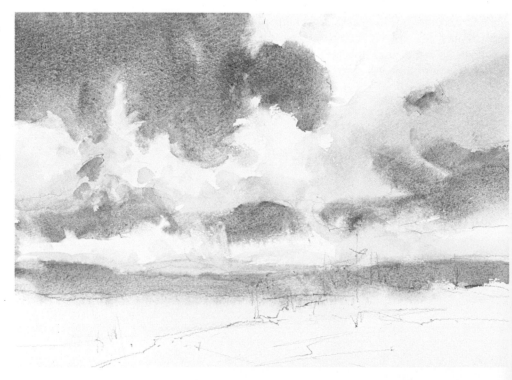

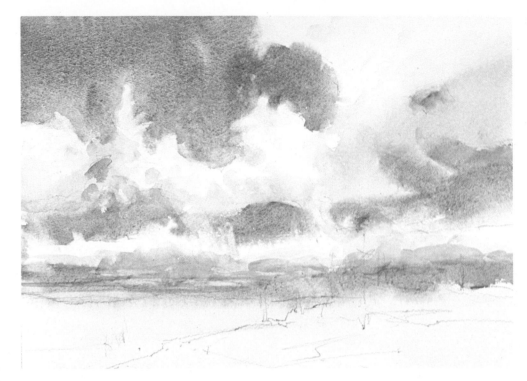

Step 3. When the shadows of the clouds are dry, more edges seem to need softening. A small bristle brush is loaded with water and used to scrub away color at various places where the edges of the clouds meet the edges of the blue sky. Then more strokes of Payne's gray and yellow ochre are added to suggest darker clouds along the horizon.

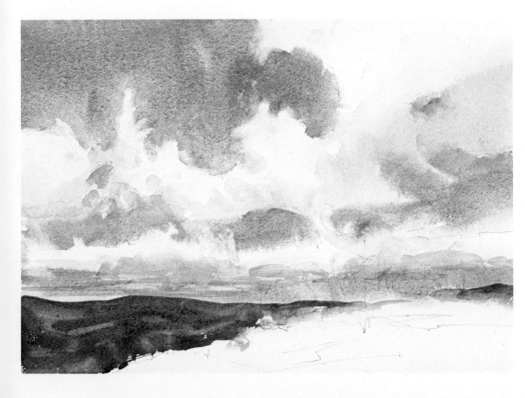

Step 4. When the sky tones are completely dry, the distant hills are painted with mixtures of ultramarine blue, cerulean blue, and burnt umber—with more burnt umber in the darker patches. Notice how strokes of clear water are used to soften some of the edges of the hills where they blend into the unpainted patch of foreground to the right.

Step 5. The hills are allowed to dry, and then the trees are painted with Hooker's green and burnt sienna, warmed here and there with a bit of cadmium red or cadmium orange. The lower masses of the trees are painted with broad strokes, while the upper trunks and branches are mere touches of the tip of the brush.

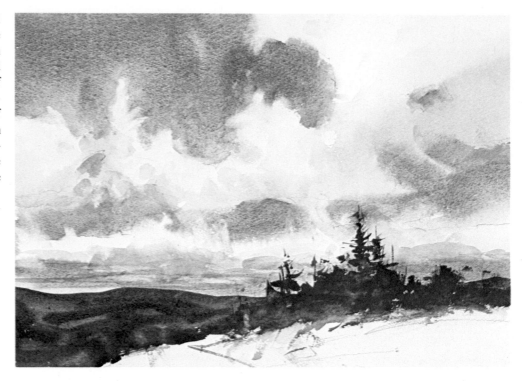

Step 6. The land in the foreground is painted with an irregular wash of Hooker's green, cadmium orange, and cadmium yellow. You can see that some areas contain more orange and some areas contain more green. A good deal of water is added in the lower right section; thus the wash becomes pale and suggests sunlight falling on the grass.

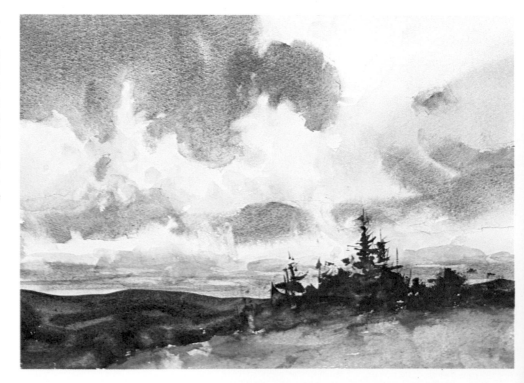

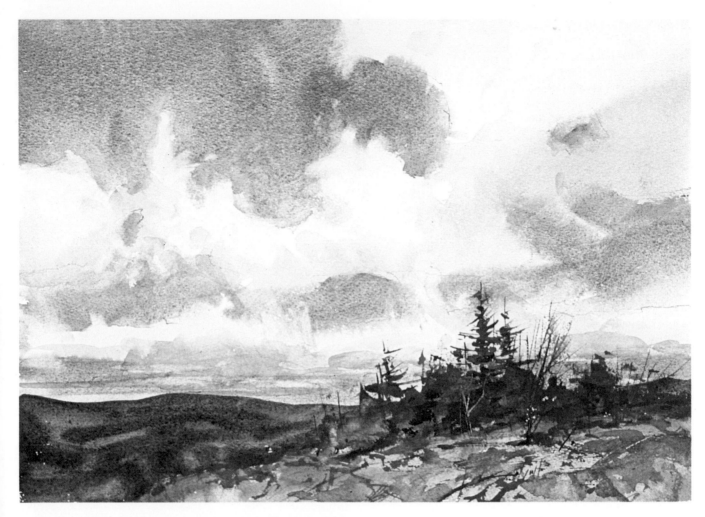

Step 7. The final touches of detail are concentrated entirely in the trees and grass in the immediate foreground. A dark blend of Hooker's green and burnt umber is used to add more detail to the trees—more trunks and branches and touches of shadow. You can see where a sharp blade is used to scratch out a light trunk beneath the tallest tree. The side of a small brush, loaded with Hooker's green and burnt sienna, is casually dragged across the grass to create darker patches. Then the tip of the brush picks up a darker mixture of Hooker's green and burnt sienna to trace some warm, ragged lines over the landscape. You don't actually see grasses, weeds, or twigs, but these strokes make you *believe* that you see them.

Step 1. Like most skies, a sunset is difficult to draw in pencil. Therefore, it's best to draw just the shapes of the landscape: the large tree to the right, the smaller trees along the horizon, and the lines of the stream. A large, flat brush is used to wet the entire sky with clear water. Then mixtures of yellow ochre, cadmium orange, burnt sienna, and cerulean blue are brushed onto the surface in long, slow strokes. The lights and darks and the warm and cool tones mingle, wet-in-wet. The sky is painted with the drawing board tilted slightly upward at the back so that the colors tend to run down.

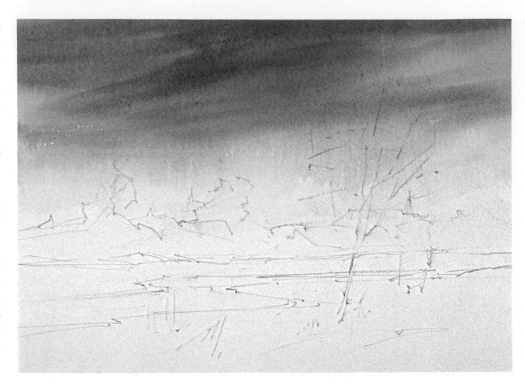

Step 2. When the sky is dry, the background trees are painted with mixtures of cadmium orange, burnt sienna, and Hooker's green. The warmer strokes are painted first and are dominated by burnt sienna. The darks contain more Hooker's green and are painted over the wet tones of the brighter colors. The ragged strokes against the sky are made by jabbing the brush against the paper, then pulling away.

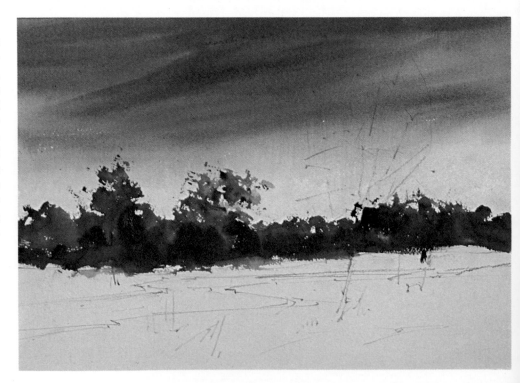

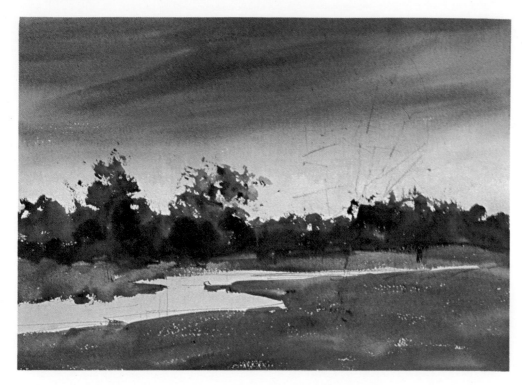

Step 3. The shapes of the land on either side of the stream are painted with mixtures of burnt sienna, Hooker's green, and cerulean blue. The immediate foreground contains more Hooker's green.

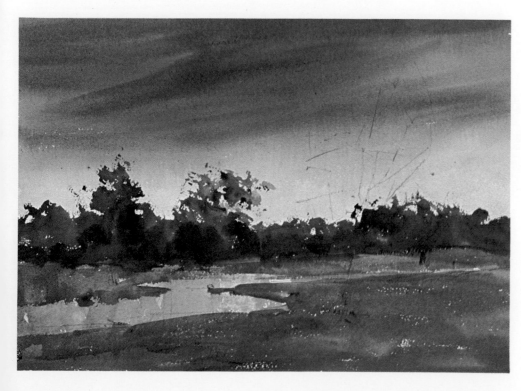

Step 4. Now the water is painted with a pale mixture of burnt sienna and cerulean blue. Notice that the strokes in the water are vertical, leaving gaps of bare paper, creating a sense of reflected darks and lights. The tone of the water is carried down over the shore to darken the left foreground.

Step 5. So far, the landscape is covered with generally warm tones—too warm to make a satisfying picture. The painting needs some strong, cool notes. The dark trees to the right are painted with short, rough strokes in a mixture of Hooker's green and burnt umber. The very ragged strokes against the sky are made by pressing the brush against the paper, pulling slightly to one side, and then pulling away. The lower tree is simply a dark, liquid mass that spreads at the bottom to suggest that it's sitting on its own shadow.

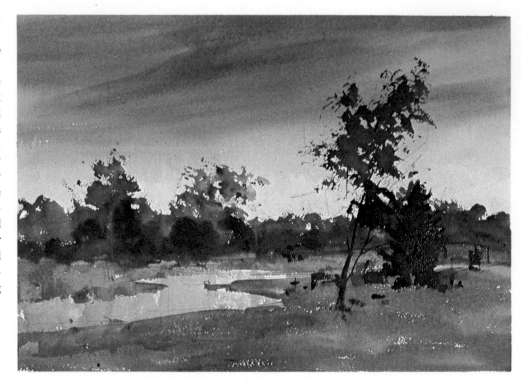

Step 6. The same mixture of burnt umber and Hooker's green is carried across the foreground with rough, irregular strokes, often made with the side of the brush. The underlying tones are allowed to break through here and there. Darker touches are added with the tip of the brush. Along the lower edge, to the right, you can see where droplets of dark color have been spattered into the wet wash. More of these darks are added to the distant trees with drybrush strokes.

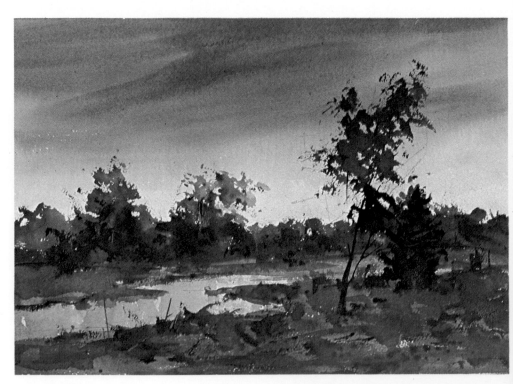

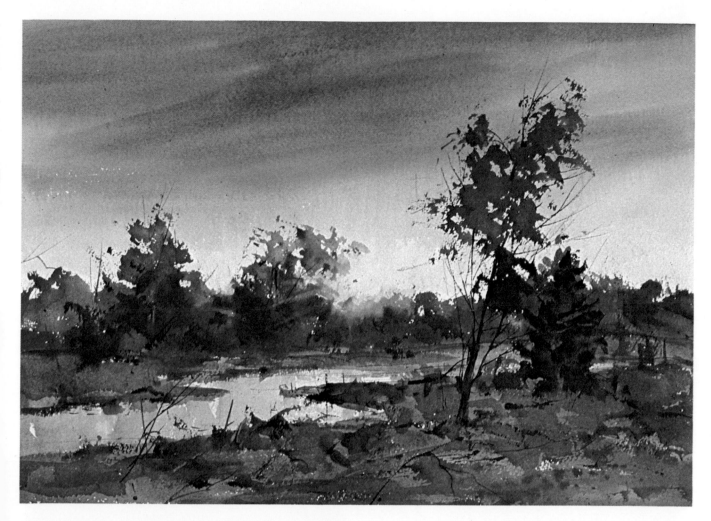

Step 7. Still darker strokes of the Hooker's green and burnt umber mixture are carried across the foreground with the tip of a small, round brush. More branches are added to the large tree, to the trees in the distance, and along the near shore. To suggest the glare of the sun going down behind the trees at the midpoint of the distant shore, a wet bristle brush is used to scrub out and soften the edges of the trees. When the color is loosened by the wet bristle brush, a paper towel is used to blot the area. The whole secret in painting a convincing sunset is *not* to overdo the hot colors. If you squint at the finished painting, you'll see that most of the colors are surprisingly dark and subdued. The whole lower half of the sky is extremely pale—just a hint of color to subdue the white paper. The only hot colors are in the upper sky, and even these bright streaks are intertwined with darker, cooler streaks. The sky looks bright precisely because it's surrounded by restrained colors.

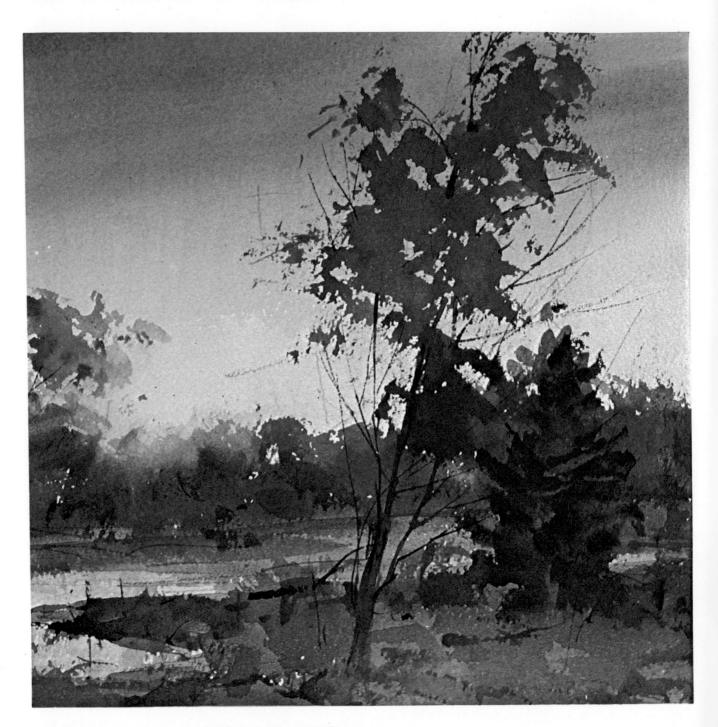

Step 7 (close-up). In this section of the finished painting, you can see the brushwork "life-size." The foliage against the sky is simply a series of flat silhouettes—patches of color without any detail. On the far shore, beside the tree at the left, it's easy to see where the tops of the lower trees have been scrubbed away to suggest the glare of the setting sun. In the sky above, the various stripes of wet color—which were brushed onto wet paper—fuse softly together.

Technical Tricks. Although brushes are the primary tools of watercolor painting, watercolorists are always discovering new "technical tricks" that they can perform with other tools. Knives, razor blades, and the pointed end of the wooden brush handle are frequently used to create lines and textures. Surprising things can also be done with sandpaper, plastic credit cards, ice cream sticks, butter knives, and other implements from the kitchen or the toolbox.

Scratching Wet Paper. The easiest way to create a line, of course, is by drawing the pointed tip of your small, round brush across the surface of the dry paper. But another way is to take some pointed implement, such as the tip of the brush *handle*, and scratch into the paper while the wash is still wet. The color will settle into that groove and make a line that has a very different character from a brushstroke. The tip of the brush handle makes a sharp, slender line. A more ragged line is produced by scratching into the wet color with the tip of a sharp knife or the pointed corner of a razor blade. You'll find that these lines are always darker than the surrounding wash, so this technique is best for suggesting things such as dark branches, twigs, weeds, and grasses.

Scraping Wet Color. One of the hardest things to paint in watercolor is a light line surrounded by darker color. Because you have no opaque color, you can't paint the dark area first, then paint light lines over it. You have to paint the dark color around the light shape. However, a blunt tool such as the rounded corner of a plastic credit card, the rounded tip of a wooden ice cream stick, or the rounded blade of a butter knife will push aside a certain amount of wet color if you use the tool properly. The trick is to press the blunt instrument against the paper and push aside the wet color the way you'd scrape butter off a slice of bread—but don't dig in and create a groove, which could actually produce a darker line. Thus, you *can* create those light treetrunks by starting with a dark wash, then scraping away some lighter lines while the wash is still wet.

Scraping Dry Color. Once a wash is dry, you can use the tip of a knife or the sharp corner of a razor blade to scratch away the dried color and reveal the white paper beneath to create twigs, branches, weeds, and grasses in sunlight. Using the flat edge of a razor blade or a knife, you can also scrape away larger areas. For example, if you want to lighten the sunlit side of a treetrunk, a cloud, or a rock, you can gently scrape away *some* of the dry color so that the underlying paper begins to peak through. Once you've scraped an area, don't paint over it—the fresh color will sink into the scrapes, and they'll come out darker than before!

Correcting Watercolors. By now, it should be clear that a watercolor painting is extremely hard to correct. Because your color is transparent, you can't simply cover up an unsuccessful passage with a fresh layer of paint. The underlying color always shines through. While the passage is still wet, you can blot off most of the color with a paper towel or a cleansing tissue. But once the color is dry, you can never restore the paper to its original whiteness and start again. However, there are several emergency measures for removing enough color to give yourself a second chance.

Sponging Out. A soft, silky natural sponge will often lighten a large, dried area—such as a sky. Soak the sponge in clear water until the fibers of the sponge are very soft, then work gently over the surface of the paper, washing out the sponge frequently. You can also start by brushing a wash of clear water over the offending passage, letting the water soak in a bit so the color loosens, and then working with the sponge. Don't scrub. Move the sponge very gently.

Washing Out. If the whole painting looks hopeless, the most drastic measure is to take the whole sheet straight to the bathtub and soak out as much color as you can in a tub full of cold water. Some colors will come off by themselves. Others will wash away under running tap water. Still others will need a gentle sponging. But don't be surprised if certain colors— such as alizarin crimson or phthalocyanine blue—stain the paper permanently and resist your efforts to remove them. When you've washed away all the color that will come loose, tack the wet paper to your drawing board so the sheet will stretch fairly smooth when it dries. At this point, you'll have a "ghost" of your original painting—you can rarely get out all the color—over which you can apply fresh strokes and washes, either while the paper is still wet or after it's dry as a bone.

Scrubbing and Lifting Out. The sponge and the bathtub are for large color areas, of course. To remove color from a smaller area, you can try scrubbing with a bristle brush—the kind used for oil painting. Work with the brush in one hand and a paper towel or cleansing tissue in the other. Dip the brush in clear water, scrub gently, and blot away the loosened color with the towel or tissue.

Step 1. If you want to make dark lines by scratching into wet color, you've got to work quickly. Let's say you want to add many little branches amid the foliage of a tree. Paint the large masses of the leaves rapidly with a sopping wet brush.

Step 2. While the masses of leaves are still wet and shiny, scratch into them with the corner of a sharp knife or razor blade. Make sure you abrade the surface so the dark color flows into the lines, which then become darker than the surrounding foliage. You can see many little lines scratched into the foreground tree and the other trees along the horizon. Then you can add more branches along the edges with the tip of a small, round brush.

Step 1. You can also scrape *light* lines out of wet color. Once again, fill your brush with lots of liquid color and paint the big masses very quickly. Don't let them dry!

Step 2. With a slightly blunt knife, the tip of your brush handle, or the corner of some improvised tool like a plastic credit card, you can scrape away the light lines of the trunks and branches against the dark background. Now you're not digging into the paper and abrading it, but simply *pushing the color aside*. Then you can use a small, round brush to paint the darker branches.

Step 1. Another way to add light details against a dark background—and to lighten broad areas—is to scratch or scrape away color when the painting is dry. Here you see the broad shapes of a rock formation and a mass of distant foliage painted in broad strokes, with very little attention to detail. The rocks need more contrast between the light and shadow areas. And the foliage needs to be enlivened with some interesting detail. When you're sure the painting is absolutely dry, reach for a razor blade or a sharp knife.

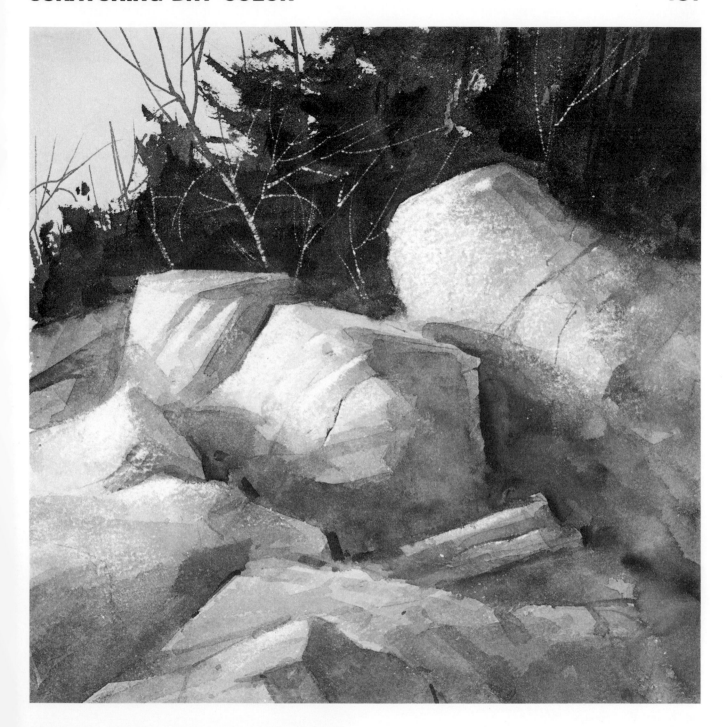

Step 2. With the sharp corner of a blade, it's easy to scratch away the light twigs and branches among the foliage at the top of the picture. If you don't scratch too hard, the blade will skip along the ridges of the paper, leaving a slightly broken white line that contains some flecks of the underlying color, like the lines you see here. If you dig in harder, you'll expose pure white. Next, the edge of the blade (not the corner) is used to scrape away the sunlit patches on the left sides of the rocks. The blade doesn't scrape the paper down to pure white, but takes off just enough color to lighten the tone and expose some irregular flecks of paper. Now you can strengthen the contrast even more by darkening the shadow sides of the rocks and adding some dark edges where one rock butts up against another.

Step 1. This sky is terribly uninteresting. It's too pale. The one distinct cloud shape is right in the middle, like a bulls-eye. Try again.

Step 2. With a silky natural sponge, you can take out most of the sky tone if you work gently. Soak the sponge until it's very soft and very wet, then gradually work across the sky with gentle strokes, wetting and removing the color. Squeeze out and rewet the sponge frequently as you work. You won't get down to bare white paper, but the sky will be light enough to repaint.

Step 3. Having sponged out a fair amount of dark color, you can let the water evaporate and go back to work on the dry paper—or you can paint right into the wetness. Here, a new sky is begun with a few strokes painted right onto the wet surface, so they begin to look like new cloud shapes.

Step 4. More darks are now added to the wet surface with big, bold strokes, and new, more dramatic cloud shapes emerge. To create a few light patches where the sun seems to shine through, some of the darks are blotted away with a wad of paper toweling.

Step 1. This painting is dull because the darks are evenly scattered all over the sheet. The distant landscape looks too close because it's just as dark as the foreground. And the water lacks delicacy. How can this be corrected?

Step 2. You can take the whole painting straight to the bathtub. Fill the bottom of the tub with cold water and soak the painting until the color begins to lift off. You can speed up the process by working over the sheet gently with a natural sponge. You can also try running the sheet under the tap. You won't get off *all* the color, but you'll remove enough to try again.

Step 3. To create a sense of deeper space and atmosphere, you can leave the "ghost" of the distant mountain and paint the trees in the middle distance with light strokes. Then you can begin to strengthen the darks in the foreground.

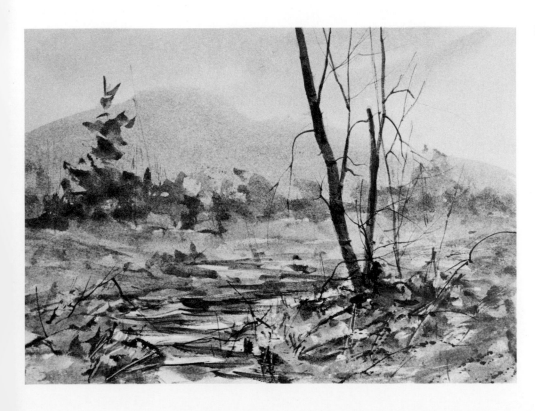

Step 4. Now you can concentrate on repainting the foreground—darkening the tree, foliage, and nearby water just enough to make them come forward in space, while the water and trees in the middle distance stay back. Quit while you're ahead. Don't overdo it or you'll be back at Step 1.

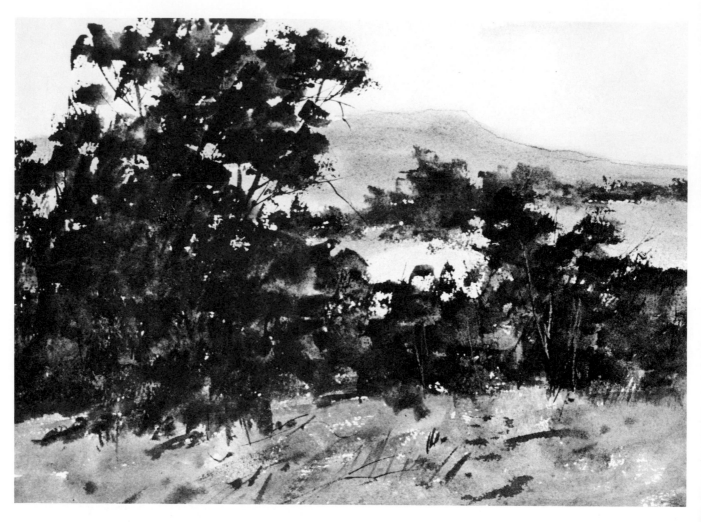

Step 1. These trees have gotten so dark that the trunks have disappeared, and the foliage forms a monotonous mass without enough detail. How can you go about adding some lighter treetrunks to relieve the monotony. You could, of course, try scratching some light lines into the darkness. But there's another solution that you might also like to try.

 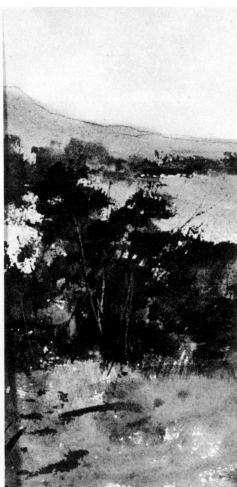

Step 2. Make a careful drawing of the shapes of the trunks on a separate sheet of sturdy white paper or thin cardboard. Then take a sharp blade and cut away the trunks, leaving gaps in the paper where the drawing of the trunks used to be. Now you've got a kind of stencil that you can place over the painting and tape down with some slender strips of masking tape—which you can see across the biggest trunk and the one to the left. The tape will hold the stencil snug against the paper.

Step 3. Wet a small, stiff bristle brush—the kind used for oil painting—and carefully scrub away the dark color that shows through the gaps in the stencil. As you scrub, blot off the wet color with a wad of paper toweling. Be sure to rinse the brush frequently, so you're always working with clear water. Don't use so much water that the liquid color runs under the edges of the stencil. Use just enough water to loosen the color and then blot it up with the paper towel. When you peel away the stencil, the painting will have light lines like those you see at the left of the picture. They don't look like treetrunks just yet, but now you've got strips of lighter paper to work on. Let the corrected areas dry before you do any further work.

Step 4. Now you can go back to work with a small round brush and turn those pale strips into treetrunks. You can add darks around the edges of the trunks to give them exactly the right shape. You can obliterate some portions of the light strips to suggest shadows and foliage crossing the trunks. A bit of drybrushing will add texture. You can also "anchor" the trunks more firmly to the ground by suggesting some shadows below. And you can extend the new trunks upward into the sky with dark strokes. Now you have a convincing mass of trees, interrupted by lighter trunks and branches.

Step 1. The dark streaks across the center of this picture are supposed to represent distant hills, but they're too dark and they don't look distant enough.

Step 2. You can lighten the tops of the hills—making them fade away into the distance—by scrubbing them with a big, wet bristle brush. As you scrub and loosen the color, blot it away with a paper towel. Keep rinsing the brush so that it removes color rather than spreading it around. When the hills are dry, you can then paint the trees in the foreground. Now the hills look really far away.

Developing Good Habits. After the excitement of painting, it's always a letdown to have to clean up. Fortunately, you can clean up quite quickly after painting a watercolor—the job takes a lot longer if you're working in oil. It's essential to develop the right cleanup habits, not merely to keep your studio looking shipshape, but because the watercolorist's tools and equipment are particularly delicate and need special care. Here are the most important steps in your cleanup. Don't neglect them!

Sponging. After a day's painting, you'll certainly leave little pools and spatters of color in all sorts of odd places. Your drawing board or drawing table will have a fair amount of dried color around the edges, which you should sponge away with an ordinary household sponge. (Don't waste an expensive natural sponge on this task.) If you don't sponge off your drawing board and other work surfaces, there's always the danger that some of this color will dissolve and work its way onto the fresh white paper during your *next* painting session. You should also sponge off the color that's accumulated on the mixing surface of your palette, since you obviously want to start with a fresh surface the next time you paint. There's no need to wash away what's left of the little mounds of tube color around the edges of the palette; at your next working session, you can simply wet them and use them again. However, these little mounds often get covered with traces of various color mixtures; it's a good idea to wash away these mixtures with a brush, exposing the original pure color.

Washing Brushes. Your most fragile and most expensive tools are your brushes. These take very special care. At the end of the painting day, be sure to rinse each brush thoroughly in clear water—not in the muddy water in the jars. If a brush seems to be stained by some tenacious color such as phthalocyanine blue, stroke the hairs gently across a bar of soap (not laundry soap) and lather the brush in the palm of your hand with a soft, circular motion. The color will come out in the lather, except with white nylon brushes, which may stain slightly. When all your brushes have been rinsed absolutely clean, shake out the excess water and then shape each brush with your fingers. Press the round brushes into a graceful bullet shape with pointed tips. Press the flat brushes into a neat square with the hairs tapering in slightly toward the forward edge.

Storing Brushes. Place the brushes in a clean, dry, empty jar, hair end up. Leave the brushes in the jar until they're absolutely dry. You can store them in this jar unless you live in some climate where moths or other pests are a threat to natural fibers. If you're worried about moths, it's best to store the brushes in a drawer or a box. Make sure that the hairs don't press up against anything—and sprinkle mothballs or moth-killing crystals among the brushes.

Care of Paper. Watercolor paper has a delicate surface and should be carefully stored. Don't just leave a stack of unused paper out where dust can discolor it or a sweaty hand can brush up against it. Store the paper flat in a drawer, preferably in an envelope, a flat box, or a portfolio so the paper isn't battered or scraped every time it goes in or out of the drawer. Keep the paper away from moist places such as a damp basement or a leaky attic.

Care of Colors. When you're finished painting, take a damp paper towel or a cleansing tissue and wipe off the "necks" of your color tubes to clean away any traces of paint that will make it hard to remove the cap the next time you paint. Do the same inside the cap itself. There's nothing more frustrating than wrestling with that tiny cap when you're desperate for a fresh dab of color, halfway through a painting. Also wash away any paint that might cover the label on the outside of the tube, so you can quickly identify your colors. Searching for the right color among all those filthy tubes can be just as maddening as wrestling with the cap. By the way, you'll get more color out of the tube—and save money—if you always squeeze the tube from the very end and roll up the empty portion as you work.

Safety Precautions. Be especially careful about putting away sharp instruments—and always keep them in the same place. If you bought a knife with a retractable blade, as suggested earlier, be sure to retract the blade before you store the knife in the darkness of your paintbox or toolbox. You don't want that sharp blade waiting for you when you grope around for the knife. Keep razor blades in a small envelope or in a box—or just wrap a piece of tape over the sharp edge. Keep pushpins or thumbtacks in a little envelope or box—or simply push them into the edges of your drawing board. Finally, there's always a certain amount of color on your fingertips while you're painting, so don't smoke or eat while you work. Keep those colors out of your digestive tract.

Permanence. A watercolor painting, properly taken care of, should last for centuries. Although the subject of framing, in particular, would take a book in itself, here are some suggestions about the proper way to preserve finished paintings.

Permanent Materials. It's obvious that you can't paint a durable picture unless you use the right materials. All the colors recommended in this book are chemically stable, which means that they won't deteriorate with the passage of time and won't produce unstable chemical combinations when blended with one another. When you buy other colors, either to expand your palette or to replace one of these eleven colors, study the manufacturer's literature to make sure that you're buying a permanent color. All the good color manufacturers have charts which tell you, quite frankly, which colors are permanent and which colors aren't. For the same reason, it's important to buy the best mouldmade or handmade paper. Although few papers are now made of rags, the manufacturers still use the phrase "100% rag" to designate paper that is chemically pure—and that's what you should buy once you feel that your paintings are worth saving. Lower grade papers will yellow and discolor with the passage of time.

Matting. A mat (which the British call a mount) is essential protection for a watercolor. The usual mat is a sturdy sheet of white or tinted cardboard, generally about 4″ (100 mm) larger than your painting on all four sides. Into the center of this board, you cut a window slightly smaller than the painting. You then "sandwich" the painting between this mat and a second board, the same size as the mat. Thus, the edges and back of the picture are protected and only the face of the picture is exposed. When you pick up the painting, you touch the "sandwich," not the painting itself.

Boards and Tape. Unfortunately, most mat (or mount) boards are far from chemically pure, containing corrosive substances that will eventually migrate from the board to discolor your watercolor paper. If you really want your paintings to last for posterity, you've got to buy the chemically pure, museum-quality mat board, sometimes called conservation board. The ordinary mat board does come in lovely colors, but you can match these by painting the museum board with acrylic colors. Paint both sides to prevent warping. The backing board can be less expensive "rag-faced" illustration board, which is a thick sheet of chemically pure, white drawing paper made with a backing of ordinary cardboard. Too many watercolorists paste their paintings to the mat or the backing board with masking tape or Scotch tape. Don't! The adhesive stays sticky forever and will gradually discolor the painting. The best tape is the glue-coated cloth used by librarians for repairing books. Or you can make your own tape out of strips of discarded watercolor paper and white library paste.

Framing. If you're going to hang your painting, the matted picture must be placed under a sheet of glass (or plastic) and then framed. Most watercolorists prefer a simple frame—slender strips of wood or metal in muted colors that harmonize with the picture—rather than the heavier, more ornate frames in which we often see oil paintings. If you're going to cut your own mats and make your own frames, buy a good book on picture framing, which is beyond the scope of the book you're now reading. If you're going to turn the job over to a commercial framer, make sure he uses museum-quality mat board or ask him to protect your painting with concealed sheets of rag drawing paper inside the mat. Equally important, make sure that he doesn't work with masking tape or Scotch tape—which too many framers rely on for speed and convenience.

What to Avoid. Commercial mat boards come in some dazzling colors that are likely to overwhelm your painting. Whether you make your own mats or have the job done by a framer, avoid the garish colors that call more attention to themselves than to your picture. Try to find a subdued color that "stays in its place" and allows the painting to occupy center stage. Resist the temptation to glue your finished painting down to a stiff board, even if the painting is a bit wavy. The painting should hang free inside the "sandwich" of mat and backing board, hinged either to the mat or the backing by just two pieces of tape along the two top corners of the picture. When you do hang the picture, keep it away from damp walls, leaky windows, leaky ceilings, and windows that will allow direct sunlight to pour onto the picture. Any painting—whether watercolor, oil, acrylic, or pastel—will eventually lose some of its brilliance with prolonged exposure to strong sunlight.

Storing Unframed Pictures. Unframed pictures, with or without mats, should always be stored horizontally, never vertically. Standing on its end, even the heaviest watercolor paper and the stiffest mat will begin to curl. Store these just as you'd store sheets of watercolor paper: in envelopes, shallow boxes, or portfolios kept flat in a drawer or on a shelf. Take proper care of your paintings and people will enjoy them for generations to come.

PART THREE

ACRYLIC PAINTING

Color Selection. The acrylic paintings in this book were done with twelve basic colors—colors you'd normally keep on the palette—plus a couple of others kept on hand for special purposes. Although the leading manufacturers of acrylic colors will offer you as many as thirty inviting hues, few professionals use more than a dozen, and many artists get by with fewer. The colors listed below are really enough for a lifetime of painting. You'll notice that most colors are in pairs: two blues, two reds, two yellows, two browns, two greens. One member of each pair is bright, the other subdued, giving you the greatest possible range of color mixtures.

Blues. Ultramarine blue is a dark, subdued hue with a hint of violet. Phthalocyanine blue is far more brilliant and has tremendous tinting strength—which means that a little goes a long way when you mix it with another color. So add it very gradually.

Reds. Cadmium red light is a fiery red with a hint of orange. All cadmium colors have tremendous tinting strength; add them to mixtures just a bit at a time. Naphthol crimson is a darker red and has a slightly violet cast.

Yellows. Cadmium yellow light is a dazzling, sunny yellow with tremendous tinting strength, like all the cadmiums. Yellow ochre (or yellow oxide) is a soft, tannish tone.

Greens. Phthalocyanine green is a brilliant hue with great tinting strength, like the blue in the same family. Chromium oxide green is more muted.

Browns. Burnt umber is a dark, somber brown. Burnt sienna is a coppery brown with a suggestion of orange.

Black and White. Some manufacturers offer ivory black, and others make mars black. The paintings in this book are done with mars black, which has slightly more tinting strength. But that's the only significant difference between the two blacks. Buy whichever one is available in your local art supply store. Titanium white is the standard white that every manufacturer makes.

Optional Colors. One other brown, popular among portrait painters, is the soft, yellowish raw umber, which you can add to your palette when you need it. Hooker's green—brighter than chromium oxide green, but not as brilliant as phthalocyanine—may be a useful addition to your palette for painting landscapes full of trees and growing things. If you feel the need for a bright orange on your palette, make it cadmium orange—although you can just as easily create this hue by mixing cadmium red and cadmium yellow.

Gloss and Matte Mediums. Although you can simply thin acrylic tube color with water, most manufacturers produce liquid painting mediums for this purpose. Gloss medium will thin your paint to a delightful creamy consistency; if you add enough medium, the paint turns transparent and allows the underlying colors to shine through. As its name suggests, gloss medium dries to a shiny finish like an oil painting. Matte medium has exactly the same consistency, will also turn your color transparent if you add enough medium, but dries to a satin finish with no shine. It's a matter of taste. Try both and see which you prefer.

Gel Medium. Still another medium comes in a tube and is called gel because it has a consistency like very thick, homemade mayonnaise. The gel looks cloudy as it comes from the tube, but dries clear. Blended with tube color, gel produces a thick, juicy consistency that's lovely for heavily textured brush and knife painting.

Modeling Paste. Even thicker than gel is modeling paste, which comes in a can or jar and has a consistency more like clay because it contains marble dust. You can literally build a painting ¼″ to ½″ (6 mm to 12 mm) thick if you blend your tube colors with modeling paste. But build gradually in several thin layers, allowing each one to dry before you apply the next, or the paste will crack.

Retarder. One of the advantages of acrylic is its rapid drying time, since it dries to the touch as soon as the water evaporates. If you find that it dries *too* fast, you can extend the drying time by blending retarder with your tube color.

Combining Mediums. You can also mix your tube colors with various combinations of these mediums to arrive at precisely the consistency you prefer. For example, a 50-50 blend of gloss and matte mediums will give you a semi-gloss surface. A combination of gel with one of the liquid mediums will give you a juicy, semi-liquid consistency. A simple mixture of tube color and modeling paste can sometimes be a bit gritty; this very thick paint will flow more smoothly if you add some liquid medium or gel.

Brushes. Because you can wash out a brush quickly when you switch from one color to another, you need very few brushes for acrylic painting. Two large, flat brushes will do for covering big areas: a 1″ (25 mm) bristle brush, the kind you use for oil painting; and a softhair brush the same size, whether oxhair, squirrel hair, or soft white nylon. Then you'll need another bristle brush and another softhair brush, each half that size. For more detailed work, add a couple of round softhair brushes—let's say a number 10, which is about ¼″ (6 mm) in diameter, and a number 6, which is about half as wide. If you find that you like working in the transparent technique, which means thinning acrylic paint to the consistency of watercolor, it might be helpful to add a big number 12 round softhair brush, either oxhair or soft white nylon. Since acrylic painting will subject brushes to a lot of wear and tear, few artists use their expensive sables.

Painting Surfaces. If you like to work on a smooth surface, use illustration board, which is white drawing paper with a stiff cardboard backing. For the transparent technique, the best surface is watercolor paper—and the most versatile watercolor paper is mouldmade 140 pound stock in the cold pressed surface (called a ''not'' surface in Britain). Acrylic handles beautifully on canvas, but make sure that the canvas is coated with white acrylic paint, not white oil paint. Your art supply store will also sell inexpensive canvas boards—thin canvas glued to cardboard—that are usually coated with white acrylic, which is excellent for acrylic painting. You can create your own painting surface by coating hardboard with acrylic gesso, a thick, white acrylic paint which comes in cans or jars. For a smooth surface, brush on several thin coats of acrylic gesso diluted with water to the consistency of milk. For a rougher surface, brush on the gesso straight from the can so that the white coating retains the marks of the brush. Use a big nylon housepainter's brush.

Drawing Board. To support your illustration board or watercolor paper while you work, the simplest solution is a piece of hardboard. Just tack or tape your painting surface to the hardboard and rest it on a tabletop—with a book under the back edge of your board so it slants toward you. You can tack down a canvas board in the same way. If you like to work on a vertical surface—which many artists prefer when they're painting on canvas, canvas board, or hardboard coated with gesso—a wooden easel is the solution. If your budget permits, you may like a wooden drawing table, which you can tilt to a horizontal, diagonal, or vertical position just by turning a knob.

Palette. One of the most popular palettes is the least expensive—just squeeze out and mix your colors on a white enamel tray, which you can probably find in a shop that sells kitchen supplies. Another good choice is a white metal or plastic palette (the kind used for watercolor) with compartments into which you squeeze your tube colors. Some acrylic painters like the paper palettes used by oil painters: a pad of waterproof pages that you tear off and discard after painting.

Odds and Ends. For working outdoors, it's helpful to have a wood or metal paintbox with compartments for tubes, brushes, bottles of medium, knives, and other accessories. You can buy a tear-off paper palette and canvas boards that fit neatly into the box. Many acrylic painters carry their gear in a toolbox or a fishing tackle box, both of which also have lots of compartments. Two types of knives are helpful: a palette knife for mixing color; and a sharp one with a retractable blade (or some single-edge razor blades) to cut paper, illustration board, or tape. Paper towels and a sponge are useful for cleaning up—and they can also be used for painting, as you'll see later. You'll need an HB drawing pencil or just an ordinary office pencil for sketching in your composition before you start to paint. To erase pencil lines, get a kneaded rubber (or ''putty rubber'') eraser, which is so soft that you can shape it like clay and erase a pencil line without abrading the surface. To hold down that paper or board, get a roll of 1″ (25 mm) masking tape and a handful of thumbtacks (drawing pins) or pushpins. To carry water when you work outdoors, you can take a discarded plastic detergent bottle (if it's big enough to hold a couple of quarts or liters) or buy a water bottle or canteen in a store that sells camping supplies. For the studio, find three wide-mouthed glass jars, each big enough to hold a quart or a liter.

Work Layout. Before you start to paint, lay out your supplies and equipment in a consistent way, so everything is always in its place when you reach for it. Obviously, your drawing board or easel is directly in front of you. If you're right-handed, place your palette, those three jars, and a cup of medium to the right. In one jar, store your brushes, hair end up. Fill the other two jars with clear water: one is for washing your brushes; the other provides water for diluting your colors. Establish a fixed location for each color on your palette. One good way is to place your *cool* colors (black, blue, green) at one end and the *warm* colors (yellow, orange, red, brown) at the other. Put a big dab of white in a distant corner, where it won't be fouled by the other colors.

Bristle Brushes. Yes, you've already seen these brushes in Part One on "Oil Painting." The point is that you can use the same sort of bristle brushes you use for painting in oil: the long, rounded *filbert* (top); the squarish brush called a *flat* (center); and the short, stiff brush called a *bright* (bottom). Of course, bristle brushes will make a rougher, more heavily textured stroke than the softhair brushes shown below.

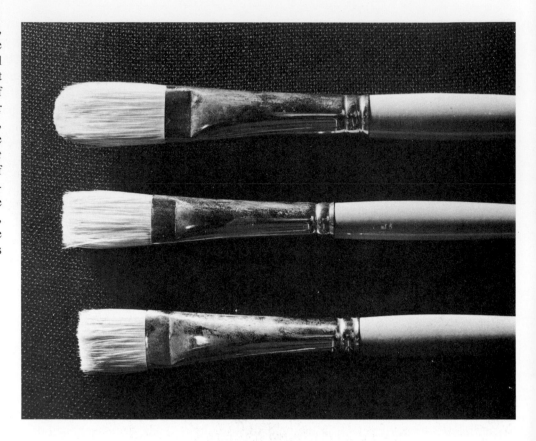

Softhair Brushes. For applying more fluid color—diluted with more water—many painters prefer softhair brushes. The top two are soft, white nylon; the round, pointed brush is good for lines and details, while the flat one will cover broad areas with big strokes. The third brush from the top is a sable watercolor brush, useful for applying very fluid color diluted with a lot of water. (You can also buy a big, round brush like this one in white nylon, which will take more punishment than the delicate sable.) The bottom brush is stiffer, golden brown nylon, equally useful for working with thick or thin color.

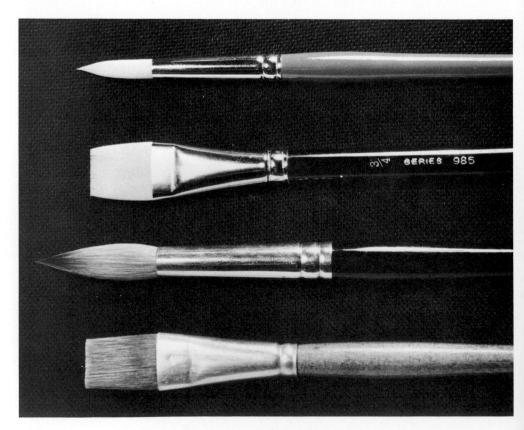

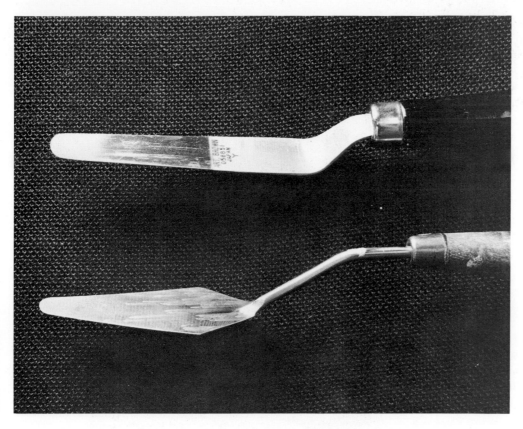

Knives. These knives will also look familiar from Part One on "Oil Painting." That's because you can use the same sort of palette knife (above) for mixing thick color on your palette—before you add water—and for scraping wet color off your painting. And you can use the same sort of painting knife (below) for spreading thick color, straight from the tube or diluted with gel me-

Sponges. A soft, natural sponge (left) is useful for wetting the painting surface when you're planning to try the wet-in-wet technique; for wiping away wet color from some part of the picture that you want to repaint; and even for applying paint. The bigger, coarser synthetic sponge (right) is convenient for mopping up spills and cleaning up the studio at the end of the working day.

Watercolor Palette. This white plastic palette was originally designed for watercolor painting, but it works just as well for acrylic painting. You squeeze your tube color into the circular "wells" and then do your mixing in the rectangular compartments. These compartments slant down at one end; thus the color will run down and form pools if you add enough water.

Enamel Tray. For mixing large quantities of color, the most convenient palette is a white enamel tray—which you can buy wherever kitchen supplies are sold. You can use this tray by itself or in combination with one or two smaller plastic palettes like those used for watercolor.

Improvised Palettes. Many acrylic painters find their palettes in the kitchen. At the left is a metal muffin tin with compartments that are just the right size for mixing acrylic colors. Discarded yogurt containers (top right) and margarine containers (bottom right) also make excellent mixing cups. Be sure to scrub the margarine container with lots of soap and water so that you eliminate all the oily residue.

Easel. Your oil painting easel will serve just as well for acrylic painting, particularly if you're working with thick color (the consistency of oil paint) that won't run down the vertical painting surface. But if you prefer to paint with fluid color—more like watercolor—a drawing board or drawing table will give you a horizontal or slanted surface that gives you more control over the fast-moving, highly liquid paint.

Wooden Drawing Board. When you paint on watercolor paper—or on any sturdy paper—it's best to tape the paper to a sheet of plywood or a sheet of hardboard cut slightly bigger than the painting. If you can, buy plywood or hardboard that's made for outdoor construction work; it's more resistant to moisture. Hold down the edges of the painting with masking tape that is at least 1″ (25 mm) wide or even wider.

Fiberboard. Illustration board is too thick to tape down, so use thumbtacks (drawing pins) or push-pins to secure the painting to a thick sheet of fiberboard. This board is ¾″ (about 18 mm) thick and soft enough for the pins to penetrate. Note that the pins don't go *through* the painting, but simply overlap the edges.

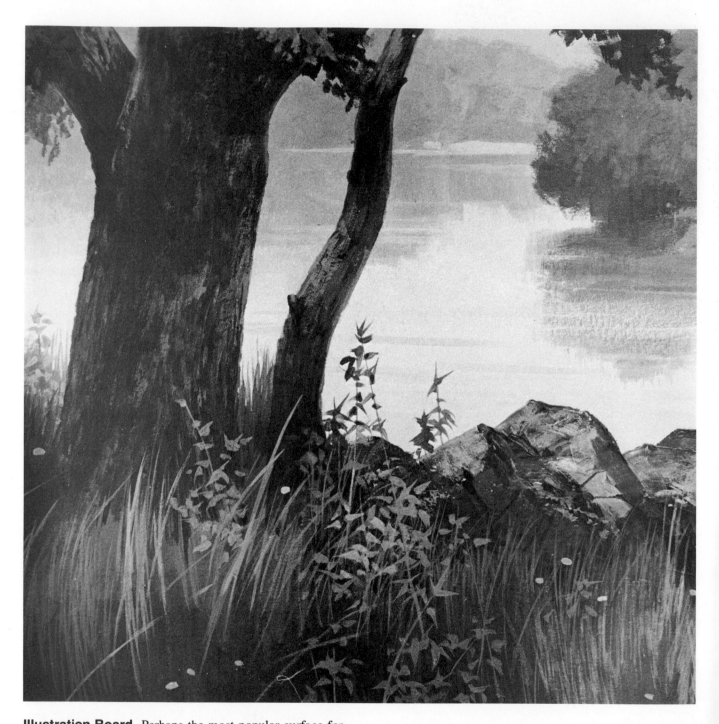

Illustration Board. Perhaps the most popular surface for acrylic painting is illustration board—white drawing paper mounted on thick cardboard. The standard illustration board has just a slight texture—or *tooth*, as painters call it—to respond to all sorts of brushwork. For example, the texture of the paper accentuates the rough brushwork on the tree-trunks. On the other hand, the paper is just smooth enough for precise, detailed work, such as the weeds and grasses in the foreground, which are painted with a slender, pointed brush and fluid color. This all-purpose surface is frequently called a "kid finish," which means that it has a slight texture. You can also buy a "high" or "plate" finish that's absolutely smooth, but this is suitable only for *very* precise, detailed work.

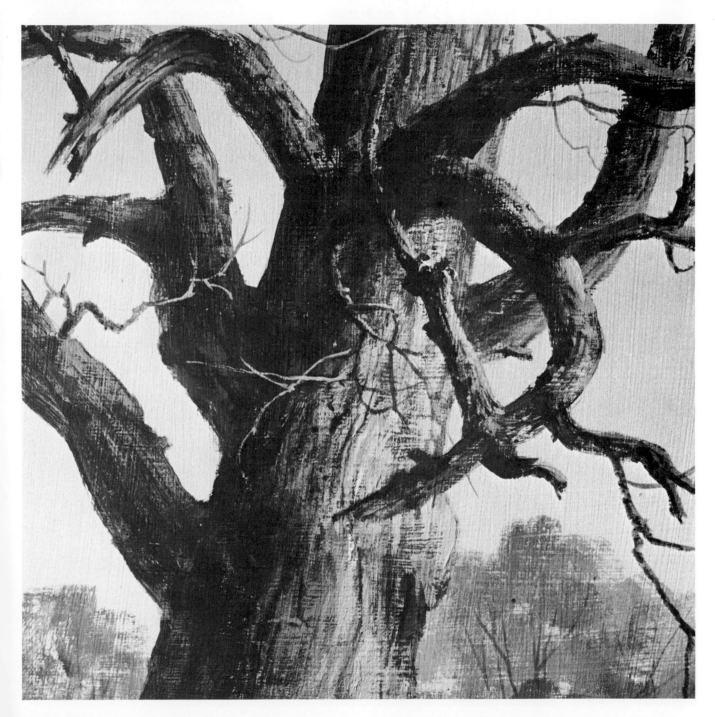

Gesso Board. Manufacturers of acrylic colors also make a thick, white paint for coating hardboard, cardboard, canvas, or any other painting surface. This acrylic gesso, as it's called, is the same chemical formula as the tube colors. As it comes from the can or the jar, the gesso is a very thick liquid. You can apply it directly from the can, without any additional water, using a nylon housepainter's brush. The bristles really dig into the paint and leave a distinct mark on the surface. This treetrunk was painted on such a surface, which roughens the stroke and produces a lively, broken texture. For a slightly smoother surface, you can thin the gesso with enough water to produce a creamy consistency: you'll probably need a couple of coats. For a *really* smooth surface, add enough water to produce a milky consistency and apply three or four coats. Apply successive coats at right angles to one another: the strokes of the first coat should move from top to bottom, while the strokes of the second coat should move from left to right. If the hardboard has a smooth side and a rough side, it's best to apply the gesso to the smooth side. If you're coating illustration board, paint an equal number of coats on both sides so that the board won't warp.

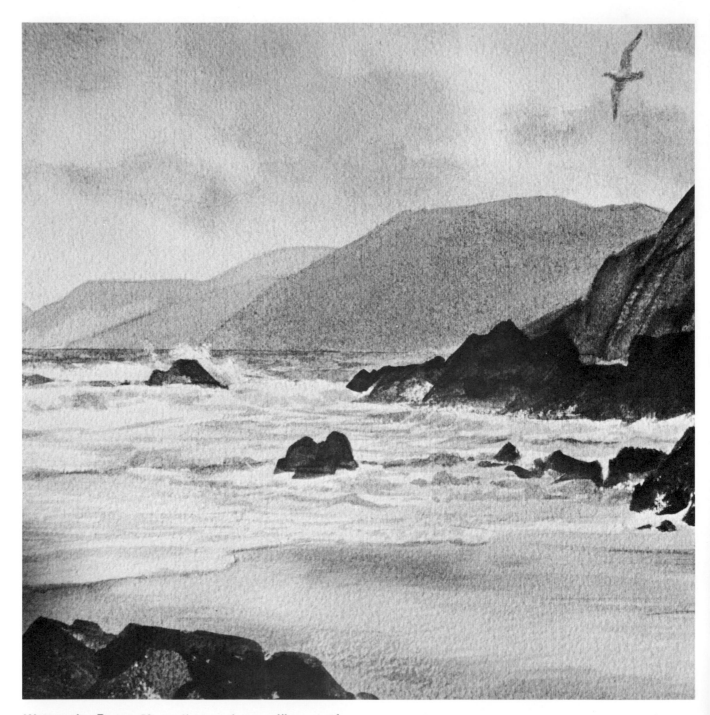

Watercolor Paper. If you discover that you like to work with very fluid color—diluted with lots of water so the paint handles like watercolor—watercolor paper is the ideal painting surface. Here's a section from a coastal scene painted on cold pressed paper, which means a surface that has a moderate texture, not too rough and not too smooth. The most versatile watercolor paper is a fairly thick sheet designated as 140 pound stock, heavy enough so that it won't curl too badly when it gets wet; it's mouldmade, which means that it's machinemade, but surprisingly close to the expensive, handmade papers preferred by professionals; and it's cold pressed—called a "not" surface in Britain. If you like bold, rough brushwork, try a rough surface instead of the cold pressed.

Canvas. Although canvas is most widely used for oil painting, it's also an excellent surface for acrylic. The weave of the canvas produces a beautiful texture that softens and enlivens the brushstroke. In this close-up of a portrait head, for example, you can see how the texture of the canvas softens and blurs the stroke, helping to produce those subtle gradations from dark to light. And the fibers of the canvas tend to appear within the strokes as flecks of light and dark, making the strokes look luminous and transparent. Canvas boards are the most inexpensive form of canvas: just thin fabric glued to cardboard and usually coated with white acrylic, which makes the surface particularly receptive to acrylic colors. You can also buy artists' canvas in rolls, which you cut into sheets and nail to a rectangular frame made of wooden strips called canvas stretchers. If you buy canvas that's precoated with white paint, be sure it's white acrylic, not oil paint. Or buy so-called raw canvas, which is plain linen or cotton. "Stretch" it yourself, and then give it two or three coats of acrylic gesso.

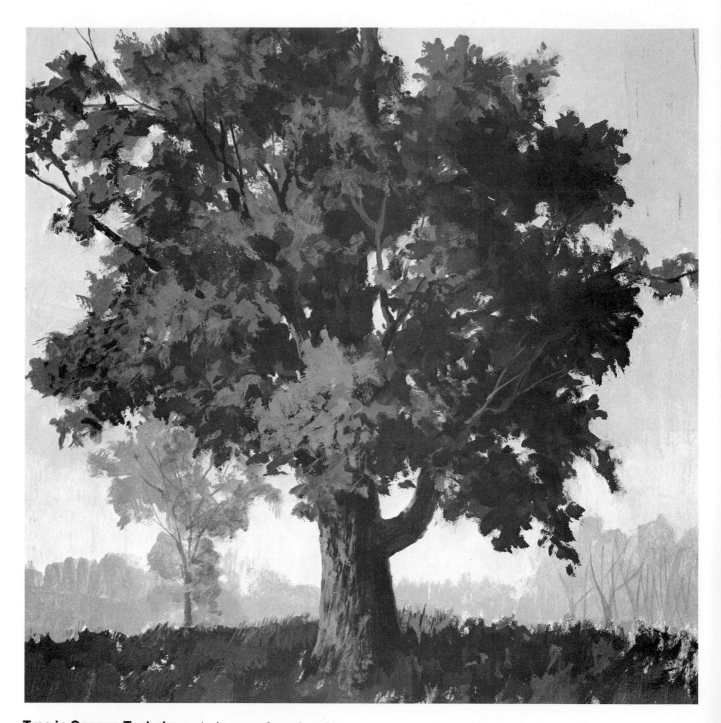

Tree in Opaque Technique. As it comes from the tube, acrylic color is thick and opaque. That is, the color will cover whatever is underneath. Normally, you add a bit of water to make the color more fluid and "brushable." And you mix it with some other colors—including white, which is the most opaque color on your palette. So even when the tube color is thinned to a more fluid consistency, it's still fairly opaque. This opacity means that one layer of color will cover another, even if the top layer is paler than the one underneath. In this tree, for example, the lighter leaves were painted over the darker leaves. The opaque technique is the easiest way of working with acrylics because you can paint dark over light, light over dark, and simply cover a mistake by painting over it.

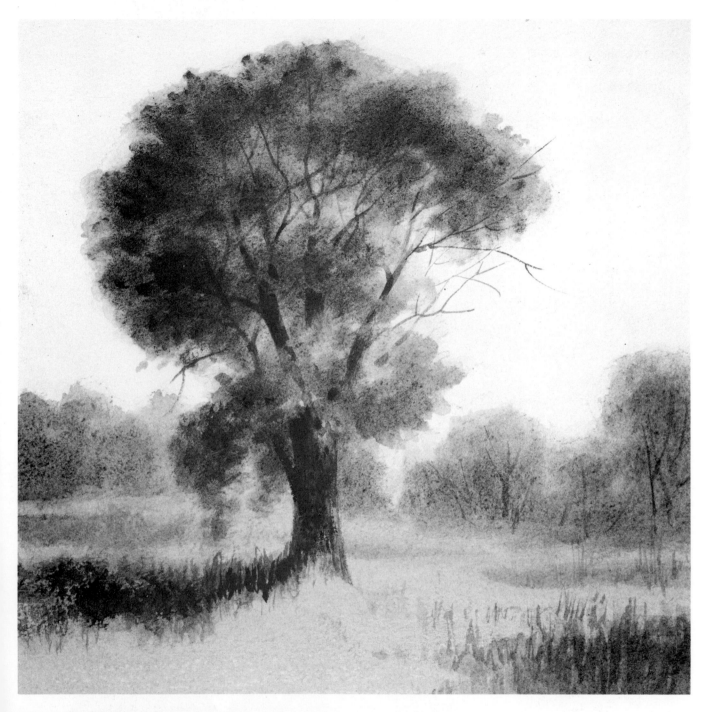

Tree in Transparent Technique. If you add lots of water to your tube color, the paint turns into something like watercolor. You're really working with tinted water. When you mix your colors, you don't add any white, which would turn the mixture opaque. When liquid color dries on the painting surface, you can see right through the color, which is like a thin sheet of stained glass. When you work in the transparent technique, it's best to proceed from light to dark, since pale strokes won't cover dark ones. In this tree, you can see how the dark branches shine through the clusters of leaves. A painting in the transparent technique has a wonderful delicacy and luminosity that are quite different from the heavier, more solid look of a painting in the opaque technique.

Step 1. For your first taste of acrylic painting, choose a simple subject like a tree. On a white sheet of illustration board or a thick, sturdy sheet of white drawing paper, make a free pencil drawing, indicating the main shapes of the tree.

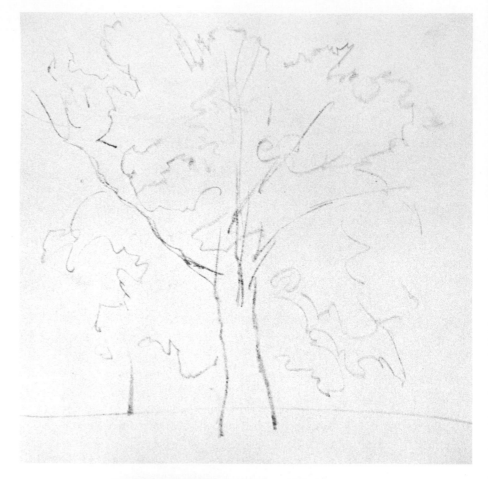

Step 2. You're going to work from dark to light, so brush in the overall shape of the tree and the ground with mixtures that are actually the darkest colors in your picture. Don't thin your tube color too much—just a few drops of water or medium will do, keeping it a rich, creamy consistency so that the paint really covers the paper. Allow this layer to dry.

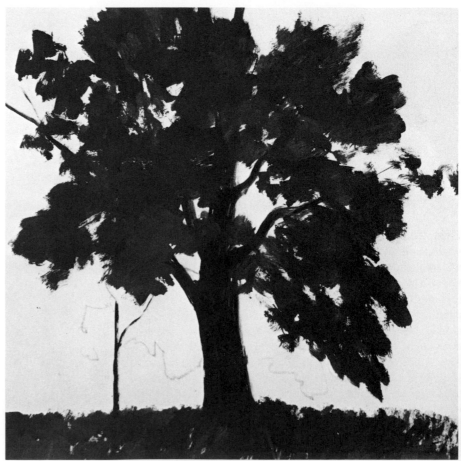

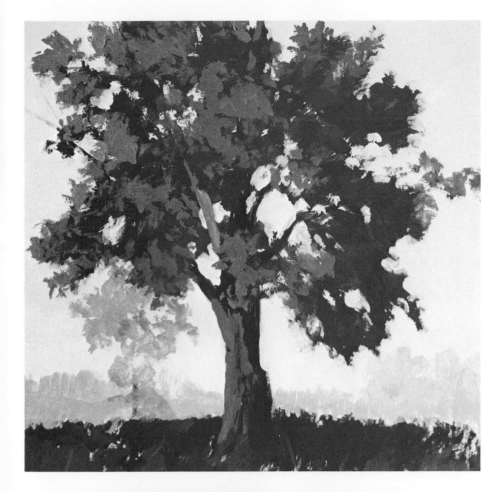

Step 3. Mix some paler tones for the sunlit parts of the tree and brush them over the darks, which now really look like shadows. Then mix even paler tones for the sky, brushing them around the leafy mass and punching some holes into the tree where the sky shows through. These lighter tones should be thick and creamy so that they really cover the darks underneath. Now you see why this is called the opaque technique.

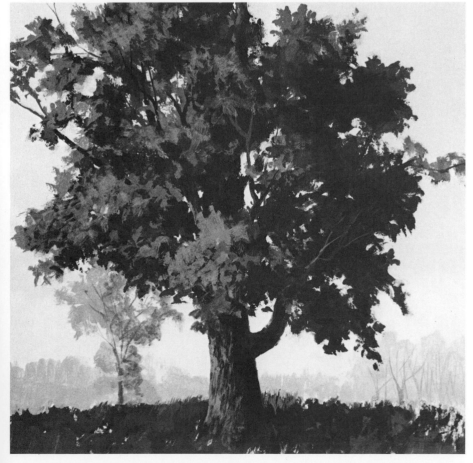

Step 4. Always save your small details for the very end. Now you can use opaque light and dark strokes to pick out individual branches, to suggest the texture of the bark, and to indicate a few leaves. The secret of the opaque technique is that each stroke is thick and solid enough to cover what's underneath.

Step 1. Now try the transparent technique by painting another tree with very fluid color that's diluted with a lot of water. On a white sheet of watercolor paper—or another piece of illustration board, if you prefer—start with a free pencil drawing that outlines the clusters of leaves, the trunk, and the landscape background.

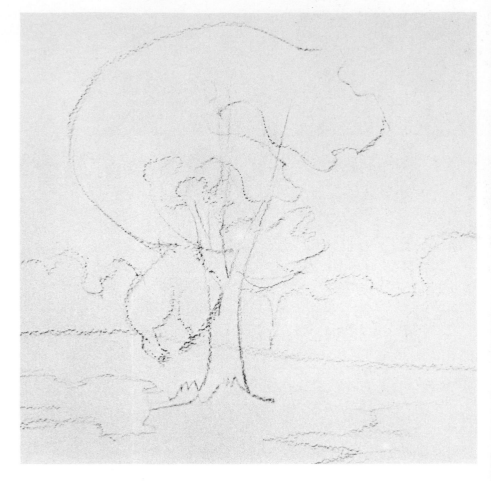

Step 2. Mix some pale *washes*, as they're called, thinning your tube color with lots of water. With a round, softhair brush, block in the palest tones of the picture with free, relaxed strokes: the general shapes of the leafy masses, the trees along the horizon, and the shadows in the foreground. Don't be too precise and don't think about details just yet.

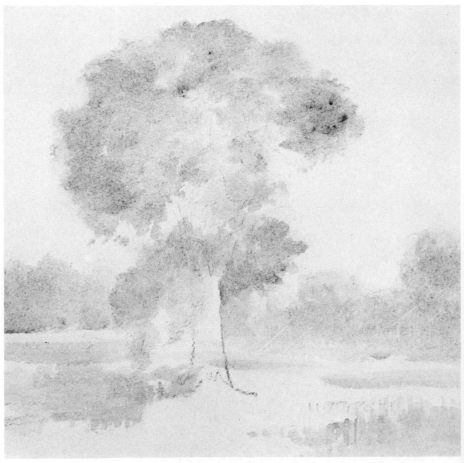

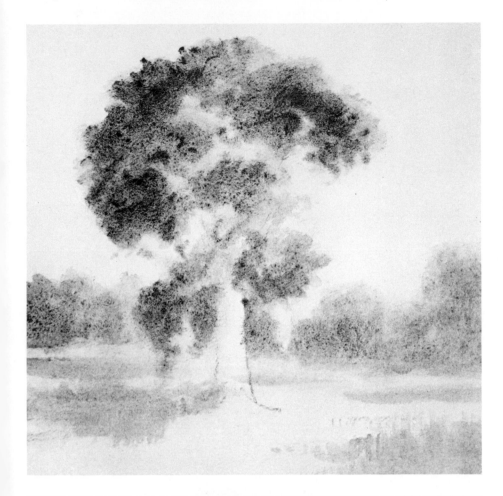

Step 3. Next, mix some darker tones on your palette. You're still using plenty of water, but not quite so much as you used in Step 2. Work with big, free strokes, darkening some parts of the tree and some areas of the trees in the background. Let the wet strokes overlap so that they blur together. Notice that the color tends to pool in the valleys of the watercolor paper, so you get darker flecks here and there, suggesting leaves.

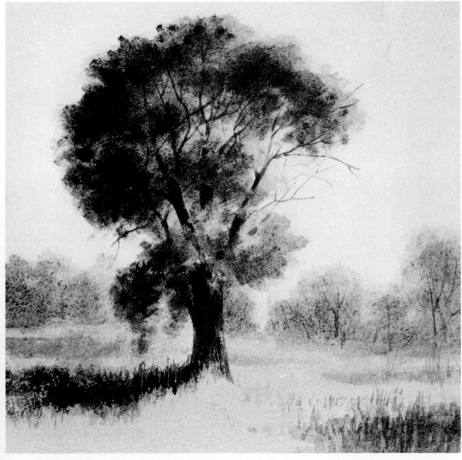

Step 4. When the previous step is dry, mix some even darker washes—less water, though still fluid—and darken the shadowy areas of the leafy masses. This is the time to paint the trunk and branches with decisive strokes made by the tip of the brush. The tip is also used to add some trunks to the distant trees and to darken the shadows in the foreground, suggesting some blades of grass.

Step 1. There are many times when a subject calls for a combination of transparent and opaque color. The luminosity of water, for example, is easy to capture with transparent color that's diluted with water—and lightened with water rather than with opaque white. The white painting surface shines right through the transparent color and gives you a sense of inner light. On the other hand, crashing surf tends to look dense and opaque, which is a good reason for painting foam in thick color that's lightened with white, not with water. The pencil drawing traces the top edges of the waves and defines the shapes of the foam.

Step 2. The shallow water in the foreground is painted with horizontal strokes of tube color diluted with a great deal of water; thus the color barely conceals the white surface of the illustration board. The tone of the water is darkened—more tube color and less water—and the brush carefully paints the shadowy tones of the face of the wave plus the dark top. The tip of the brush moves around the shape of the foam, leaving the painting surface bare. Then the distant sea and sky are stroked with clear water. While this area is still damp, the brush suggests the distant waves with horizontal strokes of transparent color that blur slightly on the moist surface.

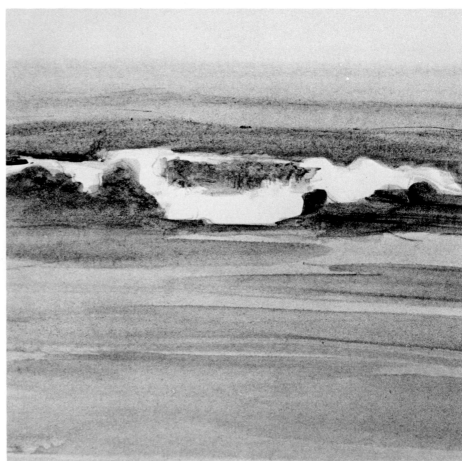

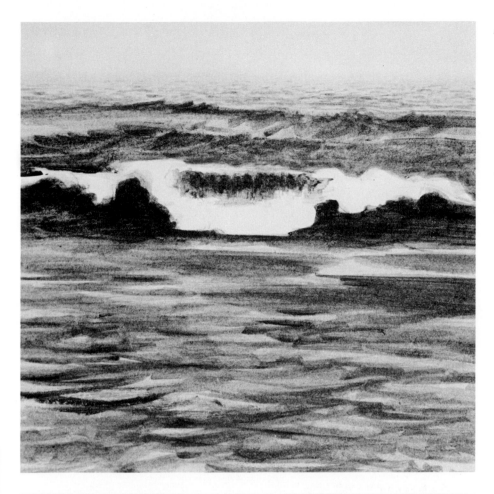

Step 3. Still working with transparent color, the tip of a round soft-hair brush adds slightly curving, horizontal strokes of dark, transparent color to the foreground. These strokes suggest the details and the movement of the shallow waves moving up the beach. More strokes of transparent color darken the face and the top of the big wave. And short, choppy strokes darken the faces of the distant waves to suggest the turbulent action of the water. So far, everything has been done with strokes of transparent color—just tube color and water.

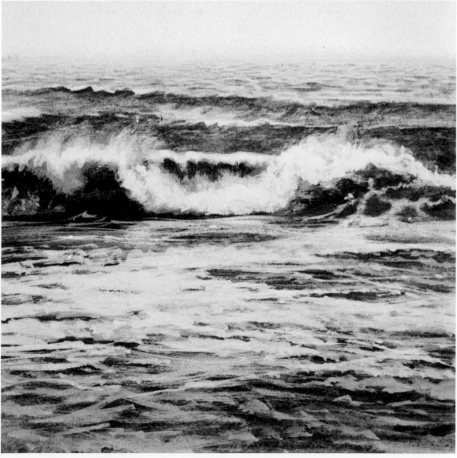

Step 4. In this final stage, the lighter tones of the foam are painted with strokes of opaque color carried right over the transparent darks. The tube color contains plenty of white and only enough water or medium to make the paint creamy. The tip of the round brush traces horizontal lines of foam across the foreground plus wandering lines of foam over the dark face of the big wave. The crashing surf is painted with thick, opaque white and so are the foamy tops of the distant waves. The shadows beneath the foam—which you can see most clearly at the left—are also opaque color, containing less white. Just as in nature, you have transparent water and opaque foam.

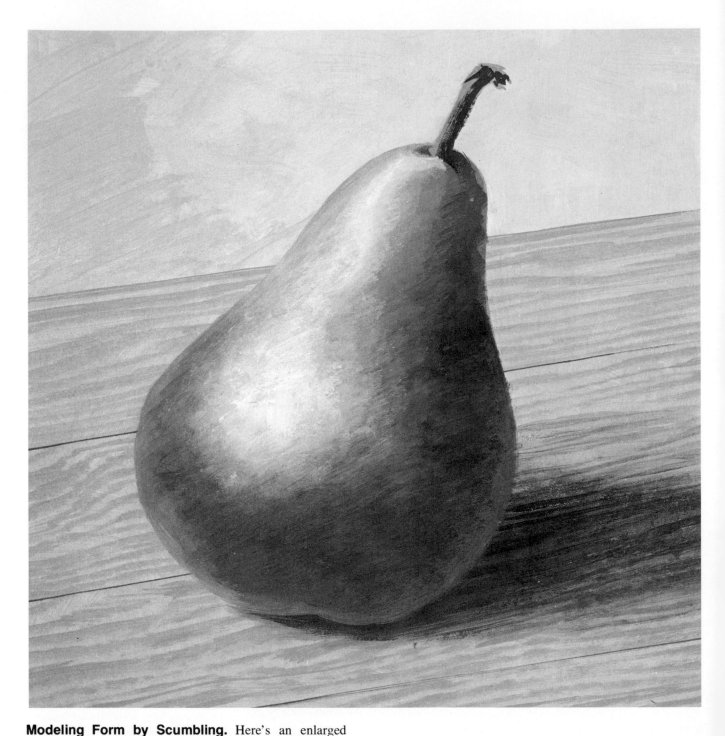

Modeling Form by Scumbling. Here's an enlarged close-up of a painting of a pear, showing the technique called scumbling. The lights and shadows on the pear are rendered by picking up a bit of paint on the tip of a brush and then scrubbing with a quick back-and-forth motion. Acrylic paint dries so quickly that it's hard to blend one wet stroke smoothly into another. Instead, you apply a series of individual strokes with that scrubbing—or scumbling—motion that blurs the mark made by the brush. One stroke overlaps another, and they seem to blend in the viewer's eye. As your eye moves from right to left over the surface of this pear, you can see dark strokes, then lighter strokes, and then *very* light strokes, all combining to give you a feeling of light and shadow traveling over the rounded form of the fruit.

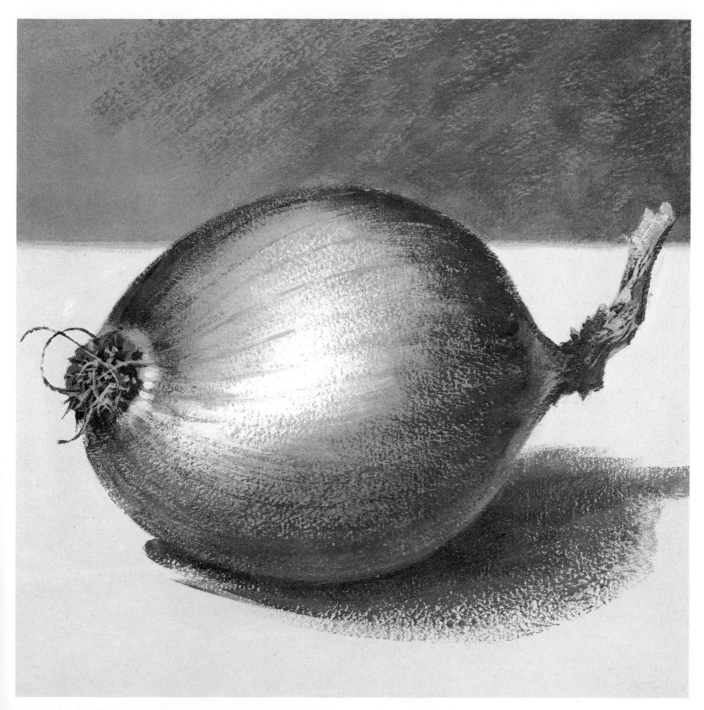

Modeling Form with Drybrush. Another way to create subtle gradations from dark to light is the technique called drybrush. The brush isn't literally dry, but carries tube color that's been thinned with just a little water. If the color on the brush is too fluid, you can touch the bristles to a paper towel and soak out some of the water. You paint on a surface with a distinct texture, such as watercolor paper, canvas, kid-finish illustration board, or a gesso panel on which the gesso has been applied so thickly that the brushstrokes have left a distinct texture. The brush travels lightly over the painting surface, hitting the high points of the texture and skipping over the low spots in between. The more pressure you apply on the brush, the more color you deposit. By passing the brush back and forth over the surface, sometimes applying more pressure, sometimes less, you gradually build up very subtle tones—actually composed of tiny flecks of color caught on the ridges of the paper. Drybrush strokes are so soft that they seem to blend into one another. On this onion, you can see dark strokes at the right and at the top, gradually giving way to paler and still paler strokes as the brush approaches the center.

SCUMBLING TECHNIQUE

Step 1. To learn the technique called scumbling, begin with some simple form like this pear. Work on a piece of illustration board or a piece of sturdy, thick drawing paper that has a slight texture. Begin with a pencil drawing that outlines the forms.

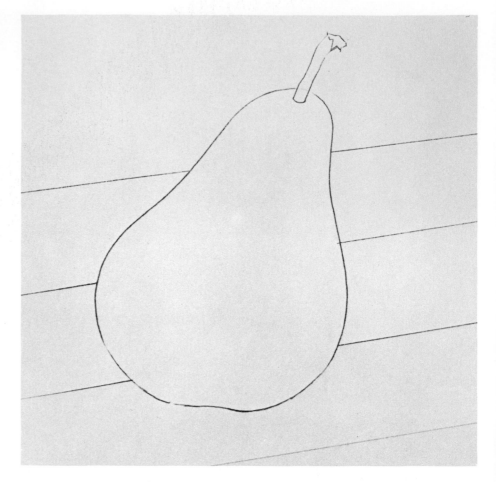

Step 2. On your palette, mix a tone for each of the main color areas. Add enough water to make the paint fairly fluid, like cream or milk. Cover each area with a flat tone. Allow each area to dry before you paint the next.

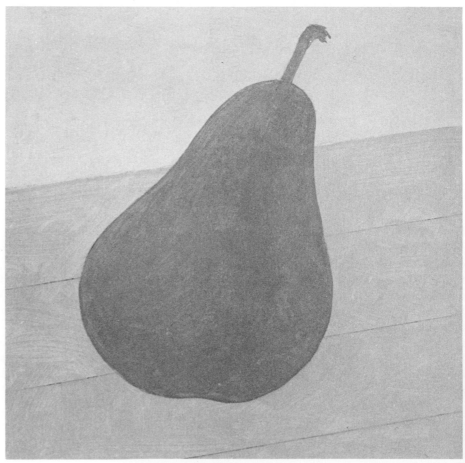

Step 3. Now mix a dark tone for the shadow side of the pear, pick up a bit of paint on the tip of a bristle or nylon brush, and apply the color in a series of strokes, moving the brush back and forth with a scrubbing motion that softens and blurs the stroke. Place some lighter strokes alongside the darker strokes so that you get the feeling of dark blending into middletone. You can also paint the grain of the tabletop with a pointed, softhair brush and more fluid color, placing darker strokes in the shadow area.

Step 4. Now mix a much lighter tone for the center of the pear. Again using a resilient brush, such as bristle or nylon, scrub on the color with a back-and-forth motion, blurring the light strokes as you approach the darker area of the pear. Placed side-by-side, the dark and light scumbled strokes will seem to blend into one another. You can also darken the shadow with more scumbling strokes.

Step 1. Drybrush is a method of producing subtle dark-to-light gradations by skimming the brush lightly over the surface of the paper. The brush is damp, never sopping wet, because the color doesn't contain too much water. It's important to work on a surface that has a distinct texture. This demonstration is painted on rough illustration board, but you could also use watercolor paper. To learn how to handle drybrush, pick some simple, natural form like this onion. Begin with a careful pencil drawing that defines the outer edge of the form.

Step 2. Cover each major color area with a thin layer of fluid color. Dilute the color with enough water to produce a milky consistency—not thick enough to obliterate the texture of the painting surface. Let each area dry before you paint the next.

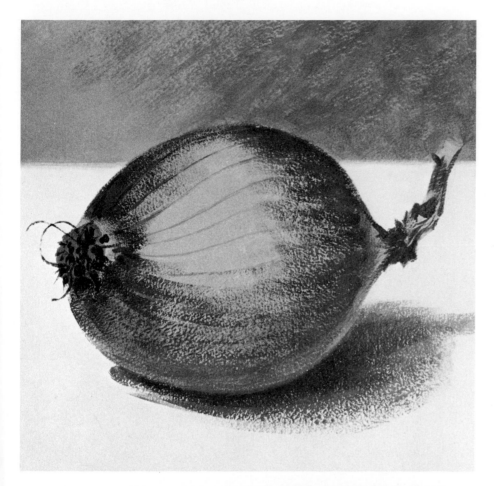

Step 3. Start by mixing the shadow tones, adding just enough water to make the paint brush easily. Move the brush lightly over the textured painting surface, hitting the peaks and skipping over the valleys so that color is deposited on the high points, while the low points shine through as lighter flecks. Move the brush back and forth over certain areas and press a bit harder to deposit more paint and make those areas darker. You can see these darks at the top of the onion, at the extreme right, and in the shadow beneath. The background is also darkened with drybrush strokes.

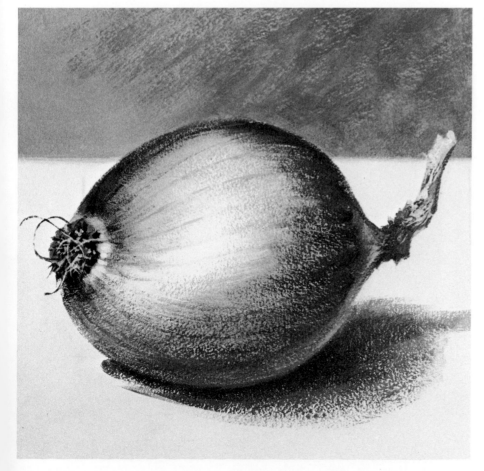

Step 4. Now wash out the brush, draw it across a paper towel to get rid of most of the water, and pick up lighter tones for the center of the form. Once again, skim the brush over the rounded form, curving the strokes to follow the shape of the onion, moving back and forth and pressing harder to deposit more color. Where the light strokes intersect with the darker strokes applied in Step 3, you get a soft gradation from light to dark. With the tip of a round, softhair brush and more fluid color, add lines and details.

Step 1. To paint a landscape in the drybrush technique, it's best to pick a painting surface with a distinct texture—a surface with lots of peaks and valleys, such as a sheet of rough watercolor paper or roughly textured illustration board. In this preliminary pencil drawing, you can see how the *tooth* of the watercolor paper—the peaks and valleys of the painting surface—breaks up the pencil lines. The same thing will happen to the brushstrokes.

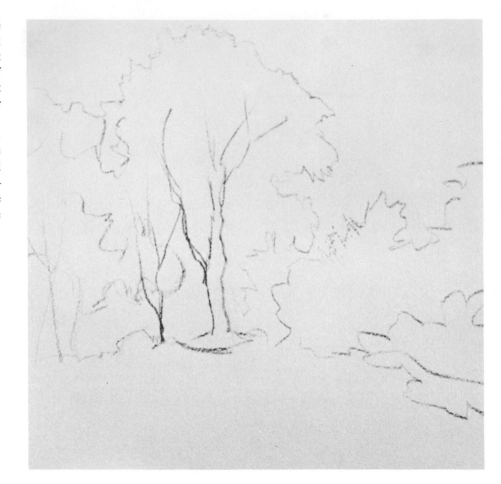

Step 2. The brush picks up a color mixture that doesn't contain too much water, so the paint isn't too fluid. Drybrush doesn't really mean that the brush is dry—but it *is* damp instead of soaking wet. Moving across the peaks and valleys of the painting surface, the brush tends to deposit color on the peaks and skips over many of the valleys. The color isn't fluid enough to run down into these valleys, so they remain bare paper. The result is a speckled effect that's perfect for suggesting dark foliage with flecks of light breaking through. In this demonstration, the big masses of foliage, grasses, and weeds are painted first with broad, rough strokes.

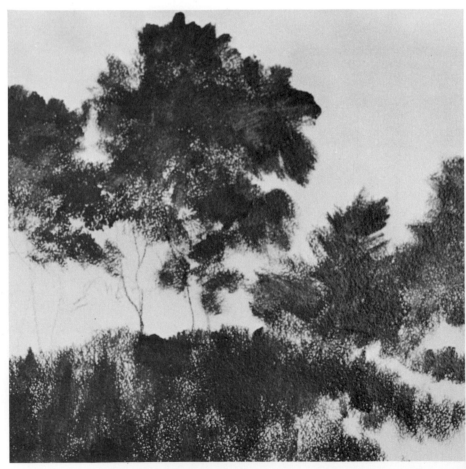

Step 3. The lighter areas—among the trees and on the meadow—are painted next. The brush is still damp, rather than wet, carrying paint that doesn't contain too much water. If the brush seems too wet or the paint seems too fluid, you can wipe some off on a paper towel. The brush should carry *less* color than you'd need to paint a smooth, even tone. The lighter strokes easily cover the darks beneath, so it's obvious that the color is opaque.

Step 4. The picture is completed by adding the darkest darks. Deep shadows are drybrushed under the leafy masses and on the patches of meadow directly beneath the trees. A path of sunlight is drybrushed beneath the trees at the lower right. Then the tip of a small, round brush picks up more fluid color to add the precise details of treetrunks, branches, and a few pale spots that suggest wildflowers in the meadow. It's difficult to paint a complete picture in the drybrush technique. Usually, it's best to paint the broad masses with drybrush strokes, then switch to more fluid color for precise details.

Step 1. A good way to create the soft edges of clouds (or foam) is the scumbling technique. Working with thick color, the brush moves back-and-forth with a scrubbing motion that blurs the strokes. This method works best with opaque color, so you can scumble light over dark or dark over light. The pencil drawing, on a sheet of illustration board, defines the cloud shapes.

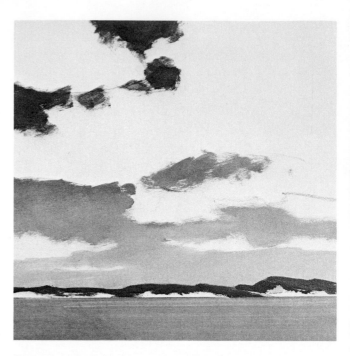

Step 2. The dark patches of sky showing between the clouds are painted first with thick, opaque color, darker at the top and lighter at the horizon. Notice that the scrubby, ragged strokes already suggest the soft edges of the clouds. The coast and water beneath are painted with smoother strokes of fluid color.

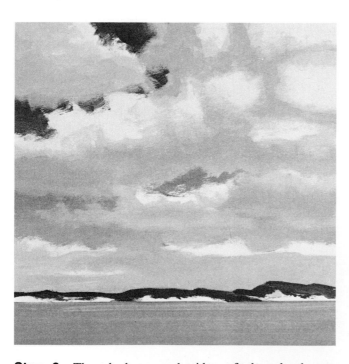

Step 3. The shadowy undersides of the clouds are scumbled with thick, opaque color, leaving bare painting surface for the sunlit areas. Once again, the scrubby strokes have ragged edges, so the shadows seem to melt into the lights.

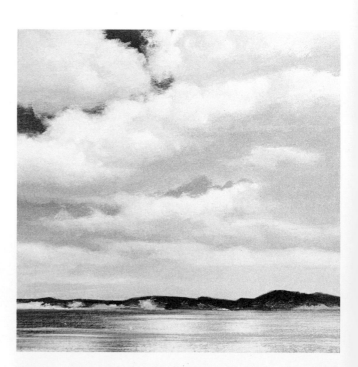

Step 4. The sky is completed by scumbling the sunlit planes of the clouds with soft, scrubby strokes that seem to blend into the shadows. Some of these strokes also overlap the dark patches of sky, which grow smaller as the clouds grow larger. The coastline and water are completed with the drybrush technique demonstrated next.

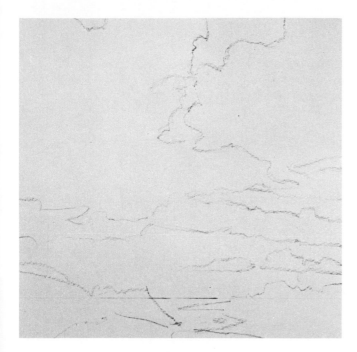

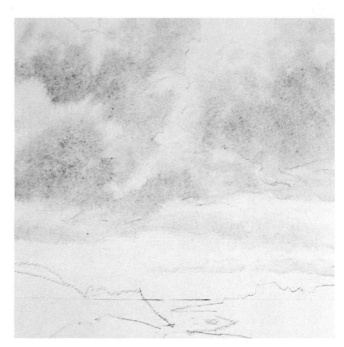

Step 1. This demonstration is painted on a sheet of cold pressed watercolor paper (called a "not" surface in Britain), which has an irregular texture that will hold the wet color in its peaks and valleys. After the clouds are drawn in pencil, the entire surface of the paper is brushed with clear water.

Step 2. As soon as the sheet is covered with clear water—and before the paper loses its shine—the shadow tones of the clouds are brushed in. When the strokes hit the paper, the color starts to spread and blur. The individual strokes disappear, leaving broad, soft tonal areas. Gaps of bare paper are left for the sunlit areas of the clouds.

Step 3. Working quickly, while the painting surface is still wet and shiny, the brush adds the darker patches of sky that show through the clouds. The tip of the brush also adds the dark lines of the cloud layers just above the horizon. The paper is a bit drier than it was in Step 2, so these new strokes don't blur quite as much.

Step 4. Before the painting surface loses its shine completely, more dark strokes are added to the undersides of the clouds. Sunlit edges are lightened by blotting away color with a damp sponge, a damp softhair brush, or a paper towel. The landscape is completed in the drybrush technique.

Step 1. The Italian word *impasto* means thick paint. There are times when you're painting a subject with a particularly rough, rugged texture, and you want to capture that texture with especially thick, rough strokes. A rocky headland is an ideal subject for trying out the impasto technique. The painting surface is a sheet of hardboard covered with several coats of smooth gesso diluted with enough water to produce a milky consistency. Then the shapes of the headland are drawn in pencil lines that define the lights and shadows.

Step 2. Acrylic modeling paste, titanium white, and a touch of darker color are blended with the palette knife to form a thick mixture that stands up in a mound. A big, stiff bristle brush picks up gobs of this pasty mixture and applies it to the headland with thick strokes that retain the grooves made by the bristles. The brushstrokes follow the diagonal slopes of the headland but make no attempt to render the lights and shadows of the rock formations. At this point, the goal is just to create a rough, rocky texture. The ragged surface is now allowed to dry thoroughly before any more color is applied.

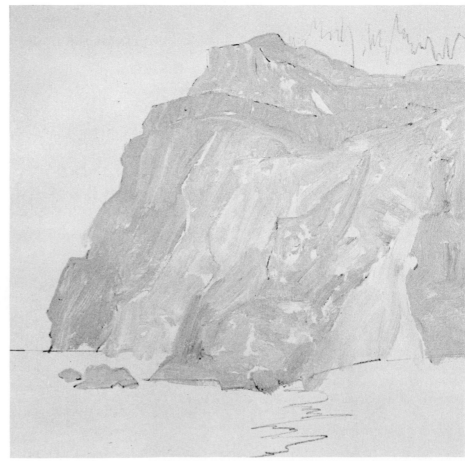

Step 3. The thick paste on the headland is now dry. The strokes are actually thick enough to cast shadows. Before going back to complete the headland, the tones of the beach, the water, and the foam between them are painted with fluid color. This liquid color is carried carefully around the base of the headland and around the small rock at the foot of the headland in the lower left.

Step 4. The rough surface of the headland is now ideal for drybrush. A flat softhair brush is dampened with dark color and moves over the dried modeling paste, skimming lightly over the sunlit planes and pressing harder in the shadows. The brush goes back and adds more fluid color in the shadows, but all the strokes are damp, not sopping wet, so the texture of Step 3 comes through clearly in Step 4. The tip of a round softhair brush picks out some cracks and shadows among the rocks. The trees at the top of the headland—which aren't covered with modeling paste—are scumbled. So are the beach and the foam to get those soft transitions from dark to light. And the dark reflections in the water are completed with horizontal drybrush strokes.

Setting the Palette. Because acrylic paint dries so quickly, do some thinking before you squeeze your colors onto your palette. For this particular painting, will you use *all* your colors—or just *some?* Which ones? Set the palette with the colors you think you'll need, and squeeze out modest quantities. Then keep the tubes nearby so you can replenish the palette as you work. Be sure to keep an eye on those mounds of color and periodically sprinkle a few drops of water on any mound that's starting to solidify.

Thinning with Water. To blend tube color with water, wet the brush *first*, then dip it into the paint—never vice versa. Touch the tip of the wet brush to the mound of color, then blend the color and the water on the mixing area of your palette. Keep the paint in the mixing area away from the edges of the palette where the moist paint is stored. Don't let the fluid mixtures foul the mounds of pure color.

Thinning with Medium. If you're going to thin your tube color with gloss or matte medium, start by wetting the brush thoroughly, then pick up some tube color on the tip and transfer the color to the mixing area. Dip the tip of the brush into the medium and blend it into the color that's waiting on the mixing surface. To keep the medium clean—so you can add it to other mixtures—it's a good idea to rinse the brush before you dip it into the cup of medium. If you want to blend tube color with gel medium, pick up some fresh color with the tip of the wet brush, squeeze out some gel onto the mixing surface, and blend them. If you want a *lot* of thick paint, just squeeze a gob of color and a gob of gel side-by-side on the mixing surface and blend them with a knife.

Keep Your Brush Wet. As you can see, it's essential to keep your brushes wet at all times. Always pick up color or medium with a wet brush and rinse the brush frequently so that no paint or medium ever dries on those delicate hairs. Once acrylic dries on a brush, the hairs will be stiff as a board. The dried paint will never wash out with water. You *can* buy a powerful solvent called a "brush cleaner," but even if you do succeed in removing the dried color, the brush is never the same.

Mixing Colors. The ideal way to mix colors is to transfer some color from the edge of the palette to the mixing surface—with a wet brush, of course—then rinse the brush before you pick up each successive color. But, in reality, many artists get carried away with the excitement of color mixing and don't take the time to rinse the brush every time they pick up a new

color. If you don't have the patience to do all that rinsing, just keep your mounds of color as clean as possible by doing your mixing in the center of the palette. And do rinse your brush before you start a *new* mixture. If you don't, the first mixture will work its way into the second.

Avoiding Mud. You've heard this warning before, but it can't be repeated too often! Try to plan your color mixtures before you touch the brush (or the knife) to the palette, and do your best to limit each mixture to two or three colors, plus white. More than three colors are apt to produce mud. If you really know what each color on your palette can do, you'll rarely need more than three.

Testing Mixtures. It's worthwhile to spend an afternoon just mixing colors. Be methodical about it: mix every color on your palette with every other color. You can brush samples of all the mixtures on sheets of thick white drawing paper and label every sample to record the components of the mixture. You might have one sheet for blues, another sheet for greens, and so on. Try varying the proportions of the mixtures. For example, if you're mixing a red and a yellow to produce orange, start with equal amounts of red and yellow; then try more red and less yellow; finally, see what you get with more yellow and less red. You'll be astonished to see how many variations you can get with just two colors. And when you start working with three—varying the proportions of all three components—the sky's the limit!

Mixing on the Painting. The palette is only one place where you can mix colors. The special qualities of acrylic make it possible to mix on the painting surface too. When a layer of color is dry, there are ways to produce *optical* mixtures, which means putting one layer of color over another, so the underlying layer shows through, and the two layers "mix" in the eye of the viewer. Over one dried layer of color, you can brush a second color that's been thinned with enough water or medium to make it transparent. When the second layer dries, it's like a sheet of colored glass through which you can see the color beneath. That transparent color is called a *glaze.* Another type of optical mixture can be produced by scumbling. When the underlying color is dry, you apply a second opaque color with a back-and-forth scrubbing motion that distributes a thin veil of paint through which you can still see the underlying hue. Unlike the glaze, the scumble consists of opaque color, but it's distributed so thinly that you can see through it.

Step 1. To learn how to model form in acrylic—that is, how to paint something so it looks three-dimensional—start with some simple, familiar shape like an apple. It's important to begin with a careful pencil drawing of the form. This study of an apple begins with a line drawing that defines the round shape of the apple, its stem, and a couple of leaves. Then a bristle brush scrubs in the background tone, which is a mixture of ultramarine blue, burnt sienna, yellow ochre, and white. Notice that the tone is darker in the foreground, where it contains a bit more ultramarine blue and burnt sienna. It doesn't matter if these casual strokes overlap the edges of the apple.

Step 2. The lines between the boards of the tabletop are drawn with a sharp pencil and a ruler. Then the tip of a round sable draws the grain of the tabletop with a paler version of the same mixture used to paint the background in Step 1. This mixture simply contains more white. A darker version of the same mixture—less white, more ultramarine and burnt sienna—becomes the shadow cast by the apple. The shadow tone is first painted with a bristle brush. Then the lines of the wood grain within the shadow are added with the tip of the round sable.

Step 3. Now the entire shape of the apple is covered with a flat tone. This is a blend of cadmium red, naphthol crimson, yellow ochre, and white, applied with a flat bristle brush. A very thin wash of yellow ochre, ultramarine blue, and burnt sienna—containing lots of water, but no white—is brushed over the leaves. A darker version of this same mixture, with less water, is used for the shadow areas on the leaves. The intricate forms of the leaves are painted with a round sable.

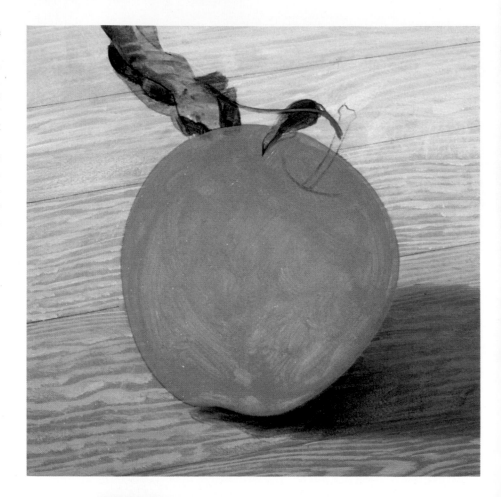

Step 4. Now it's time to start modeling the apple—which means adding darks and lights on top of the flat tone painted in Step 3. A round, softhair brush paints the dark red at the top of the apple in short, slender strokes that curve to follow the round shape. These strokes are a mixture of naphthol crimson, cadmium red, yellow ochre, and white. More white is added to these strokes as they move downward from the midpoint of the apple to the bottom. The highlights on the apple are mainly yellow ochre and white, with just a hint of the reddish mixture that's used to paint the rest of the apple. These lights are painted with scumbling strokes, so they seem to blend into the red.

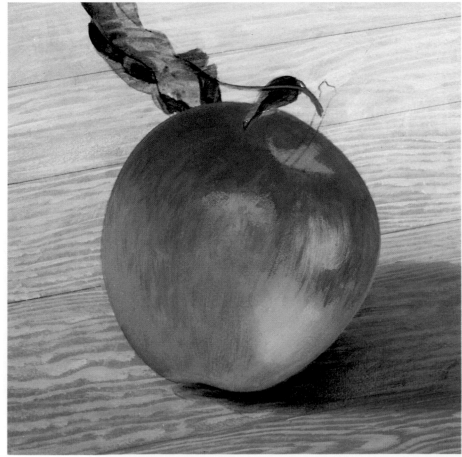

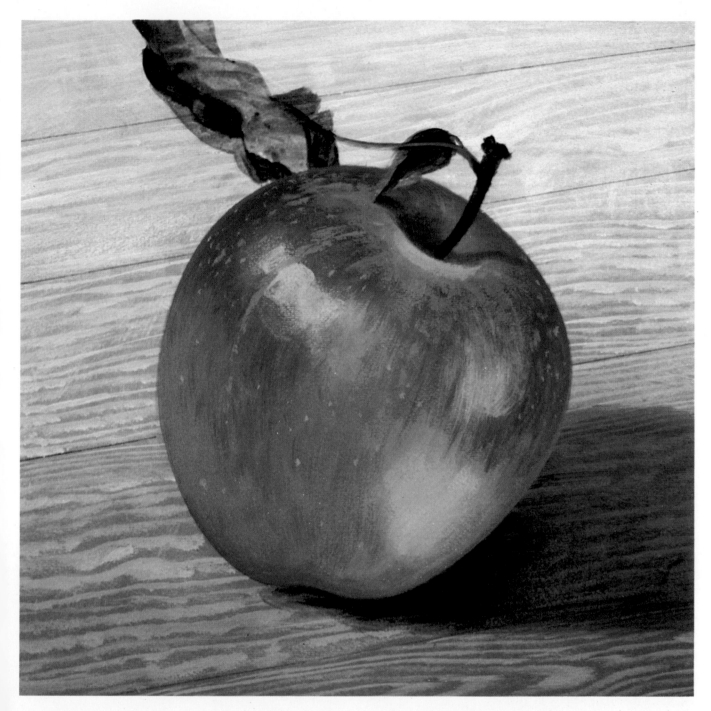

Step 5. Here's an enlarged close-up of the apple, so you can really see the brushwork. The precise details of the apple are saved for the final stage. The subtle tone around the stem is painted with the tip of a round, softhair brush carrying a mixture of ultramarine blue, yellow ochre, and burnt umber. Tiny spots of this mixture are added to the sides of the apple with the point of the brush. The stem is a dark mixture of burnt sienna and ultramarine blue. Now review the basic modeling procedure. You begin by painting the flat, overall tone of the subject. Then you block in the lights and darks. Next come the highlights. You finish with the details. And you'll enhance the three-dimensional feeling if your brushstrokes follow the form, just as the strokes curve around the apple here.

Step 1. Painting a slightly more complicated natural form such as this green pepper will give you an opportunity to develop your skill with drybrush. Once again, start with a simple pencil drawing and then brush in the background with free strokes. This demonstration is painted on watercolor paper whose slightly rough texture is especially good for drybrush. The tones of the wooden tabletop are drybrush strokes made by the edge of a bristle brush dampened with a mixture of ultramarine blue, burnt sienna, and white. The lighter strokes obviously contain more white. For the shadowy wall at the top of the picture, the same brush carries the same mixture.

Step 2. To unify the strokes of the tabletop, the bristle brush coats the entire area with a transparent wash of burnt sienna and ultramarine blue—and lots of water. When this is dry, the entire shape of the pepper is covered with a mixture of phthalocyanine green, yellow ochre, a little burnt umber, and white. The lines in the center of the pepper are reinforced with the pencil, since they'll be helpful in guiding the modeling in Step 3.

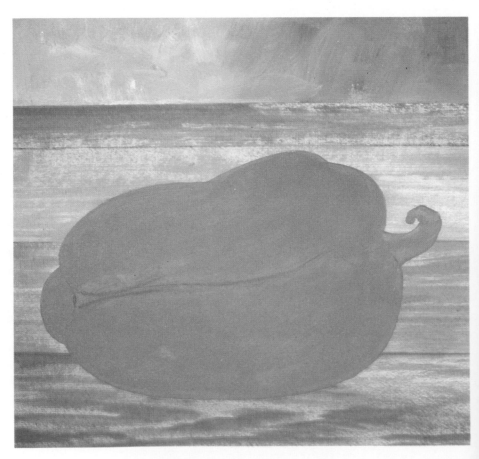

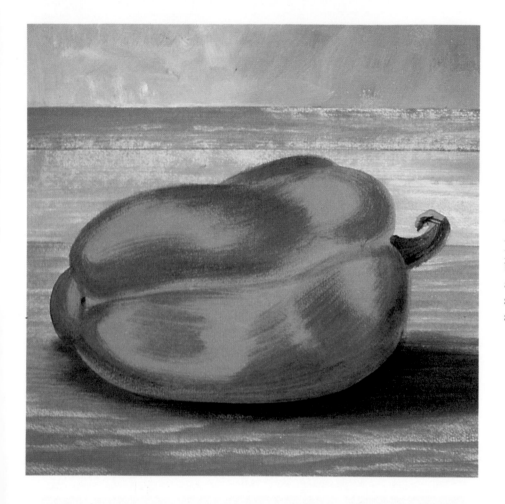

Step 3. Now the darks are added with a mixture of phthalocyanine green, burnt umber, and yellow ochre. There's just a bit of color on the brush so that the bristles are damp, not wet. And the brush skims quickly over the surface of the paper, depositing ragged, broken strokes rather than solid color. The darks are built up gradually, one stroke over another. The same method is used to paint the shadow cast by the pepper and to darken the grain of the tabletop in front of the pepper—mixtures of ultramarine blue, burnt umber, yellow ochre, and white. These soft drybrush strokes are executed with a round, softhair brush.

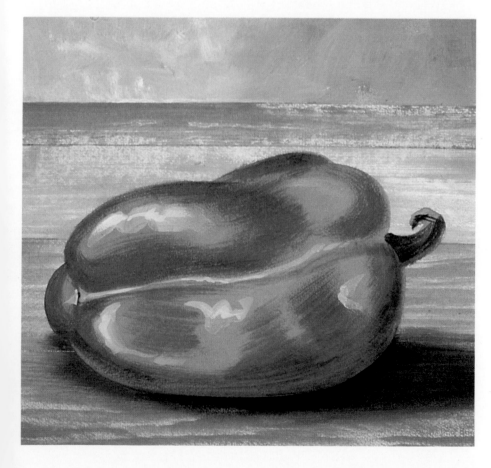

Step 4. Now the light areas between these shadowy strokes are strengthened with the same green mixture used in Step 2, but with a bit more white added. Finally, the highlights are added with the tip of a round, softhair brush. These are mainly white, with just a bit of the green mixture, plus lots of water. As you can see, drybrush is used mainly for modeling, while more fluid color is used for the precise, final touches.

Step 1. Painting the fuzzy surface of a peach is particularly good practice in the technique called scumbling. To make the job a bit easier, you might like to select a sheet of textured watercolor paper that will accentuate the scrubby character of the back-and-forth scumbling strokes. This demonstration begins with a pencil drawing that carefully defines the contours of the peaches, the dish, and the line of the tabletop. A flat, softhair brush covers the background with a fluid tone of black, yellow ochre, and a touch of white. The same brush covers the tabletop with this mixture, plus phthalocyanine blue and a lot more white.

Step 2. Ultramarine blue, burnt sienna, and white are blended on the palette to a thick mixture that contains only a bit of water. Then this thick paint is scrubbed onto the peaches with short, back-and-forth strokes of a bristle brush. The dark sides of the forms contain less white. Bare paper peeks through the lighter areas. You can see how the texture of the paper roughens and breaks up the brushstrokes.

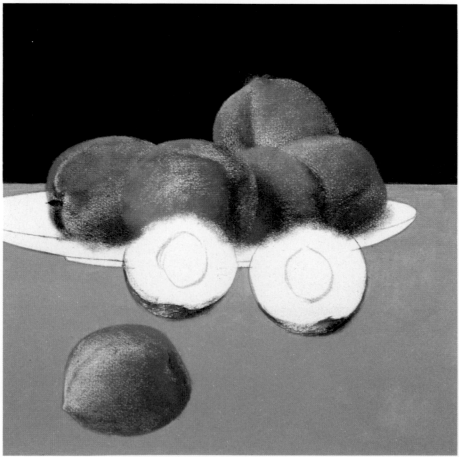

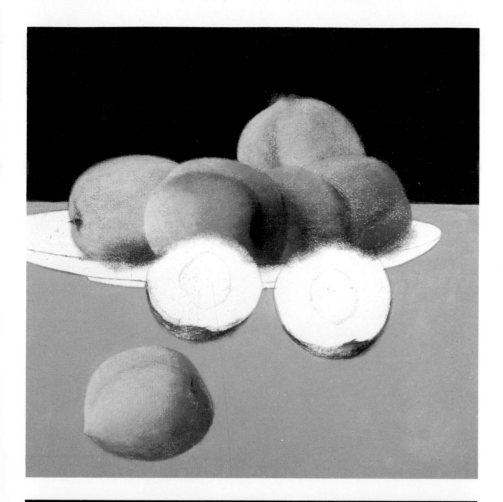

Step 3. The purpose of Step 2 is to establish the pattern of light and shadow on the peaches. Now the same brush and the same short, scrubbing strokes are used to build color over this undertone. When Step 2 is dry, a simple mixture of yellow ochre and white is then scumbled over several of the peaches to suggest a golden tone. The ruddy tone is a mixture of naphthol crimson, cadmium red, a little ultramarine blue, and white. These colors aren't completely opaque; thus the underlying shadowy tone comes through.

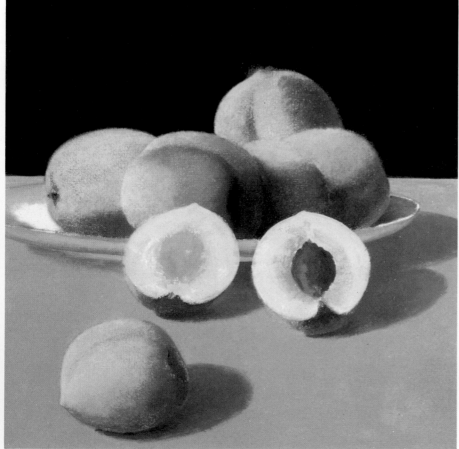

Step 4. The lighter tops of the two peaches to the right are scumbled with this yellow ochre and white mixture. The shadows on the peaches are strengthened with the same mixture used in Step 2. The ruddy tone used in Step 3 is added to the undersides of the two peach halves. The shadows are scumbled with ultramarine blue, naphthol crimson, yellow ochre, and white. Now the juicy insides of the peaches are painted with a round, softhair brush and mixtures of yellow ochre, cadmium red, ultramarine blue, and white.

Step 5. The warm tones of the peaches are now scumbled with a flat bristle brush—a mixture of naphthol crimson, yellow ochre, ultramarine blue, and white. The lighter areas are strengthened with more scumbling strokes of yellow ochre and white. Placed side-by-side, these scrubby strokes of thick color, broken up by the texture of the paper, seem to blend into one another.

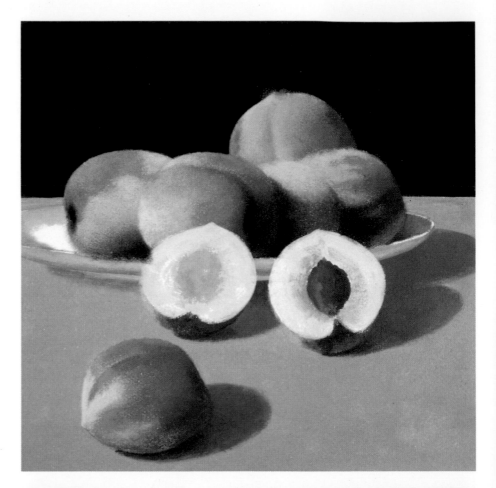

Step 6 (close-up). The precise details are saved for the final stage, as usual. Now the tip of a round, softhair brush picks up fluid color to paint the pit of the peach to the right, plus the juicy fibers of the peach to the left. The darks of the pit are ultramarine blue and burnt sienna. The warm glow around the pit is the same mixture used for the ruddy tones in Step 5. This same warm mixture appears inside the cut peach to the left, with the glistening fibers painted in a pale mixture of yellow ochre and white. The slender, pointed brush is also used to paint the precise form of the plate with the same mixture used for the shadows in Step 4, plus more white.

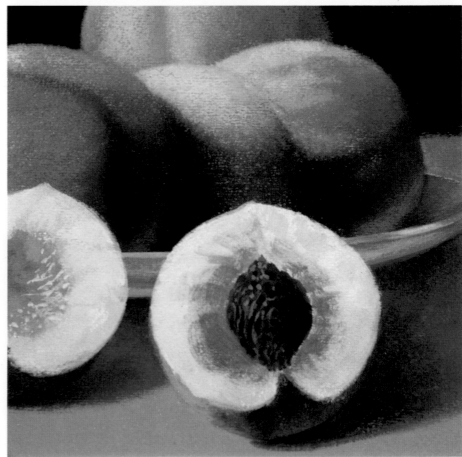

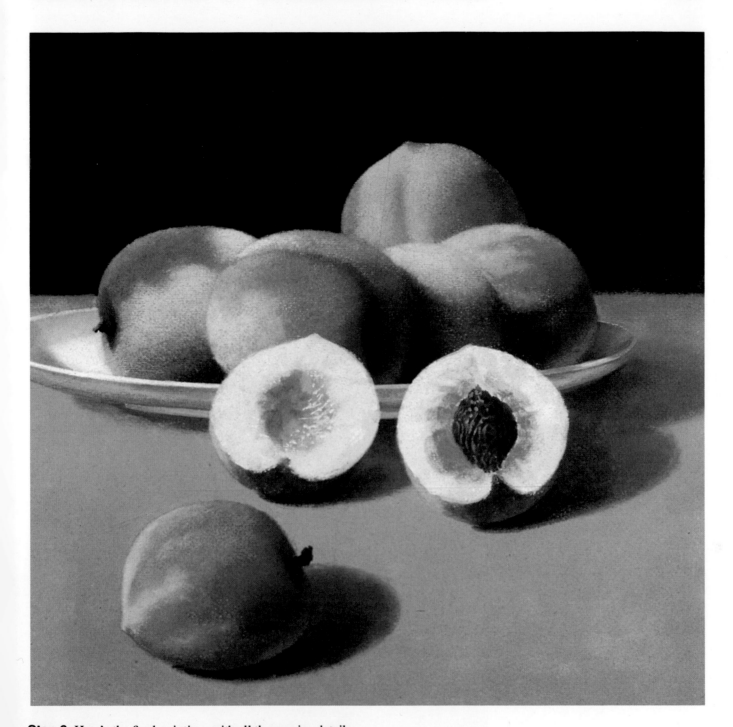

Step 6. Here's the final painting, with all the precise details added with the tip of a round, softhair brush. Dark notes are discretely added to complete the stems of the peaches and to darken the shadows right under the edges of the peaches on the tabletop. Such subtle darks aren't black, but blue-brown mixtures, such as ultramarine blue and burnt umber. Study the brushwork carefully. The beautiful gradations on the peaches *are not* the result of blending one wet color into another, but the result of placing scumbled strokes side-by-side. These ragged, scrubby strokes do overlap just a bit, but they seem to blur softly into one another. The whole trick is to work with thick color and light strokes, gradually laying one stroke over another so that the color builds up gradually.

Step 1. Underpainting and glazing is an old-master technique that takes advantage of the transparency of the acrylic painting medium. To practice this technique, find some common household object like this kettle. This demonstration is painted on a canvas board and begins with a pencil drawing of the intricate forms of the kettle, plus the lines of the tabletop. Then the shadow areas of the kettle and table are painted with a fluid mixture of black, white, and ultramarine blue, diluted with lots of water. A thicker version of the same mixture (less water) is used for the background, which is painted very carefully around the shape of the kettle.

Step 2. The pattern of shadows on the kettle is now painted with the same mixture, but containing much less water so that the paint is really thick and opaque. For the first step, where you're working with very fluid paint, you can use a softhair brush. But now it's best to switch to a bristle brush to carry the thick color of Step 2.

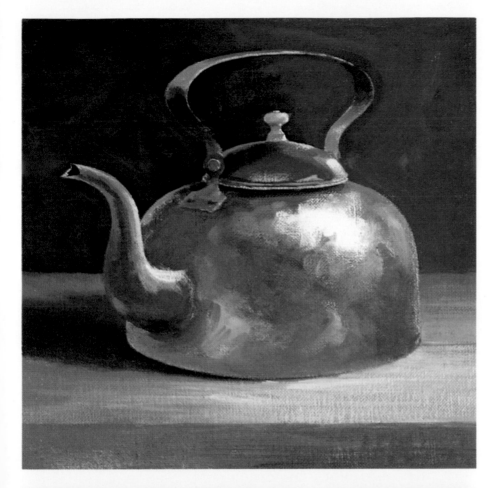

Step 3. The pattern of lights and shadows on the kettle is now completed. A bit more white is added to the same mixture for the middletones. A lot more white is added for the lightest areas. The tabletop is painted with exactly the same mixtures. The shadow that's cast by the kettle is painted with the same dark mixture used in the background. As you can see, the entire picture is painted in monochrome, concentrating only on the pattern of light and shade. Color is saved for the final step.

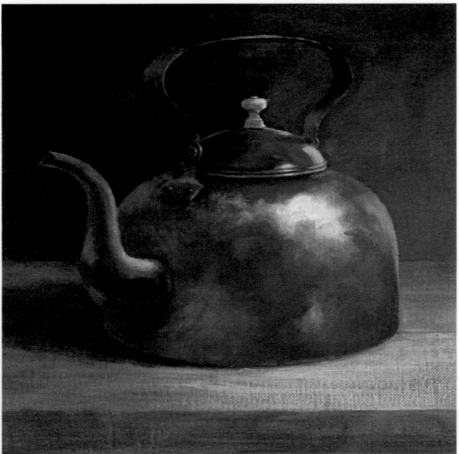

Step 4. A fluid, coppery glaze is mixed on the palette—burnt sienna, cadmium red, yellow ochre, and gloss medium. This luminous, transparent tone is brushed over the entire kettle, which suddenly turns a warm, metallic hue. A few touches of ivory black are added to strengthen the darks on the kettle. A much paler glaze of burnt sienna, yellow ochre, and ivory black—with lots of gloss medium—is carried over the background and the tabletop to add a touch of warmth. The underpainting and glazing technique is extremely useful when you're painting a subject in which the lights and shadows are complicated: first you paint the lights and shadows in monochrome; then you complete the job with colored glazes.

Step 1. To practice rendering textures, find yourself some rough, weathered outdoor subject like this old, dead tree. You'll also find it helpful to paint on a roughly textured surface. This demonstration is done on a sheet of illustration board that carries two coats of thick acrylic gesso applied with a stiff, nylon housepainter's brush that leaves the marks of the bristles in the surface. One coat is applied from top to bottom; the other coat runs from right to left, creating a crisscross texture. The painting begins with a careful pencil drawing, and a transparent sky tone is brushed right over the pencil lines with ultramarine blue, white, just a hint of burnt sienna, and lots of water.

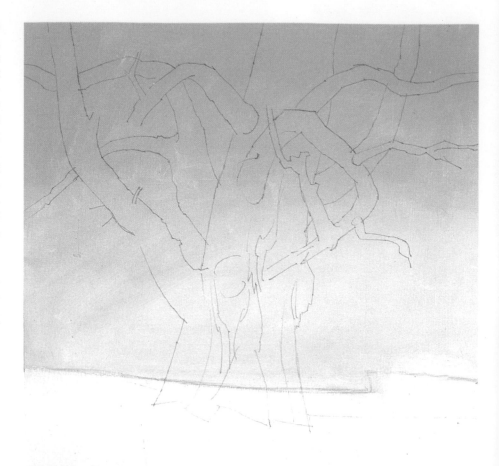

Step 2. When the sky is dry, the tree is painted right over it with a mixture of burnt sienna, ultramarine blue, black, and just a little white. The general shape of the tree is blocked in with a flat, softhair brush; then the lines in the bark are drawn with a pointed, softhair brush. In the lighter areas of the trunk, the brushes are skimmed quickly over the painting surface, hitting just the ridges of the rough gesso to produce a drybrush effect. More pressure is applied, and the color is more fluid in the darker areas. The leaves at the base of the tree are painted with the same mixture, dabbed on with the tip of a filbert.

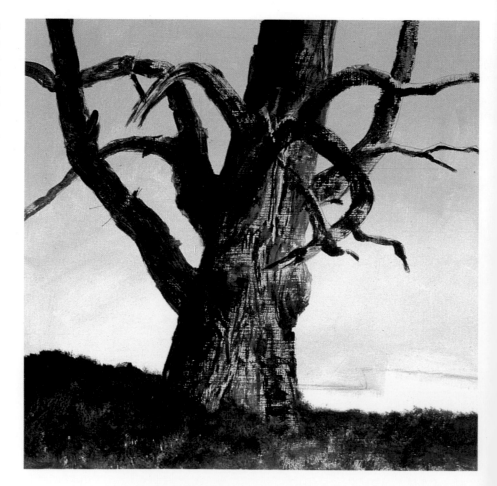

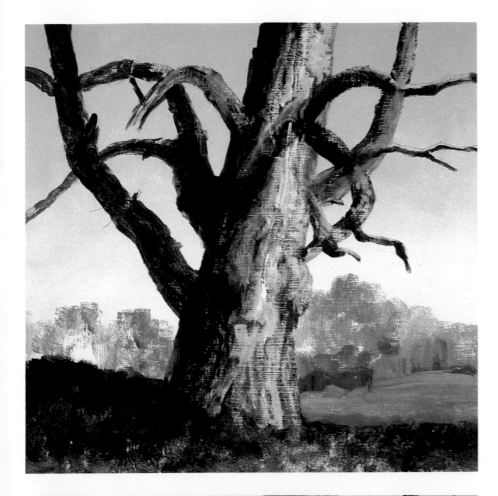

Step 3. Next come the lighter tones on the tree. A bristle brush picks up a thick mixture of burnt sienna, ultramarine blue, yellow ochre, and lots of white—very little water— and drags this mixture over the surface of the rough gesso without pressing too hard. Once again, the texture of the gesso breaks up the strokes into a drybrush effect. The warm tone of the distant trees is a mixture of burnt sienna, yellow ochre, white, just a hint of ultramarine blue, and not too much water. This thick mixture is scumbled over the rough gesso, whose texture comes through once again. The bit of meadow to the right is a more fluid version of this same mixture, with more ultramarine blue and more water.

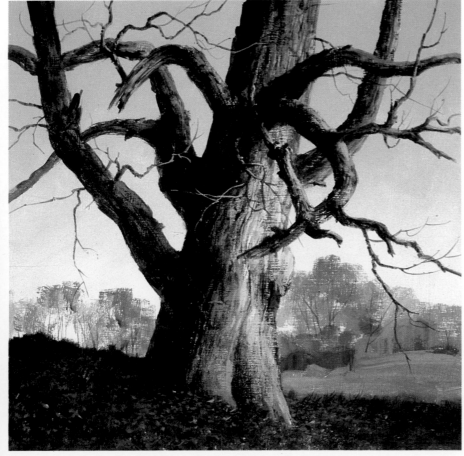

Step 4. The tip of a round, softhair brush adds the twigs and other details of the tree, using the same dark and light mixtures introduced in Steps 2 and 3, but with more water for a precise, fluid stroke. The same mixture and the same brush add some trunks to the distant trees. A transparent glaze of cadmium red, yellow ochre, and water is carried over the leaves on the ground to complete the picture.

Step 1. Now that you've tried out a variety of acrylic painting techniques, it's time to put them to work on a more ambitious still life. A wooden bowl of fruit, with so many different colors and textures, is a good subject. Once again, begin with a careful pencil drawing that defines the outer edges of all the forms. This demonstration begins with a background tone of black, white, and a little yellow ochre, applied with a bristle brush. The strokes are bold and obvious. Notice how the background is darker behind the fruit—to dramatize their shapes and colors.

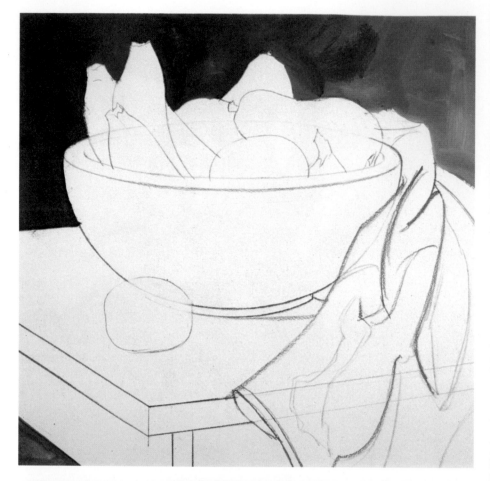

Step 2. The flat tones of the bananas and pears are painted with a smooth, fluid mixture of cadmium yellow, white, and just the slightest hint of ultramarine blue. The plums are painted with slightly thicker color and scumbling strokes—a mixture of ultramarine blue, naphthol crimson, and white. The bowl is begun with burnt sienna, ultramarine blue, yellow ochre, and white. A flat, softhair brush is used for all the operations in Step 2.

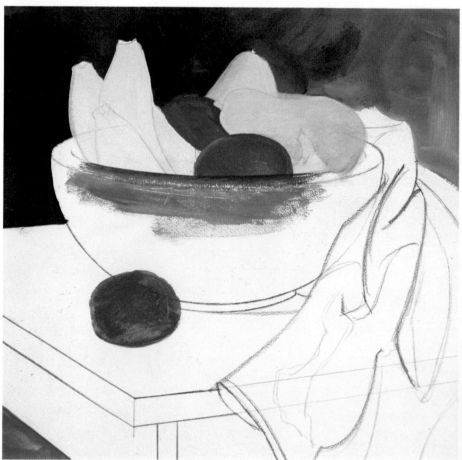

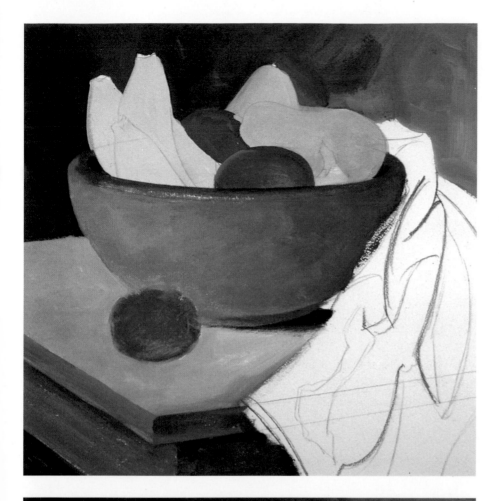

Step 3. The wooden bowl and table are painted with fluid mixtures of burnt sienna, yellow ochre, ultramarine blue, and white, with enough water to produce a creamy consistency. The darks obviously contain more blue and brown. A flat, softhair brush places the wet strokes side-by-side and quickly blends them together before they dry—a technique called wet blending. This kind of brushwork produces a casual, irregular blend in which the strokes are still partly visible—just right for the texture of the wood.

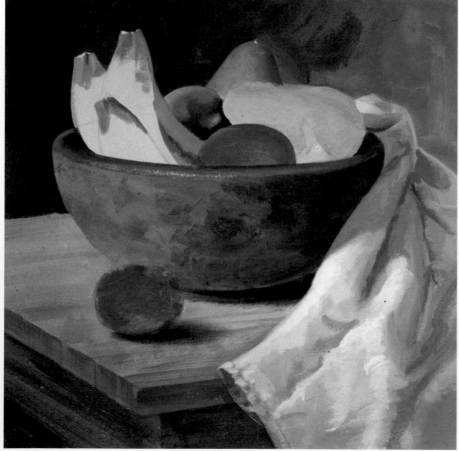

Step 4. The darks of the banana and the shadow side of the more distant pear are painted with touches of burnt sienna, yellow ochre, ultramarine blue, and a bit of white. The warm notes in the pears are burnt sienna, cadmium yellow, and yellow ochre. The grain of the wood is drybrushed with a darker version of the mixture in Step 3— more blue and brown. One plum in the bowl is modeled by scumbling phthalocyanine blue, naphthol crimson, and white. The napkin is painted with form-following strokes of ultramarine blue, burnt sienna, yellow ochre, and white.

Step 5. Now it's time to start refining the forms of the fruit. A round, softhair brush paints the lighted sides of the bananas with yellow ochre, cadmium yellow, white, and just a touch of burnt umber. The shadow sides are scumbled with burnt umber, yellow ochre, ultramarine blue, and white. To make the big pear rounder, the darker tones are scumbled with ultramarine blue, yellow ochre, burnt sienna, and white—with wet, juicy highlights of white and yellow ochre quickly brushed onto both pears when the scumbles are dry. The other plum in the bowl is scumbled with the same mixture used in Step 4, adding a bit more crimson and a lot of white in the highlights.

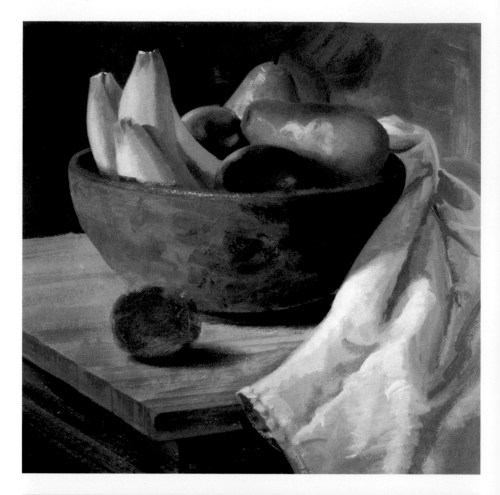

Step 6 (close-up). Here you can see how the finishing touches are added in the final stage. The tip of a bristle brush adds quick dabs of burnt sienna, ultramarine blue, and yellow ochre to suggest the dark spots on the bananas. The point of a round, softhair brush adds the stems with ultramarine blue and burnt umber. Compare the highlights on the pears and the plums. The former are quick, fluid strokes, while the latter are thick scumbles.

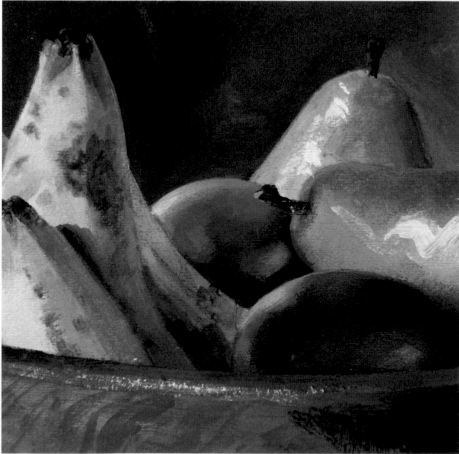

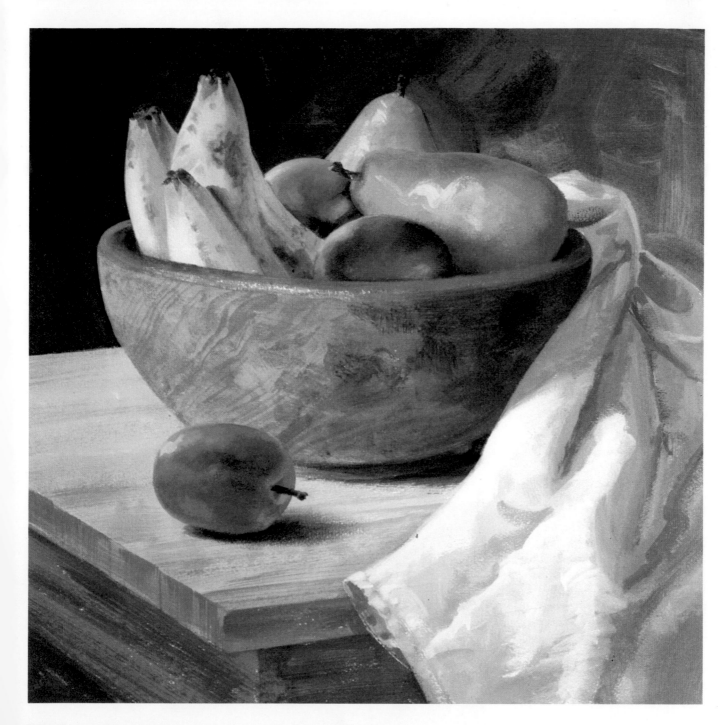

Step 6. A round, softhair brush traces the lines of the grain in the wooden bowl with a mixture of ultramarine blue, burnt umber, and white. The same mixture—and the same brush—add a bit more grain to the table. The plum on the table is modeled by scumbling—the same mixtures as the plums in the bowl. You can see quite clearly that the shadow under the plum is drybrushed with the same colors used on the shadow side of the bowl. By now, you know that there's a logical sequence of operations in all these paintings: covering the shapes with flat tones; modeling the lights and darks over the flat tones; then adding highlights, textures, and details.

Step 1. For your next still-life project, now try the more complex shapes of flowers, perhaps in a transparent vase—a particularly interesting challenge to paint. You'll need to make a precise pencil drawing of the flowers, leaves, and stems. Pick a simple, geometric vase, nothing ornate. As usual, this demonstration begins with a freely painted background—broad, bristle brushstrokes of ultramarine blue, burnt sienna, black, and a fair amount of white on the right side. This demonstration is painted on a canvas board whose woven surface will soften the strokes.

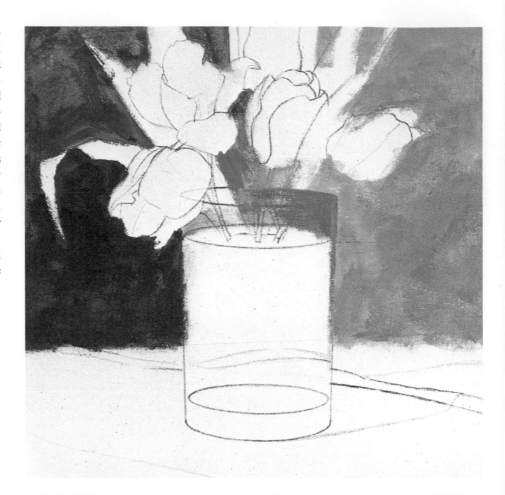

Step 2. The flat undertones of the flowers are painted with liquid color and a bristle brush. The yellow flowers are covered with a shadowy tone of yellow ochre, white, and ultramarine blue; the more brilliant colors will be painted over these muted tones in the later steps. In the same way, the white flower begins as a shadowy tone of ultramarine blue, burnt umber, and white. Only the red flower is painted with its full brilliance, since this will be the brightest note in the picture—a mixture of cadmium red and naphthol crimson, with a touch of ultramarine blue.

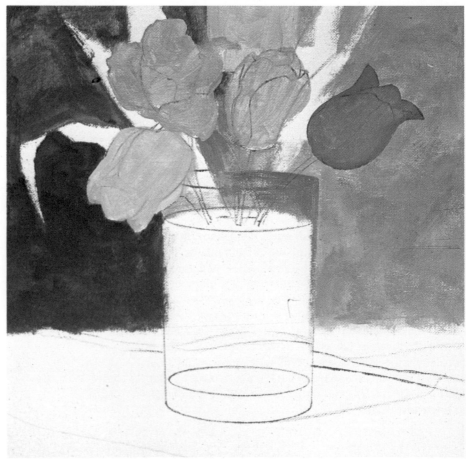

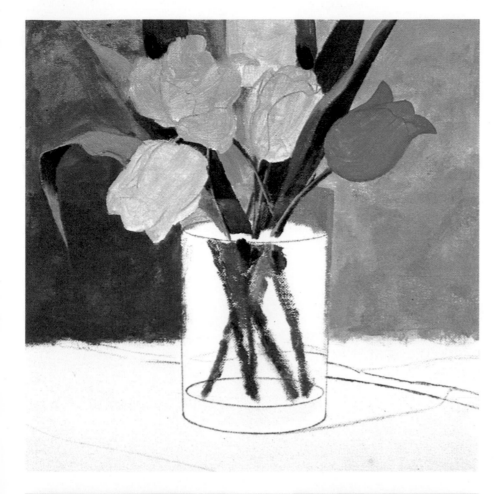

Step 3. The darks of the leaves and stems are painted with a mixture of ultramarine blue, yellow ochre, and burnt sienna. Then the lights are painted right over the darks with cadmium yellow, ultramarine blue, burnt sienna, and white. Inside the vase, notice how roughly the stems are painted, since they'll be partly obscured by the reflections in the glass.

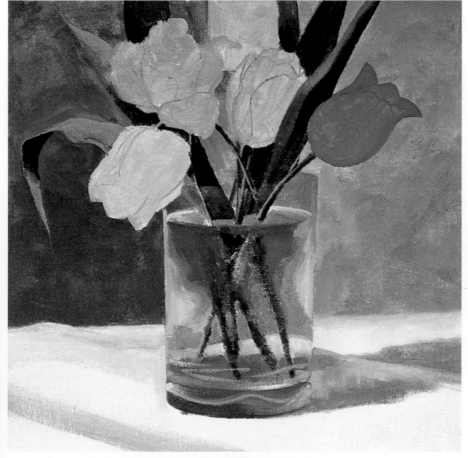

Step 4. Clear glass and clear water have no color of their own, but simply reflect the color of their surroundings. In Step 1, you may have noticed that the color of the background was carried over into the upper portion of the vase. Now the same color is carried down into the water to the very bottom of the vase. The mixtures are the same as the background—ultramarine blue, burnt sienna, black, and white—with more white for the lights and middletones. There's no special trick to painting water or glass; you just have to forget that you're painting a transparent substance and simply paint the patches of light and dark. The same mixtures are used to paint the shadows of the folds in the tablecloth.

Step 5. The dark tones on the yellow flowers are added with a fluid mixture of burnt sienna, yellow ochre, and ultramarine blue, diluted with plenty of water so the color really flows onto the canvas. A flat, softhair brush applies the color very smoothly. The rough brushwork done in the background will now accentuate the smoother brushwork of the flowers and the leaves.

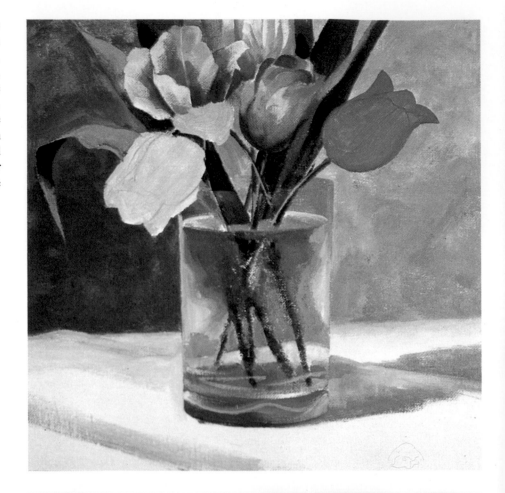

Step 6 (close-up). This "life-size" close-up shows you the modeling on the flowers. The light areas of the yellow flowers are applied with a round, softhair brush carrying a fluid mixture of cadmium yellow, yellow ochre, a little burnt sienna, and white. The edges of the strokes are scumbled, so they seem to merge softly with the shadow tones. Strong darks are added to the undersides of the red and yellow flowers with burnt umber and ultramarine blue. This same mixture, with a lot of water, is used to add some subtle darks to the bright side of the red flower. Observe how the texture of the canvas breaks up and softens the brushstrokes.

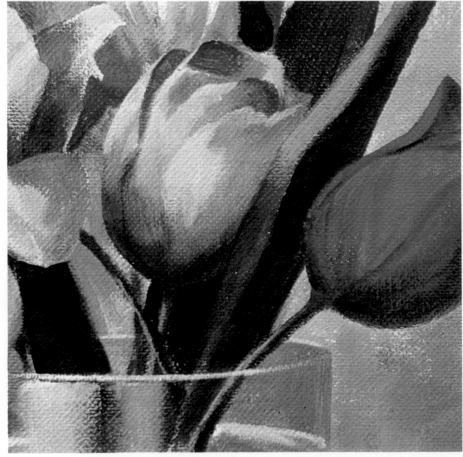

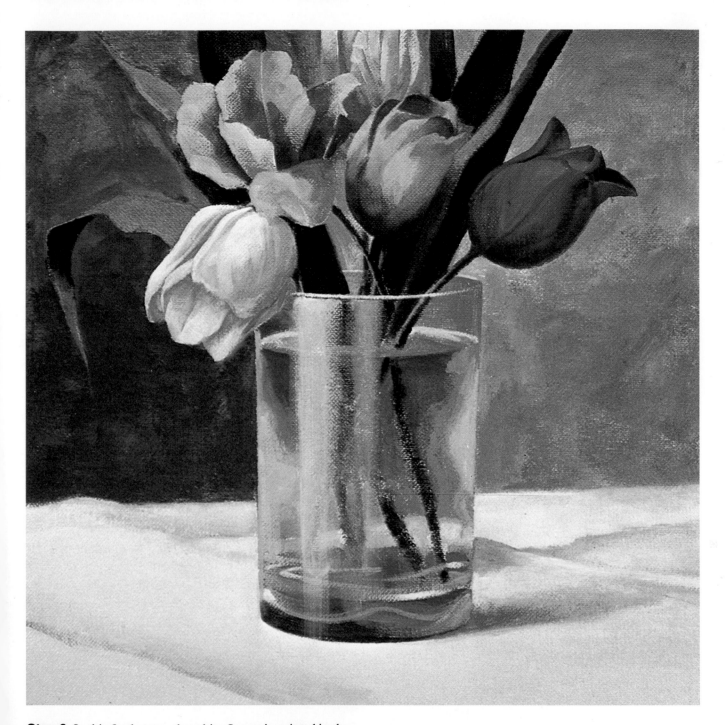

Step 6. In this final stage, the white flower is painted in the same way as the yellow ones. Soft shadows are added with ultramarine blue, burnt sienna, and white. Then the lights are added with almost pure white, faintly tinted with the shadow mixture. The vertical highlights and the bright edges of the vase are painted with this same mixture—mostly white, with just a little burnt sienna and ultramarine blue. The highlights on the glass are painted with just enough water to make the tones translucent so that you can still see the stems within the glass and the background tone beyond. Some of this mixture is brushed into the center of the shadow on the tablecloth, which seems a bit too dark in Step 5. It's worth noting that the bright tones of the flowers look even brighter because they're surrounded by muted colors.

Step 1. Having practiced your basic techniques on several still-life subjects, this is a good time to try a landscape. You can make some sketches outdoors and then go back home to paint your picture from these sketches. Or you can load your paintbox, take along a big plastic bottle of water, and try painting on location. Begin with a pencil drawing of main shapes—trunks, branches, rocks, and the masses of leaves—but don't try to draw every leaf. Here, the sky is painted right over the pencil lines with phthalocyanine blue, ultramarine blue, a little burnt sienna, and lots of white. The mixture contains much water, so the color doesn't completely obscure the pencil lines.

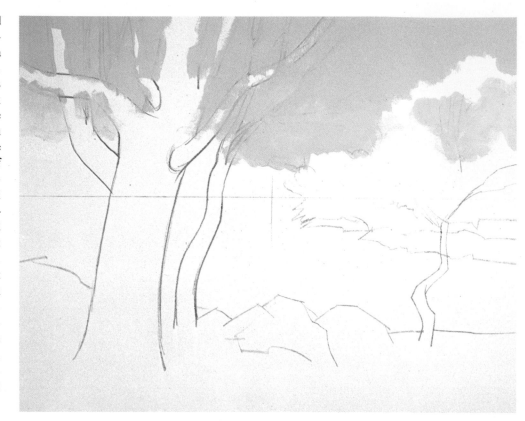

Step 2. The sky mixture is carried down over the water with just a bit more white. Then the trees are painted with short, scrubby strokes of phthalocyanine green, cadmium yellow, a little burnt umber, and white. The distant trees contain more white, while the darker trees on the right contain more green and brown. The reflections in the water are the same mixtures, softened with a bit more brown. The warm strip along the shore to the right is burnt umber, phthalocyanine green, and white. Everything in Steps 1 and 2 is done with the bold strokes of a bristle brush.

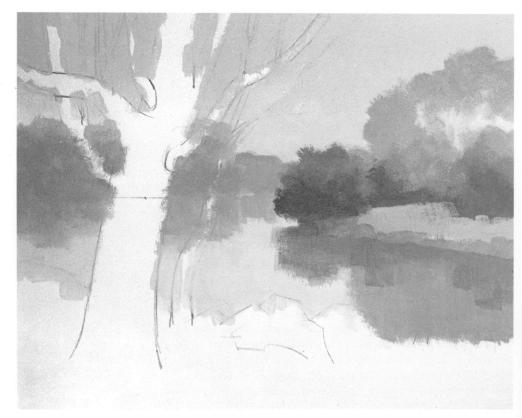

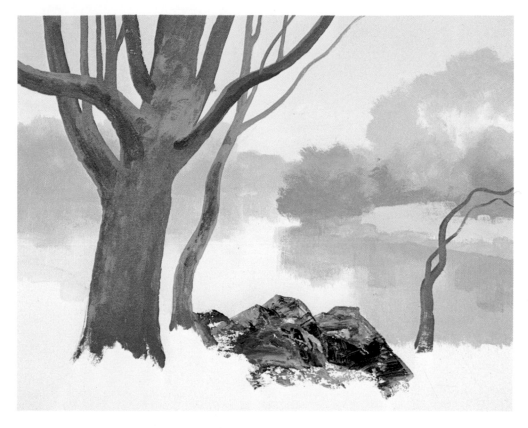

Step 3. Shifting to a flat, softhair brush, the trunks are painted with black, white, and yellow ochre. Notice how the strokes follow the direction of the trunks and branches. The mixture on the palette is thick enough to pick up with a painting knife, which is used to paint the rocks with straight, squarish strokes. The darks of the rocks are painted first; then more white is added to the mixture, and the lighter tones are painted right on top of the darks. The knife strokes are rough and imprecise—just right for the texture of the rocks.

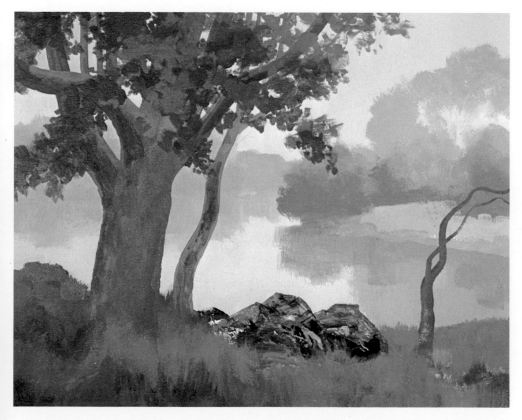

Step 4. The tip of a filbert is tapped against the painting surface—which is illustration board—to suggest clusters of leaves. The leafy tones are phthalocyanine green, burnt sienna, yellow ochre, plus a touch of white for the lighter leaves. The same mixtures are used to paint the darks and lights of the grass. The tip of a round, softhair brush paints the darks first; while these tones are still wet, lighter strokes are painted over and into them. The vertical strokes follow the direction of the grass.

Step 5. Some light tones are added to the trees on the most distant shore—chromium oxide green, ultramarine blue, yellow ochre, and a lot of white—so you can now see a clear division between light and shadow. This same mixture, with a little less white, adds some lighter details to the foliage on the shore to the right. For the light shining on the water, even more white is added to the mixture; now the mixture is fairly thick, and it's drybrushed across the water with the horizontal strokes of a round, softhair brush. It doesn't matter if some of these lines are carried over the trees, which will be darkened in the next step.

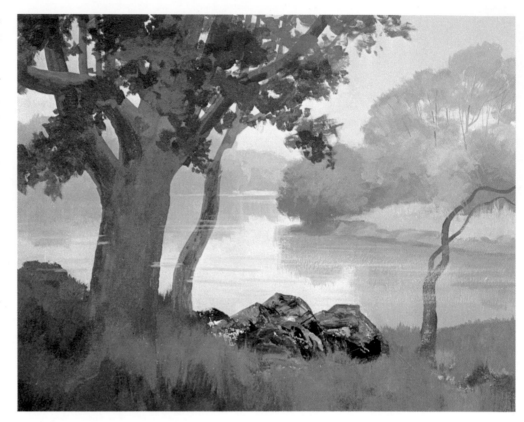

Step 6. A transparent glaze of phthalocyanine green, burnt umber, and water is brushed over the trunks and branches. When this is dry, the dark textures of the bark are painted with this same mixture, but containing more brown. Individual blades and clusters of grass are added to the immediate foreground with mixtures of phthalocyanine green, cadmium yellow, and a touch of burnt sienna, plus a little white to make the strokes stand out against the darker background. Touches of richer green are added to the foliage with the tip of a round, softhair brush—mixtures of phthalocyanine green, cadmium yellow, burnt umber, and a little white.

Step 7. The last, precise details are saved for this final step. More blades of grass plus some leafy weeds are added to the foreground with the same mixtures used in Step 6. Notice, however, that the *entire* foreground isn't covered with these strokes; you can still see lots of the broad, rough brushwork from Step 4. A few tiny touches of cadmium yellow suggest scattered wildflowers among the weeds. A few more touches of really bright green—phthalocyanine green, cadmium yellow, and white—are added to the foliage. The small tree to the right is completed with strokes of ultramarine blue, burnt umber, and white. You'll notice a slight change in the color of the trees on the distant shore to the right. They're enriched with a glaze of chromium oxide green, yellow ochre, and water. This transparent tone is carried down over the reflection of these trees in the water to the right. A very fluid, transparent glaze is an almost invisible way to enrich the color of your painting in the final stages.

Step 1. The shapes of the trees, road, and clouds are drawn in pencil. Then the dark trunks are drybrushed with a bristle bright carrying a blackish mixture of ultramarine blue and burnt sienna. The blue patches in the sky are painted with ultramarine blue, yellow ochre, and white. Some burnt sienna is added to this mixture for the shadow areas of the clouds. Then the sunlit edges of the clouds are scumbled with a mixture of white and yellow ochre, connecting the blue and the gray. These cloud tones will flow more softly if you add gloss or matte medium. The white-yellow ochre mixtures carry down toward the horizon; this will add a warm glow to the lower sky.

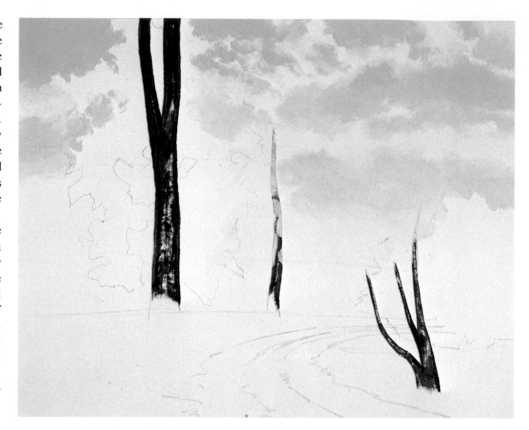

Step 2. The brilliant tones of the autumn trees are painted with scrubby, scumbling strokes of cadmium red and yellow ochre applied with a bristle bright. These slightly ragged strokes suggest the texture of the foliage. The strip of landscape at the horizon is painted with a mixture of ultramarine blue, naphthol crimson, burnt sienna, and white—with a bit less white at the lower edge. The short, stiff bristles of the brush give this shape a ragged edge. Notice that the hot color of the foliage begins to overlap the dark treetrunks, but the color is still quite thin and doesn't obscure the trunks just yet. In later stages, the trunks will begin to disappear under foliage.

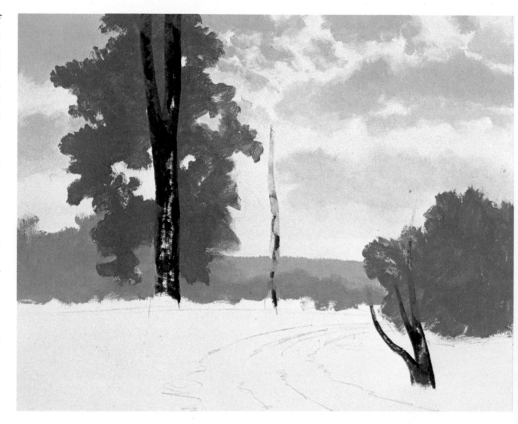

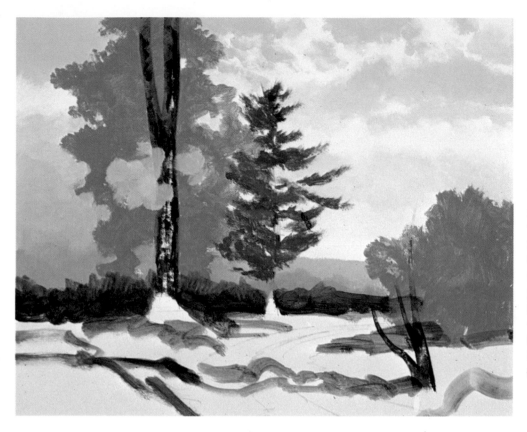

Step 3. The same stiff, short brush scrubs in the foliage of the dark evergreen with ultramarine blue and yellow ochre. At the extreme left, the lower sky is darkened with a thin, fluid mixture of ultramarine blue, burnt sienna, and white, scumbled downward to blur the outline of the distant horizon. Some of the blue sky mixture from Step 1 is painted into the center of the tree to suggest gaps in the foliage where the sky shines through. The dark mass of trees just below the horizon, plus some of the darks in the foreground, are brushed in with a very fluid mixture of burnt umber, ultramarine blue, a little naphthol crimson, and lots of water.

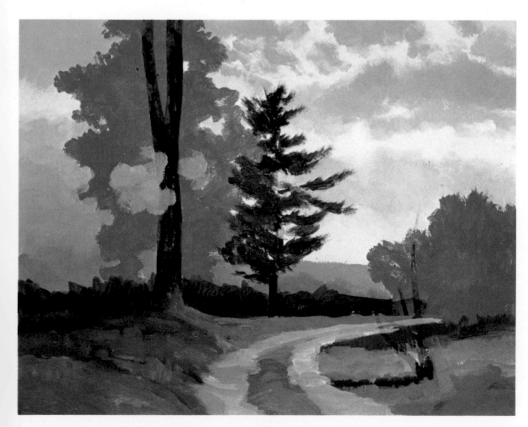

Step 4. The cool tones of the grass are scrubbed in with a bristle bright and a mixture of ultramarine blue, yellow ochre, burnt sienna, and white—with less white in the shadows and more white in the sunlit patches. In the warmer areas, cadmium red is substituted for the burnt sienna. The road is painted with ultramarine blue, burnt sienna, and white, with more blue in the shadows. Notice that the tree in the lower right is beginning to disappear under all that paint; but its shape will be strengthened in the final stages.

Step 5. The lighter trees to the left are brushed in with cadmium red, cadmium yellow, burnt sienna, and white, dabbed onto the illustration board with the tip of a filbert. The shadow tones on the big tree and on the smaller tree to the right are painted with short, scrubby strokes of the same brush—a mixture of ultramarine blue, burnt sienna, and cadmium red. The tones of the foliage are gradually working their way over the shapes of the treetrunks. This same mixture, with more blue, is scrubbed in over the dark strip at the horizon.

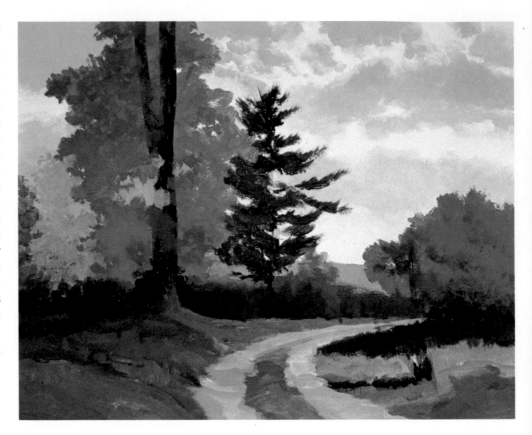

Step 6. The tip of a filbert now adds lighter, sunlit foliage to the trees at the left with cadmium red, cadmium yellow, and yellow ochre. The big treetrunk is now partially covered by foliage. A round, softhair brush adds trunks to the smaller trees at the left and branches to the big tree—a mixture of ultramarine blue and burnt umber. The light edges on the trunks are white with just a hint of burnt umber. A trunk and branches are added to the evergreen with the same dark mixture, which is also used to reconstruct the tree at the right. Then the light foliage mixture is scattered across the right with taps of the filbert.

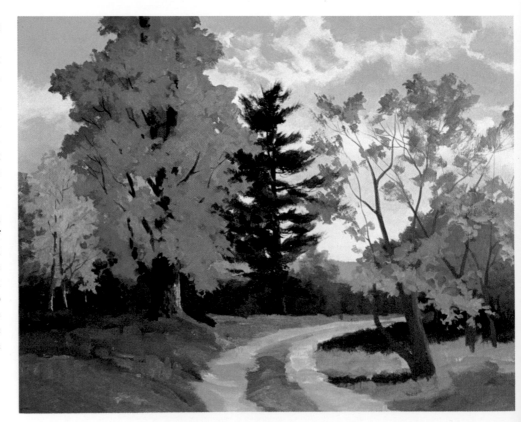

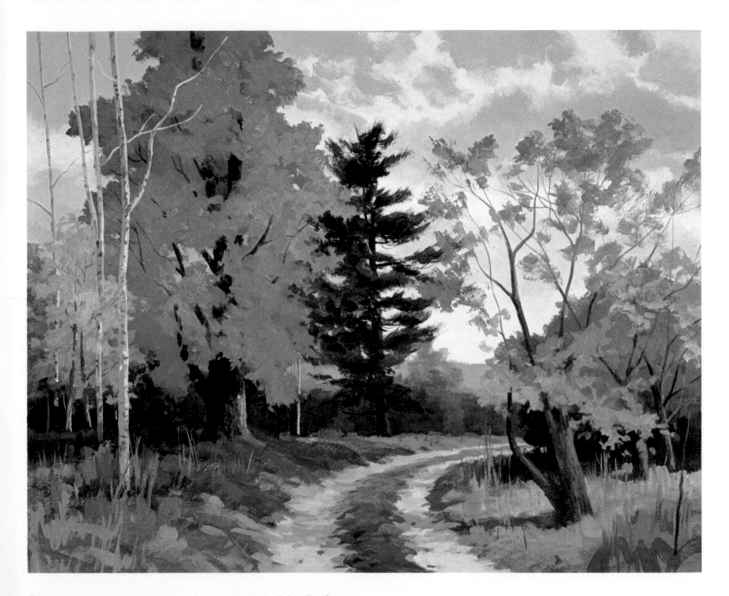

Step 7. Clumps of dead weeds are suggested in the foreground with a round, softhair brush. These strokes are all mixtures of ultramarine blue, burnt sienna, yellow ochre, and white, with more brown in the warmer strokes, more blue in the cooler strokes, and more white in the paler tones. The very tip of the brush uses the pale mixture to indicate individual blades of dried grass. The pale trunks of the birches at the left are painted with two mixtures: white with a faint tinge of burnt umber on the sunlit side; burnt umber, ultramarine blue, and white on the shadow side—with a darker version of this same mixture for the flecks on the bark. This dark mixture is also used to add dark edges to the trees and branches on the right. The somber, grassy tones in the center of the picture, running up the road and reappearing under the evergreen, are ultramarine blue, yellow ochre, white, and an occasional hint of burnt sienna. Although the painting seems to be full of rich detail, the entire landscape is very loosely painted. It's hard to pick out a single leaf— the leaves are just rough touches made by the tip of the brush. Although the ground *seems* to be covered with withered weeds and grasses, only a few individual blades are suggested by the brush.

Step 1. The pencil drawing defines the outer edges of the big, snow-covered tree, the snow-covered rocks, and the frozen stream. Equally important, the pencil lines trace the shapes of the dark rocks that appear within the snow to the left. Then a bristle brush scrubs a thick, opaque mixture of ultramarine blue, burnt sienna, cadmium red, and white over the sky. The sky is dim and overcast, but some light comes through to the left of the big tree. This tone contains less ultramarine blue and more white.

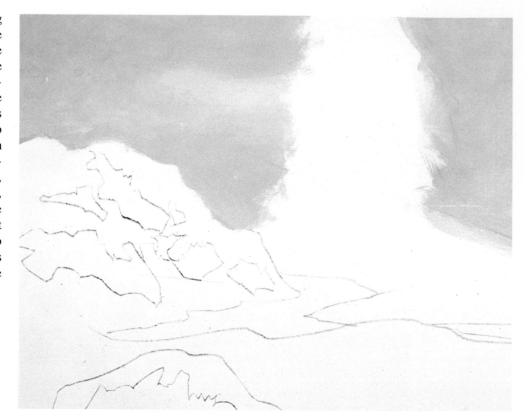

Step 2. The dark patches of rock, so carefully drawn in Step 1, are now painted with a blend of ultramarine blue, burnt sienna, and white. The color isn't too thoroughly mixed on the palette. Nor are the strokes blended together on the painting surface—a sheet of illustration board. So these strokes have a ragged, irregular texture, like that of the rocks. The snow-covered branches on either side of the tree are painted with wavy strokes of white, tinted with a little sky tone.

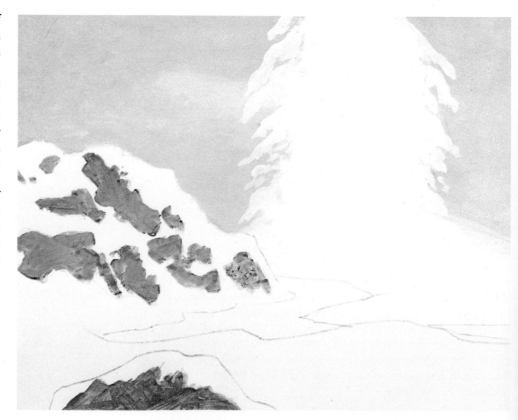

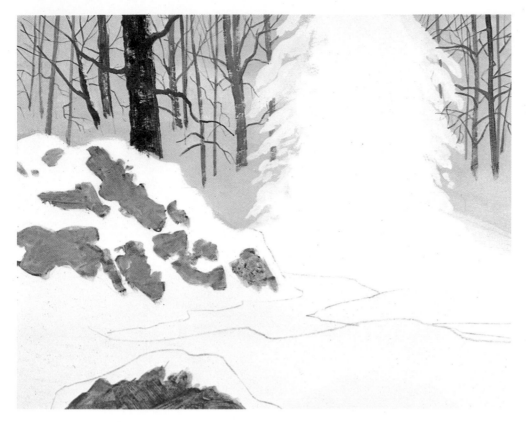

Step 3. The trunks and branches of the distant trees are painted with a mixture of ultramarine blue, cadmium red, yellow ochre, and white. The thicker trunks are painted with a flat softhair brush, while the thinner trunks and branches are painted with a round softhair brush. The paint is thick and creamy, so it doesn't flow too smoothly over the painting surface; the result is an effect something like drybrush, which you can see most clearly in the trunk of the dark tree. As the trunks grow more distant, more white is added to the mixture.

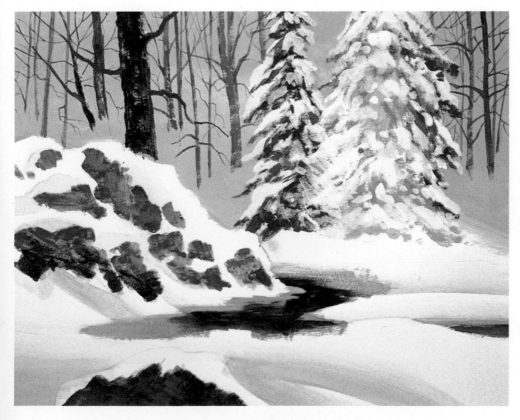

Step 4. The original sky mixture is thinned with more water to paint the shadows on the snowbanks with transparent color. The edges of these shadow strokes are softened with clear water. The rocks are darkened with a thick mixture of ultramarine blue, burnt sienna, yellow ochre, and white. This same mixture, with a little more white, is used to paint the pale edges of the frozen stream, while a darker version is used to paint the deepest tones. A few strokes of sky color divide the big tree shape in two. Strokes of rock tone suggest shadowy branches. Then strokes of white, tinted with sky color, represent the clumps of snow resting on these branches.

Step 5. More strokes of white, tinted with a little sky tone, are added to thicken the snow on the trees. The shadowy band of trees at the horizon is scumbled in with ultramarine blue, cadmium red, yellow ochre, and white, partially obscuring the bases of the treetrunks. Snowbanks are added beneath the horizon and between the trees with more sky mixture and white. The edges of the snowbank to the left are sharpened with pure white toned with the faintest touch of sky color.

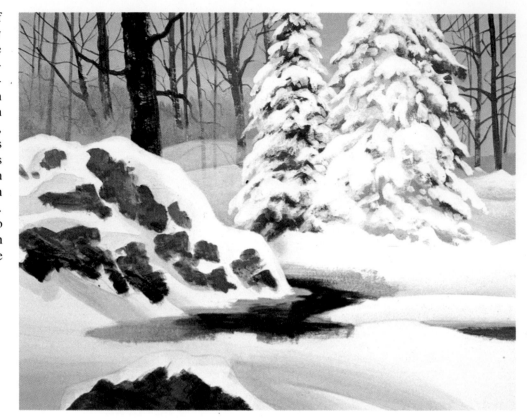

Step 6 (close-up). In the finished painting, the solid patches of snow on the rocks and branches are painted with thick strokes of creamy, opaque color. The darks of the rocks and branches, showing through the snow, are done with thinner, more fluid color. The dark tones of the frozen stream are painted in the same way. Then a bit of the snow color, tinted with sky tone, is scumbled over the dark strokes of the rocks and branches here and there. This same color is thinned with water to paint the reflection of the snowbank in the frozen stream; these semi-opaque strokes allow the darkness of the stream to shine through.

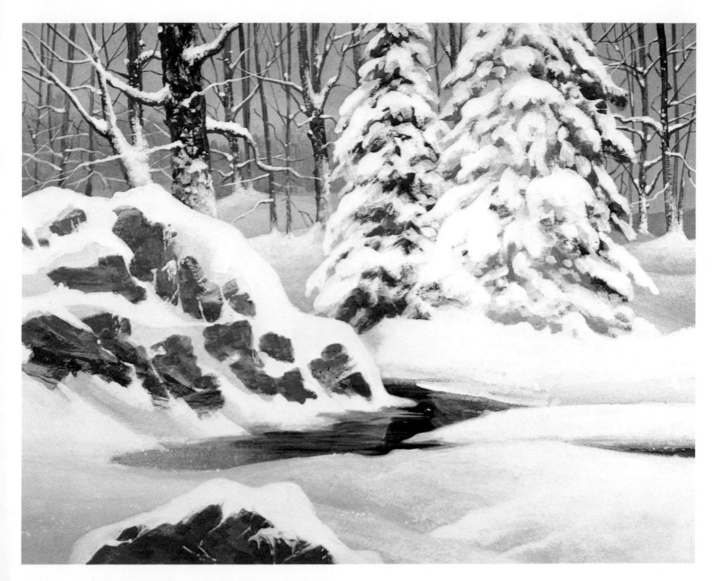

Step 6. The distant treetrunks are reinforced with thick strokes of burnt sienna, ultramarine blue, yellow ochre, and white. When these strokes are dry, snow is dabbed on the trunks and branches with thick white tinted with a little ultramarine blue and applied with the tip of a small bristle brush. The point of a round softhair brush draws snowy lines on the tops of the thinner branches. A large bristle brush scumbles this same bluish-white mixture over the sunlit portions of all the snowbanks in the middle distance and the foreground. The back-and-forth scrubbing stroke blends the pale tops of the snowbanks into the darker shadow planes. Thick strokes of this snowy mixture are car-ried over the top of the dark rock in the left foreground. A few touches of snow are drybrushed over the dark shapes of the rocks. The tip of a round brush paints a few light lines on the rocks to suggest snow that's settled in the cracks. Pure white is mixed on the palette with lots of water. A big bristle brush—or perhaps a toothbrush—is dipped into this milky fluid. Then a stiff piece of wood, such as a brush handle or an ice cream stick, is drawn over the tips of the bristles to spatter a few snowflakes over the foreground. You can see them clearly in the lower left. Notice how the warm sky tone, which you first saw in Step 1, remains behind the trees, just above the horizon.

Step 1. The pencil drawing—on a sheet of illustration board—defines not only the shapes of the various peaks, but also traces the details within these peaks. These lines record the complicated pattern of light and dark shapes that will appear in later steps. Then the sky is roughly covered with a mixture of phthalocyanine blue, ultramarine blue, white, and just enough water to make a mixture that is milky and semi-opaque so that the pencil lines will shine through. This combination of the two blues is worth remembering. Phthalocyanine blue may be too bright for the sky, while ultramarine blue can be too subdued. When you blend them and add white, you get the perfect compromise.

Step 2. The darker tones of the distant mountains in the upper right are painted with a blend of burnt sienna, ultramarine blue, and white. The strokes are made with a flat softhair brush, pulled downward and quickly lifted to leave an effect something like drybrush. Then a touch of this mixture is added to a great deal of white to paint the snowy peak with the point of a round softhair brush.

Step 3. The darks of the tallest mountain are brushed in with a mixture of burnt umber, ultramarine blue, a little cadmium red, and some white. The paint is thinned with water and a little gloss medium to a creamy consistency; thus the flat nylon brush carries the paint across the board in smooth, solid strokes. Between the strokes, strips and patches of bare paper are left to suggest the snow. Now you can see why the preliminary pencil drawing is so important: the beauty of the mountain depends on that intricate design of lights and darks, which must be followed carefully with the brush.

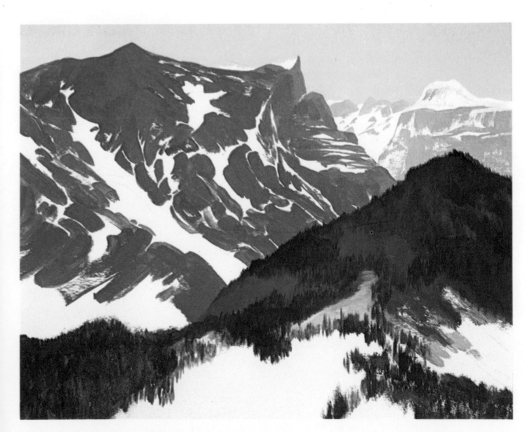

Step 4. The remaining slopes of the high mountain are painted with the same mixture used in Step 3: burnt umber, ultramarine blue, a little cadmium red, and white. Throughout, the paint is kept thick and creamy. Then the dark shape of the tree-covered mountain in the foreground is brushed in with that same mixture, containing less white. When the dark tone dries, a small, flat nylon brush scribbles in the suggestion of trees with up-and-down strokes of burnt umber, ultramarine blue, cadmium red, and yellow ochre. The shadows on the snow are the same mixture used for the distant mountains, but with more white. And the sunlit patches of snow are still the bare painting surface.

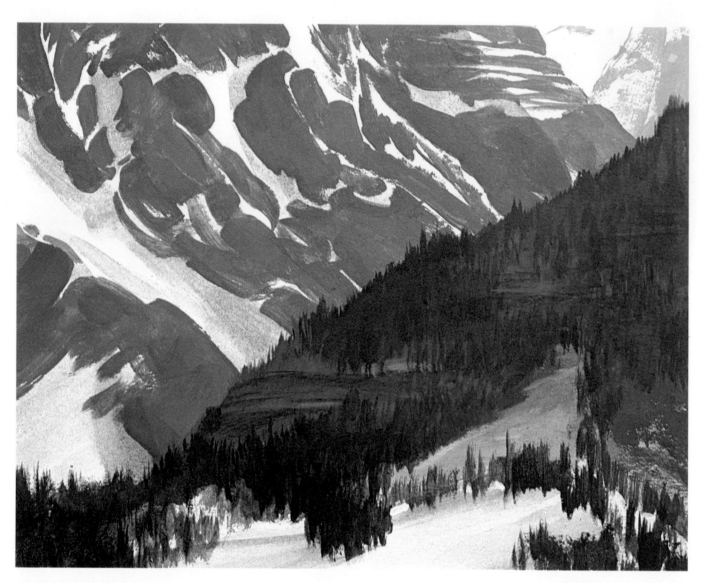

Step 5 (close-up). This life-size section of the finished painting shows the various kinds of brushwork used to paint the mountains, snow, and trees. The dark shapes of the rocks peeking through the snow on the slopes are painted with straight and curving strokes of a flat brush. The strokes follow the diagonal contours of the mountainside. The layered rock formations in the upper right are painted with horizontal strokes. The pine forest on the shadowy slope of the mountain in the foreground is painted with the point of a round softhair brush that moves up-and-down with a scribbling movement. You can't really pick out the form of any single tree, but the scribbling strokes cluster together to suggest hundreds of evergreens. The shadows on the snow are also painted with form-following strokes that move up the steep, diagonal slopes of the rocky mountainside, but move in a more horizontal direction on the snowy slopes of the mountain in the foreground, which is less steep.

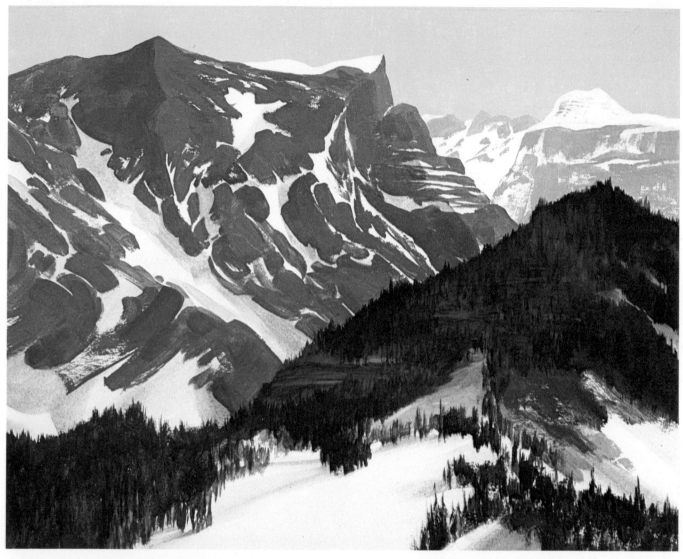

Step 5. The shadows on the snow are glazed with a transparent tone of ultramarine blue and cadmium red, plus a good deal of water and a little painting medium. The job is done with a flat softhair brush. It makes sense to use transparent color to paint the transparent shadows on the snow. Among the trees of the dark mountain in the foreground, a small, round softhair brush paints some traces of shadow with ultramarine blue, cadmium red light, and white. This brush picks up some pure white to paint a snowy shape along the topmost edge of the tall mountain. Pure white is also used to "trim" the lower edges of some of the tree strokes in the foreground, giving the impression that the trunks are growing out of thick snow. Finally, the tip of a small, round softhair brush adds tiny strokes of dark color—burnt umber, ultramarine blue, yellow ochre, and a whisper of white—to the silhouette of the pine forest, suggesting individual trees that stand up clearly against the paler mountains beyond.

Step 1. This demonstration shows how to use acrylic in a fluid, transparent technique that's similar to watercolor. The shapes of this rocky coastal scene are drawn with a pencil on cold-pressed (called "not" in Britain) watercolor paper. Then the entire sky area is brushed with clear water—you can use a large, flat brush or a sponge—and the water is allowed to sink in for just a moment. While the paper is still wet and shiny, the dark shapes of the clouds are brushed onto the wet surface with a mixture of ultramarine blue, naphthol crimson, and yellow ochre. The strokes spread and blur. If any color goes where you don't want it, you can blot it up with a paper towel or tissue.

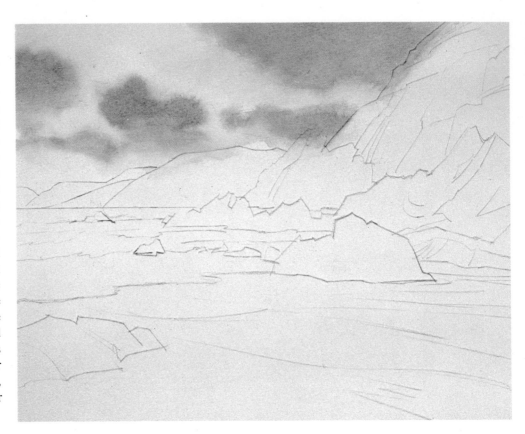

Step 2. The cloud shapes are allowed to dry. Because acrylic is waterproof when it dries, the clouds won't dissolve when more color is brushed over them. Now the sky area is brushed with clear water once again. A pale mixture of ultramarine blue and phthalocyanine blue—with lots of water—is brushed over the entire sky area, right down to the horizon. The color is carried over the distant hills. While the sky is still very wet, a hint of yellow ochre is brushed between the horizon and the lower clouds to add a suggestion of warmth. Notice that no white is used to make the colors lighter. It's all done with water; thus the colors remain transparent, like watercolor.

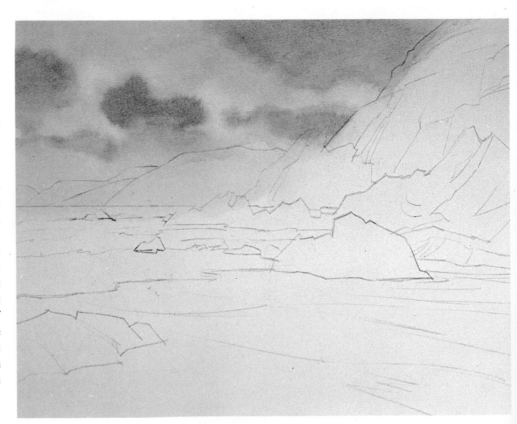

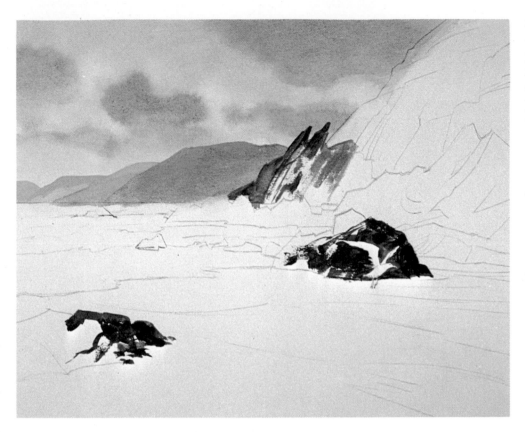

Step 3. When the sky is bone dry, the distant hills are painted over it with the same mixture as was used for the clouds. The paler hills are painted first, then allowed to dry. The darker tones of the cliff and the foreground rocks are begun with the sky mixture, containing more blue and with burnt umber added. The dark side of the big rock is carefully painted around the shape of the gull. Like a watercolor, this entire picture is painted with only softhair brushes.

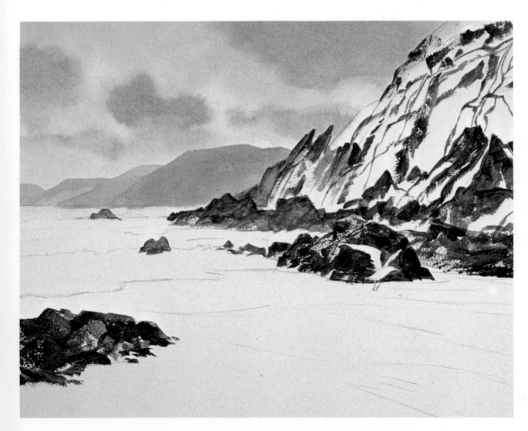

Step 4. More darks plus some details of cracks and crevices are added to the cliffs and rocks with the same mixture used in Step 3. Notice how drybrush strokes accentuate the craggy texture of the rocks. The details of the rocks are painted with great care and allowed to dry. They're now waterproof, so wet tones can be washed over them.

Step 5. A fluid wash of ultramarine blue and burnt sienna is brushed over the entire cliff area. While this tone is still wet and shiny, the dark rock mixture is blended in at the top of the cliff; thus this looming rock formation becomes more shadowy. The tip of a round brush carries slender, curving strokes of the cloud mixture across the water. This same brush draws slender lines of burnt sienna and ultramarine blue across the beach to suggest ripples in the sand. The beach in the immediate foreground is first sponged with clear water and then the ripples are painted onto the wet surface, where they tend to blur.

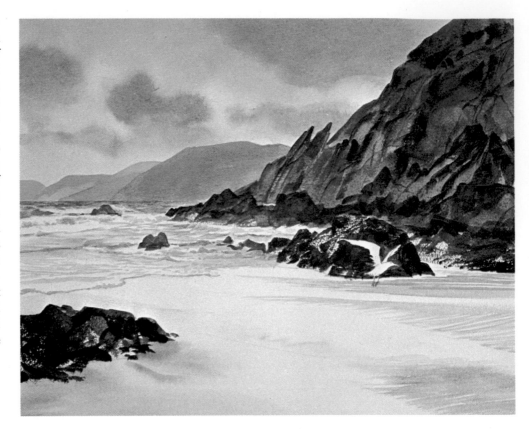

Step 6 (close-up). In the final stage, the rocks at the foot of the cliff are darkened with a wash of burnt sienna and ultramarine blue. The brushwork is interesting. Notice how the lower edges of the rocks are drybrushed so they seem to disappear into the foam of the breaking waves. Drybrush strokes also suggest the rough texture of the rocks in the lower right section. The dark flecks in the distant hill are a phenomenon called granulation, which adds to the atmospheric feeling: a very wet wash of acrylic color, diluted with lots of water, settles into the valleys of the textured paper.

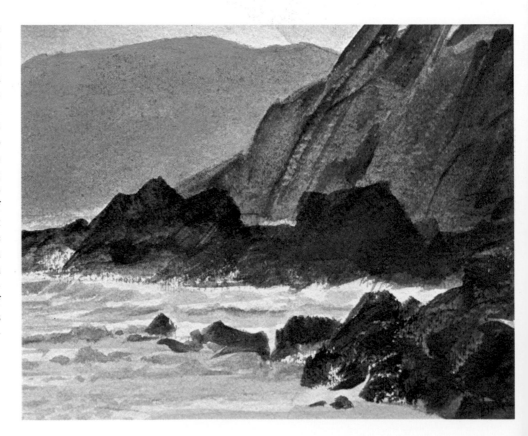

Step 6. The delicate ripples on the beach are allowed to dry. Darker strokes are added on the right to accentuate the ripples—a mixture of burnt umber and ultramarine blue. This same mixture adds reflections beneath the rocks and cliff at the right. And a paler version of this mixture adds the shadows under the wings and body of the gull. When this detailed work is dry, the entire beach is brushed with clear water once again. While the surface is wet, a mixture of burnt sienna, ultramarine blue, and yellow ochre is brushed over the foreground, fading away into the distance. Before the beach loses its shine, a paper towel blots up a light path from the lower right to the edge of the water, suggesting sunlight reflecting on the wet beach. For dry-brush strokes like those on the rocks, one good trick is to work with the side of a round, softhair brush, not with the tip. The side will make a more ragged stroke.

DEMONSTRATION 37. DESERT

Step 1. These desert rock formations and their sandy surroundings are painted on smooth watercolor paper. The rocky forms are complicated, so the pencil drawing records them as precisely as possible. The pencil traces not only the outer edges of the rock formations, but the planes of light and shadow that will make the forms look three-dimensional. The cloud forms and the shapes of the sandy foreground are drawn more freely.

Step 2. The pencil lines are lightened with an eraser and are practically invisible. The sky is painted with a transparent wash of ultramarine blue, phthalocyanine blue, and water, carried around the rock formations. The shadow side of the big shape is painted with ultramarine blue, naphthol crimson, and water. Cadmium red, ultramarine blue, and water are freely brushed over the lighted side and blended into the wet shadow tone. This same warm mixture is brushed over the rocky shape to the right. Then a little white and a lot of water are mixed with the shadow tone, which is brushed over the foreground and over the edge of the rocky shape.

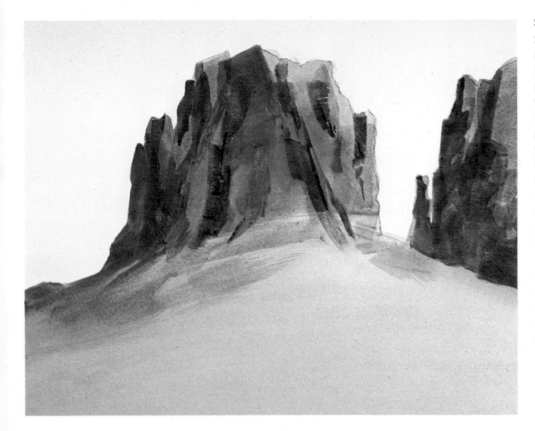

Step 3. When Step 2 is dry, a flat softhair brush picks up the same shadow mixture—ultramarine blue, naphthol crimson, and less water—to paint the shadows with squarish strokes. When these strokes are dry, a darker wash of cadmium red and ultramarine blue (containing less water) is carried over the rocks with the same brush. At this stage, there are clearly defined planes of light and shadow on the two big rock formations, creating a feeling of strong sunlight striking the rocks from the right. A bit more of the shadow mixture is brushed along the sand at the base of the biggest rock.

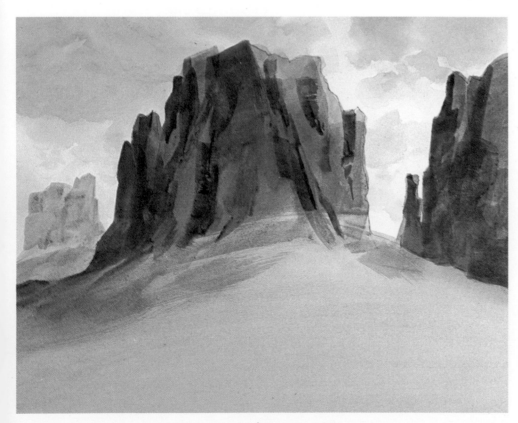

Step 4. At the end of Step 3, the sky is still the very pale blue that was applied at the very beginning. Now deeper blues are added with a round softhair brush: ultramarine blue, plus a little naphthol crimson and yellow ochre and a lot of water. Alongside these wet patches, the same brush brings in shadowy tones of the same mixture— with more crimson and less blue—to blend wet-in-wet with the blue shapes. Here and there the brush softens the edges of the wet shapes with clear water, as you can see most clearly in the upper right. The distant rock formation at the left is painted with the shadowy sky mixture— more water on the lighted side and less on the shadow side.

Step 5. A touch of white is added to each of the sky mixtures—the blue and the shadow tone—making them more opaque. Then these mixtures are scumbled over the sky area in the upper left, still leaving the sky in the upper right untouched. The cloud behind the small rock formation at the left is scumbled with white tinted with just a little ultramarine blue and naphthol crimson. The curving contours of the sandy foreground are suggested with scrubby strokes of cadmium red, ultramarine blue, yellow ochre, and white. A few touches of this mixture are added to the sunlit planes of the biggest rock formation.

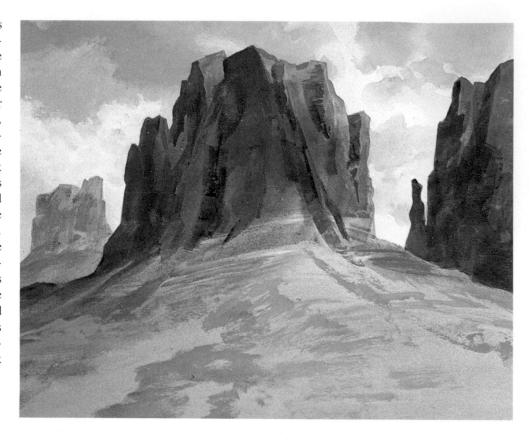

Step 6. Strong shadows are added to the bigger rock formation with square strokes made by a flat softhair brush. These darks are a mixture of ultramarine blue, cadmium red, and a little water. The point of a round softhair brush draws some crisp lines over the rocks to suggest cracks and crevices. A touch of white is added to this mixture for the shadow that's carried across the left. A few strokes of the sandy tone—cadmium red, yellow ochre, and white—are carried up into the base of the center rock.

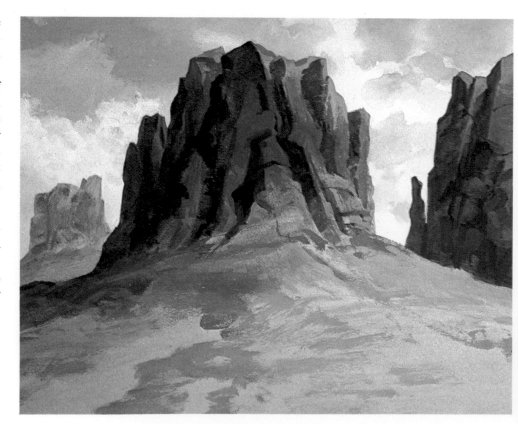

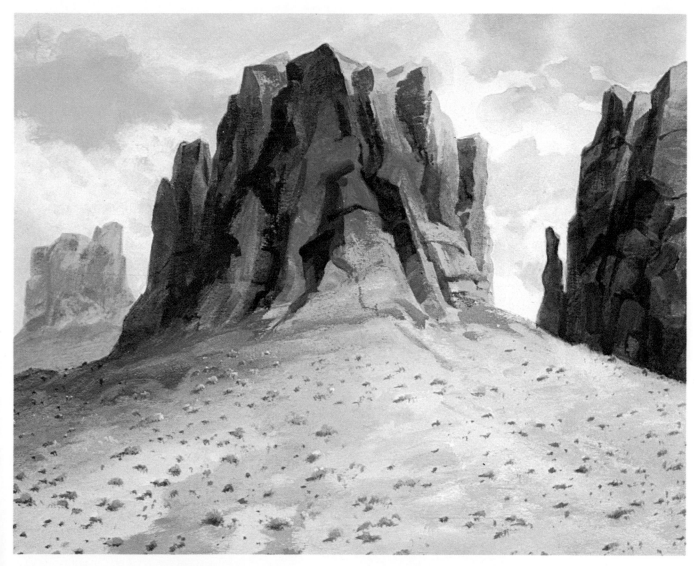

Step 7. Now is the time to simplify some of the major areas of the picture before going on to the final details. The sky behind the big rock formation looks a bit too dark; the rock will stand out more strongly against a lighter sky. So a pale, opaque mixture of ultramarine blue, naphthol crimson, phthalocyanine blue, and white is scumbled around the big, ruddy shape to make the sky drop back slightly. Too much seems to be happening in the sandy foreground, so this is scumbled with various mixtures of naphthol crimson, cadmium red light, yellow ochre, cadmium yellow, ultramarine blue, and white—never more than three or four of these colors to a mixture. These sandy tones obliterate a lot of the distracting brushwork that you saw in Step 6, producing a slightly smoother tone. The last details are those small touches of green that suggest the desert weeds. These are nothing more than little dabs made by the tip of a bristle brush carrying a thick, not-too-fluid mixture of chromium oxide green, yellow ochre, and white. The touches of dark shadow under these weeds are the same mixture used for the shadows on the rocks: ultramarine blue, naphthol crimson, and a hint of white. These touches of shadow are often placed slightly to the left of the green strokes, reinforcing the feeling that the strong sunlight comes from the right. One strong shadow remains in the foreground, just left of center, subtly leading the eye upward toward the central rock formation. Once again, this landscape is an effective combination of transparent and opaque color. The most brilliant, luminous colors on the rocks are transparent washes, thinned only with water. The softer colors of the foreground are opaque. The sky is painted in transparent color at the beginning, but opaque color is added for certain necessary corrections.

Step 1. This pencil drawing defines the outer edges of the clouds, the shapes of the landscape below, and the line of the water. Then the deep, cool tones of the sky are scumbled with a bristle bright carrying a mixture of ultramarine blue, phthalocyanine blue, a touch of naphthol crimson, and white. More white is added to this mixture as the brush moves downward toward the horizon. The brush scrubs the darker and lighter strokes together to produce a subtle dark-to-light gradation. The big cloud at the center is bare paper. The smaller clouds above the horizon are strokes of white tinted with a little sky mixture. The picture is painted on cold pressed watercolor paper.

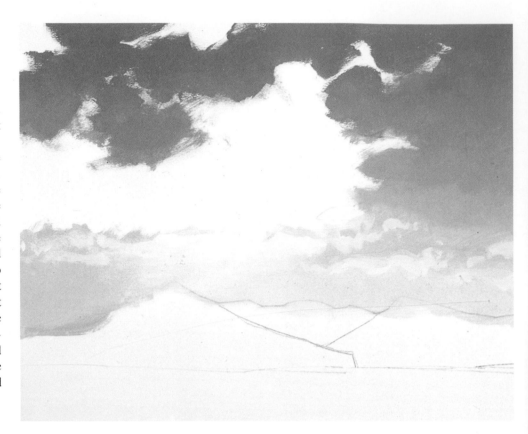

Step 2. When the sky is dry, the dark tones of the clouds are scumbled with a deep mixture of ultramarine blue, cadmium red, and just a hint of white. The back-and-forth scrubbing stroke produces soft edges where the clouds meet the sky. More white and blue are added to this mixture for the paler clouds in the lower sky. Along the bottom of the big, dark cloud, the bristle brush scumbles a mixture of cadmium red, yellow ochre, and white. Looking back at Step 1, you can see that the sky is palest directly under the sunlit edge of the big cloud; this suggests the intense light of the sun behind the cloud.

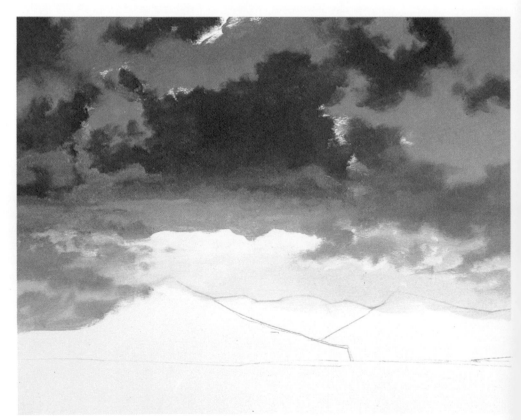

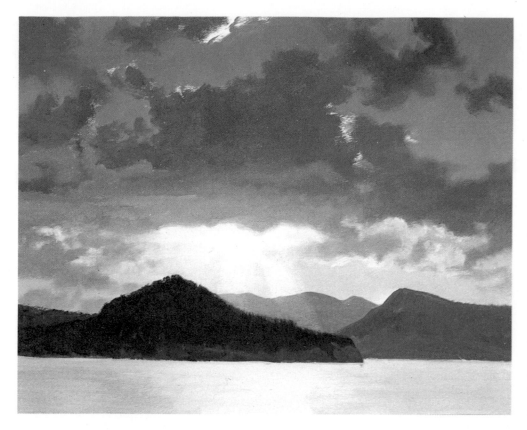

Step 3. A mixture of cadmium red, yellow ochre, ultramarine blue, and white—the consistency of cream—is brushed smoothly over the shapes of the island peaks. The most distant peak contains more white and blue; the nearest peak contains almost no white. This same mixture, containing more white and more water, is drybrushed over the band of water below the horizon, leaving some bare paper at the center to suggest the reflection of the sun. Sunlit edges are added to some of the lower clouds with strokes of thick white tinted with a speck of cadmium red, ultramarine blue, and yellow ochre. This same mixture is drybrushed downward from the center of the sky to suggest rays of light.

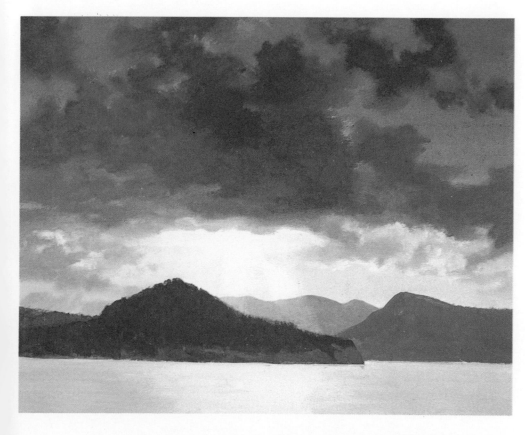

Step 4. A big, flat softhair brush glazes the upper sky with a transparent mixture of ultramarine blue, naphthol crimson, and mars black, thinned with water and gloss painting medium. Now the upper sky is darker and contrasts more dramatically with the sunlit lower sky. The dark clouds are reshaped and enlarged with scumbled strokes of ultramarine blue, cadmium red, and some white. The ruddy band at the bottom of the central cloud becomes narrower. The brilliant light of the lower sky is strengthened with pure white tinted with cadmium yellow. And the water is cooled with the same transparent glaze as the upper sky, but containing much more water here.

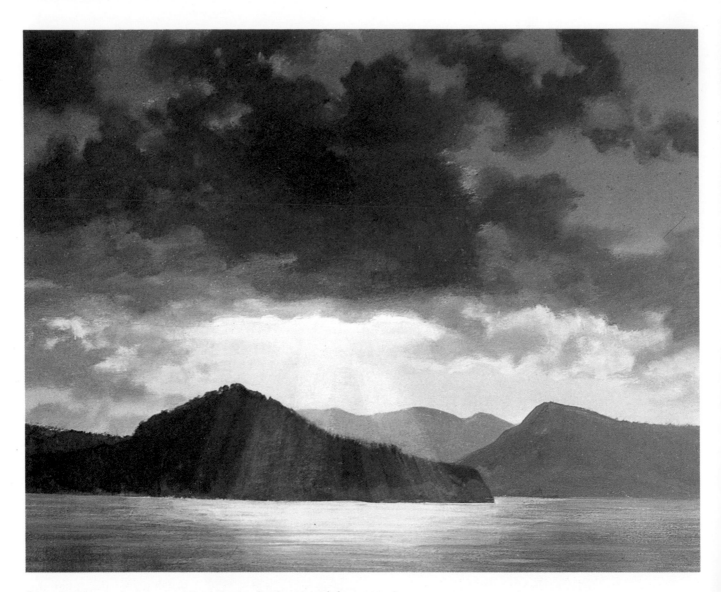

Step 5. The sky is now complete. In the final step, subtle
touches are added to the islands and the water to make them
harmonize with the sky. At the right and left, the water is
darkened with drybrush strokes of cadmium red, yellow
ochre, ultramarine blue, and white to suggest the reflections
of the dark islands in the water. When these reflected tones
are dry, a small softhair brush is used to drybrush thin, hori-
zontal lines across the water. These strokes are the same
combination as the dark reflections, but the proportions of
the colors change from stroke to stroke. The strokes at the
edges contain more blue or red. The strokes at the center
contain more yellow and white to suggest the brilliant sun-
light shining on the water. This same pale mixture is dry-
brushed with diagonal strokes over the islands to carry the
sun's rays all the way down to the water. This final land-
scape demonstration shows three different ways to apply
color: scumbling in the sky; creamy, fluid color on the is-
lands; and drybrush in the water.

Improvised Tools. Acrylic is such a versatile medium that artists are still finding new ways of applying paint. Although brushes are certainly the most popular painting tools, artists are always improvising—always coming up with new and unexpected painting tools. Here are some. As you experiment with acrylic, you'll probably come up with others.

Scratching. A dried layer of acrylic paint is a lot tougher than oil or watercolor, but you *can* produce some interesting effects with the sharp point of a knife or the sharp corner of a razor blade. If you're working on illustration board or watercolor paper, you can scratch through a layer of paint to expose the white surface beneath. This can be a very effective way to suggest blades of grass in sunlight or sunstruck twigs against a background of dark trees. If one layer of paint covers another, you might also try scratching away the top layer to reveal a bit of the underlying layer.

Painting with Cloth. You can also roll up a rag into a ball or a rectangular wad, dip this in acrylic color, and apply the paint with a dabbing motion. You actually *pat* the color onto the paper. If the cloth dabber is covered with a lot of color and you press hard, you'll leave behind a fairly solid layer of paint. Less paint and less pressure will leave behind a veil of color. You can also experiment with different textures of cloth: smooth cloth will obviously leave behind a different imprint than rough cloth.

Painting with Paper. Just as you make a dabber out of cloth, you can wad up paper to produce an interesting painting tool. A soft, absorbent paper towel will soak up color and generally leave a soft, blurry mark on your painting surface. A stiffer, less absorbent sheet of paper, such as smooth drawing paper, will make a wrinkled, irregular dabber that will leave a more irregular mark on the painting surface.

Spattering. For subjects like a pebbly shore or a roughly textured stone wall, you can spatter color onto the painting surface. One way is to dip the brush into color, hold one hand stiffly in front of the painting surface, and then whack the handle of the brush against that hand so the color flies off the bristles and leaves an irregular pattern of droplets on the painting. Another way is to dip a stiff toothbrush into liquid color and spray the paint by pulling a flat piece of wood across the bristles.

Sponging. The soft, irregular texture of a natural sponge can become one of the most versatile painting tools. Wet the sponge first, of course, and squeeze out as much water as you wish—depending upon how fluid you want the paint to be. Then dip the sponge into the color on your palette and apply the paint by patting or scrubbing.

Textural Painting. For painting richly textured subjects like rocks or weathered wood, you can use or *create* thickly textured paint. You can work with paint directly from the tube, without water. You can blend the paint with gel medium or acrylic modeling paste or a combination of both. And you can apply this color either with stiff bristle brushes (leaving the imprint of the bristles in the paint) or with any of the improvised tools listed above—each of which will leave its own special texture in the thick color. When that heavily textured layer of paint is dry, you can accentuate the texture with drybrush strokes. Or you can apply very liquid color that sinks into the pits and valleys of the irregular paint surface.

Correcting by Darkening. When things have gone wrong, an acrylic painting is easy to correct. Let's say you've painted a picture in which the drawing, composition, and detail all seem right, but some portion is just too pale. You want to darken that area without covering up all the hard work you've done. A thin wash of transparent acrylic color—diluted with water or with one of your liquid mediums—can be brushed carefully over the offending section. The section will become darker, but the underlying brushwork will still show through.

Correcting by Lightening. What if you have exactly the opposite problem? The drawing, composition, and detail all seem right, but some part of the painting is just too dark. By blending color, water or liquid medium, and just a hint of white, you can create a semi-transparent "fog" of color to wash over the problem area. This veil of liquid color will lighten the offending passage but still allow a certain amount of your careful work to show through. It's usually best to apply two or three very thin veils of semi-transparent color—rather than one heavy coat—to be sure you're not covering up too much.

Correcting by Repainting. Because a dried layer of acrylic paint is insoluble in water, nothing is easier than *repainting* a passage that's gone wrong. You can apply a fresh coat of acrylic gesso to bring that part of the painting back to pure white so you can start again. Or you can just ignore the offending passage and paint over it with fresh color until you get the effect you want—and the problem literally disappears.

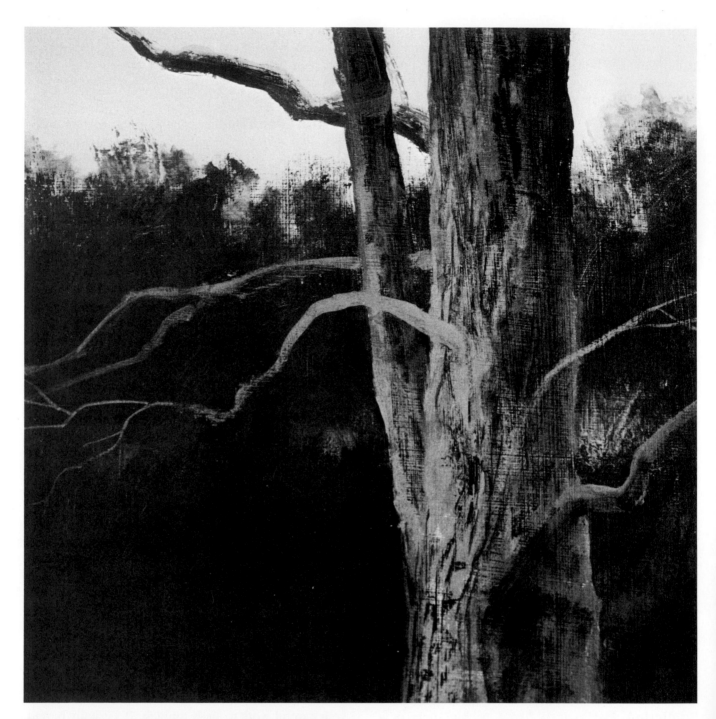

Step 1. This tree and its dark background are painted on illustration board coated with acrylic gesso. The gesso is applied thickly so that the bristles of the nylon house-painter's brush leave grooves in the surface. You can see the texture of these brushmarks peeking through the shadow side of the trunk. At this stage, the picture is painted with broad, rough strokes. You can see a lot of drybrush work in the bark. A few branches and some cracks are added to the trunk with the tip of a round brush. But most of the details will be added in the next stage—with a sharp blade.

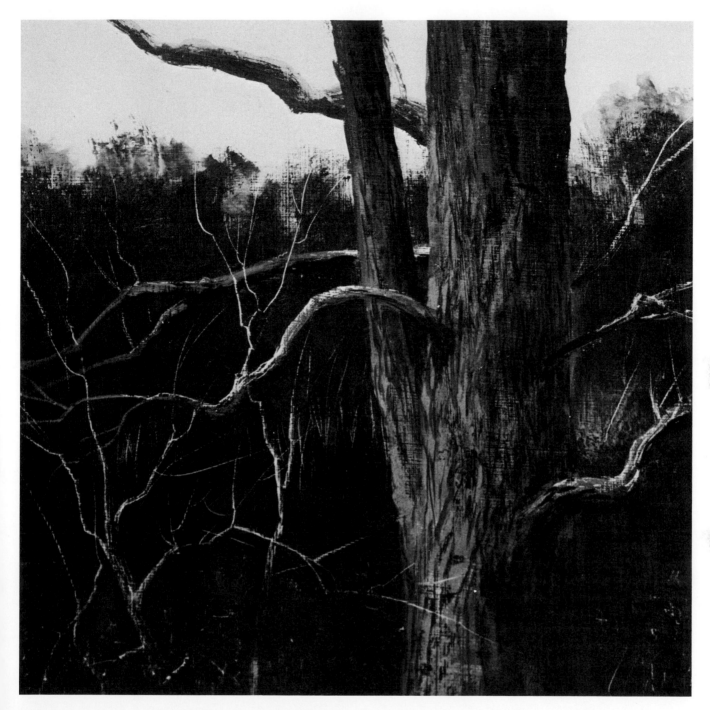

Step 2. When the first layer of paint is completely dry, the tip of a sharp blade—or the corner of a razor blade—scratches into the dark color to reveal the white gesso underneath. The blade lightens the edges of the heavier branches to suggest sunlight striking these branches from above. And a network of smaller branches is suggested to the left of the trunk. The rough texture of the gesso makes the scratches look rough: they're not continuous, wiry lines, but have an irregular texture, like wood. Now the tip of a small, round brush is used to add the final details to the trunk.

Step 1. Brushes and knives aren't the only painting tools. The soft cloud forms in this sky are painted with a rag that's been rolled into a ball, dipped into some paint, and patted against the painting surface. In this first step, the dabber carries a pale tone and is pressed lightly against the illustration board.

Step 2. Now the dabber picks up a slightly darker tone and presses harder against the painting surface to deposit denser color. The sky is darkened in certain areas, while other areas remain pale to suggest light breaking through the shadowy clouds. Brushes are used to indicate the landscape at the bottom of the picture.

Step 1. Another improvised painting tool is a sheet of paper squeezed into a ball, dipped in color, and pressed against the painting surface. Crumpled paper is particularly effective for painting trees. But it's best to begin by painting the background—like these fields, hill, and sky—and letting it dry before you paint the trees over it.

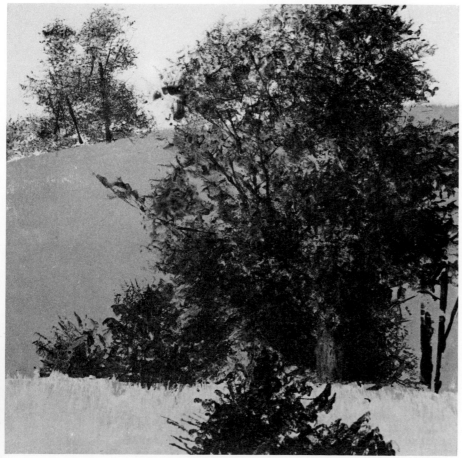

Step 2. A thin sheet of drawing paper is crumpled into an irregular ball, soaked in water to soften the paper a bit, dipped in thick color, and pressed against the painting surface to suggest the clusters of leaves. In the shadow areas of the trees, the paper carries more color and is pressed down harder. Less pressure is applied on the fainter trees at the horizon. When the leaves are dry, a small, round brush adds trunks and branches.

SPATTERING

Step 1. One of the hardest subjects to paint is a pebbly beach. You can't possibly paint every pebble. One good solution is to paint the broad tones of the beach with a brush, then follow with the technique called spattering. In this first step, the brush renders the cloud forms in the sky, the shape of the distant dunes to the right and a strip of sea to the left, the overall tone of the beach, and the shadows in the foreground.

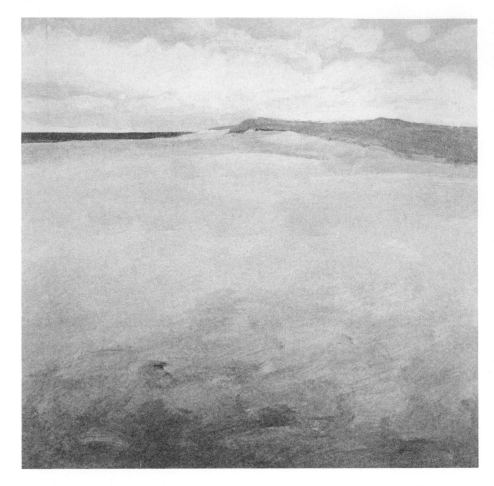

Step 2. Now a stiff brush—it might be a toothbrush, a bristle brush, or a stiff housepainter's brush—is dipped into liquid color. The handle of another brush (or a flat piece of wood such as an ice cream stick) is drawn over the tips of the bristles, which spring back and spray droplets of color against the painting. The brush is dipped first into light color, then into dark color, and then into light color again to produce this pepper-and-salt effect. It's a good idea to cover the distant dunes and sky with stiff paper or masking tape.

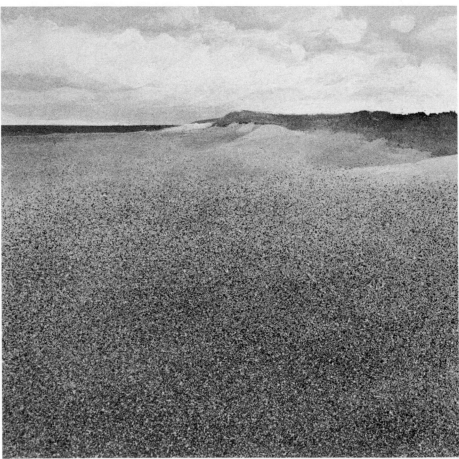

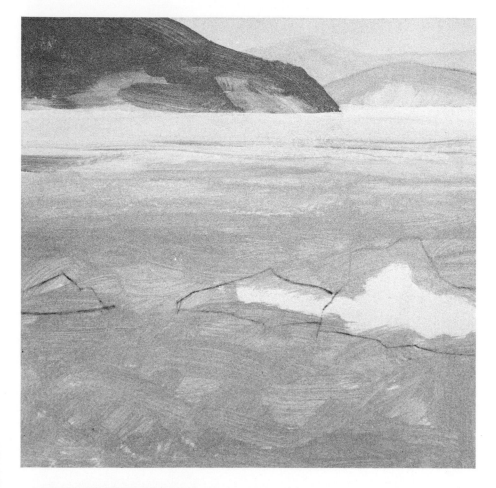

Step 1. If you want to paint a beach with even bigger pebbles, a sponge may be the ideal painting tool. Once again, it's best to begin by painting the major forms of the landscape with brushstrokes. The distant shore, the water, and the beach in the foreground are painted with free strokes. Only the rocks on the nearby beach are left untouched.

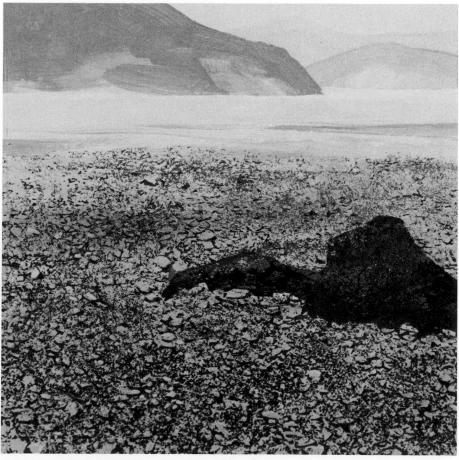

Step 2. A rounded, rough, natural sponge is dipped in clear water, squeezed out until it's just damp, and pressed against a pool of very thick color on the palette. Then the sponge is pressed against the foreground, depositing a pattern of irregular flecks of color. When these flecks are dry, the point of a small, round brush adds a few lines and shadows around some of the bigger flecks to make them look like pebbles. The entire beach is covered with this rough texture, and then the rock is painted right over it with semi-transparent color that allows the marks of the sponge to shine through.

Step 1. A good way to suggest the rough texture of a rock formation is to work with thick, rough paint. This piece of illustration board is first covered with a pale tone that will later become sea and sky. When this tone is dry, the rock formation in the foreground and the smaller rock formation in the distance are both covered with a claylike mixture of acrylic modeling paste, white tube color, and just enough gloss medium to make the paste easier to brush on. The paste is applied with thick, rough brushstrokes and knife strokes.

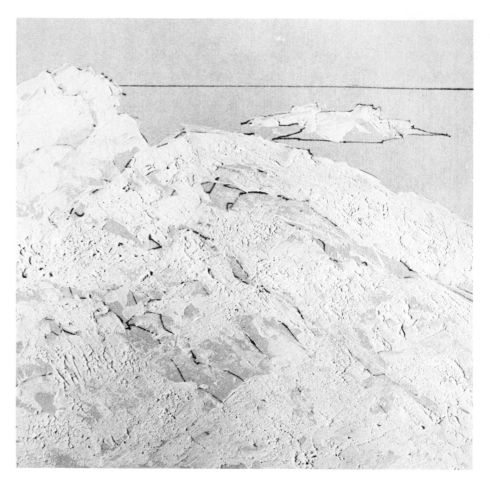

Step 2. When the rocks are absolutely dry, they're covered with liquid color—containing lots of water—which darkens the surface and sinks into the cracks and crevices left by the brush and knife. The dark wash accentuates the rough texture of the thick underpainting.

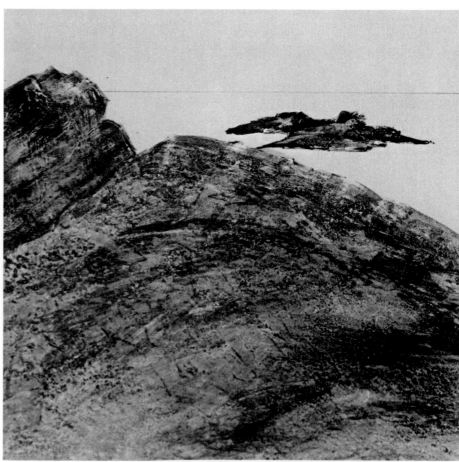

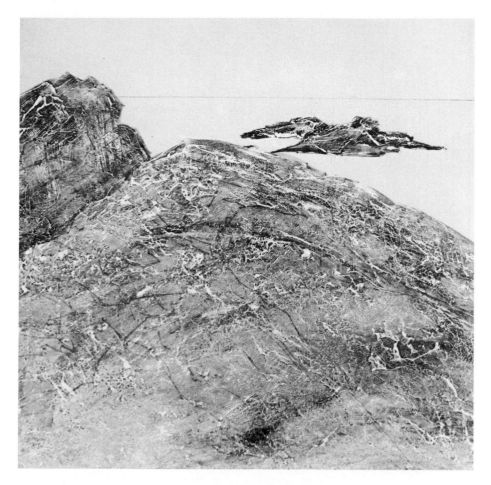

Step 3. When the dark wash is dry, the edge of a sharp blade—not the tip—is skimmed over the rock formation. Wherever the brush and knife strokes stand up highest, the blade shaves them away like sandpaper. (In fact, you might like to try sandpaper.) Now, a network of rough, white lines interweaves with the network of dark cracks and crevices created in Step 2.

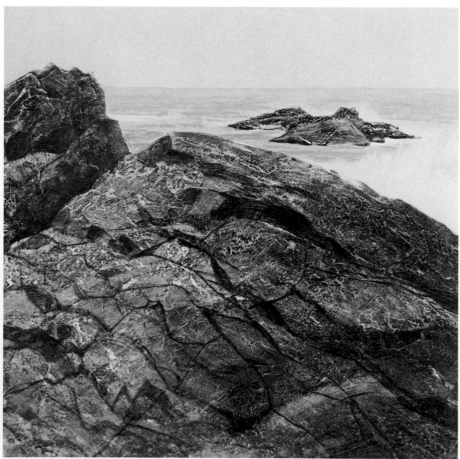

Step 4. In this final stage, a round, softhair brush is used to paint shadows, cracks, and other details that complete the rock formation. The tone of the sky is darkened, and the distant sea is painted with horizontal strokes. When you experiment with textural painting, you might also try working simply with thick paint straight from the tube; with tube color and gel medium; and with various combinations of modeling paste, gel medium, gloss or matte medium, and tube color. Some combinations will be thicker and rougher, while others will be smoother and more fluid.

Before. When something goes wrong with an acrylic painting, corrections are easy because acrylic paint is so versatile. One common problem is a painting that's too pale. Everything else seems right: you're satisfied with the composition, the drawing, and the complex pattern of lights and shadows that you worked so hard to render accurately. You know that some parts of the painting need to be repainted—made darker—but you don't want to obliterate the work you've done so far. In this coastal scene, the sky and the shapes along the horizon are just right, but the island in the foreground is too pale; it needs to be repainted so that it's darker and moves forward in the picture. How do you do it?

After. The trick is to repaint the island and its surrounding rocks with transparent color. You mix up a fresh batch of color with lots of water or with one of your mediums—gloss or matte, whichever you prefer. As you brush the liquid color over the painting, you can see right through the strokes and follow all the forms you've labored so hard to render. When the transparent color dries, the underlying brushwork will still show through. If you look closely at the island, you'll see that all the original shadows have been darkened and so have the trees, but none of the original detail has been lost. On the contrary, the detail has been strengthened by dark strokes built on top of the lighter strokes. All the original shapes are still there, but now the island moves forward in the picture, while the distant shapes are much farther away. Because the island and the rocks are now darker, it's important to darken their reflections in the sea below. So the sea is also repainted with transparent strokes.

Before. An equally common problem is some section of a painting that looks too dark. Once again, you've worked hard to get all the details exactly right. The pattern of lights and shadows seems right too. You want to lighten the whole section without covering up your original work and having to redo everything. In this mountainous landscape, there's something wrong with the distant peaks to the left. Because they're too dark, they seem too close—they're not distant enough. The extraordinary versatility of acrylic paint provides the solution.

After. The trick is to mix up a fresh batch of paint that's not transparent, but just *semi-transparent*. You mix the color that you want, add plenty of water or medium, and then add just enough white to make the wash hazy. When you brush this semi-transparent color over the distant mountains, this smoky wash seems to cover the painting surface with a kind of fog through which you can see all your original brushwork. The original pattern of lights, shadows, and details is intact, but everything is paler. The mountains suddenly recede into the distance, where they belong. Beware of one danger, however. It's easy to add too much white to the semi-transparent wash and discover, when the wash is dry, that you've covered up too much. It's best to work in several stages. Add lots of water and just a little white. Brush on one veil of color and let it dry. Then brush on a second veil if you think you need it. And don't be surprised if you need a third or a fourth veil to complete the job.

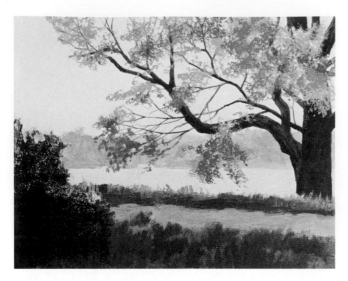

Step 1. How do you correct an acrylic painting if something is in the wrong place—like this tree—and needs to be moved elsewhere in the picture? You've already seen that you can darken an acrylic painting with transparent color and lighten it with semi-transparent color. Here's where opaque color comes into play. The tree is too close to the edge of the picture and needs to be moved toward the center.

Step 2. Working with opaque color, diluted to the consistency of cream and containing a fair amount of white, you can just paint out the tree. Here, the tones of sky, distant shore, and water are just carried over the tree—which disappears altogether.

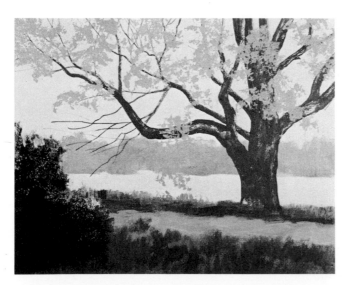

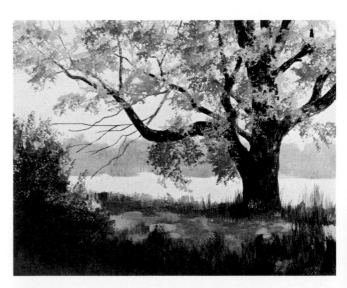

Step 3. When the sky, shore, and water tones are dry, you can just start again. A new tree is painted right over them, starting with the lighter tones of the trunk, branches, and leaves.

Step 4. When these lighter tones are dry, the trunk, branches, and leaves are completed with darker tones and touches of detail. (The leaves are painted with a sponge, by the way.) A shadow is added to the ground at the foot of the tree. Blades of grass are added with the tip of a round brush. The original tree has disappeared totally, and the new tree is in exactly the right place.

Learning the Rules. Acrylic is extraordinarily durable, but this can be a problem if you don't learn certain "rules." The basic thing to remember is that acrylic, once it dries, is almost impossible to remove from any absorbent surface. So be sure to wear old clothes when you paint. Like every artist, you'll get paint on your clothes, and you won't want to bother washing out every spot before it dries. So simply expect to ruin what you wear—and wear something you were ready to throw out anyhow. This includes footwear: wear your most battered old shoes, sandals, or sneakers so you won't worry when they're spattered with paint. You can also expect drops of paint to land on the top of your work table, the floor, and perhaps even the wall. So try to avoid working in a room where you've got to worry about antique furniture, your best rug, or new wallpaper. It's best to work in a room where you can really make a mess. If that's not possible, protect your surroundings with newspapers or the kind of "dropcloth" used by housepainters.

Care of Brushes. Your brushes are your most valuable equipment. While you're painting, always keep your brushes wet, wash them frequently, and (above all) never let acrylic paint dry on the brush. When you're finished, rinse each brush thoroughly in clear water—not in the muddy water that remains in the jars. That rinsing should remove most of the visible color, but there's often some invisible paint, particularly at the neck of the brush, where the hairs enter the metal tube called the ferrule. So it's wise to stroke the brush gently across a bar of mild soap (not corrosive laundry soap) and lather the brush in the palm of your hand with a soft, circular motion until the last trace of color comes out in the lather. Rinse again. When all your brushes have been washed absolutely clean, shake out the water and shape each brush with your fingers. Press the round brushes into a bullet shape with a pointed tip. Press the flat brushes into a neat square with the hairs tapering in slightly toward the forward edge. Don't touch them again until they're dry.

Storing Brushes. Allow the brushes to dry by placing them in a clean, empty jar, hair end up. When they're dry, you can store them in this jar, unless you're worried about moths or other pests who like to eat natural fibers. If these insects are a problem, store bristles, sables, and oxhairs in a drawer or box. Just make sure that the hairs don't press up against anything which might bend them out of shape. Sprinkle mothballs or moth-killing crystals among the brushes. You don't have to worry about synthetic fibers like nylon, which you can leave in the jar if you prefer.

Cleanup. As you work, you'll certainly leave droplets and little pools of liquid color on your work table, your drawing board or drawing table, your easel, and your paintbox. Ideally, you should sponge these up as they happen, but it *is* hard to do this in the excitement of painting. So sponge up what you can—while it's still wet—but then be prepared for more cleanup work after the painting session is over. At that point, the droplets and spills will be dry. If they've fallen on newspaper or a dropcloth, you can just toss out the papers, fold up the dropcloth, and forget about them. But you *will* want to remove dried color from other surfaces. Some of the color will come off if you scrub vigorously with a damp sponge or a wet paper towel: the paint won't really dissolve, but the dampness will soften it, and the friction will rub it away. If that doesn't work, try a mild household cleanser.

Cleaning Your Palette. By the time you've finished painting, a lot of paint will certainly have dried on your palette. You can easily wash off the remaining liquid color, but that leathery film of dried color won't come off under running water. If you're working on an enamel tray or a palette that's made of metal or plastic, the simplest solution is to fill the tray or palette with a shallow pool of cold water and let the dried paint soak for half an hour. The color won't dissolve, but the water will loosen it, so you can peel off the dried color or rub it away with your fingertips. A blunt tool such as a flat wooden stick or a plastic credit card may also help. Don't use a razor blade or a knife, which will scratch the palette. Of course, if you use a tear-off paper palette, just peel away the top sheet and you are done.

Care of Tubes and Bottles. At the end of the painting session, take a damp paper towel and wipe off the "necks" of your tubes and bottles to clean away any traces of paint or medium that will make it hard to remove the caps the next time you paint. Do the same inside the caps themselves. If you do have trouble getting off the cap, soak the tube or bottle in warm water for ten or fifteen minutes. That should soften the dried color in the neck so that you can then wrestle off the cap.

Washing Your Hands. There's no way to avoid getting paint on your hands. So don't eat or smoke while you paint, since certain pigments such as the cadmiums are mildly toxic and should be kept away from your mouth. Wash your hands carefully with soap and water after a painting session. Human skin contains oil, so it won't be too hard to remove dried acrylic color. A small scrub brush will help.

Permanence. The surface of an acrylic painting is far tougher than the surface of an oil or watercolor painting, but *all* paintings require special care to insure their durability. Although the subject of framing, in particular, is beyond the scope of this book, here are some suggestions about the proper way to preserve finished paintings in acrylic.

Permanent Materials. You can't paint a durable picture unless you use the right materials. All the colors recommended in this book are chemically stable, which means that they won't deteriorate with the passage of time and won't produce unstable chemical combinations when they're blended with one another. However, it's not always a good idea to mix one *brand* of acrylic color with another. The good brands are equally permanent, but there are sometimes slight variations in the formulas of the different manufacturers. The biggest problem isn't the acrylic paint; it's the painting surface, which is often less durable than the paint itself. While you're learning, there's nothing wrong with working on illustration board or canvas board, but remember that the cardboard backing will deteriorate with age. Once you feel that your paintings are worth preserving, work on real artists' canvas or prepare your own boards by coating hardboard with acrylic gesso. And if you're working on watercolor paper, invest in "100% rag" stock, which means paper that's chemically pure and won't discolor with age.

Matting. Like a watercolor, an acrylic painting that's done on paper needs the protection of a mat (called a mount in Britain). You've already read about matting (or mounting) in Part Two on "Watercolor Painting," but you may want to turn back to page 192 on "Preserving Watercolor Paintings" to refresh your memory. Whether your acrylic painting is on a thin sheet of paper or a thick sheet of illustration board, it's *still* on paper, and a mat is essential protection.

Boards and Tape. In the section on "Preserving Watercolor Paintings," I warned you about the importance of using chemically pure, acid-free, museum quality mat board—not the usual (often less expensive) mat board that's made of wood pulp. Of course, one of the temptations of wood pulp board is that it comes in lovely colors, while museum board comes in a more limited color selection. However, it's easy to mix acrylic colors to produce the hue that you want for your mat. Thin the mixture to the consistency of cream and brush it on both sides of the board, so it won't curl. (*Don't* spray acrylic paint onto your mat; all types of airborne paint are bad for your lungs—and the acrylic color is apt to clog your spray gun). I'll also repeat the warning to avoid so-called *pressure sensitive* tapes, such as Scotch tape, Sellotape, masking tape, or drafting tape. The best tape for holding your painting to the mat or the backing board—you can do it either way—is the glue-coated cloth that librarians use for repairing books. Or make your own tape out of drawing paper scraps and white, water-soluble paste.

Framing. If you're planning to hang an acrylic painting that's done on paper or illustration board, the matted picture must be placed under a sheet of clear glass (or plastic) and then framed. Most painters feel that a matted picture looks best in a simple frame: slender strips of wood or metal in muted colors that harmonize with the painting. Avoid bright mat colors or ornate frames that command more attention than the picture. An acrylic painting on canvas, a gesso board, or a canvas board doesn't need a mat or glass. A frame is enough. Since there's no mat, you can choose a heavier, more ornate frame, like those used for oil paintings. If you're planning to make your own mats and frames, buy a good book on picture framing. If you turn the job over to a commercial framer, make certain that he uses museum-quality mat board and tell him *not* to use masking tape or Scotch tape—which too many framers use just to save time and money.

Varnishing Acrylic Paintings. The tough surface of an acrylic painting can be made still tougher with a coat of varnish. The simplest varnish is an extra coat of gloss medium, thinned with some water to a more fluid consistency than the creamy liquid in the bottle. At first, this coat of medium will look cloudy on the painting, but will soon dry clear. If you want a non-glossy finish, follow the coat of gloss medium with a coat of matte medium, again diluted with water to a fluid consistency. If the manufacturer of your colors recommends that you use a varnish that is different from the medium, follow his advice. Apply the medium or varnish with a big nylon housepainter's brush. Work with straight, steady strokes. Don't scrub back and forth too much or you'll produce bubbles. For an acrylic painting framed under glass, varnish is optional. Without glass, a coat or two of varnish will give you a surface that cleans with a damp cloth and resists wear for decades to come.

PART FOUR

PORTRAIT AND FIGURE PAINTING

Color Selection. For mixing flesh and hair tones, portrait and figure painters lean heavily on warm colors—colors in the red, yellow, orange, and brown range. As you'll see in a moment, these colors dominate the palette. However, even with a very full selection of these warm colors, the palette rarely includes more than a dozen hues.

Reds. Cadmium red light is a fiery red with a hint of orange. It has tremendous tinting strength, which means that just a little goes a long way when you mix cadmium red with another color. Alizarin crimson is a darker red with a slightly violet cast. Venetian red is a coppery, brownish hue with considerable tinting strength too. Venetian red is a member of a whole family of coppery tones that include Indian red, English red, light red, and terra rosa. Any one of these will do.

Yellows. Cadmium yellow light is a dazzling, sunny yellow with a tremendous tinting strength, like all the cadmiums. Yellow ochre is a soft, tannish tone. Raw sienna is a dark, yellowish brown as it comes from the tube, but turns to a tannish yellow when you add white—with a slightly more golden tone than yellow ochre. Thus, yellow ochre and raw sienna perform similar functions. Choose either one.

Orange. You can easily mix cadmium orange by blending cadmium red light and cadmium yellow light. So cadmium orange is really an optional color—though it is convenient to have.

Browns. Burnt umber is a rich, deep brown. Raw umber is a subdued, dusty brown that turns to a kind of golden gray when you add white.

Blues. Ultramarine blue is a dark, subdued hue with a faint hint of violet. Cobalt blue is bright and delicate.

Green. Knowing that they can easily mix a wide range of greens by mixing the various blues and yellows on their palettes, many professionals don't bother to carry green. However, it's convenient to have a tube of green handy. The bright, clear hue called viridian is the green that most painters choose.

Black and White. The standard black used by almost every oil painter is ivory black. Buy either zinc white or titanium white; there's very little difference between them except their chemical content. Be sure to buy the biggest tube of white that's sold in the store; you'll use lots of it.

Linseed Oil. As I pointed out in Part One on "Oil Painting," your tube color contains some linseed oil, but just enough to produce a thick paste that you may find *too* thick for free brushwork. So most oil painters buy a small bottle of linseed oil, pour some into the palette cup (or "dipper"), and add some oil to the tube color as they work. Some portrait and figure painters prefer one of the heavier versions of linseed oil, called stand oil or sun-thickened oil. You might try them too.

Turpentine and other Solvents. As you read in Part One on "Oil Painting," turpentine is the traditional solvent for oil paint. I suggested that you buy a big bottle so you can pour a bit into your second palette cup (or "dipper") to dilute your tube color, and pour a larger quantity into a jar for cleaning your brushes as you work. If you dislike the odor of turpentine—or you're actually allergic to it—try mineral spirits (called white spirit in Britain) or one of the new petroleum solvents now sold in art supply stores. Whatever solvent you choose, work in a well-ventilated room so you don't breathe evaporated solvent. And keep it off your skin.

Painting Mediums. You probably recall my pointing out that the simplest and most widely used painting medium—for making your color mixtures more fluid—is just a 50-50 blend of linseed oil and turpentine. And I also suggested that you try a readymade blend of linseed oil, turpentine, and resin—damar, copal, or mastic—also sold in small bottles in art supply stores. Still another interesting possibility is the new alkyd medium, which comes in liquid or gel form. (The gel is sold in a tube.) Alkyd medium adds luminosity to your color mixtures, like the other resins, but also accelerates drying. The more medium you blend into your paint, the faster your painting will dry. This can be enormously helpful if you're painting a portrait under the pressure of a deadline. And if you like the behavior of oil paint with alkyd medium, you can buy alkyd tube colors, which behave like fast-drying oil paint.

Palette Layout. Before you start to paint, squeeze out a little dab of each color on your palette, plus a *big* dab of white. Establish a fixed location for each color so that you can find it easily. One good way is to place your *cool* colors (black, blue, green) along one edge and the *warm* colors (yellow, orange, red, brown) along another edge. Put the white in a corner where it won't be soiled by the other colors.

Buying Brushes. As I said when I talked about buying brushes in Part One on "Oil Painting," buy the biggest and the best you can afford. It's better to buy a few really big and really good brushes than a fistful of small, inferior ones. You'll save money in the long run because the good brushes will outlast the mediocre ones. Top quality brushes will also save you a lot of aggravation because they're more satisfying to paint with.

Recommended Brushes. If you go back and reread page 11, you'll see that I suggested buying your brushes in pairs: two big bristles for large color areas, two medium-sized ones for somewhat smaller passages, and so on. The usual oil painting tools are bristle brushes for big, bold strokes; flat sables or the less expensive oxhairs for smoother strokes and for blending; and round sables or oxhairs for linear details and accents, like eyebrows and highlights. But you might also enjoy trying some of the new synthetics that have come along in recent years, specifically the red and white nylon brushes that behave amazingly like the more expensive sables, but cost far less money. The white nylons are especially interesting because they tend to be a bit stiffer than sables, but softer than bristles. This makes them particularly good for portrait and figure painting. Don't worry if your local art supply store just sells the white nylon brushes with the short handles used for watercolor painting. You can still use them for oils. And I might add that nylon brushes are delightfully easy to clean after a day of painting!

Knives. Don't forget to keep a palette knife on hand for mixing colors on the palette or scraping them off the canvas when you want to make a correction. If you'd like to try painting portraits or figures with a knife, buy several of the flexible, diamond-shape *painting knives* in different sizes. Don't waste your time trying to paint with a palette knife; it's too stiff and the blade is the wrong shape.

Painting Surfaces. Most beginning oil painters start out with canvas boards—canvas glued to sturdy cardboard—and that's certainly a convenient, inexpensive painting surface to work on while you're learning your craft. You might also be surprised to know that George Passantino painted many of the portraits and figures in this book on a canvas-textured paper that's specially made for oil painting and sold in pads, just like drawing paper. This is also a cheap, and convenient painting surface for beginners. But once you feel ready to work on the kind of painting surface that professionals use, buy stretched canvas at the art supply store—sheets of white canvas nailed or stapled to a rectangular wooden framework—or buy canvas by the yard and stretch it yourself on the wooden stretcher bars that are sold in varied sizes for this purpose. If you'd like to try painting on a smooth surface—in contrast with the woven texture of canvas—buy sheets of hardboard and coat them with several thin coats of acrylic gesso, a white paint that's made for this purpose.

Easel, Palette, Paintbox. For painting portraits and figures in oil, you can use the same sort of easel, paintbox, and palette that I recommended for beginning oil painters on page 11. However, you might want to buy an extra-large palette for all those subtle color mixtures. Or just try a sheet of thick glass resting on white paper on a table.

Odds and Ends. To hold turpentine, linseed oil, or painting medium, buy two metal palette cups (or "dippers"). Make a habit of collecting absorbent, lint-free rags to wipe mistakes off your painting. Paper towels or old newspapers (a lot cheaper than paper towels) are essential for wiping your brush after rinsing it in turpentine.

Furniture. Be sure to have a comfortable chair or couch for your model. Not many people have the stamina to *stand* for hours while they're being painted! If you're working at an easel, you're probably standing while the model sits or sprawls—which means that the model is below your eye level. That's why professional portrait and figure painters generally have a model stand. This is just a sturdy wooden platform or box about as high as your knee and big enough to accommodate a large chair or even a small couch. If you're handy with tools, you can build it yourself. (Of course, you can always work sitting down!) Another useful piece of equipment is a folding screen on which you can hang pieces of colored cloth—which can be nothing more than old blankets—to create different background tones.

Lighting. If your studio or workroom has big windows or a skylight, that may be all the light you need. Most professionals really prefer natural light. If you need to boost the natural light in the room, don't buy photographic floodlights; they're too hot and produce too much glare. Ordinary floor lamps, tabletop lamps, or hinged lamps used by architects will give you softer, more "natural" light. If you have fluorescent lights, make sure that the tubes are "warm white."

Front View. Memorize the proportions of a "classic" head. Although no two heads are *exactly* alike, most heads are slight variations of this basic scheme. Seen from the front view, the "classic" head is taller than it is wide. The eyes are about midway between the top of the head and the chin. The underside of the nose is about midway between the eyes and the tip of the chin, while the edge of the lower lip is roughly midway between the tip of the nose and the tip of the chin. At its widest point, usually halfway down the head, the head is "five eyes wide." The space between the eye and the ear is the width of one eye. So is the space between the eyes.

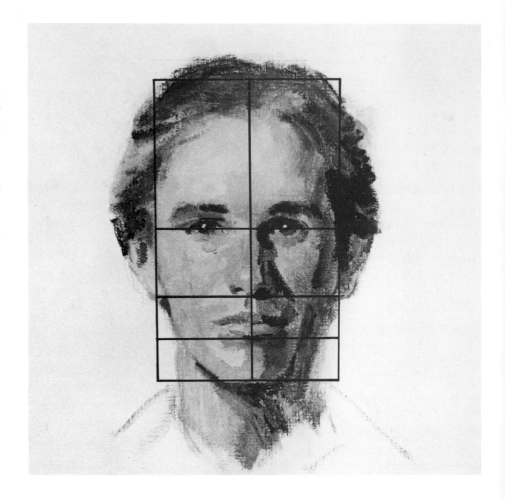

Profile View. Seen from the side, the "classic" head reveals the alignment of the features. The corner of the eye lines up with the top of the ear. The underside of the nose lines up with the lower edge of the ear-lobe. The lower lip lines up with the squarish corner of the jaw. Measuring from top to bottom and from front to back, the height and the width of the head are roughly equal in this side view. Without the neck the entire head would fit quite neatly into a square box.

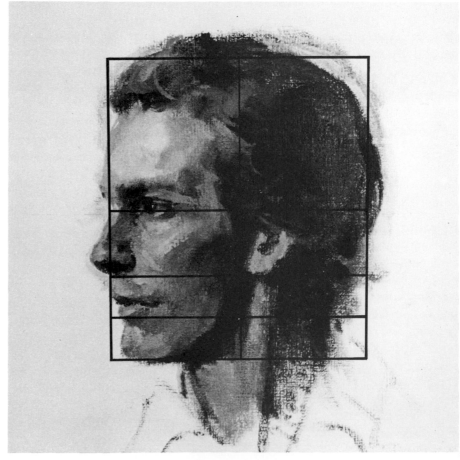

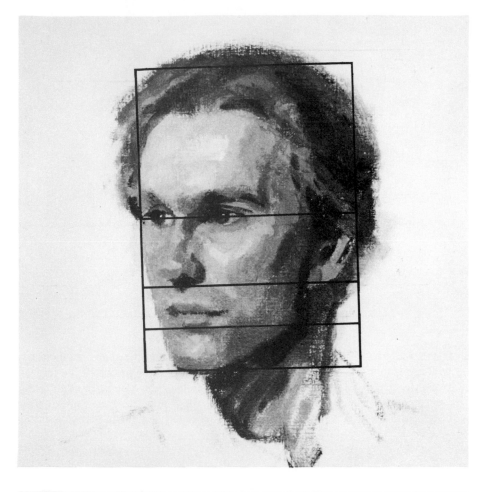

3/4 View. Even when the head turns slightly—so it's no longer a front or side view—the proportions remain essentially the same. The eyes are still halfway down the head and they line up with the top of the ear. The bottom of the nose is still midway between the eyes and the chin, aligning with the lower edge of the earlobe. And the lower lip still falls midway between the tip of the nose and the tip of the chin, lining up with the corner of the jaw.

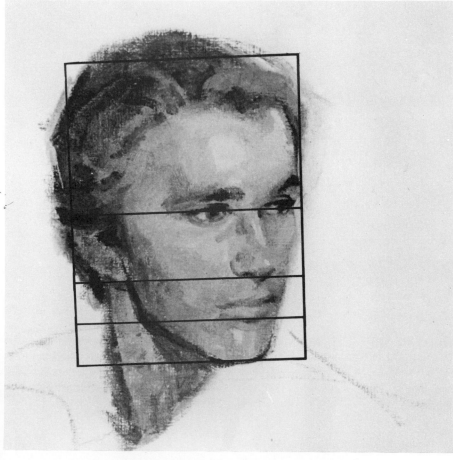

3/4 View. This is also a 3/4 view, but now the head is seen from slightly above. The proportions are fundamentally the same, but you'll discover some very subtle differences if you look closely. The most obvious difference is that you see more of the top of the head. If you draw a line through the corners of the eyes, that line will slant downwards slightly from right to left. So will all the lines that are parallel with the line of the eyes. The dark, diagonal line of the jaw also has a slightly steeper slant. From this angle the nose looks just a bit longer, and you see less of the tops of the eyes. In painting a portrait note these subtle differences, but never lose sight of the essential proportions of the head.

Step 1. A round, softhair brush defines the shapes and proportions of the head. Tube color is thinned with turpentine to the consistency of watercolor. The face is defined as an oval. Just a few lines locate the features. Notice the vertical center line that divides the face symmetrically and helps you to place the features more accurately.

Step 2. Next, a bristle brush defines the shapes of the shadows with broad strokes. The light comes from the left, so there are shadow planes on the right side of the hair, forehead, eye socket, cheek, lips, jaw, chin, and neck. Now there's a clear distinction between light and shadow. The face already looks three-dimensional.

Step 3. A bristle brush covers the lighted area of the face—the forehead, brow, ear, cheek, nose, upper and lower lips, and the lightstruck patch on the cheek that's in shadow. Now the brush begins to add some halftones (lighter than shadows, but darker than lights) on the cheek, jaw, chin, and neck. Dark strokes begin to define the eyes and ear.

Step 4. More halftones are added to model the forms of the hair, ear, eyes, nose, mouth, and chin. A bristle brush begins to blend darks, lights, and halftones together. Dark strokes sharpen the edges of the features, and some touches of darkness bring the shoulders forward.

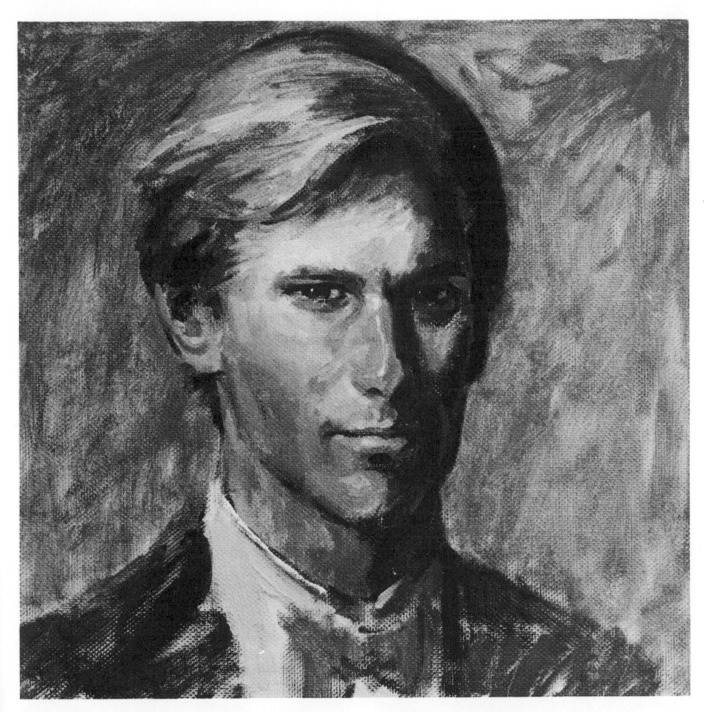

Step 5. In this final stage, a bristle brush strengthens the darks and the lights, blends the tones together, and adds the last touches of detail. Bristle brushes add darker strokes to deepen the shadows and the halftones, then pick up pale color to brighten the lights on the forehead, brow, cheeks, lips, and chin. These tones are brushed together with soft, back-and-forth strokes that blur the transitions between light, halftone, and shadow. The tip of a round softhair brush adds the dark lines of the eyebrows, eyes, nostrils, lips, and ear. This same round brush adds highlights to the eyes and touches of light along the nose and lips. A bristle brush suggests the texture of the hair with swift, spontaneous strokes that follow the direction of the hair. The background is darkened and the portrait is complete. Remember the sequence of operations. The preliminary brush drawing defines shapes and proportions. The darks establish the light and shadow planes of the face. Lights and halftones come next. Darks, lights, and halftones are amplified and brushed together. Finally, the darks, lights, and halftones are further defined and adjusted—and the painting is completed with crisp touches of dark and light that define the features. You may have noticed that the background tone appears early in the development of the picture and is then modified in the final stage as the head is completed. A professional always remembers that the background is part of the picture—not an afterthought—and he works on the background as he works on the head.

Step 1. A round, softhair brush draws the contours of the head, hair, neck, and shoulders. After placing a vertical center line through the head, the brush draws horizontal guidelines to locate the features.

Step 2. Working with slightly darker color, the brush draws the shapes of the eyes, nose, and mouth.

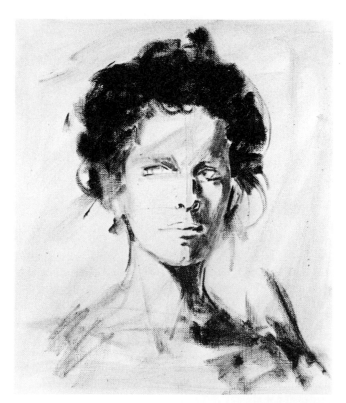

Step 3. A bristle brush places the darks on the face, neck, and shoulder, indicates the darks within the features, and covers the mass of hair.

Step 4. A bristle brush covers the lighted side of the face and the lighted sides of the features with a pale tone. This tone is carried downward over the lighted areas of the neck and shoulder.

Step 5. Halftones are paler than shadows but darker than the light areas. Now these halftones are placed in the eye sockets, on the nose, and where the lights and shadows meet on the forehead, cheek, and chin.

Step 6. The lights, halftones, and shadows are brushed softly together. Now the tones are smoother and more continuous. A small brush darkens the shadows and sharpens the lines of the eyes, nose, and mouth.

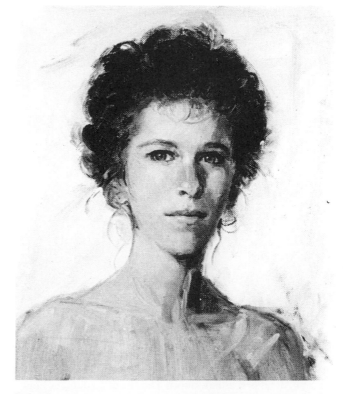

Step 7. A bristle brush strengthens the lights on the forehead, cheek, nose, lips, chin, neck, and chest. These touches of light are blended into the surrounding tones. A small brush begins the details of the eyes.

Step 8. Small brushes add the last details: the curls of the hair; the dark lines of the upper eyelids; the contours of the mouth and the dark corners of the lips.

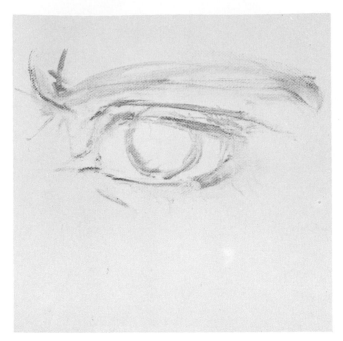

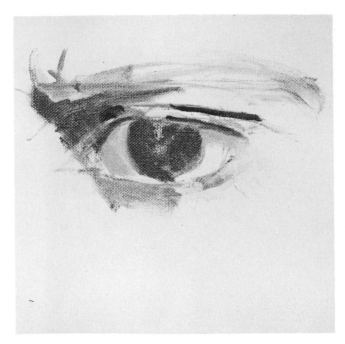

Step 1. A round softhair brush sketches the lines of the eyebrow, the lid, and the eye itself. Memorize the subtle contours of the lids. Starting from the outer corner, the top lid follows a long, flat curve, turning downward at the inside corner. The lower lid does the opposite, starting from the inside corner as a long, flat curve, then turning upward at the outside corner.

Step 2. A bristle brush scrubs in the darks: the shadow of the inside corner of the eye socket, the tone of the iris, and the shadow lines within the upper lid. Then a paler tone is brushed in to suggest the delicate shadow on the white of the eye and the shadow beneath the lower lid.

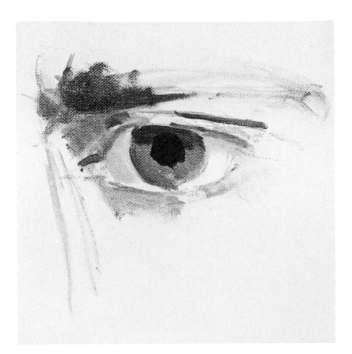

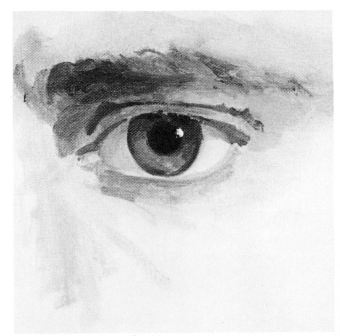

Step 3. The upper lid casts a shadow across the top of the iris—and this tone is added by a flat softhair brush. This same brush adds the dark pupil. The tip of a round softhair brush adds the shadow line in the corner of the eye and then paints a slender strip of light along the edge of the lower lid. A bristle brush begins to scrub in the hair of the eybrow.

Step 4. The tip of a round softhair brush strengthens and refines both the shadows within the upper lid and the shadow cast on the white of the eye. This same brush sharpens the rounded shape of the iris and the pupil, adding a brilliant white highlight. The shadows in the eye socket are strengthened. The round brush extends the eyebrow with delicate, linear strokes.

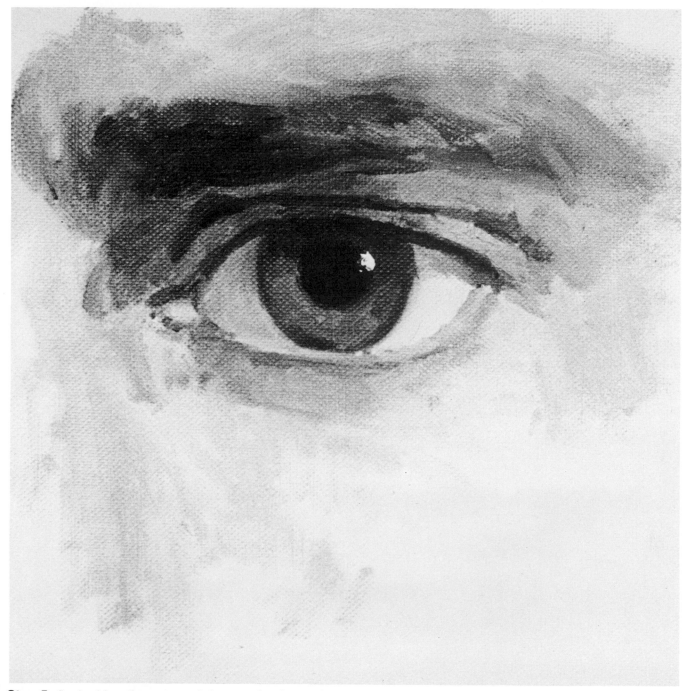

Step 5. Study this enlargement of the completed eye. A bristle brush has added more shadow beneath the brow to make the eye socket look deeper. A round softhair brush has strengthened the shadow lines within the upper lid. Notice the modeling of the lights and shadows on the eye itself. The eye is a rounded form, after all, so the lights and shadows should emphasize its curving shape. Thus the white of the eye is brightly lit at the right but curves gradually into shadow at the left. The three-dimensional form of the eye is emphasized by the strip of shadow that's cast by the upper lid and curves over the ball of the eye. The sequence of painting operations is the same sequence you've already seen in the step-by-step demonstration of the head: brush lines for form and proportion; broad masses of darks, halftones, and lights; final darks, lights, and details.

Step 1. The brush drawing not only defines the bridge of the nose and the nostrils, but also suggests such surrounding structures as the eye sockets and the center line of the upper lip. The lines also make a clear distinction between the shape of the tip of the nose and the "wings" of the nostrils.

Step 2. A bristle brush adds the darks. The light comes from the left and from slightly above, creating deep shadows in the corner of the eyesocket, beside the bridge and the tip of the nose, alongside the nostril "wing," beneath the nose, and on the side of the upper lip. The brush also indicates a halftone for the brow above the bridge of the nose.

Step 3. The halftones and the lighter tones come next. The rounded corner of the eye socket on the lighted side of the face is modeled with a halftone. The nose and the cheeks are painted with lighter tones that are distinctly paler than the surrounding darks.

Step 4. The lights and halftones are strengthened, so you can now see a sharper distinction between the lighted bridge of the nose and the darker tones of the brow, eye socket, and tip. The darks are strengthened with strokes that define the contours of the nose more clearly, shape the "wings" of the nostrils, and indicate the darks of the nostrils themselves.

Step 5. In this final stage, the lighted bridge of the nose and the lighted cheek are adjusted with paler color. Additional dark strokes model the eye sockets and strengthen the shadow that's cast by the tip of the nose across the upper lip. Where the darks, lights, and halftones meet, they're gently brushed together to create soft transitions. You can see this most clearly in the tip of the nose, which now looks softer and rounder than in Step 4. Wherever shadow meets light or halftone, there's a soft, slightly blurred transition—except at the bridge of the nose, where a hard, dark edge suggests the sharp contour of the bone. With all the broad tones completed, a small softhair brush moves over the face to strike in touches of light such as the highlights on the nose and the light strokes where the nostril "wing" meets the cheek and upper lip. These final touches of light give luminosity to the skin.

Step 1. The brush draws horizontal lines for the top of the upper lip, the division between the lips, and the bottom of the lower lip. It's important to visualize the mouth in relation to the nose and the chin, which are also indicated with quick touches of the brush. A vertical center line divides the face into equal halves and helps you to place the features symmetrically.

Step 2. The darkest notes are placed first—the underside of the upper lip, the shadow beneath the lower lip, and a nostril. Halftones define the planes above and below the lips, including the concave valley that joins the nose and the upper lip. The lightest tones are placed within this valley, at the center of the upper and lower lip, and at the center of the chin.

Step 3. Dark strokes are added to suggest the shadow that's cast by the corner of the nose plus the shadow on the side of the chin. Halftones are added around the lips and chin. The brush begins to blend these tones together with casual strokes that merge darks, halftones, and lights.

Step 4. The darks are strengthened with precise strokes that sharpen the contours of the lips, nose, and chin. The light planes are made still lighter to emphasize the contrast between light and shadow, making the face look more three-dimensional. A pointed brush sharpens the dividing line of the mouth, deepens the shadow beneath the lower lip, and adds the nostrils.

Step 5. In this enlarged close-up of the finished study of the mouth, you can see how the tones have been softened and blended to make the face look rounder and more lifelike. The brush has blurred the edges of the darks to make the nostrils and the lips look softer and rounder. Much of the scrubby brushwork around the mouth has been softened to make the strokes flow together more smoothly. Soft, blurry strokes of light have been added to the lower lip and the chin, which now come forward more distinctly. Notice how the corner of the mouth at the left has been darkened and softened. As you paint the mouth, you'll notice that the upper lip is usually in shadow, while the lower lip tends to catch the light. Beneath the lower lip there's another pool of shadow. As the chin curves outward, it catches the light and then moves back into shadow as it curves inward at the very bottom.

Step 1. The brush drawing defines the general shape of the ear and then locates the ear in relation to the eye, nose, cheek, and jaw. The curve of the cheek comes right next to the ear. The top of the ear aligns with the corner of the eye, while the lobe lines up with the nose. The angular corner of the jaw is well below the ear and level with the mouth.

Step 2. Dark strokes define the two deep shadows within the ear, the shadow beneath the lobe, the shape of the hair, and the dark edge of the jaw, which continues up past the lobe. With just these few dark touches, the ear already begins to look three-dimensional.

Step 3. The two pools of shadow within the ear are carried downward with strokes of halftone. The rest of the ear is covered with a pale tone that represents the light. Now the planes of the ear are clearly defined in three distinct tones: darks, halftones, and lights. So far, only the major planes of the ear have been defined.

Step 4. Now the brush adds more lights and halftones to define the smaller forms of the ear. A single stroke suggests the valley that appears just below the top rim—and a touch of light appears where the rim shines against the hair. Small strokes of halftone make the lobe look rounder where the ear joins the jaw.

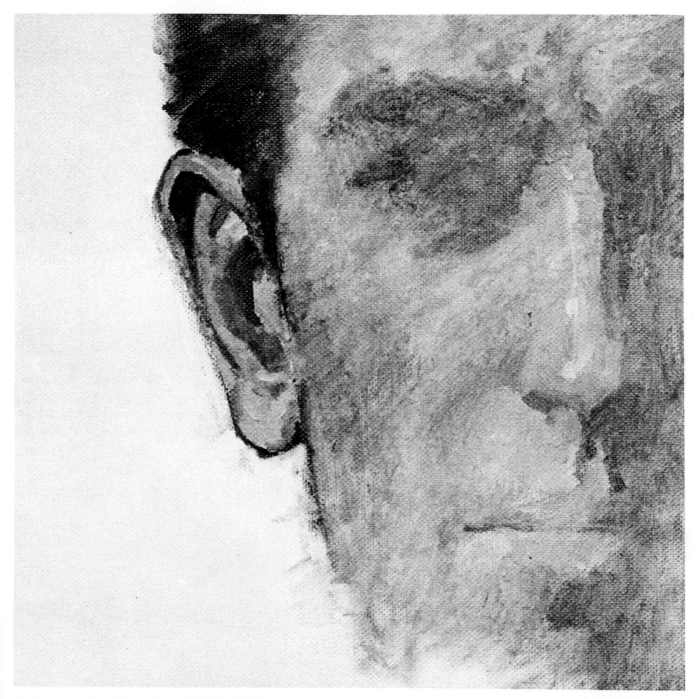

Step 5. A small softhair brush carefully blends the edges of the darks with the halftones and the lights. You can see this most clearly in the two pools of shadow, which are softened and blurred to make the tones flow together more smoothly. The point of the brush adds touches of darkness beneath the rim, within the hollow of the ear, and at the corner of the lobe. Then this same brush adds touches of light within the ear and the lobe. Now there's a much sharper contrast between the lights and shadows, although they flow softly together to make the forms of the ear look round and solid.

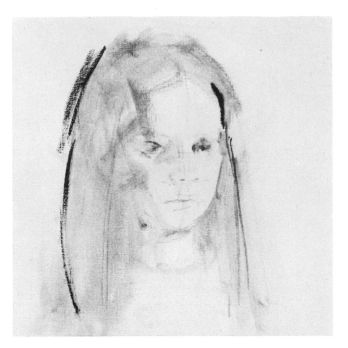

Step 1. A round softhair brush draws the contours of the head and then locates the features with tube color thinned with turpentine to the consistency of watercolor. A flat bristle brush picks up this color and begins to suggest the shadows on the hair, forehead, cheek, jaw, and neck; it also adds touches of shadow within the eyesockets.

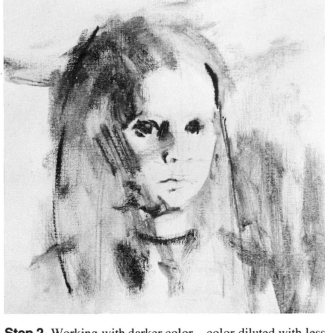

Step 2. Working with darker color—color diluted with less turpentine—a small bristle brush darkens the shadows on the hair, forehead, cheek, jaw, chin, and neck. The shadow is indicated alongside the nose. More darks are added to the eyes. The brush begins to darken the hair and the background. A round brush sharpens the lines of the nose and mouth.

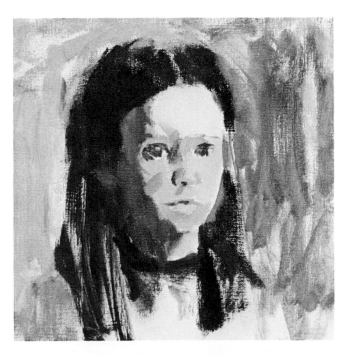

Step 3. The color is diluted with painting medium to the consistency of thin cream. Now a large bristle brush paints the darks as big, flat shapes. Another bristle brush paints the big lighted patches on the front of the face. A small bristle brush begins to add the halftones—those subtle tones that are lighter than the shadows but darker than the lights.

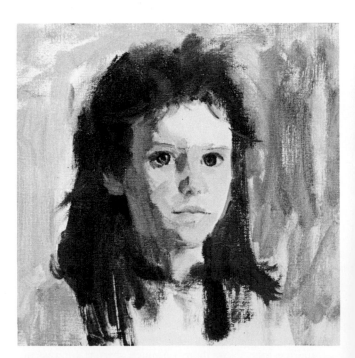

Step 4. Having established the broad pattern of lights, shadows, and halftones, the large bristle brush begins to adjust these tones. Paler mixtures are brushed over the hair and into the shadow side of the face and neck. Stronger darks are added to the shadow side of the nose. Small brushes strengthen the tones and details of the eyes, nose, and lips.

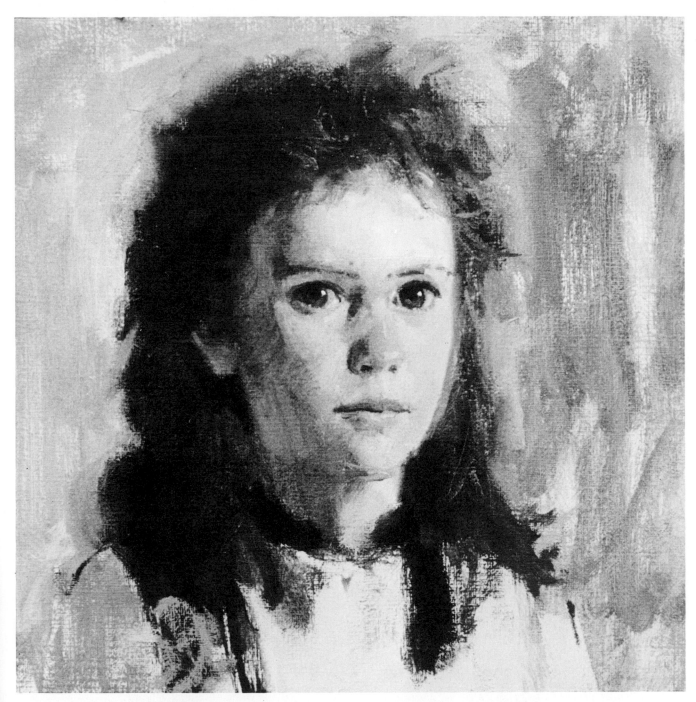

Step 5. The blending of the lights, shadows, and halftones is saved for the final stages. Now a flat brush—which can be either a bristle or a softhair—softens the areas where lights, halftones, and shadows meet. The brush, however, doesn't "iron out" the original strokes, but allows the lively, casual brushwork to remain. You can see this most clearly on the shadow side of the cheek and jaw. A big bristle brush moves over the hair, blending the strokes, softening the tones, and roughening the edges of the hair where it melts away into the background. At the left the big bristle brush blends and smoothes the background tone to contrast with the rough brushwork of the hair; the original background strokes, however, remain untouched at the right. The final touches and details are saved for the very end. The tip of a round softhair brush completes the eyes and the eyebrows and then moves down to sharpen the contours of the nose and mouth. The small brush doesn't overdo these details. One nostril is more distinct than the other. The dark line between the lips fades away at the right. The tip of the small brush adds just a few highlights to the eyes, the nose, and the lower lip. Observe how the outer contours of the face remain soft and slightly blurred. This is produced by free, casual brushwork that's particularly suitable for the softness of a young girl's face.

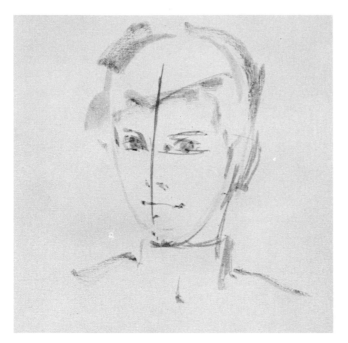

Step 1. The portrait begins with a brush drawing in tube color diluted with turpentine. A round softhair brush draws the oval shape of the face, the curves of the hair, and the lines of the neck, collar, and shoulders. To place the features accurately, the brush draws a vertical center line through the face. The eyes are placed on either side of that line, while the nose and mouth cross it.

Step 2. A big bristle brush blocks in the shadows with color that's diluted with painting medium to the consistency of thin cream. The brush also locates dark patches within the eyes and ear. Another bristle brush begins to cover the lighted patches of the face. The brush moves quickly to establish the broad pattern of lights and shadows—it's not important to cover the canvas evenly.

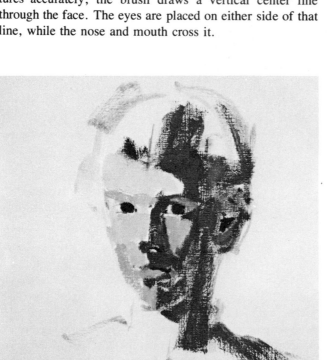

Step 3. A bristle brush completes the tonal pattern of the face by adding the halftones that appear within the eye sockets, between the eyes, and on the cheeks, lower lip, and chin. The lights, halftones, and shadows are as flat and simple as a poster.

Step 4. Now a big bristle brush begins to adjust the tones. First the brush completes the shadow side of the hair, darkens the back of the neck, and covers the lighted plane of the hair. Then the brush adds more halftones to the eyes, nose, cheeks, and chin. The tip of a round brush begins to refine the contours of the eyelids and mouth. The brushwork is still broad and flat.

Step 5. The face and hair are now completely covered with tone, and a bristle brush begins the job of softening and blending. The brush moves over the areas where light, shadow, and halftone meet, softly brushing them together to make the face look round and three-dimensional. You can see these soft transitions most clearly where the shadow meets the light on the forehead, cheek, and chin. Notice that the shadow doesn't meet the light abruptly; there's always a suggestion of halftone that forms the bridge between the shadow and the light. A small bristle brush also adjusts the tones, darkening the shadow on the side of the nose, filling the eye sockets with more tone, and strengthening the con- tours of the lips. Compare Step 4 and Step 5 to see how the hard line of the jaw is now blurred softly into the dark shadow of the neck. Having made these necessary adjust- ments in the tones, the small bristle brush then moves over the hair to pick out individual locks with light and dark strokes. As always the precise brushwork is saved for the very end, when the face is completed with the last touches of detail. The tip of a round brush sharpens the lines of the eyelids, strengthens the eyebrows, and defines the line where the lips meet. Scan the entire head and you'll see that this is the only precise brushwork in the portrait. Every- where else the strokes are broad and rough.

Step 1. The preliminary brush drawing defines the outer shape of the eye, the line of the upper lid, and the circle of the iris, which is overlapped by the upper lid. (Remember that you almost never see the full circle of the iris.) A hint of tone suggests the darker color of the iris plus the shadow that's cast by the upper lid on the iris and on the white of the eye.

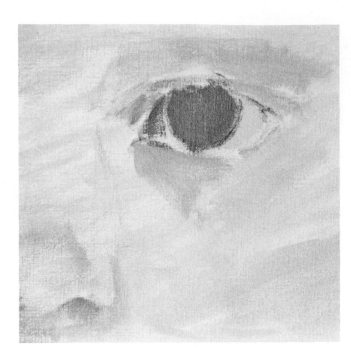

Step 2. A very soft tone is brushed above and below the eye to suggest the delicate shadows within the eye sockets. The iris is covered with a flat tone. Some of this tone is added to the shadowy inner corner of the eye. A paler tone is brushed over the white of the eye.

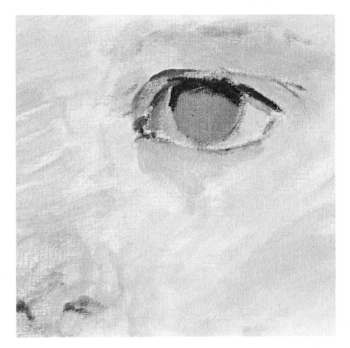

Step 3. The tip of a round brush adds the slender shadow lines that appear along the edges of the lids. The brush also adds the curving shadow that the upper lid casts on the iris and on the white of the eye, which you can see most clearly at the right. The shadowy inner corner of the eye is blended with a softhair brush.

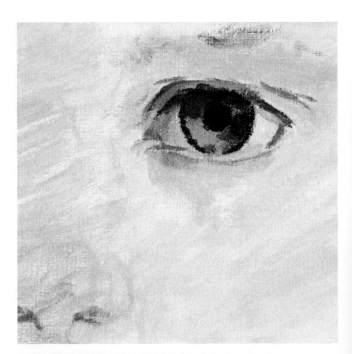

Step 4. The shadowy upper lid is darkened slightly. Then the iris is darkened too, and the pupil is added at the center. The tip of a round brush traces the dark edge of the iris. The same round brush strengthens the outer contours of the eye and blends the shadow that's cast by the upper lid.

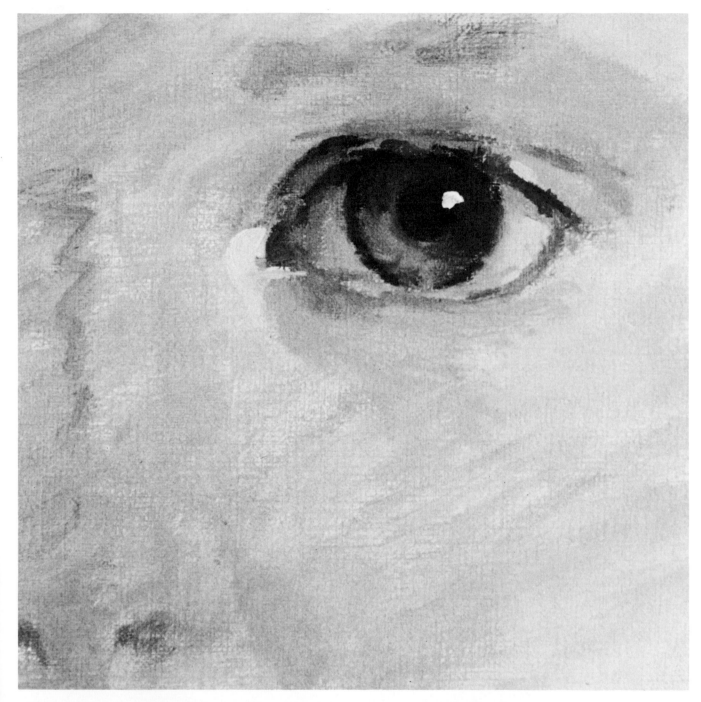

Step 5. By the end of Step 4, the tonal pattern of the eye is completely established. Now the tip of a round softhair brush makes the final adjustments, blends the tones, and adds the last details. The dark and light areas of the iris are blended softly together, while the dark edge is softened and blurred. The tip of the brush darkens the shadowy edges of the lids and strengthens the shadow at the inner corner of the eye. A crisp shadow line is added beneath the upper lid at the outside corner of the eye. A single bright highlight is added to the pupil—not at the center, but off to one side. A few pale, scrubby strokes suggest the child's eyebrow without actually drawing a single hair. Study the shape of the eye carefully. Notice that the top is a flat curve that turns sharply downward toward the inner corner. Conversely, the lower edge of the eye is a flat curve that turns sharply upward at the outer corner. It's rare to see deep shadows within a small child's eye sockets. The strong contrasts of light and shadow generally occur within the eye itself, not beneath the eyebrow or around the lids, which tend to be pale and smooth.

Step 1. A round softhair brush draws the contours of the nose at the same time as all the other features. The brush indicates the shadow above the bridge of the nose, the shadow on one side of the nose, the nostrils and the shadowy underside of the nose, the valley beneath the nose, and the diagonal shadow that's cast by the nose downward to the upper lip.

Step 2. A bristle brush covers the original brush lines with solid tones. Now there's a strong shadow on one side of the nose, leading from the eye socket down the bridge of the nose to the nostril. The shadowy underside of the nose is indicated by a soft tone that's carried diagonally downward over one side of the upper lip.

Step 3. A big bristle brush adds the lights and halftones on the nose and the surrounding cheeks, brow, and upper lip. A smaller bristle brush strengthens the darks on the shadow side of the nose, indicates the nostrils, and solidifies the shadow that's cast by the nose over the upper lip. At the same time, work continues on the other features.

Step 4. It's time to begin adjusting the tones. The brush solidifies the big shadow on the side of the nose into one continuous tone and then softens and lightens the harsh shadow strokes that appear in Step 3. The lighted planes of the nose, cheeks, and upper lip also become softer and paler. The tip of a round brush begins to define the nostrils more precisely.

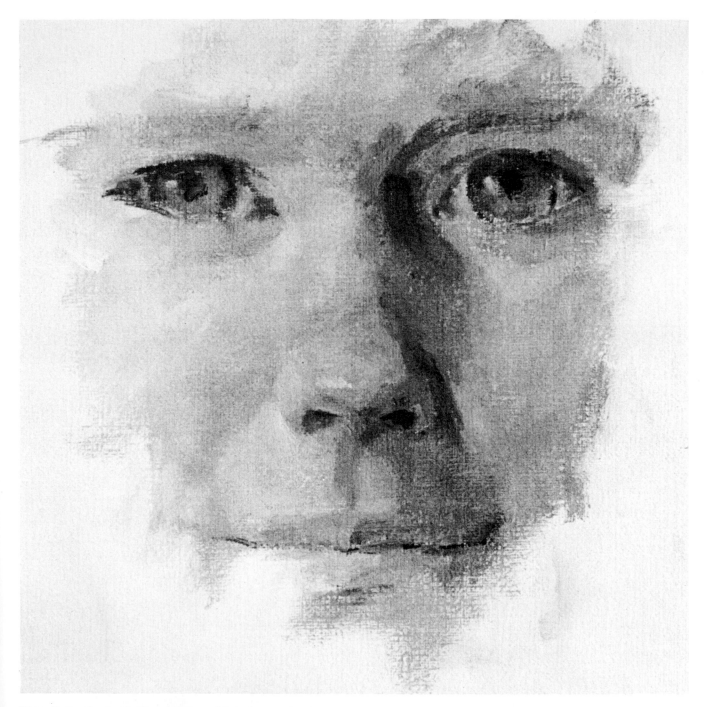

Step 5. In the final stage a flat, softhair brush blends the shadow side of the nose delicately into the lighted cheek at the right. This same brush softens the meeting place of the lighted front of the nose with the shadow side. The blending action of the softhair brush makes the underside of the nose look rounder and then blurs the cast shadow on the upper lip. The shadow side of the nose is strengthened in only one place; the flat softhair brush adds a single dark where the bridge of the nose meets the corner of the eye socket. Then the tip of a round softhair brush completes the job by sharpening the dark shapes of the nostrils and adding a highlight at the tip of the nose. Throughout the child's face the softhair brush carefully blurs all harsh lines except for the edges of the eyelids, the darks of the nostrils, and the slender line where the lips come together.

Step 1. A round softhair brush begins by drawing the outer contours of the jaw and chin. The brush draws a vertical center line and then draws the horizontal lines that locate the nose and lips. With these guidelines the brush lightly draws the upper lip, darkens the line between the lips, and suggests the shadow beneath the lower lip.

Step 2. A small bristle brush fills the upper lip with a solid tone and then repeats this tone *beneath* the lower lip. The upper lip is usually in shadow, while the lower lip is usually brighter. The brush also suggests a touch of shadow at the corner of the nose alongside the upper lip as well as the shadow under the chin.

Step 3. A big bristle brush covers the shadow side of the face with a broad, continuous tone. A smaller bristle brush paints the shadowy side plane of the lower lip and then adds the lighted areas. A big bristle brush covers the lighted planes of the face above and below the lips. The shadow beneath the lower lip is strengthened, and a touch of shadow is added to the chin.

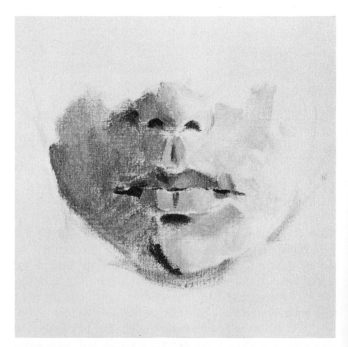

Step 4. The round brush continues to define the light and shadow planes of the lips, which are more complex than they might seem at first glance. The corners of the lips are darkened. A shadowy cleft divides the lower lip, and a touch of shadow is added to accentuate the central curve of the upper lip.

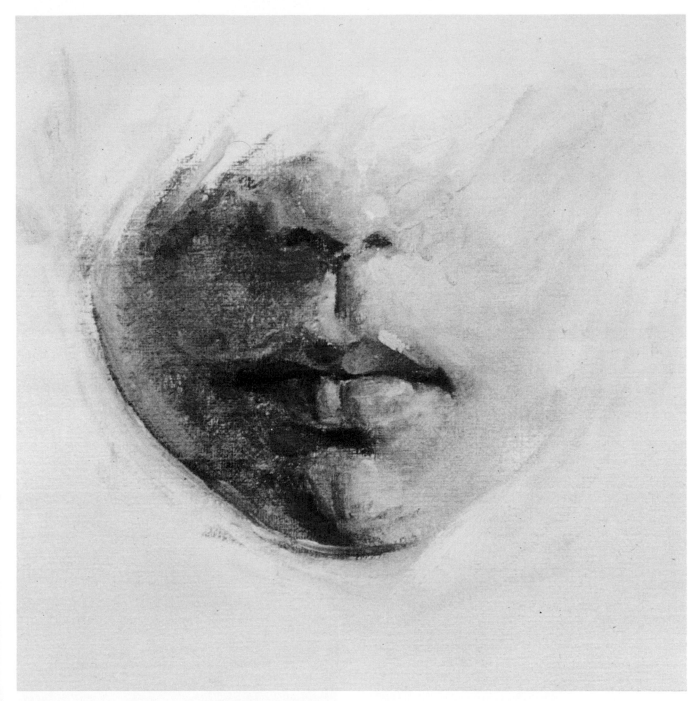

Step 5. Softhair brushes—both round and flat—blend and modify the tones and add the final details. The shadow sides of the upper and lower lips (at your left) are darkened and blended softly into the surrounding skin so that there's no harsh dividing line. The shadow beneath the lower lip is darkened and then blurred softly into the surrounding skin. The lighted areas of the lips are brightened with paler color. The dark corners of the mouth are blurred, and then the tip of the round brush strengthens the dark dividing line where the lips meet. The vertical valley that leads from the nose to the upper lip is clearly divided into a light plane and a shadow plane. There's a dark, distinct stroke where these planes meet. There's a similar valley at the center of the lower lip. All the forms are now quite distinct, but the lights and the shadows blend softly into one another. The tone of the lips blends delicately into the tone of the surrounding skin.

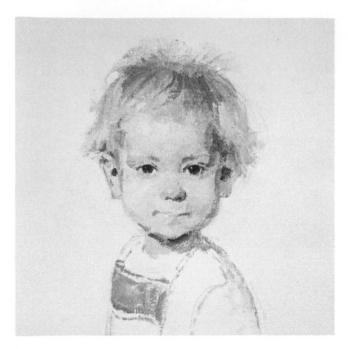

Two Years Old. At this early age a child usually has a very large forehead, round cheeks, and big, bright eyes. On the other hand, the nose, mouth, and chin are small and still undeveloped. The hair is often thin and wispy.

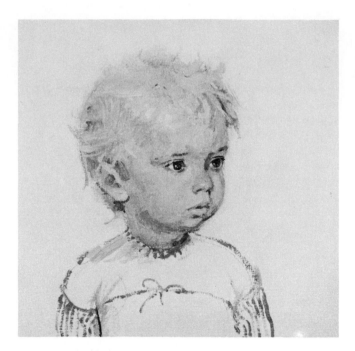

Two Years Old. Seen here from a 3/4 view, the size of the cranial mass—the upper half of the head—is even more obvious. The ear is also quite large in relation to the other features. The nose and lips are tiny and soft. The jaw is round and undeveloped. The neck is slender.

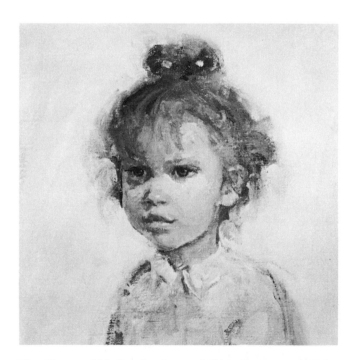

Five Years Old. By the time a child is five years old the forehead and the cranial mass are still large, but they look slightly smaller because the lower half of the face has begun to develop. The contours of the nose and mouth are more pronounced and the jaw has a more distinct shape. The ear is still fairly large in relation to the rest of the features. The neck is still slender and delicate.

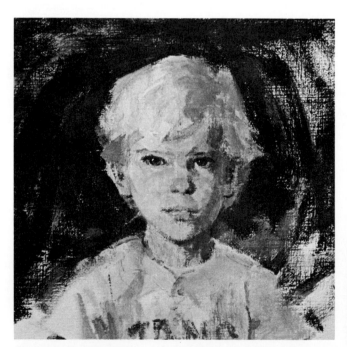

Seven Years Old. The lower half of the face continues to develop. The eyes and ears aren't quite so big in relation to the rest of the face. The bony structure of the nose becomes slightly more apparent. The mouth begins to look more adult. The round cheeks are growing more slender. The bony structure of the jaw becomes firmer and so does the chin.

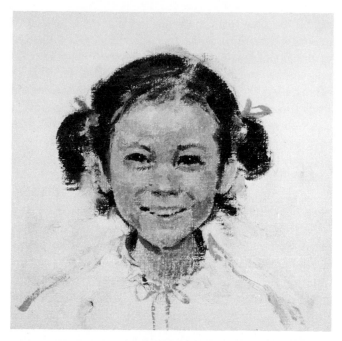

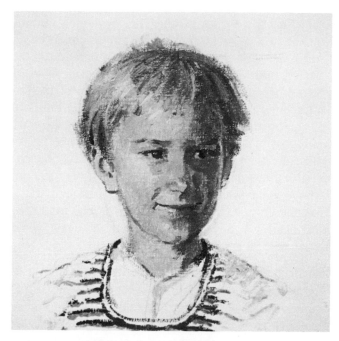

Nine Years Old. The lower half of the face grows more prominent and the features are more sharply defined. The jaw is leaner and the chin is longer and sharper. The mouth grows larger in relation to the other features, while the eyes are a bit less prominent than they were at an earlier age. The ears also look smaller in relation to the other features.

Eleven Years Old. The proportions of the head are very much like those of an adult, although the head is obviously smaller. The head is more elongated and so are the nose and chin. You begin to see the bridge of the nose. The mouth grows more slender, while the lines of the jaw and chin are stronger. The head sits more solidly on the firm cylinder of the neck.

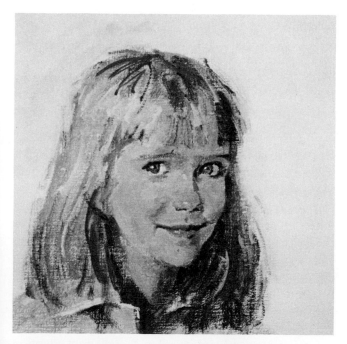

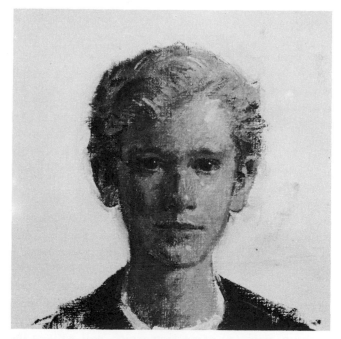

Twelve Years Old. The facial proportions are like those of a mature woman. The line of the brow is sharper. The curves of the cheek, jaw, and chin are more precise. The lines of the mouth are crisp. The eyes are still large and luminous, but they seem smaller in relation to the total head—compared with the five-year-old on the facing page.

Thirteen Years Old. At the beginning of adolescence the face grows longer and leaner. The bony structure becomes more obvious. The nose has a clearly defined bridge. The jaw and chin are firm and solid. The eye sockets grow deeper. The details of the eyelids and mouth are more clearly defined. Yet the face still has a smooth, tender quality because the contours flow softly together.

Deciding the Pose. All the painting demonstrations you see in this book are what the professionals call a "head-and-shoulders." This is what you might call the "basic" portrait. It's also the most intimate kind of portrait because it's essentially a close-up of the sitter's face. At first glance, it may seem easy to establish the pose for such a simple portrait—but there are more possibilities than you might think. Above all, try to find a pose that looks *active*, not static. Ask the sitter to lean his head to the left or right. Have the sitter turn—or you walk around him—until you find the most flattering angle. Some sitters will look (and feel) most natural if they slouch or lean in the chair, while others will prefer to sit upright.

Finding the Flattering View. Portrait sitters usually want to be shown at their best. They want you to emphasize their most attractive features and minimize their least attractive ones. Some portrait painters don't hesitate to reduce the size of a big nose, enlarge a small chin, or square up a weak jaw. Other painters consider this "dishonest." Whether you want to flatter your sitter—by redesigning his face—is your decision. However, another method is to try to find the most flattering *view* of the sitter. A big nose looks even bigger if you paint the head from slightly above—but tends to get smaller if you ask the sitter to tilt his chin upward so that you're painting him from slightly below. That same nose may look unattractive in a profile or three-quarter view, but may become strikingly handsome when the sitter faces you head-on. If a sitter is particularly proud of her luxuriant hair, paint her from slightly above so you can see more hair; this view also emphasizes the eyes and de-emphasizes the chin.

Relaxing the Sitter. The whole painting will go more smoothly if you can keep the sitter relaxed and entertained. Watching television, listening to a radio broadcast, or hearing a record will not only reduce the tedium of sitting for a portrait but will make the sitter look alive and alert. After all, if your sitter is tired and bored, it's difficult to keep that feeling out of the portrait. If you can carry on a natural, relaxed conversation with the sitter—without making it obvious that you're trying too hard—that's an excellent way to keep the sitter entertained. The sitter will look at you with an animated expression which will enliven the portrait. Many professionals place a large mirror behind them so the sitter can see how the portrait is coming along—a process more fascinating than *any* television show!

Experimenting With Lighting. The most common portrait lighting is called 3/4 lighting. The light does not hit the face from the front, but hits it slightly from one side; thus *most* of the face is in light, but the angle of the light creates clearly defined shadow planes on one side of the brow, cheek, jaw, and nose. This is often called "form lighting" because it emphasizes the three-dimensional quality of the face. Women often like "form lighting" because it makes a round face look rounder, while men often like it because they feel that the strong contrast between light and shadow makes them look more masculine. On the other hand, there are times when you want to emphasize the softness and delicacy of the face by using frontal lighting. When the light strikes the face head-on, rather than from the side, shadows tend to melt away, softening harsh features and de-emphasizing wrinkles. Move the sitter around—place him or her close to the light, further away, facing the light, facing away—to see how different kinds of light affect each sitter's face.

Making Preliminary Drawings. As you study different poses, angles, and kinds of lighting, it's helpful to make quick pencil sketches of all these possibilities. These don't have to be elegant, finished drawings, or even a good likeness. The drawings simply record all the different options. Spread out the drawings and choose the one that represents the best approach to the final portrait. Having chosen the sketch that looks best, some artists dive right into the painting, while others like to make some more drawings of the sitter—or perhaps a quick oil sketch—before they begin the actual painting. This may seem like extra work, but many professionals consider it a shortcut. As he makes these studies, the artist gets to know the contours of the face so intimately that he can execute the final painting without hesitation.

Some Final Do's and Don'ts. Female sitters often insist on going to the hairdresser just before they come to the studio. The fresh hairdo may have a tight, artificial quality that's much less attractive than the sitter thinks. Ask her to go to the hairdresser a day or two before the sitting, so there's time for the hair to soften and become more natural. If she shows up with a hairdo that's just an hour old, tactfully ask her to soften it slightly with her fingers or with a comb. Ask the sitter to dress simply, preferably in solid colors or clothes with a subdued pattern. Urge the sitter to avoid ornate jewelry and violent colors that distract attention from the face. Never tell a sitter to smile; no one can hold a smile long enough for you to paint it. And be sure to let the sitter take a break—for a walk, a rest, a snack—every twenty or thirty minutes.

Getting to Know the Sitter. When you begin to paint children's portraits, it's best to start with sitters whom you already know—members of your family, friends, neighbors. Since you already know them, your sitters will be fairly relaxed with you. And it's easy to talk to them about how you'd like them to pose, what you'd like them to wear, and how you'd like their hair done. But if the sitter is just a casual acquaintance, or perhaps a stranger, it's a good idea to take some time to get to know the sitter and establish a relaxed, friendly relationship before you begin to paint. When a professional specializes in painting children, he often invites the sitter to the studio a few days before the first painting session—or pays a preliminary visit to the sitter's home, if that's where the portrait will be done. Each professional has his own way of making friends with the sitter. Children are fascinated by the process of painting, and a child may respond with great interest if you show him your paints and brushes, explain how they're used, and perhaps let the child handle them. Other professionals are good at the friendly chitchat that puts a child at ease. To paint children's portraits, you've really got to *like* children—and lots of professionals are perfectly comfortable sitting on the floor, playing with the child and his toys. Some artists make friends with the sitter by using that first session to make some preliminary portrait sketches while the sitter watches, asks questions, and generally enjoys seeing an artist at work. Whether that first session takes place a week before you start to paint or just half an hour before the painting session, it makes the job a lot easier.

Talking to Children. The whole secret in talking to children is to be yourself and to treat the child as a *person*. Small children are *not* amused by "baby talk." Teenagers are *not* impressed when adults pepper their conversations with teenage expressions—which sound natural when a kid uses them, but sound silly and artificial when an adult tries to use them in order to seem like a teenager. Young people of all ages respond to honest, straightforward conversation. Talk simply and openly about yourself, your work, and the portrait. Ask questions and encourage your sitter to ask questions. Don't struggle to make clever conversation or tell lame jokes. The conversation will move along quite naturally if you just talk about how you hope to paint the portrait and how you'd like the sitter to help.

Entertaining the Sitter. When the painting is finally under way, you *will* have to cope with the natural vitality and impatience of children. Whether your sitter is a tiny tot or a teenager, you'll find that children don't like to sit still for very long. That's why professional portrait painters always provide some sort of entertainment to keep the sitter in one place as long as possible. We all know about the hypnotic effect of television—and a television set is probably the most effective device for immobilizing the sitter. For small children, you may want to provide some picture books or toys. Or you can ask the parents to bring along some of the child's own favorite books or toys. Older children may enjoy looking at magazines or at your art book collection. If you have a hi-fi set, you might provide some popular music for a teenage sitter—or suggest that the sitter bring along some favorite records. Be sure to interrupt the pose with frequent rest periods: every fifteen or twenty minutes for a teenager, and more often for a young child. During these rest periods, invite the sitter to look at the canvas and see how the painting is coming along.

Clothing. Always encourage the sitter—or the sitter's parents—to select clothing that's simple, natural, and comfortable. Children don't really like to dress up for a portrait, but prefer loose, casual clothing. Such clothing is not only easier to paint, but the sitter becomes easier to paint because he or she is more relaxed. If possible, discuss the sitter's clothing at least a day before the first portrait sitting so that you can make it clear that the portrait will look best if the sitter's clothes are a solid, subdued color in a simple, unobtrusive style. Explain that a strong color, a blatant pattern, or a dramatic style will distract attention from the sitter's face. If some proud parent insists that the child wear a favorite dress or blouse, ask if you can see it so you can have a chance to say: "Do you have some other favorite that doesn't have such strong stripes?"

Hair. Hair, like clothing, is most "paintable" when it's loose and natural. If a mother insists on sending her child to the hairdresser in preparation for the portrait, ask her to allow a day or two for the hair to loosen up before the painting session. If the hair still looks too tight and artificial when the sitter arrives, you can do a bit of work with a brush or comb. If a boy comes directly from the barber to the studio and his hair looks too neat, hand him a comb and tell him that his hair will look more masculine if he roughens it up a bit.

Preliminary Studies. An adult may be willing to spend as much as two or three hours posing for a portrait, while a teenager will probably begin to fidget after an hour, and a preschooler may start to run around the studio after half an hour. This means that you've got to work quickly when you paint children's portraits. The painting will go more rapidly if you make a number of preliminary sketches in pencil, chalk, or charcoal, before you attack the canvas.

Preliminary Brush Drawing. In the demonstrations that follow, you'll see that George Passantino normally starts with a preliminary brush drawing in a single color—on a toned painting surface. He begins by selecting (or mixing) some color that will harmonize with the final painting, diluting this color with lots of turpentine, and scrubbing it casually over the canvas with a rag. This toned painting surface has two important functions. First, by quickly covering the canvas with color, you subdue that glaring white canvas—which beginners often find so intimidating that they're afraid to touch it with a brushload of paint. Now you can dive right in and start painting! Second, when you start to apply color on top of that toned canvas, you can see how your colors look in relation to an undertone that bears some resemblance to the final painting—instead of working on bare, white canvas that looks *nothing* like the final painting. The brush drawing is made with a darker version of this undertone, containing less turpentine. The drawing establishes the overall shape of the head, neck, and shoulders; the placement of the features; the general shapes of the features; and sometimes the broad pattern of lights and shadows.

Lights and Shadows. Using the preliminary brush drawing as a guide, but never hesitating to cover the original brushstrokes, Passantino then goes on to block in the shadows with thicker, richer color, diluted with painting medium rather than turpentine. Now the paint is more like the consistency of thin cream, in contrast with the original brush drawing, which is like watercolor. As soon as a few strong shadow shapes appear, the head suddenly begins to look three-dimensional. Next, Passantino usually turns to the lighter side of the face, covering the lights with broad strokes. Even at this early stage, the face beings to look "real" because there's a clear contrast between the lighted planes of the head and the planes that are in shadow. The paint is applied broadly and flatly, without any blending or detail. The purpose is to define the lights and shadows quickly and simply.

Halftones. Between the lights and the shadows are subtle tones that the professionals call *halftones.* When you look carefully at the head, you see that there isn't a sudden shift from light to shadow, but a transitional tone that connects the brightest and the darkest areas of the face. This transitional tone—or halftone—is darker than the lights but paler than the shadows. Halftones appear throughout the head in those areas which are neither light nor dark, but fall somewhere between these two extremes. Generally, Passantino applies the halftones next and then begins to blend the edges where the lights, darks, and halftones meet. The brushwork is still broad and free, with no precise details.

Blending, Refining, Heightening, Finishing. Having placed the lights, darks, and halftones where they belong, Passantino continues to blend these tones together—although you'll see that he doesn't overdo it. He doesn't "iron out" his tones to a smooth, mechanical finish, but handles the brush loosely, allowing the strokes to show. This is the stage at which forms and contours are modified to make the drawing more accurate. Shadows are strengthened and colors are enriched. The brush moves over the face, heightening the tones with touches of light and color. Finally, the artist focuses on a few details: the dark shapes of the nostrils and the pupils of the eyes; the line between the lips; a few strands of hair.

Summary of Painting Operations. That sequence of operations is worth remembering: toned canvas, preliminary brush drawing in one color, darks, lights, halftones, blending, refining, heightening, and final details. However, don't regard that as a fixed set of "rules." There's no law that says you've got to follow that sequence of operations rigidly every time. As you'll discover when you study the demonstrations, Passantino often varies his sequence of painting steps to suit the subject. Furthermore, in the excitement of painting, a lot of things start to happen by themselves and a lot of these operations begin to overlap. Ultimately, you'll find *your own* way of working. However, nearly all professional portrait painters agree that it's usually best to begin with big brushes and broad strokes—setting down the pattern of lights, shadows and halftones as simply as possible—and save the refinements, the details, and the small brushes for the very end.

Tips About Color Mixing. When you're trying to capture the subtle colors of skin, hair, and eyes, the name of the game is *planning*. Think carefully about your color mixtures before you touch your brush to the palette. Analyze your model's complexion and decide in advance what color mixtures will come closest. If you're not sure—or you think that several different mixtures might work—try a few color sketches with sample mixtures on scraps of canvas or paper. In the same way, analyze the model's hair and eye colors, and try some color samples if necessary. When you're sure which mixtures will work, *then* you can dive into the painting with that feeling of certainty that produces fresh color and lively brushwork.

Step 1. A rag tones the canvas with a mixture of ultramarine blue, burnt umber, and white diluted with plenty of turpentine. A darker version of this same mixture, but with less turpentine and no white, is used to make the preliminary brush drawing. The outer contours of the face are drawn first, and then the brush indicates the loose curls with quick, scrubby strokes. The eyes of the sitter are particularly magnetic, and they're drawn with greater care than one would normally take in a preliminary drawing. A few strokes define the nose and mouth. The brush begins to indicate the shadows on the face and neck with very light tones—diluted with a great deal of turpentine—and the light areas of the face are wiped away with a rag wrapped around a fingertip. Just a few strokes define the shoulders and the neckline.

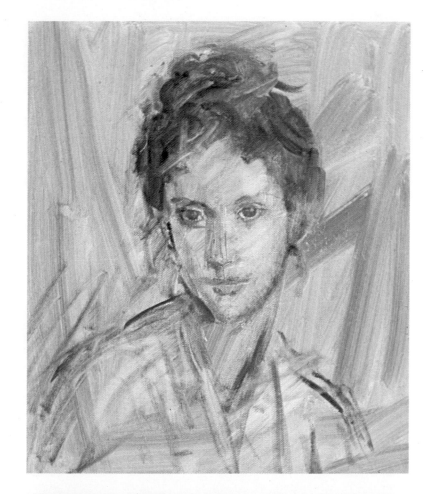

Step 2. A big bristle brush covers the background with a thicker version of the original mixture: ultramarine blue, burnt umber, and white, diluted with painting medium—not just turpentine. A smaller bristle brush places the shadows on the brow, cheek, jaw, chin, neck, eye socket, nose, and lips. This shadow tone is a mixture of raw umber, cobalt blue, and white. Study the eye socket on the shadow side of the face: the upper eyelid catches the light, while the lower eyelid is in shadow. Conversely, the upper lip is in shadow because it turns away from the light, while the lower lip turns upward and catches the light. The dark side of the hair is indicated with a dark mixture of burnt umber and ultramarine blue.

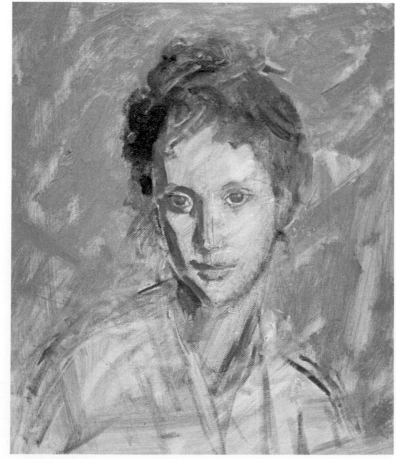

Step 3. The light planes of the face are covered with broad strokes of raw umber, Venetian red, raw sienna, and white. Notice that the lower half of the face is a bit darker than the forehead; these darker tones contain slightly less white. The first halftones begin to appear in the eye sockets, along the lower jaw, and beneath the chin. These halftones are a slightly darker version of the flesh mixture—to which a minute quantity of the background color has been added. The light tone is carried down the neck and over the chest. A halftone is placed directly beneath the chin. Some background color is also brushed into the hair. Observe how these light areas all grow slightly darker where the rounded edges of the forms turn away from the light.

Step 4. Working with a slightly darker version of the original flesh mixture, stronger halftones are added on the front of the nose and chin and along the lighted edge of the face next to the ear. The eye sockets are darkened, and then the tip of a round brush adds the dark lines of the eyelids. The darks within the eyes are added with the original hair mixture of burnt umber and ultramarine blue. Cadmium red is added to the flesh tone to block in the tones of the lips. A slightly paler version of this color suggests the ear on the shadow side of the face. And a big bristle brush begins to indicate the curls of the sitter's hair. A round brush begins to add linear details like the eyebrows and the dark corners of the mouth.

Step 5. A big bristle brush works on the lighted top and side of the hair with ultramarine blue and burnt umber, lightened with just a touch of white. On the shadow side of the face—particularly on the cheek—the halftones are enriched with more raw umber and Venetian red. This warm color is also brushed into the lighted cheek. The halftones are strengthened beneath the eyes, within the eye sockets, and along the lighted jaw. The darks of the eyelids are also deepened, and the pupils are added with touches of pure black warmed with burnt umber. The brush begins to blend the lights, halftones, and shadows on the cheeks. So far, the lighted ear is nothing more than a patch of pale color for the lobe and rim, plus a dark patch for the hollow.

Step 6. A flat softhair brush blends the darks and halftones on the shadow side of the face and then darkens the eyelids with the shadow mixture. The lips are shaped more carefully, darkening the upper lip and placing a shadow beneath the lower lip. The shadow beneath the nose is carried downward to the lip. A pointed brush begins to add details like the eyebrows, the dark lines of the upper lids, the whites of the eyes, and the dark contours of the nostrils. A shadow is added where the hair overhangs the forehead. The shadow on the neck is pulled downward, and the chest is darkened to a halftone. In addition to the original components of the flesh mixture, all these darker notes contain a small quantity of the background color.

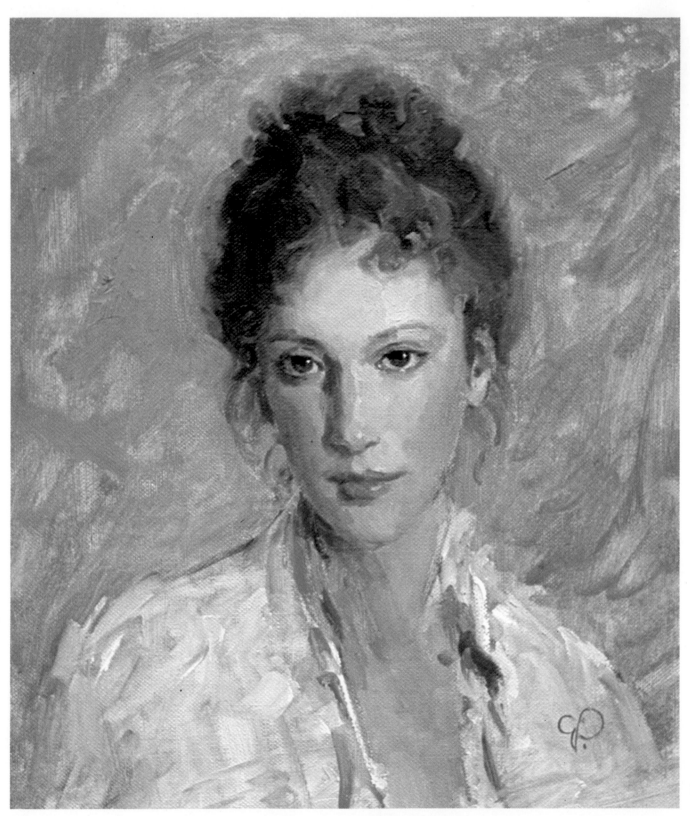

Step 7. Broad strokes of ultramarine blue, burnt umber, and white cover the background. A small, round brush suggests individual curls and then adds highlights to the hair with ultramarine blue, just a little raw umber, and white. More white is added to the flesh mixture to build up the lights on the forehead, cheeks, and chin. A round-brush picks up this mixture to add highlight to the nose and lips. The same brush lightens the upper lids and darkens the shadows beneath the lids; defines the nostrils more precisely; and then softens the lines of the lips. A flat softhair brush moves gently over the face, softening such contours as the eye socket and the lower lip; blending lights and halftones; adding hints of warm color to the chin and the hollow of the ear; and blurring the shadow on the neck. Strokes of white tinted with background color complete the blouse.

Step 1. The canvas is toned with a mixture of burnt umber and cadmium red diluted with turpentine to the consistency of watercolor. The shape of the face is drawn with the tip of a round softhair brush, which then indicates the features. This is done with burnt umber and ultramarine blue. A small bristle brush uses the same mixture to draw the hair with free strokes, and then the brush adds a few touches of shadow to the brow, cheek, nose, upper lip, and chin. The bristle brush picks up the background mixture to suggest the shoulders and the collar with a few big strokes.

Step 2. A bristle brush blocks in the shadows with a thicker, creamier mixture of raw umber, a little raw sienna, and white diluted with painting medium. You can now see solid shadow tones on the forehead, cheek, jaw, eye socket, nose, lips, and ear. The shadow planes of the hair are also brushed in with burnt umber and ultramarine blue, a combination which makes a beautiful dark tone which is more colorful than black. The head is strongly lit from the left; this accounts for the shadow cast by the nose. A thicker version of the background color—burnt umber, cadmium red, and white—is scrubbed in around the head. It's important to do this early so you can see how the colors of the head relate to the background tone.

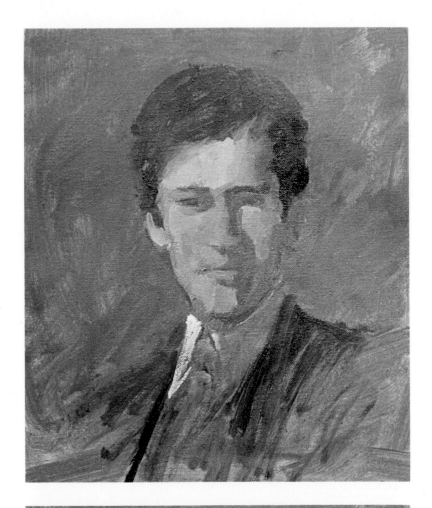

Step 3. A bristle brush lays in the lights with a thick, creamy mixture of raw umber, raw sienna, Venetian red, and plenty of white. The halftones—made with the same mixture but with less white and more raw umber—are placed between the lights and shadows. You can see these halftones most clearly on the forehead, next to the shadow; in the eye socket on the lighted side of the face; on the bridge of the nose; underneath the cheek on the lighted side of the face; and on the chin. The dark area of the hair is now completely covered with rough strokes of burnt umber and ultramarine blue. The same color suggests the jacket. A few strokes of white faintly tinted with raw umber indicate the lighted planes of the collar, while the shadow areas are suggested with cobalt blue, raw umber, and white. More white is added to the original background mixture, and this tone is carried over most of the background with a big bristle brush.

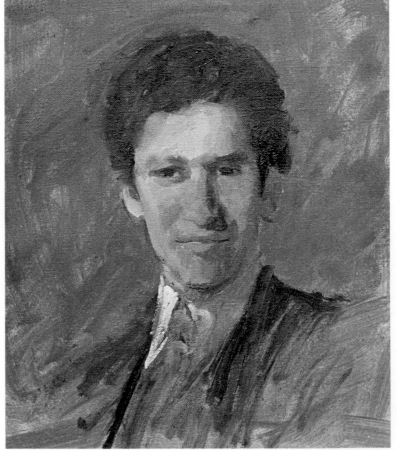

Step 4. A bristle brush begins to blend the lights, halftones, and shadows. The shadows around the eyes, nose, and mouth are strengthened with strokes of raw umber, raw sienna, Venetian red, and white. The halftones on the nose, cheek, and chin are also strengthened with this mixture, but with more white and less raw umber. A small softhair brush deepens the lines of shadow around the eyes, adds the dark notes within the eyes, and strengthens the darks of the eyebrows. These darkest notes are simply the hair mixture. The shadowy tone of the upper lip is redrawn, and then a dark shadow line is drawn between the lips. Work also continues on the background, which is now enriched with a warmer, deeper mixture of burnt umber, cadmium red, and white.

Step 5. A small bristle brush continues to solidify the shadows with a creamy mixture of raw umber, raw sienna, Venetian red, and white. This tone is applied with direct, simple strokes that move down the shadow side of the face, starting with the eye socket and then moving on to the nose, the shadow cast by the nose on the upper lip, the upper and lower lips, and finally the jaw and chin. A slightly paler version of this tone darkens the eye socket on the lighted side of the face and strengthens the shadow on the lower lid. A few thick touches of light are added to the lighted areas of the forehead and cheeks. Compare this step with Step 4 and you'll see that the shapes of the shadows are now more solid and distinct. You can also see the first touches of light on the hair.

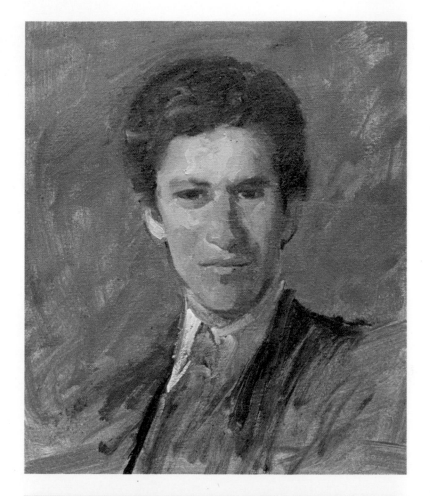

Step 6. Small brushes begin to build up the lights on the face, adding thick, creamy strokes to the forehead, cheeks, nose, lips, and chin. This pale tone is still the basic flesh mixture of raw umber, raw sienna, Venetian red, and white—but the mixture is now *mostly* white. More white is added to the hair mixture, and this tone is blended into the lighted side of the hair. A small brush darkens the corners of the lips and strengthens the darks at the corners of the eyes. Then the tip of a round softhair brush draws the dark lines of the eyelids more precisely, adds the dark pupils (with the hair mixture) and finally adds the whites of the eyes and the highlights on the pupils with pure white tinted with a minute touch of skin tone.

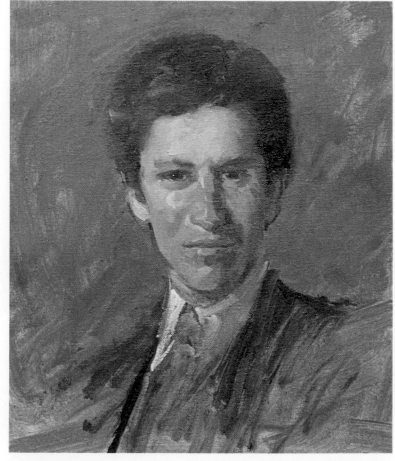

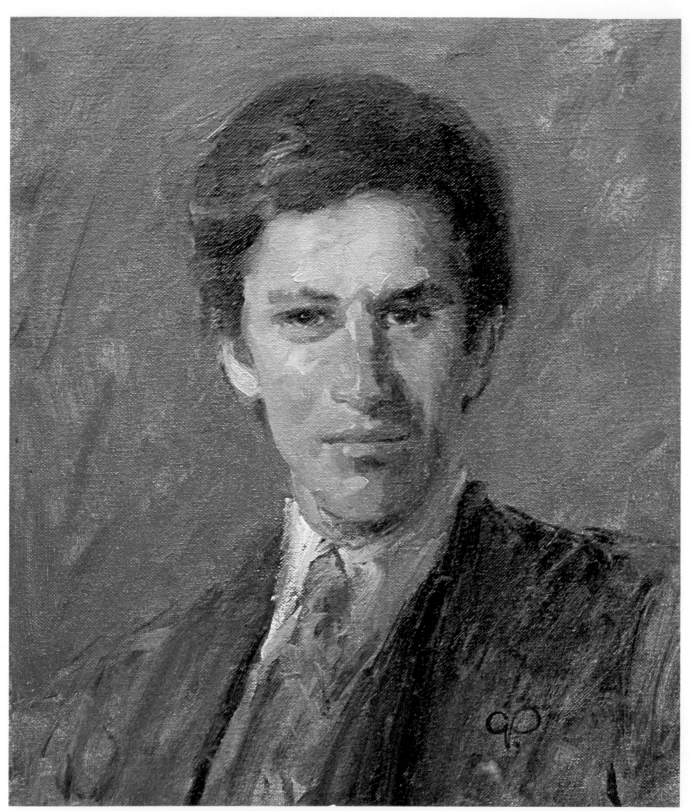

Step 7. Small brushes move over the face to add the last *accents* of light and dark that make the portrait more vivid and alive. Extra touches of darkness are added to the eyebrows, the corners of the eyes, the nostrils, and the corners of the lips. These darks are the same mixture as the hair tone, with just a little Venetian red. Extra dashes of shadow are carefully placed between the lips, beneath the lower lip, and beneath the chin. Thick, juicy touches of light are added with thick strokes above the eyes and with tiny strokes around the lips. More strokes of light are blended into the hair, while the hair mixture is used to complete the jacket. Touches of cobalt blue, raw umber, and white suggest the tie—without painting it completely. And the corners of the background are darkened with raw umber to make the head seem surrounded by a warm glow.

Step 1. Because the finished picture will be generally pale, only the area of the head is toned with cobalt blue, a touch of raw umber, and turpentine. Then a clean corner of the rag wipes away the lighted areas of the face, and the preliminary brush drawing is executed with the same mixture with less turpentine. The brush drawing suggests the wide, loose shape of the hair, the contours of the face, the darks of the eyes, the big shadow that runs down the side of the head and neck, and the small shadows that define the shapes of the features.

Step 2. A bristle brush paints the big shadows on the side of the face and neck with raw umber and white warmed with a touch of cadmium red and then subdued with a hint of cobalt blue. This same mixture is placed in the eyes and in the shadows of the lips. The lighted planes of the face, neck, and chest are painted with raw umber, white, and a touch of cadmium orange. A wisp of cadmium red is added to this mixture for the warm tone on the cheeks and nose. More white is added to the shadow tone to paint the dress. At this stage the mixtures contain a great deal of painting medium, and the color is applied very thinly.

Step 3. A big bristle brush surrounds the face with the darker tone of the hair—a mixture of raw umber, raw sienna, and white, with less white in the darker areas that surround the lower face. Another bristle brush gradually builds up the color on the face. First the shadow tone on the side of the face is completed and the shadows are strengthened within the eye sockets, on the side of the nose, and around the mouth and chin. Then more color is added to the lighted areas of the face. Warmer, richer tones—containing a little more cadmium red and cadmium orange—appear on the nose, cheeks, and chin. The dark edges of the irises are defined by a small round brush that carries a mixture of cobalt blue and raw umber.

Step 4. The small round brush continues to sharpen the features. The shadows around the eyes are darkened with the same mixture that appears in the hair: raw umber, raw sienna, and white, with the slightest touch of cobalt blue. The corners of the eyes are darkened, and the eyebrows are brushed in. This same mixture darkens the shadow at the side of the nose, defines the lines between the lips, darkens the shadow beneath the lower lip, and darkens the shadow under the chin to bring the head forward. A stroke of this mixture sharpens the edge of the cheek at the right. A few more strands of hair are added above the forehead.

Step 5. A flat softhair brush starts to blend the brushwork on the face to create smoother, more continuous tones. The brush adds more white to the flesh mixture and begins to build up the lights on the forehead and the bridge of the nose. As the brush blends and smoothes the shadow side of the face, it darkens the inner edge of the shadow with a little more raw umber, cobalt blue, and white. The shadow on the neck is darkened with this mixture. The tip of a round brush sharpens the lines of the eyes, nose, lips, and chin with raw umber, raw sienna, a touch of Venetian red, and white. Work continues on the hair, which is now fuller and more distinct. A few broad strokes of cobalt blue, raw umber, and white are added to the background.

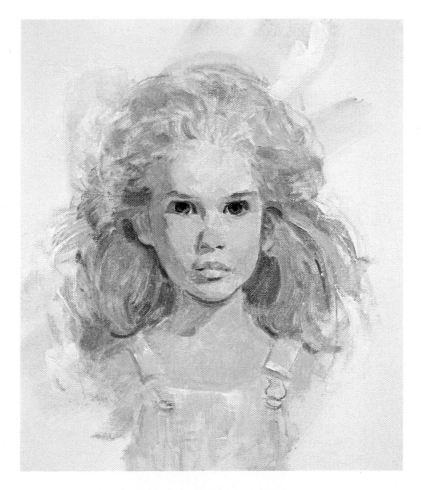

Step 6. The tip of a round brush concentrates on the eyes, which are the darkest notes in the painting. The whites of the eyes are painted with a very pale version of the flesh mixture. The dark edges of the irises and the dark notes of the pupils are carefully drawn with a mixture of raw umber and cobalt blue, which is also used to draw the shadowy lines beneath the upper lids. The highlights on the pupils are placed with pure white tinted with flesh tone. A little more cadmium red is blended into the lips, and the forms are more precisely drawn. The shapes of the earlobes are sharpened with lines of the hair mixture—and the details of the hair begin to appear.

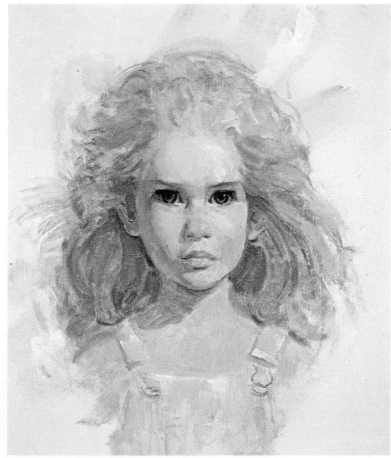

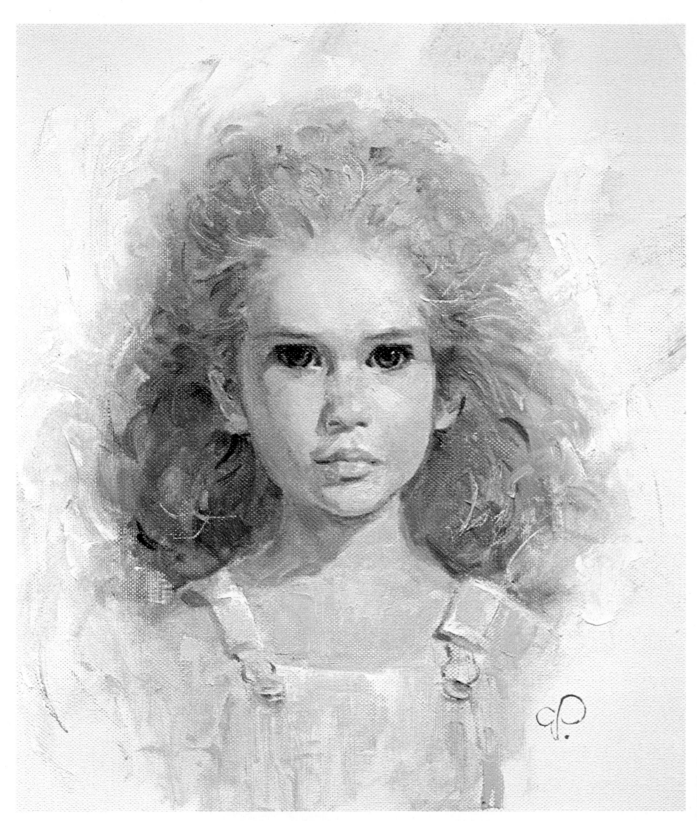

Step 7. In this final stage a flat softhair brush builds up the lights on the forehead, cheeks, nose, chin, and chest with the original flesh mixture and still more white. The nostrils and the line between the lips are sharpened. Subtle highlights are added just above the eyebrows, on the bridge and tip of the nose, and on the lips and chin. The background is completed with very pale strokes of cobalt blue, raw umber, and white—and this tone is blended into the lighter areas of the hair, which now merge softly with the background. Some of this mixture is blended into the shadowy hair around the neck. A small brush picks out individual strands of light and dark hair; the lighter strands are scratched away by the pointed end of the brush handle.

Step 1. The canvas is toned with a pale wash of cobalt blue and turpentine. A round softhair brush draws the head with the same mixture, and then a clean cloth wipes away the lighted areas of the skin. The shadow side of the face is only a bit darker than the lighted side. There are also very pale shadows within the eye sockets, beneath the nose, and within the lips. The brush indicates only one very strong shadow—beneath the chin. Then a big bristle brush surrounds the head with a much darker tone and carries this tone over the sitter's jacket. A rag wipes away the pale tone of the sweater inside the jacket.

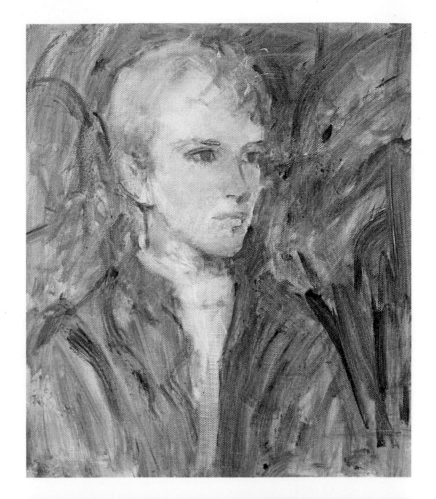

Step 2. The round brush defines the dark edges of the forms on the shadow side of the face—the brow, cheek, nose, lips, jaw, chin, and neck. At the same time the brush darkens the shadow lines of the upper eyelids and the underside of the earlobe. These darks are a mixture of raw umber, Venetian red, cadmium orange, and a little white. Then a flat bristle brush adds a great deal of white and painting medium to this same mixture and begins work on the lighted areas of the face. The cheek contains slightly more Venetian red. The first touches of background color are placed around the head—a mixture of cobalt blue, raw umber, and white.

Step 3. Working with the same mixture of raw umber, Venetian red, cadmium orange, and white, the flat bristle brush covers the entire face and neck. The shadow side of the face, the eye sockets, the nose, and the lips contain less white and just a bit more Venetian red. Notice that the lower half of the face is distinctly darker and warmer than the forehead. The neck is darker still. The dark shadow beneath the chin is the same mixture used for the darks in Step 3. A few strokes of raw umber, a hint of cadmium yellow, and white suggest the color of the sweater.

Step 4. A large bristle brush starts to indicate the tones of the hair with raw umber, raw sienna, and white. More white is added to the lighted area of the hair. The short strokes suggest the curly texture that will become more apparent later on. The darks of the irises are strengthened with cobalt blue and white. The pupils are located with a single touch of cobalt blue and raw umber.

Step 5. A big bristle brush darkens the entire background with rough, irregular strokes of cobalt blue, raw umber, and white. These strokes don't completely cover the underlying blue tone, which still shines through. The same brush covers the jacket with a dark mixture of cobalt blue and raw umber; there's a little white in the lighted areas, but no white in the shadows. The sweater is brushed in with strokes of raw umber, cadmium yellow, and white, with some burnt umber in the shadows. A smaller bristle brush begins to build up the tones of the hair with the same mixtures that first appeared in Step 4. And the flat bristle brush begins to blend the strokes of the face into smoother, more continuous tones. A round brush adds more darks to the shadow side of the face.

Step 6. A small bristle brush adds more white to the basic flesh mixture and builds up the lighted areas with thicker color. You can see that the forehead, the cheeks, the upper lip, and the chin are more luminous than Step 5. Some of this light tone is also blended into the neck. A small bristle brush sharpens the shapes of the nose and the lips. The tip of a round brush strengthens the dark lines of the upper eyelids.

Step 7. A flat softhair brush continues to blend the tones of the face, which are now soft and smooth. The brushwork on the neck remains a bit rougher. The tip of a round brush darkens the lines of the upper eyelids, and strengthens the pupils with cobalt blue and raw umber, and then places highlights on the pupils with pure white tinted with the slightest touch of cobalt blue. A few more darks are blended into the shadow side of the face with the original skin mixture, but with more raw umber and Venetian red added. A round brush adds some freckles with this mixture. The eyebrows are completed with soft, blurry strokes of the same mixture that appears in the hair: raw umber, raw sienna, and white. Dark curls are added to the hair with this mixture. More white is added for the brighter curls. The short, curving brushstrokes emphasize the lively texture of the blond hair.

Step 1. The overall tone of this portrait will be cool, so a rag picks up a mixture of cobalt blue, raw umber, and turpentine to cover the bare canvas. This same mixture is used to draw the outlines of the head, hair, neck, shoulders, and dress. A vertical center line divides the face. The eyes are carefully placed on either side of this line, while the nose and mouth are placed right on the line.

Step 2. The dark background is covered with quick, rough strokes of cobalt blue, raw umber, and white. Now the paint is thick and creamy, thinned with medium instead of turpentine. The dark, warm tone of the hair is suggested with a few strokes of raw umber, cobalt blue, and a little white. Some white is added to the background tone—and this mixture is used to scrub in a few strokes that suggest the dress.

Step 3. The shadow side of the head, neck, and shoulder are suggested with just a few broad strokes of a big bristle brush. The shadow tone is a mixture of raw umber, cobalt blue, a touch of cadmium red, and white. Notice how these strokes overlap the hair. Then the first few hints of pale flesh tone are brushed across the face and chest—a delicate mixture of raw umber, cadmium red, cobalt blue, and lots of white. Now the portrait has clearly defined planes of light and shadow.

Step 4. The lighted planes of the face are strengthened with heavier strokes of the pale mixture that first appeared in Step 3. The pale tones of the forehead, cheeks, shoulder, and chest are now clearly defined. Soft halftones are brushed between the lights and shadows. These halftones are the same mixture as the lights— raw umber, cadmium red, cobalt blue, and white—but they contain less white and less cadmium red. These halftones are so subtle that they're only a bit darker than the lights. You can see them most clearly on the brow, cheek, chin, and neck. A small softhair brush blends more cobalt blue into the shadow tone and adds darks to the eyebrows, the eyes, and the underside of the nose. An extra touch of cadmium red is blended into the flesh mixture to suggest the warmth of the lips. A touch of white is blended into the dark background mixture to paint the shadow side of the dress with broad strokes of a big bristle brush.

Step 5. A flat softhair brush begins to blend the whites, halftones, and shadows with delicate, back-and-forth strokes. As the pale tones are brushed into the darks, the shadow side of the face becomes softer and paler. The lighted planes of the face and chest are strengthened with thicker strokes of the original flesh mixture; these strokes are brushed out smoothly. The shape of the hair is solidified with heavier strokes of raw umber, yellow ochre, a little cobalt blue, and white. A round softhair brush picks up the hair mixture to sharpen the lines of the eyebrows and the eyelids. The round shapes of the iris are carefully redrawn, as are the shape of the nostril and the dark line that divides the lips.

Step 6. Flat softhair brushes continue to blend the lights, halftones, and shadows. Now the darker tones of the neck and shoulder flow softly into the paler tones of the chest. There's also a softer transition between light and shadow on the brow and jaw. The contours of the eyes are darkened; the dark pupils appear. A single pale stroke defines the lighted front plane of the nose, and a highlight is added to the tip. The nostril and the side of the nose are drawn more precisely. The upper lip is darkened, while more distinct shadows appear beneath the lower lip and the chin.

DEMONSTRATION 43. BROWN-HAIRED WOMAN

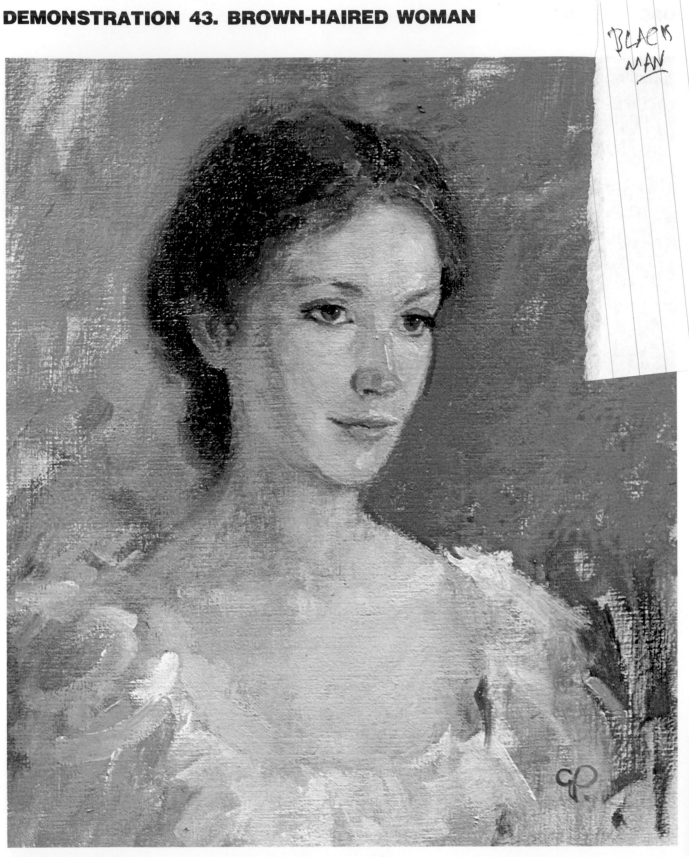

Step 7. The lighted areas of the hair are heightened with the original mixture plus a bit more white, while the background is darkened to emphasize the lighted side of the face. Thick strokes of the palest skin tone make the face, neck, and chest more luminous. More white is added to this tone for the. highlights that appear on the forehead, nose, lips, and chin. A dark line is drawn between the lips. Some halftone is lightly rubbed into the shadow side of the face, which now becomes more delicate and transparent. The lighted areas of the dress are completed with rough strokes of white tinted with background color.

Step 1. A mixture of cobalt blue and just a hint of raw umber diluted with plenty of turpentine is wiped over the canvas with a rag. Then the preliminary brush drawing is made with pure cobalt blue diluted with enough turpentine to make the paint handle like watercolor. This brush drawing is interesting because it emphasizes broad patches of light and shadow. The domelike shape of the hair is a solid tone. The dark eye sockets are also filled with tone, as are the shadow planes beneath the nose, lower lip, and chin; the dark planes where the cheeks and jaw turn away from the light; and the shadow cast by the chin on the neck. Now work begins on the darks of the hair just above the ears with a mixture of ivory black, ultramarine, and burnt umber.

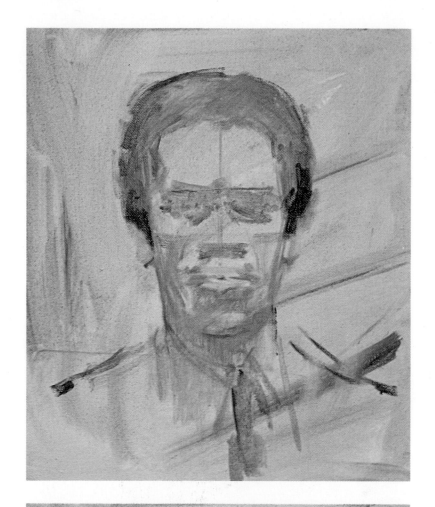

Step 2. The hair is the darkest note in the portrait, so the tones of the hair are placed first with ivory black, ultramarine blue, and burnt umber. Now it will be easier to determine all the other tones in the portrait, since even the darkest of these tones must be lighter than the hair. The darks of the face—first indicated in Step 1—are now solidified with heavier strokes of burnt umber, ultramarine blue, a little cadmium orange, and white. These rich darks contrast beautifully with the lighted planes of the face. The head already looks boldly three-dimensional. Thicker background color—cobalt blue, raw umber, and white diluted with medium—is brushed in above the shoulders and around the face. The collar and tie are suggested with a darker version of this color containing less white. A stroke of white is placed on the lighted side of the collar.

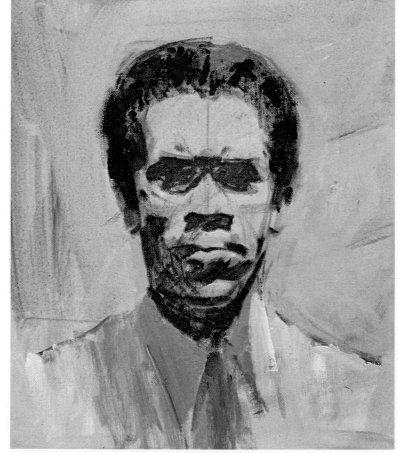

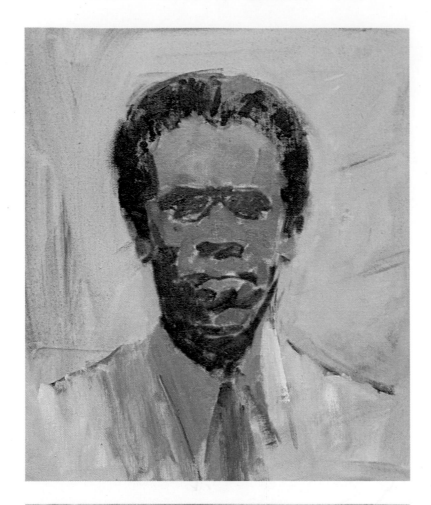

Step 3. The lighted planes of the face are placed beside the darks. These lights are a blend of burnt umber, ultramarine blue, cadmium orange, and white. The forehead receives the strongest direct light, so this plane is a little paler than the lower half of the face. A warmer shadow tone is brushed over the darks, which become richer and more solid. The shadow mixture is also burnt umber, ultramarine blue, cadmium orange, and less white. These shadow shapes are very carefully designed to reveal the form. Study how the shadow runs down the side of the face, curving in with the brow, cutting under the cheek and into the corner of the mouth, and then moving under the lip and chin. On the brightly lit forehead, notice how the color darkens slightly at the curving edge of the form.

Step 4. More white is blended into the shadow tone to produce the halftone mixture. Then halftones are added between the light and shadow—along the lower edge of the brow, on either side of the nose, on the cheeks, and on the lips. The brush begins to blend the edges of the halftones where they meet the light. In this boldly painted head, all the work is done with bristle brushes. Just as softhair brushes add delicacy to a female face, bold strokes of a bristle brush can accentuate the strength of a masculine face.

Step 5. More white is blended into the basic flesh mixture of burnt umber, ultramarine blue, cadmium orange, and white. Just enough medium is added to make this mixture rich and creamy. Then a bristle brush begins to emphasize those areas that catch the most light—the forehead, cheek, bridge of the nose, and upper and lower lips. Another brush blends the edge where the lighted forehead meets the dark shape of the hair; some cool background color is blended in at this point.

Step 6. The dark strokes of the hair are fused into one soft, continuous tone. The outer edge of the hair is blended softly into the background. Stronger lights are added to the forehead, cheek, nose, and lower lip with thick strokes. The brush begins to blend the edges of the shadows, which now melt softly into the halftones; you can see this most clearly around the eye socket, on the shadowy cheek, and around the mouth. A small brush begins to add details such as the whites of the eyes—which are almost as dark as the halftones—and the darks of the eyes, which are the shadow mixture. A softhair brush blends a touch of Venetian red into the shadows to add a hint of warmth beneath the nose and on the jaw. The shadow on the neck is blended into one continuous tone.

Step 7. In this final stage, a small brush strengthens the darks around the eyes, ears, nose, and mouth with a mixture of ultramarine blue and burnt umber. The eyebrows, the nostrils, the hollows of the ears, and the line between the lips are all sharpened with precise strokes of this mixture. The shadows are warmed with touches of Venetian red, which you can see most clearly on the cheek, jaw, and chin. Touches of cool background color are also blended into the shadows beneath the eyes, nose, and lower lip. The portrait captures the beautiful interplay of warm and cool color which is typical of black skin.

Step 1. The canvas is toned with a rag that carries raw umber diluted with turpentine. A clean corner of the rag wipes out the lighted area of the face, neck, shoulder, and chest. Then the preliminary sketch is completed with raw umber. It's instructive to compare this sketch with the preliminary brush drawing for Demonstration 43. Because the painting of the brown-haired woman has very little contrast between light and shadow, the brush drawing simply defines the shapes and then stops. In this painting of a red-haired woman, there are very clearly defined light and shadow planes, which are carefully rendered in the brush drawing.

Step 2. The background color is blocked in with broad strokes of viridian, ultramarine blue, burnt umber, and white. This tone completely surrounds the head and establishes the sharp contrast between the dark background and the brightly lit skin. A small bristle brush adds the shadows with a mixture of raw umber, burnt umber, cadmium red, and white. Two variations of the same mixture are used to paint the hair with short, squarish strokes: the dark strokes contain more burnt umber and the light strokes contain more cadmium red. The dark at the center of the eye is the same dark tone that appears in the hair. The color of the dress is quickly scrubbed in with broad strokes of cobalt blue, alizarin crimson, and white.

Step 3. The lighted tones of the skin are brushed in with a creamy mixture of raw umber, burnt umber, cadmium red, and white—actually the same mixture as the hair, but with much more white and diluted with painting medium to make the color flow smoothly. The strokes across the center of the face contain a little more cadmium red to heighten the tone of the cheeks and nose. Notice that the brush leaves the halftone areas of the face untouched—the forehead and lower jaw.

Step 4. A slightly darker version of the flesh tone—containing less white—is brushed across the forehead, the underside of the nose, the undersides of the cheeks, and the lower jaw. These are the subtle halftones that fall between the lights and the shadows. A little more white is added to this halftone mixture, which is then brushed downward over the neck and chest. The eye socket on the lighted side of the face is darkened. This same tone is carried down the back of the neck where the form turns away from the light. More cadmium red is added to the halftone mixture for the color of the lips. As usual, the upper lip is darker because it's in shadow.

Step 5. A flat softhair brush blends together the lights, halftones, and shadows on the face. Now the head begins to take on a soft, rounded quality. Notice how the edges of the hair are blurred so that the dark areas of the hair seem to melt away into the dark background. The softhair brush travels down the neck and chest to blur the meeting of light and shadow. Compare the flat patches of color in Step 4 with the soft, blended tones of Step 5. A round softhair brush moves carefully around the eyes to darken the lids and then adds the whites to the eyes with pure white faintly tinted with the pale fleshtone. The dark hair is carried down the back of the neck and softly blended into the skin.

Step 6. The tip of the round softhair brush continues to define the eyes with the same mixture used for the dark areas of the hair. Crisp lines are drawn for the shadows of the lids, and the eyebrows appear for the first time. A mixture of ultramarine blue, viridian, burnt umber, and a little white is blended into each iris. The small brush also sharpens the shapes of the lips and adds some of the lip tone to the cheek. The shadow on the side of the nose is darkened along with the shadow beneath the lower lip. More white is blended into the pale flesh mixture, and this tone is carried over the lighted areas of the face with thick, creamy strokes.

Step 7. More white is blended into the background mixture, and a large bristle brush travels over the background to soften the distracting strokes. With short, curving strokes the tip of a round brush suggests individual locks of hair. The pupils of the eyes are added with burnt umber and ultramarine blue, followed by a tiny dot of pure white for the highlight. A flat softhair brush blends the lighted side of the face, neck, and chest to soften the thick strokes applied in Step 6. And the tip of the round brush applies highlights to the nose, cheek, lips, and chin.

Step 1. This portrait is painted on a gesso panel rather than on canvas. A sheet of hardboard is brushed with several coats of acrylic gesso diluted with water to the consistency of thin cream. The gesso is allowed to dry overnight, and then the surface is toned with a rag dipped in raw umber and turpentine. The preliminary brush drawing is executed with this same mixture. The drawing emphasizes the two strongest darks: the hair and the eyes. A subtle wash of raw umber and turpentine, as thin as watercolor, indicates a shadow that's cast by the hair over the forehead and the bridge of the nose. This same soft tone appears on the shadow side of the face to the left—only slightly darker than the lighted side of the face.

Step 2. The background is covered with knife strokes of cadmium orange, raw umber, and white. A big bristle brush places casual strokes of color on the blouse: cadmium yellow softened with raw sienna, raw umber, and white. Another bristle brush begins work on the hair with raw umber, ultramarine blue, and a little white at the top; the brush doesn't carry too much color, so the bristles make a ragged, scrubby stroke that suggests the wispy texture of the hair. A round brush places the darks of the irises with burnt umber and ivory black. The first strokes of flesh tone are raw umber, raw sienna, a little Venetian red, and white, diluted with painting medium.

Step 3. A bristle brush finishes the job of covering the face with various mixtures of raw umber, raw sienna, Venetian red, a speck of cadmium red, and white. The strokes contain more raw sienna and raw umber on the shadow side of the face, between the eyes, on the side of the nose, and in the shadowy areas beneath the nose and lower lip. A bit more Venetian red is added to the lighted areas of the cheeks. Notice how extra touches of Venetian red and cadmium red warm the chin, nostrils, lips, and ear. The whites of the eyes are painted with white tinted with raw umber. The dark irises are warmed with tiny touches of Venetian red and raw sienna.

Step 4. A flat softhair brush begins to blend the brushstrokes of the face together to produce a smoother, more delicate tone. The shadows are strengthened in the eye sockets, on the nose and cheek, and alongside the jaw. Blending more Venetian red and cadmium red into the shadowy flesh mixture, a round brush paints the shapes of the lips with curving strokes. The shadow on the forehead is darkened by adding a little more raw umber to the flesh mixture. The shape of the hair is solidified with heavier strokes of ultramarine blue and raw umber. A pointed brush sharpens the lines of the eyes, adds the pupils with this same dark mixture, and then adds tiny highlights with pure white tinted with flesh tone.

Step 5. The painting knife covers the background with thicker strokes of the original mixture: cadmium orange, raw umber, and white. Softhair brushes continue to work on the face, building up the light on the cheeks, upper lip, chin, and earlobe. At the same time the lips are darkened and blended to look warmer and rounder. A flat softhair brush blends the strokes on the forehead, nose, chin, and shadowy cheek. The blended paint has a particularly smooth, delicate character on the smooth surface of the gesso panel, which enhances the tender quality of the little boy's skin.

Step 6. The tone of the blouse is enriched with heavier strokes of cadmium yellow, raw sienna, raw umber, and white. The tip of a round brush adds the lighter tones of the hair with raw umber, ultramarine blue, and white, picking out individual strands and blending the edges of the hair softly into the pale background. The tip of a round brush modifies the contour of the shadow side of the face with strokes of warm flesh tone containing more Venetian red. These strokes are blended softly into the skin, leaving a dark edge where the cheek turns away into the shadow. The entire shadow side of the face is darkened slightly and blended more smoothly.

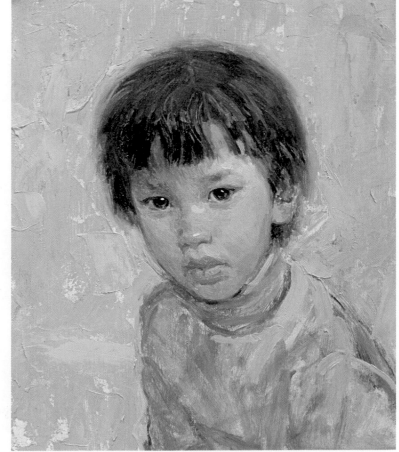

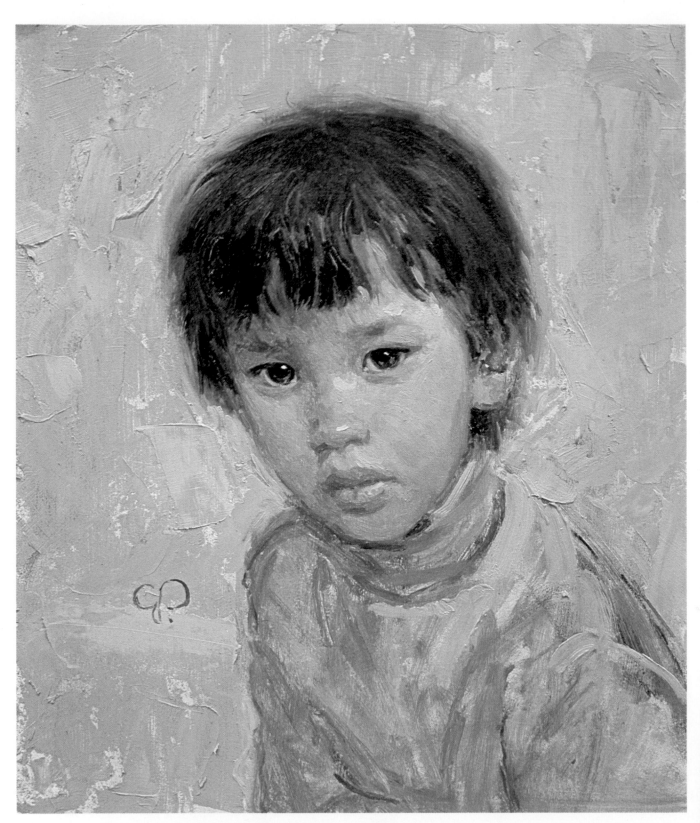

Step 7. Blending more white into the palest flesh mixture, a small brush adds thick touches of light to the brow above the eye on the lighted side of the face, the lighted cheek, the bridge and tip of the nose, just above the upper lip, and the side of the lower lip. The eyebrows and the dark lines of the upper eyelids are the same mixture as the hair: ultramarine blue and raw umber. The dark line on the side of the face in Step 6 has virtually disappeared as it's blended into the tone of the flesh. A few small strokes of flesh tone are carried upward from the forehead into the hair to suggest bright skin shining through the dark locks. On the gesso panel, which lacks the rough weave of canvas, the only texture is the texture of the paint itself—rough where the paint is applied roughly, smooth where the strokes are softly blended.

Drawing the Nude. For centuries, drawing the nude—or *life drawing*, as it's called—has been a basic requirement in art schools. The figure is certainly the most complex of all painting subjects and demands years of study. Professionals agree that the best way to master the figure is to draw the nude as often as you can. This takes discipline, but it's a delightful discipline. Life classes are enormously popular—not only as a means of studying the figure, but for the pure pleasure of drawing the human body. So contact your nearest art school, college, university, or adult education center to enroll in a life class. You'll often find that there are two different kinds of life classes: a class with an instructor, or a sketch group that has no instructor, but simply a monitor who supervises the model. If you're a beginner, it's best to enroll in a class that has an instructor who coaches you as you learn to draw. Later on, when you've more experience, you can join an unsupervised life class for practice and for the pleasure of drawing. If you have time, you can join both.

Quick Studies. Most life classes begin with a series of short poses—one minute, two minutes, five minutes—as a kind of warm-up. You draw as swiftly as you can, doing your best to capture the shapes, the proportions, and the pose with rapid strokes. Try different kinds of quick studies. With a sharp pencil point, simply trace the contours of the figure with thin, wiry lines, paying no attention to the shadows; "contour drawing" will strengthen your feeling for the shapes of the figure. Then switch to a blunt, tonal drawing tool like a stick of charcoal or chalk, a charcoal pencil, or a Conté crayon. Working with broad, rapid strokes, concentrate on the shapes of the shadows. These studies will strengthen your feeling for the three-dimensional form. Using these same broad drawing tools—in contrast with the sharp pencil— make some quick studies with scribbly lines that emphasize the action of the figure. The purpose of all these quick studies is to force you to visualize the figure as rapidly and as simply as possible, paying attention to the biggest forms, the shapes of the lights and shadows, and the action, without worrying too much about detail.

Prolonged Studies. After this series of quick studies, the life class usually switches to longer poses that encourage slower, more careful drawing. The model is apt to hold the same pose for fifteen or twenty minutes, perhaps half an hour. Sometimes the model holds the same pose for the rest of the class session— with a five- or ten-minute break every half hour, allowing both the model and the students to relax. These slow, careful drawings are most often done in charcoal or chalk, which handle somewhat like oil paint in the sense that you can gradually build up and blend shadows and halftones. The long poses give you a chance to draw and then *redraw* the contours until you get them exactly right. You also have time to develop your tones very gradually and with maximum precision. Charcoal is the most convenient drawing medium for these long studies because corrections are easy to make with a kneaded rubber (putty rubber) eraser; a chamois cloth or any soft cloth; or even a cleansing tissue.

Running Your Own Life Class. If you're lucky enough to have your own model—or if you join with a group of friends to organize your own life class—here are a few suggestions about how to run things. Natural light is always best. If you have a big window or a skylight, place the model where the light will strike her from one side and from slightly in front, producing what's known as 3/4 lighting. This kind of lighting produces the most clearly defined planes of light and shadow: one side of the figure, as well as the front of the figure, will be in the light, while the opposite side of the figure is in shadow. This is often called "form lighting" because it's easiest to see the three-dimensional shapes. It's harder to see the forms if the light comes from directly above, behind, or in front. If you don't have enough natural light, but must depend upon artificial light, place the lighting fixtures where they'll give you the best 3/4 light. Avoid spotlights and photographic floodlights. They exaggerate the contrast between the lights and darks on the figure, producing black murky shadows. Try to find lighting fixtures that will give you a soft, diffused light that looks more like natural light. If possible, paint the room white or very pale gray; the walls will serve as a reflecting surface and fill the room with a soft, diffused light that flatters the model and makes drawing more enjoyable. If you start with a series of short poses, requiring the model to change position frequently, remember that these poses can be tiring; give her a five-minute rest period every fifteen minutes. When you switch to longer poses, she can probably hold a simple, standing pose for twenty minutes before you give her a rest. She can probably hold a reclining pose for twenty minutes or even half an hour. Discuss the sequence and the length of the poses with the model before the class begins so that she knows what to expect and can tell you how long she thinks she can hold a particular pose. The model's comfort is important: keep the studio warm enough; give her a private room somewhere where she can change her clothes in privacy; and encourage her to tell you if a particular pose turns out to be a problem. Halfway through the class, it's traditional to take a coffee or tea break. Be sure to invite the model to join you.

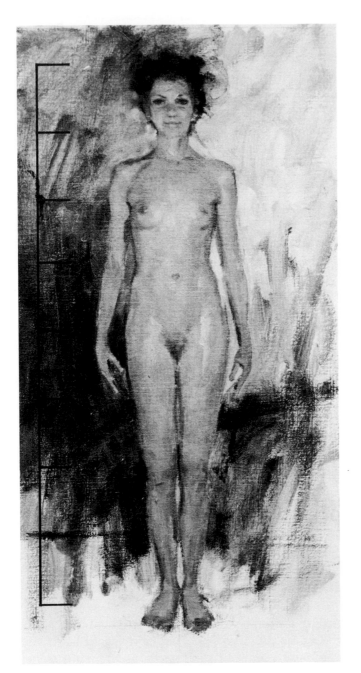

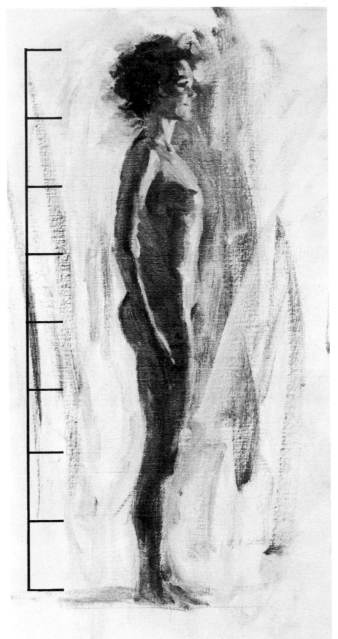

Front View. Although figures vary, it's helpful to memorize the proportions of an "ideal" figure and keep these proportions in mind as you paint. The most convenient method is to use the head as the unit of measurement. Painters generally visualize a figure which is eight heads tall. The torso is approximately three heads tall from the chin to the crotch, divided into thirds at the nipples and navel. The upper leg is two heads tall, and so is the lower leg. At the widest points—the shoulders and hips—the torso measures about two head lengths. It's obvious that not every model will have these "ideal" proportions. Nor will every pose be as easy to measure as this standing figure. But if you stay *reasonably* close to these measurements, making some adaptations to suit the particular build of the model, the proporations of your figures will always be convincing.

Side View. It's also important to remember the alignments of the various forms of the figure. The lower edge of the breast is halfway down the upper arm, while the elbow usually aligns with the waist. Comparing the front and side views, you can see that the wrist aligns with the crotch and with the widest points of the hips.

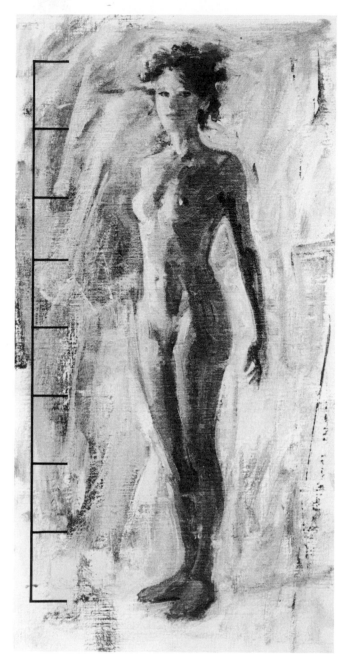

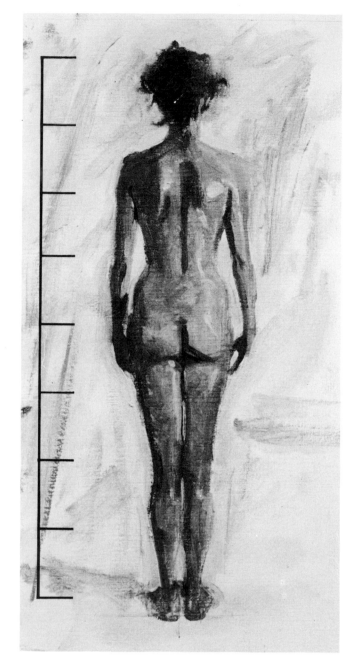

3/4 View. As the model turns, certain proportions will remain the same, while others will obviously change. In this 3/4 view, the model is still roughly eight heads tall; the torso is three heads tall; and the legs are four heads tall, which means two head lengths for the upper legs and two head lengths for the lower legs. The elbow still aligns with the waist, while the wrist still aligns with the crotch and the widest points of the hips. In this view, however, the figure is less than two heads wide at the shoulders and the hips. The foot, by the way, is usually just a bit less than one head length from toe to heel.

Back View. Seen from behind the figure displays essentially the same proportions as the front view. The figure is still eight heads tall, of course, and about two heads wide at the shoulders and at the widest points of the hips. Notice that the hips are widest just above the lower line of the buttocks. It's always useful to look for other alignments when you draw or paint the figure. For example, in this view the points of the shoulders line up with the wide points of the hips, while the armpits line up with the bulges of the hips just below the waist.

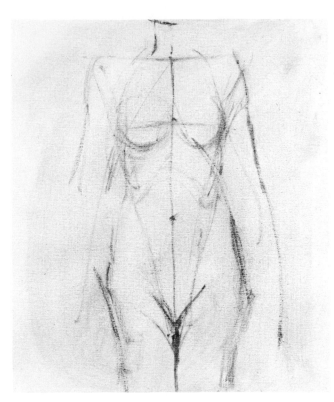

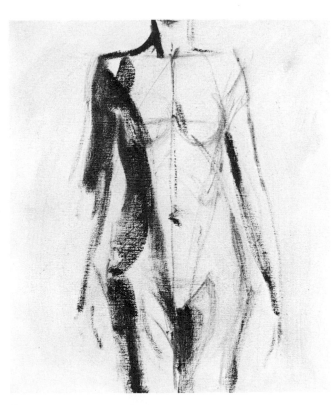

Step 1. A round softhair brush sketches the shapes. A vertical center line aids symmetry; horizontal lines locate the shoulders and the centers of the breasts; diagonals show the alignment of the shoulders, waist, and crotch.

Step 2. A bristle brush covers the shadow side of the figure with broad strokes of dark color. These darks appear not only on the outer edge of the torso, but on such smaller forms as the breast and abdomen.

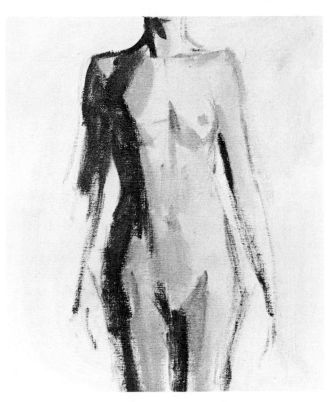

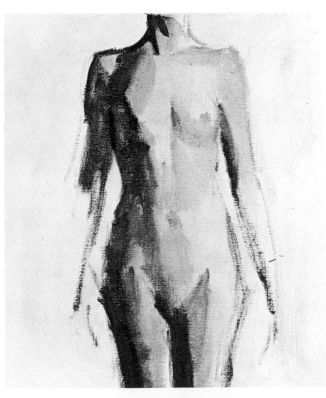

Step 3. A big bristle brush covers the lighted areas of the torso with pale color, obliterating the guidelines that still remain visible in Step 2.

Step 4. A bristle brush adds the halftones where the light and shadow meet. These are most visible in the areas of the waist, hip, and thigh. A halftone is carried down the side of the abdomen.

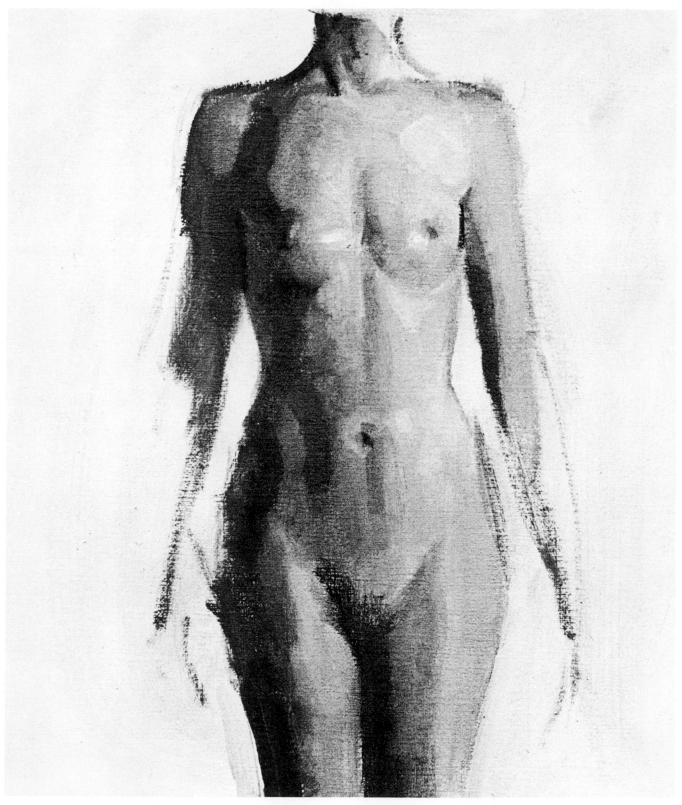

Step 5. A flat brush blends the meeting places of the lights, halftones, and shadows on the dark side of the figure. The shadows are darkened and blended to produce a smoother tone. The lighted areas are strengthened on the chest, breasts, ribs, and abdomen—and these pale strokes are blended softly into the surrounding skin tone. Notice how the shadow has been deepened on the dark side of the abdomen. A small brush places the last touches, darkening the nipples, the division between the breasts, the navel, and the valley that runs down the center of the torso, and adding highlights to the breasts, rib area, and navel.

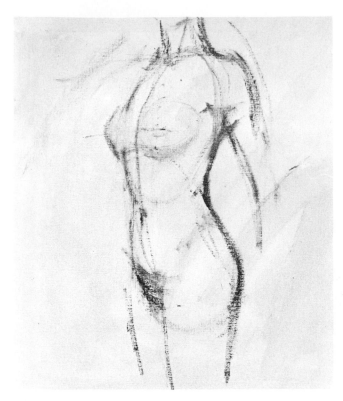

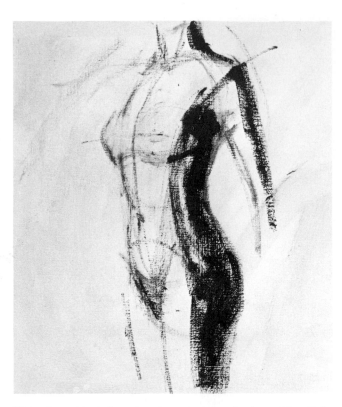

Step 1. A round brush draws the contours. As the figure turns, the vertical center line follows the convex curve of the body. Other curving guidelines visualize the upper and lower torso as egg shapes.

Step 2. A big bristle brush covers the shadow side of the torso with a single mass of dark color, repeating this tone on the shadow sides of the neck, shoulder, and arm.

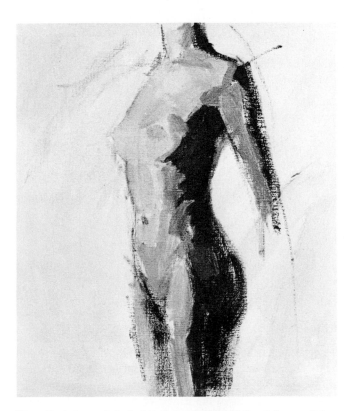

Step 3. A large bristle brush covers the lighted front of the torso with a pale tone. Then the brush blocks in the half-tones that fall between the light and shadow areas.

Step 4. A flat brush begins to blend the lights, halftones, and shadows into smoother, more continuous tones. Now the figure looks softer and rounder.

Step 5. A flat brush strengthens the lighted areas on the chest, breasts, rib cage, abdomen, and thighs. To accentuate the lighted planes of the figure, the background is darkened at the left. The shadow side of the figure is also strengthened; note that the background is paler on this side. The brush continues to blend the meeting places of light, shadow, and halftone; compare the thighs in Step 4 and Step 5 to see how this blending makes the forms look rounder and more lifelike. A small brush adds such finishing touches as the nipples and ribs.

Step 1. The contours of the figure are drawn with the tip of a round softhair brush. A vertical center line aids symmetry, while other guidelines emphasize the diamond shape of the back.

Step 2. A big flat brush covers the shadow side of the figure with broad strokes. Darks also appear on the shoulder blade, in the valley of the spine, and between the buttocks.

Step 3. A large flat brush covers the lighted areas of the torso. The buttocks are palest because they project outward into the light.

Step 4. Halftones are placed between the lights and shadows. You can see these most clearly on the lower back and the buttocks. The brush begins to blend the lights, halftones, and shadows.

Step 5. A flat brush blends the lights, halftones, and shadows, which now fuse into smooth, continuous tones. The lights are built up selectively on the shoulder blades and the buttocks. The darks are also strengthened—particularly on the shoulder blades, in the valley of the spine, and beneath the buttocks. A small round brush adds the last few details such as the dark line of the spine between the shoulder blades, the shadow lines in the armpits, and the dark line between the buttocks.

Step 1. The tip of the round brush draws the shapes of the upper arm, the forearm, and the hand. A diagonal guideline indicates the meeting place of the upper arm and the forearm, where a shadow will begin. A second, smaller guideline indicates the end of that shadow on the wrist.

Step 2. A small bristle brush carries a dark line of shadow along the undersides of the upper arm and the forearm. A bigger bristle brush blocks in the light and halftone on the upper arm, the shadow on the side of the forearm, and the lighted areas of the hand.

Step 3. The tip of a round brush defines the lighted edge of the forearm and then indicates the intricate pattern of lights, halftones, and shadows on the hand. A flat brush darkens the shadow on the forearm and then adds some pale strokes to suggest reflected light within the shadow. A flat brush begins to blend the lights, halftones, and shadows on the upper arm.

Step 4. A flat brush darkens the underside of the upper arm and then begins to blend the shadowy underside of the forearm. The round brush continues to define the shapes of the hand, brightening the lighted tops of the forms and darkening the shadowy undersides.

Step 5. Now the light, halftone, and shadow of the upper arm are smoothly blended, although you can actually see each tone quite distinctly. The lighted edge of the forearm is now a single bright line. The shadow side of the forearm is really like a very dark halftone curving around to a line of deep shadow on the underside. The round brush carefully paints the zones of light, halftone, and shadow on the upper half of the hand, the forefinger, and the thumb. The other fingers turn downward and are in shadow. When you paint the arm, it's important to remember that you're not dealing with a single, continuous form, but with a series of forms: the upper arm, the forearm, the upper half of the hand, and finally the fingers. Because each of these forms may move in a different direction, each will have its own specific pattern of light, halftone, and shadow.

Step 1. A round brush draws the contours of the upper and lower legs and the feet. The feet are drawn as simple shapes—the details of the toes are ignored.

Step 2. A large bristle brush paints the shadow sides of the forms in broad, flat tones. A few strokes of dark background are added. These dark strokes make it easier to visualize just how dark to make the shadow sides of the forms.

Step 3. The lighted planes of the lower legs are painted in flat tones. The background is also covered with tone to make it easier to visualize the correct distribution of tones on the legs. A few strokes darken the calf of the near leg.

Step 4. A flat brush begins to blend the light and dark areas of the legs. In the process of brushing the lights and darks together, halftones emerge. (This is another way of creating halftones.) A small brush begins to sharpen the forms of the feet and strengthen the darks.

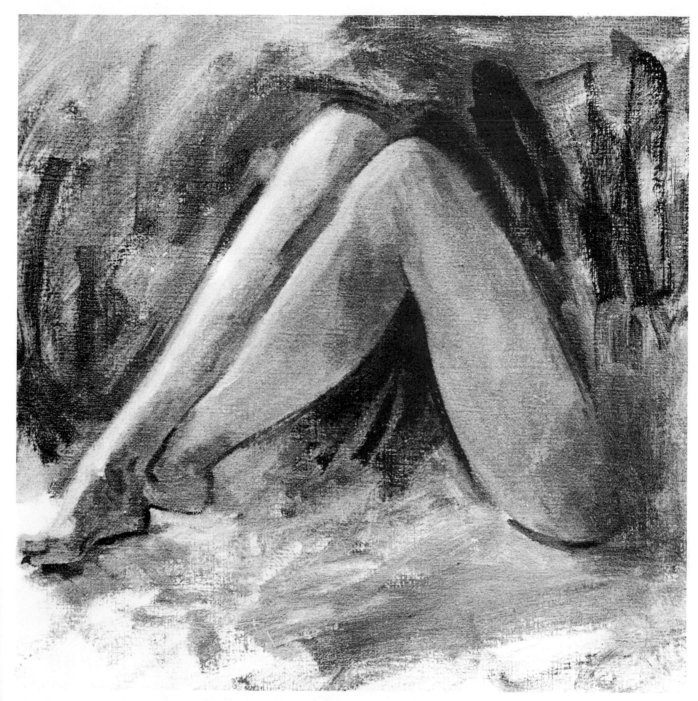

Step 5. The light comes from the upper left, illuminating the knees and the frontal planes of the lower legs that turn upward toward the light. The shadow areas of the legs, however, are not a uniform dark tone; they seem to be picking up light from a secondary source. Thus, there's a subtle gradation from dark to light within the shadows themselves. The calves are dark just below the knees, growing lighter as they approach the ankles, then darkening again at the ankles and feet. There are no "rules" governing the distribution of lights, halftones, and shadows. You've just got to look carefully and then paint what you see. In this final stage a flat brush makes these subtle adjustments in the tones, adding touches of light and dark, and blending the tones to make the forms look smooth and round. The tip of a round brush finishes the job by sharpening the lines of the feet, adding a few strokes to suggest toes, and placing a shadow where one foot touches the ground.

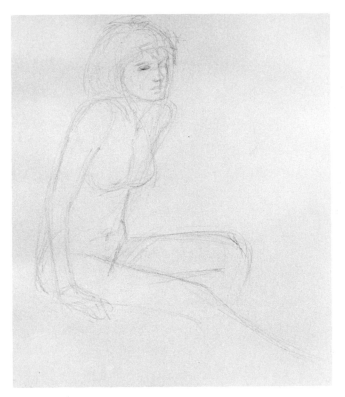

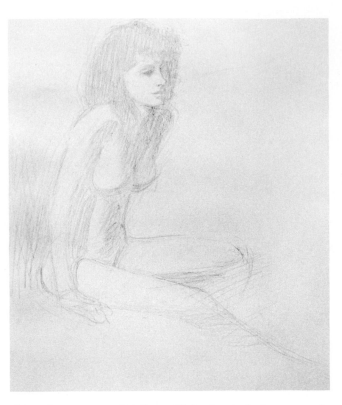

Step 1. The pencil moves lightly over the paper, tracing the contours of the forms with curving, rhythmic strokes. At times the pencil redraws the same contour several times to get the shape right.

Step 2. Pale, parallel lines fill in the dark shapes on the shadow sides of the forms as well as the dark mass of the hair. This is very much like blocking in the dark areas of a painting with broad brushstrokes.

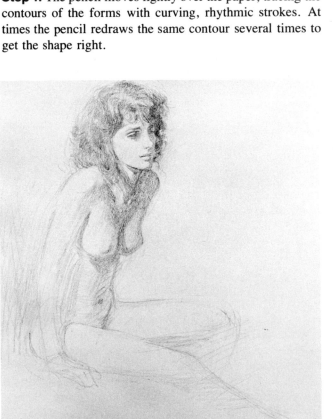

Step 3. Pressing a bit harder the pencil moves back and forth to strengthen the darks. The pencil begins to define the shapes of the hair and such details as the features, nipples, and navel.

Step 4. The pencil continues to darken the shadows and retraces the contours with firm lines—as a kneaded rubber (putty rubber) eraser removes excess lines. The point picks out individual locks of hair and sharpens the features.

Step 5. Holding the pencil at an angle so that the side of the lead strikes the paper, the artist strengthens the darks with firm, parallel lines which you can see most clearly on the shoulder and on the torso beneath the arm. Pressing more lightly and still working with parallel lines, the pencil defines the halftones, which are most evident on the forearm and the thighs. Crisp, dark lines made with the point of the pencil define individual locks of hair, strengthen the features, and add a line of shadow where the thigh rests on the model stand. A few strokes curve around the edges of the figure to suggest the background.

Beginning with Broad Strokes. There's a famous painter who always tells his students to start out with brushes that "look just a bit too big for the job." His strategy is to train his students to begin with big, broad strokes—and to discourage beginners from starting with small, timid strokes. In the early stages, your task is to cover the head or figure with broad planes of flat color to establish the shapes of the lights and shadows. Between these two tones, you place the halftones, which are darker than the lights but lighter than the shadows. These three basic tones—lights, shadows, halftones—should be placed on the canvas with your largest bristle brushes. At this stage, the brushstrokes can be broad, simple, and quite rough. Don't worry about rendering the contours precisely. Save all the precise brushwork for later on. Start out by visualizing the painting as a kind of "poster" with big masses of flat colors.

Finishing with Precise Brushwork. Save your small brushes and your more exact brushwork for the later stages. When the entire painting is covered with broad masses of flat color, then you can begin to blend the areas where lights, halftones, and shadows meet. You can do some of this blending with the big bristle brushes you started out with. But now you can also bring in the smaller bristle brushes and the flat softhair brushes. However, don't overdo the blending—don't keep "brushing out" the paint until the surface is so smooth that all the brushstrokes disappear. Even when you're working with smaller brushes, try to make bold, decisive strokes. And save your smallest brushes—particularly the round softhair brushes—for the very last stages of the painting. You'll need these small brushes for details such as eyes and eyebrows, fingers and toes. But be very selective about these final, small strokes. Don't paint every strand of hair—just pick out a few. Don't try to paint every eyelash. And when you place those last few highlights with small strokes, don't cover the face or figure with shining dots that make the model look like she's perspiring: just pick out a few of the bigger highlights and then stop.

Working from Thin to Thick. Thin color is a lot easier to handle than thick color. So professional figure painters generally do most of their work with fairly thin color, saving their thicker strokes for the very end. It's best to do the preliminary brush drawing with tube color that's diluted with turpentine to the consistency of watercolor. This color is so thin that you can easily wipe away a mistake with a clean rag and then correct the drawing with fresh strokes. For blocking in the lights, darks, and halftones, it's best to dilute your color mixtures with painting medium—not just turpentine—to a consistency somewhat like thin cream. This consistency makes it possible for you to work quickly and decisively, moving the brush across the canvas with broad, sweeping strokes. When you've established the broad pattern of lights, darks, and halftones, you'll begin to enrich the surface of the painting by blending in smaller strokes of richer color. Now you can add a little less painting medium so that these strokes of richer color are the consistency of *thick* cream. Professionals generally save the thickest color for the highlights, which are sometimes pure tube color—undiluted with painting medium—but more often contain just a touch of painting medium to produce thick, rich consistency like warm butter. Of course, for those last touches of precise detail, it's important to add quite a lot of painting medium. The final touches are usually placed on the canvas by a small, round softhair brush that needs fluid color for precise, linear strokes.

Mixing Skin Tones. Every portrait and figure painter has his own favorite mixtures for skin tones. George Passantino has a very simple method that you've seen in the portrait demonstrations. He often begins his skin mixtures with white and a subdued brown called raw umber. The darker the skin tone, the more raw umber he adds. Then he adds one or two warmer hues to establish the precise skin color. For very pale skin, he starts with raw umber and white, then adds cadmium red and a hint of cadmium orange. For pinkish skin, he adds cadmium red and a bit of alizarin crimson. For brownish skin, he adds Venetian red and a touch of raw sienna. When he paints black skin, Passantino often substitutes burnt umber for raw umber, beginning with raw umber and white, then adding Venetian red, cadmium red, cadmium orange, and alizarin crimson or ivory black, depending upon the sitter. When he paints oriental skin, Passantino likes to add a touch of raw sienna to his basic mixture of raw umber and white; then he'll modify this with Venetian red and perhaps a touch of cadmium orange. When you turn to the figure demonstrations, you'll see that Passantino doesn't always follow these procedures too rigidly. But they *are* useful guidelines to keep in mind when you start out. Later on, you may discover your own favorite skin mixtures. Experiment and find the mixtures that work best for *you*.

Step 1. The bare canvas is toned with a few broad brush strokes of raw umber, Venetian red, and turpentine. Then a round softhair brush draws the shape of the figure with this same mixture. A horizontal guideline establishes the alignment of the shoulders. A single curving line defines the spine, which also serves as a vertical center line which makes it easier to draw a symmetrical figure. Initially many of the lines are surprisingly straight; later on the contours of the figure will become rounded. A big flat brush covers the hair with a darker mixture of raw umber, Venetian red, and turpentine and then begins to block in the dark tone of the background.

Step 2. A rag lightens the heavy lines that were drawn in Step 1. The tip of the brush redraws these contours more carefully, and then the dark background tone is carried down alongside the figure. The straight guideline for the shoulders is wiped away entirely. The dark strokes of the spine and buttocks are wiped down to pale lines. A flat bristle brush carries a broad plane of shadow down one side of the back, over the hip, and then over the upraised thigh. Paler shadows are also suggested on the dark sides of the thighs, on the arm and neck, and down the spine.

Step 3. A big bristle brush paints the solid tone of the shadow with raw umber, raw sienna, Venetian red, and white. This tone is placed not only on the back, hip, and thigh, but also on the shadow sides of the face, arm, and shoulder blade. The dark tone of the hair is reinforced with burnt umber, ultramarine blue, raw sienna, and a touch of white. The warm tone of the background is cooled with scrubby strokes of cobalt blue, cadmium red, and white—with more white at the left and more blue at the right. A paler version of this mixture suggests the fabric on which the model is seated.

Step 4. A bristle brush covers the lighted side of the figure with a pale blend of raw umber, raw sienna, Venetian red, and plenty of white, making the mixture just a bit darker on the arm and thigh. The same mixture becomes just a bit darker—containing a little more raw umber—as the brush places the big patch of halftone down the center of the back between the light and shadow planes. This same halftone mixture is carried up the neck and along the arm. Most of the arm is now shadow and halftone, with just a small rim of light.

Step 5. A bristle brush carries the halftone further down the back to the base of the spine and then up over the shoulder to the arm. The artist begins to blend the lights, halftones, and shadows where they meet on the back and neck. A little halftone mixture is brushed into the edge of the shadow side of the figure to make the dark tone more luminous and transparent. Further in from the edge the shadow tone is darkened with more raw umber. A dark line reinforces the spine. The lighted patches of hair are painted with touches of burnt umber, raw sienna, and white.

Step 6. A flat softhair brush moves over the entire back and thighs to soften and blend the meeting places of light, halftone, and shadow. Now the forms look smoother and rounder. The brush carefully retraces the curves of the lighted side of the back and then darkens the lighted thigh, which doesn't receive quite as much light as the back.

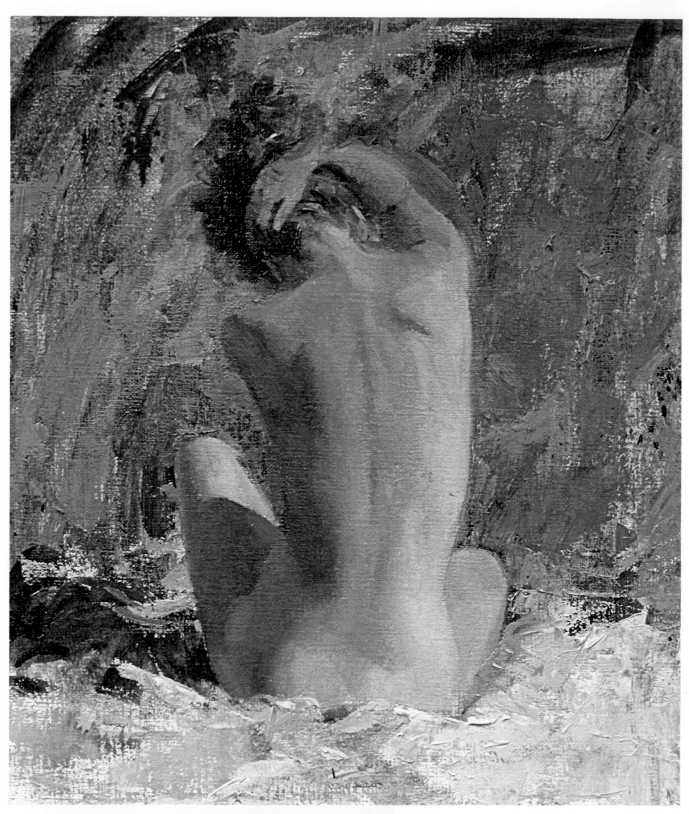

Step 7. A small, flat softhair brush blends the lights, shadows, and halftones on the upraised arm. Then the same brush blends a little more pale color into the lighted side of the figure, which now stands out more boldly against the darker background. The flexible blade of a painting knife places thick strokes of cobalt blue, cadmium red, and white on the foreground to suggest the soft fabric. The cast shadow at the left is the mixture that was originally placed there in Step 2—and left untouched. The red ribbon is a few quick strokes of cadmium red, alizarin crimson, a hint of cobalt blue, and white.

Step 1. Instead of starting with warm color, the artist sweeps a wash of cobalt blue and turpentine over the canvas with a big bristle brush. A darker tone of cobalt blue is scrubbed over the hair. Then a round brush begins the sketch with long, simple lines that capture the overall form and movement of the figure. A single curve defines the contour of the face, and two short lines are enough to suggest the neck. A horizontal stroke aligns the shoulders. Long, arc-like lines follow the contours of the arms, torso, and legs. A curving center line runs through the torso and helps locate the breasts, the waist, and the division between the legs.

Step 2. Darker strokes of cobalt blue, containing much less turpentine, cover the entire background. A clean rag wipes away the pale tone of the skin as the tip of a round brush sharpens the contours of the feet and indicates the details of the features, breasts, and hands. The figure is evenly lit and contains no strong areas of shadow.

Step 3. A bristle brush covers the entire figure with a pale mixture of raw umber, raw sienna, a little Venetian red, and white. Because there are no strong shadows, the artist pays careful attention to very slight variations in tone. The cheeks, nose, arms, and thigh are slightly darker than the torso. A hint of shadow appears on the breast and on one side of the midriff and hips. A much darker version of the same mixture—containing less white and more Venetian red—is brushed over the upper background. The dark shape of the hair is blocked in with burnt umber and ultramarine blue. A small brush sketches in the kittens on the model's lap with the dark hair mixture repeated on one kitten, the warm background tone repeated on the other.

Step 4. Still searching for the subtle color variations, a small brush deepens the flesh mixture with a little more raw umber and Venetian red and adds dark touches to the chin, neck, shoulders, arms, breasts, and midriff. Still more Venetian red and raw sienna are added to the mixture to enrich the tones of the face, nipples, and thighs. A little cadmium red is added to this mixture for the lips.

Step 5. Darkening the flesh mixture with more raw umber, a round brush sharpens the features and continues to strengthen the contours of the torso. A flat bristle brush darkens the edges of the forms, while another bristle brush adds more white to the basic flesh mixture to build up the lights all over the figure. A small brush begins to define individual strands of hair. Bristle brushes start to suggest a floral background with warm strokes of cadmium orange, raw sienna, raw umber, and white, plus cooler strokes of cobalt blue, raw sienna, and white. The chair is painted with thick strokes of cobalt blue and white.

Step 6. A flat softhair brush blends the rough strokes of Step 5. The tip of a round brush adds shadow lines beneath the chin, on the neck, and beneath the breasts. The cheeks and nipples are warmed with just a little cadmium red added to the flesh mixture. The brilliant patch of red on the seat is cadmium red, alizarin crimson, a little cobalt blue, and white. The floral background grows more detailed as a small brush adds bright touches of cadmium orange, raw sienna, raw umber, and white.

Step 7. The tip of a round brush moves over the entire figure, sharpening the edges of the forms with slender strokes of Venetian red, raw umber, raw sienna, and white. You can see where the brush has strengthened the lines of the nose and lips, the curve of the jaw, and the edges of the arm and breasts. The forearm and hand are completed with small strokes of the same mixture. The hair is carried down the sides of the face with burnt umber and ultramarine blue; the eyes and eyebrows are darkened with this mixture. The warm background tone is carried closer to the face and blended into the edges of the hair. Two tiny dabs of flesh tone suggest the ear. The patch of blue in the lower left suddenly becomes a vase as a shadow is added with a broad stroke of the hair mixture. Wildflowers are added with quick, spontaneous strokes of cobalt blue and white.

Step 1. A large bristle brush tones the background with raw sienna, burnt umber, a little cadmium orange, and turpentine. The top half of the canvas is darkened with more burnt umber. A round brush draws the contours of the figure with the same mixture, while a clean rag wipes away the lighted areas. More burnt umber is blended into the mixture to brush on the dark area of the hair. The face isn't wiped clean; some tone is left by the rag because the face is in shadow. The shadow tone is also carried over one shoulder and over the upper arm. The rest of the torso and the thighs are brightly lit—with few shadows—and these few darks are indicated with pale tones.

Step 2. The tip of the round brush carefully draws the shape of the figure with a darker version of the background tone. Features are suggested within the shadowy tone of the face. Small brushstrokes indicate the curly texture of the model's hair. A flat, softhair brush and a rag work together—the brush adding subtle tones to the figure and the rag wiping away the lights. The sketch is completed.

Step 3. The deep shadow on the chest, shoulder, and arm is darkened with burnt umber, raw sienna, cadmium orange, and white. Smaller strokes of this mixture indicate the shadow beneath the opposite arm and the shadow that runs from the midriff to the hips. The same color combination, but with much more white, is brushed over the lighted areas of the figure. Notice that the upraised arm, midriff, and thighs are just slightly darker than the chest and abdomen. A darker version of this flesh tone is brushed over the face. At this point all the work is done with bristle brushes.

Step 4. There's so little difference between the lights and the halftones that the artist develops both at the same time. Working with a darker version of the pale skin mixture, one brush deepens the tones of the upraised arm, chest, midriff, abdomen, and thigh on the shadow side of the figure. At the same time another bristle brush blends more white into the skin mixture and builds up the lights on the upraised shoulder and the breasts; on the lighted areas of the midriff, abdomen, and thighs; as well as on the lighted wrist and hand of the opposite arm. The same combination of colors is used to paint the hair—with more burnt umber on the shadow side and more cadmium orange and white on the light side. The lighter hair tone is used to brighten the face; the eyes are added with the dark hair tone. The background is lightened around the head and darkened at the upper left.

Step 5. A flat softhair brush begins to blend the lights and halftones on the upper torso. The rough brushwork of Step 4 melts away into smooth tones. A warmer version of the shadow mixture—containing more cadmium orange—is blended into the dark area on the chest, shoulder, and upper arm. Some of this mixture is added to the underside of the breast to suggest reflected light. Then the shadows beneath the breasts are darkened with more burnt umber. The tip of the painting knife scratches away some wet color from the hair to indicate light falling on the curls.

Step 6. The flat softhair brush continues to work down the figure, blending the tones of the lower torso and the thighs. Adding more white to the pale flesh tone, a small bristle brush builds up the lights on the brightly lit sides of one breast, the abdomen, and the hip. Adding still more cadmium orange and burnt umber to the shadow mixture, a small bristle brush deepens the shadows on the dark sides of the neck, midriff, and hips; crisp lines of the same mixture are added to the crease at the waist, the navel, and the dividing lines of the crotch and thighs. A little white is added to this mixture, which is then scrubbed around the hair.

Step 7. The lights are built up on the upraised shoulder and along the upper edge of the arm. Touches of bright color enrich the shadow on the underside of that same arm, the lighted edges of the hair, the dark side of the cheek, the shadow beneath the chin, the shadows on the midriff and abdomen, and the upper half of the arm that's in shadow. Free strokes of this same bright mixture—still the same combination of cadmium orange, burnt umber, raw sienna, and a little white—animate the background to suggest the color of autumn foliage. For the bright touches of gold around the figure and in the lower right, cadmium yellow is substituted for raw sienna. The tip of a round brush adds the last few dark lines to sharpen the upraised shoulder, the features, the nipples, the side of the thigh that's in shadow, and the fingers. Tiny dabs of bright yellow suggest wildflowers.

Step 1. The canvas is toned with cobalt blue and turpentine. Then the preliminary sketch is begun with a bristle brush that carries the same mixture. The brush scrubs in the dark tone of the distant trees in the upper half of the picture. The shapes of the model are blocked in with thick, straight strokes. The brush indicates a few masses of shadow. Notice that the face and most of the hair are in shadow. As always, the artist looks for alignments. The vertical line of the neck lines up with the vertical line of the inner thigh; a single diagonal line connects the shoulders; and another diagonal line connects the undersides of the buttocks.

Step 2. A flat bristle brush continues to darken the trees in the upper half of the canvas and then indicates their reflections in the pond that fills the lower half of the picture. The sharp point of a round softhair brush goes over the contours of the figure, drawing them more precisely as a rag wipes away the lights and the unnecessary strokes. Most of the figure is brightly lit, but there are strong patches of shadow on the face, arms, back, and buttocks.

Step 3. A mixture of raw umber, cadmium orange, Venetian red, and white is lightly brushed over the shadow tone, with some of the underlying blue allowed to shine through. Then a big brush blends raw umber, yellow ochre, Venetian red, and white, and scrubs this lightly over the sunlit areas of the body, again with some of the underlying blue allowed to come through. More yellow ochre is added to the flesh mixture for the sunlit patches on the hair. Strokes of soft green are brushed into the foliage and carried downward into the reflecting surface of the water; this is a mixture of ultramarine blue, cadmium yellow, raw umber, and white. A warmer, more subdued tone is brushed around the head and over the foliage with a mixture of ultramarine blue, Venetian red, and white.

Step 4. Working with thicker paint diluted with painting medium to a creamy consistency, bristle brushes now begin to apply more solid color to the figure. The pale skin mixture is enriched with more yellow ochre and Venetian red to darken the upper back, arms, and thighs. A paler version of this mixture is carried down over the buttocks, and this mixture is cooled with a speck of cobalt blue for the halftones. Brighter, thicker color is added to the shadow areas of the face and body.

Step 5. Having covered the upper back with a darker tone, a bristle brush blends more raw umber into the shadow mixture to strengthen the darks on the back and shoulder. This darker tone is brushed into the shadow areas of the hair and carried into the face to define the features. The sunlit top of the hair is brightened with thick strokes of yellow ochre, raw umber, and white. Foliage reflections are added to the water with ultramarine blue, cadmium yellow, raw umber, and white. The patch of beach in the lower right is covered with broad strokes of Venetian red, cobalt blue, and lots of white.

Step 6. Now a flat brush concentrates on the arms, buttocks and thighs. Warmer, darker tones are brushed down the length of the downstretched arm and thighs, since the limbs are normally darker than the torso. A hint of darkness is added inside the crook of the bent arm. Adding more white to the pale flesh mixture, the brush begins to build up the lights on the buttocks. Notice the cool notes of cobalt blue blended into the shadows beneath the buttocks and in the halftones. The tip of a round brush continues to brighten the sunlit hair with yellow ochre, raw umber, and white, and adds some touches of light to the features with the same mixture.

Step 7. Small flat brushes blend the lights and shadows on the back and downstretched arm, build up the lights on the back and buttocks, and darken the shadow sides of the thighs. The tip of a round brush sharpens the features, blends touches of the cadmium orange and bluish background tone into the hair, sharpens the eyes with raw umber and cobalt blue, and brightens the face with tiny touches of cadmium orange, cadmium red, and blue background color. Finally a small brush moves over the entire background, suggesting sparkling sunlight on the leaves and water with thick strokes of white tinted with cobalt blue and alizarin crimson.

Deciding the Pose. The most important thing to remember is that the pose ought to look natural. The simplest poses are usually best. If the model is standing, let her plant her feet firmly on the ground so she can hold the pose without stress; don't ask her to take a dancing pose or twist her body into some dramatic contortion that she can't possibly hold long enough to paint. A seated pose is particularly easy to hold for a long time; if the model naturally slouches or leans in one direction, let her do what's most comfortable. Of course, reclining poses are the easiest for the model because she can relax totally and hold the pose indefinitely. Whatever pose you agree upon, let the model move around until she feels stable and relaxed. Remember that what's naturally comfortable for *one* model may not be right for *another*. If the model feels right in a particular pose, she'll look right too—and your painting will reflect her sense of comfort, relaxation, and stability. If she feels awkward, your painting will look awkward. In short, although you may start out with a general idea of the kind of pose you want to paint, work along with the model to establish a pose that's most natural for her particular build and temperament.

Lighting. In most cases, you'll probably work indoors, preferably with natural light that comes from a fixed location like a window or a skylight. In the pages that follow, you'll find examples of different kinds of lighting. Move the model around your work area to see how she looks in different kinds of light. It's usually best to start out with 3/4 lighting because it's the easiest to paint. When you've painted a number of pictures in 3/4 light, then you can go on to the more complex effects of frontal lighting, back lighting, and rim lighting. Of course, if you're working with artificial light, you can let the model stay in one place and just move the light fixtures around to get the effect you want. The lighting, like the pose, ought to be as simple as possible. If you have a big window or a skylight that illuminates the whole room, that's probably all the light you need. If you're working with artificial light, don't surround the model with lighting fixtures which hit her from so many different directions that you can no longer tell the lights from the shadows. Arrange the lighting fixtures so that the rays strike her from just one direction, perhaps adding a very small lamp on the opposite side to make the shadows a bit more transparent. For artificial lighting, choose the warm light of incandescent bulbs or "warm white" fluorescent tubes; avoid the harsh, mechanical light of "cool white" fluorescent tubes.

Outdoor Light. If you can find some secluded place to paint the figure outdoors, keep in mind the same guidelines. You'll find it easiest to paint the model when the sun strikes her from one side and also from slightly in front, producing 3/4 or "form lighting." Later on, you can try placing her with the sun directly in front or directly behind to produce frontal or back lighting. You'll get the best outdoor lighting effects in the early morning, mid-morning, and middle or late afternoon—rather than midday, when the sun is directly above the model, creating harsh lights and shadows. (Besides, the model can get a nasty burn from the midday sun.) And don't neglect the soft, diffused light of an overcast day, which can be particularly delicate and beautiful.

Background and Props. Whether you're painting the figure indoors or outdoors, the model will be surrounded by the shapes and colors of walls, floors, furniture, trees, ground, or sky. These background elements are an important part of the picture. Pay careful attention to them; choose colors that flatter the model's skin and hair; but avoid any distracting details that might divert attention from the model. The cool tone of a blue wall or drape, or perhaps a mass of green trees, will heighten the warmth of the model's skin. But paint these with broad strokes that minimize the pattern in the wallpaper, the weave of the drape, or the detail of the foliage. Work in broad strokes that simplify the background to a mass of color. Save your more precise, intricate brushwork for the figure itself. Look for backgrounds that will provide flattering contrasts with the figure. A dark background tone will accentuate the light falling on the figure. A pale background will accentuate the shadows on the figure—particularly if the figure is lit from behind, with most of the front in shadow. Keep the background colors more subdued than the figure, so the flesh looks luminous and vital. If the model sits on a chair or reclines on a couch, choose the simplest furniture and avoid upholstery with an elaborate pattern. Professional figure painters often collect inexpensive fabrics (in flat, simple colors) to create various background colors. The model can sit or recline on an old blanket or bedspread. Or the fabric can be draped behind the model on a folding screen.

Some Do's and Don'ts. Avoid "glamor" poses that exaggerate the model's charms like a publicity photograph of a star. Such paintings tend to look like caricatures. For the same reason, don't exaggerate details like eyelashes, ruby lips, pink cheeks, painted fingernails or toenails. In fact, it's usually best for the model to wear a minimum of makeup. In general, avoid *all* kinds of exaggeration. A nude figure in a natural, relaxed, harmonious pose is *inherently* beautiful.

3/4 Lighting. The light illuminates one side of the figure and part of the front, throwing the other side into shadow. The light source is also slightly above, illuminating the tops of such forms as the head and arms.

3/4 Lighting. Now the figure turns slightly toward the light. In this example of 3/4 lighting, most of the figure is illuminated, but there are still strong darks on the shadow sides of the forms.

Frontal Lighting. In this type of lighting the entire front of the figure is flooded with light. There are no clearly defined masses of light and shadow. Instead there are simply shadowy edges around the forms.

Frontal Lighting. The figure turns, but the forms are still flooded with light, and the strongest darks are just around the edges. A bit more darkness appears on the abdomen where the form curves away from the light.

Side Lighting. When the light source is to one side of the figure, there's a clear division between light and shadow. In this frontal view of the figure, the sides of the forms are brightly lit, and the rest is in shadow.

Side Lighting. As the figure turns away from the light source, there are still bright patches of light on one arm, the breasts, and one thigh, but the rest of the figure (including the head) grows dark.

Rim Lighting. Again the light source is behind the model. Most of the figure is in shadow. A bit of light creeps around the edge to create an illuminated "rim" on the hair, shoulder, breast, abdomen, and thighs.

Rim Lighting. The light source is *behind* the figure and slightly above, spilling just a bit of light over one edge of the torso, but leaving most of the figure in shadow.

3/4 Lighting. If you ask portrait painters to choose their favorite type of lighting, most will agree on 3/4 lighting. The light hits one side of the sitter's face, as well as part of the front, throwing the other side of the face into shadow. As you sit at your easel facing this particular sitter, the light is coming diagonally over your right shoulder. The lighted side of the face is at your right, while the shadow side is at your left. One side of the nose is also in shadow. The eye socket on the shadow side of the face is distinctly darker than the socket on the lighted side of the face. The chin casts a shadow on one side of the neck. This is often called *form lighting* because it makes the face look round and three-dimensional.

3/4 Lighting. Here's another kind of 3/4 lighting. Now as you sit at the easel facing this sitter, the light moves diagonally over your left shoulder, but the light source is higher—somewhere above your head. The model's face is turned slightly, giving you a three-quarter view instead of the frontal view in the portrait of the girl above. Both eye sockets are in deep shadow, and there's a strong shadow under the nose. One side of the face is in deep shadow, and there's a strong shadow under the chin—but there's only a halftone on the shadow side of the nose. Notice the strong contrast between the light and shadow planes of the hair.

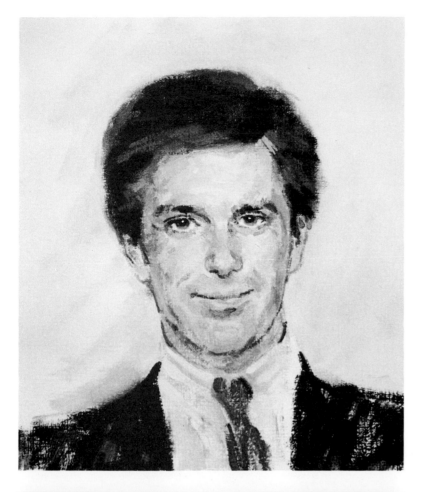

Frontal Lighting. When the light hits the sitter in the center of his face, this is called frontal lighting. As you stand at the easel, facing the sitter, it's as if the light source were your own face, pointing straight at him. Frontal lighting bathes the face in a smooth, even light that minimizes shadows. The shadow planes of the head are only slightly darker than the light planes. The darks tend to be the features themselves: eyebrows, eyelids, eyes, nostrils, and the lines of the lips. Frontal lighting is particularly effective when you want to minimize wrinkles and other surface irregularities in the sitter's face.

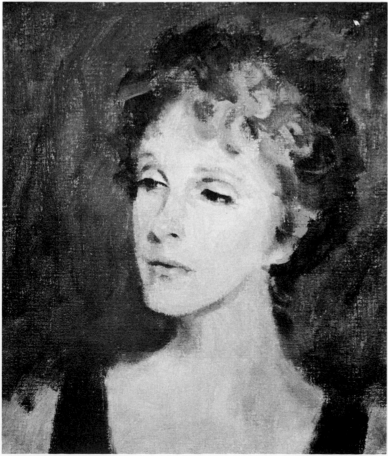

Frontal Lighting. When the sitter turns, frontal lighting may produce slightly more shadow. Hints of shadow appear in the eye sockets, beside the nose, around the lips, and beneath the chin. These shadows, however, are still inconspicuous and not much darker than the lights. The face still looks bright, smooth, and evenly lit. Frontal lighting can be particularly flattering to a female sitter, emphasizing her smooth, soft complexion. The dark background heightens the luminosity of her skin.

Side Lighting. When the light comes directly from the side—as if the sitter is next to a window—the face tends to divide into equal planes of light and shadow. For this reason side lighting is sometimes called half-and-half lighting. In a head-on view of the sitter, the dividing line tends to be the nose: on one side of the nose the face is in bright light; on the other side the face is in deep shadow. A suggestion of light sometimes creeps into the cheek on the shadow side of the face, as you see here. Side lighting will dramatize a sitter who has a strongly cut head and bold features.

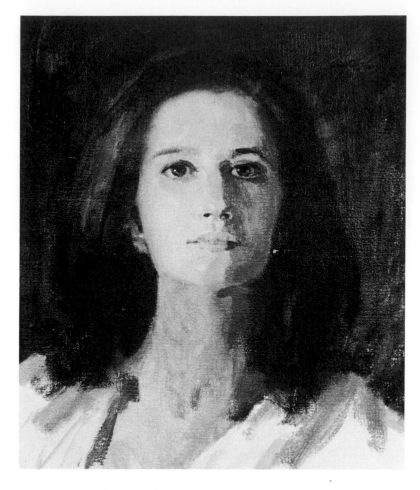

Side Lighting. As the head turns, the distribution of light and shadow may change. Here the dividing line is still the nose, but there's more shadow on the forehead, chin, and neck. In fact there's more shadow than light on this face. Within the deep shadow, there are still subtle variations in tone: patches of darkness around the eyes, nose, and mouth; and a suggestion of reflected light on the cheek. Light sometimes bounces off a reflecting surface such as a white wall, adding luminosity to the shadow side of the head.

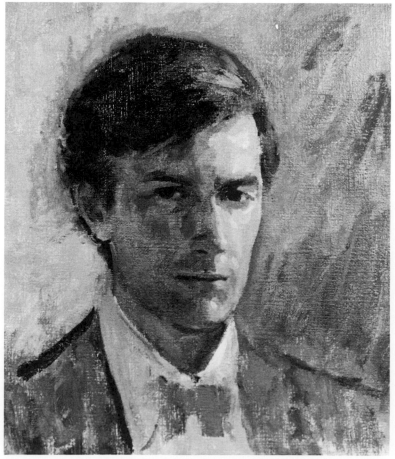

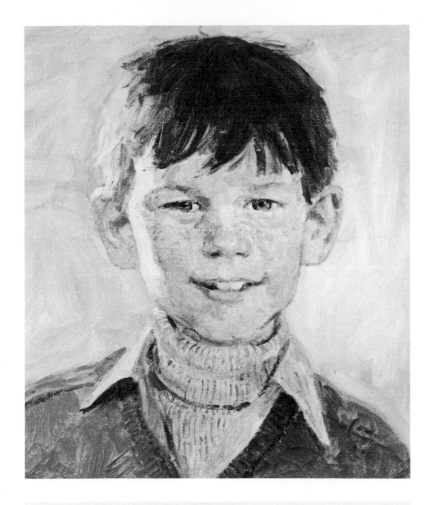

Rim Lighting. When the light source is behind the sitter and slightly to one side, most of the face is in shadow, and there's just a *rim* of light along one side of the brow, cheek, and jaw. This rim of light also appears on his hair and along the edge of one ear. To keep the front of the face from becoming too dark, place a reflecting surface or small lamp where it will lighten the shadows. Now you can see the dark contours of the features more clearly.

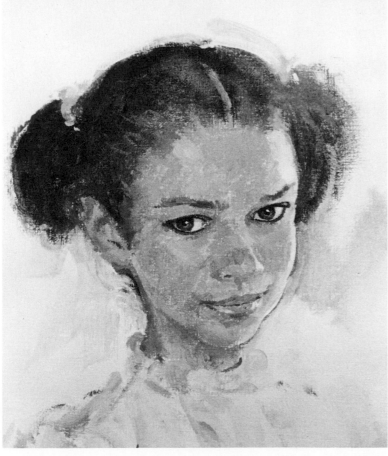

Rim Lighting. As the sitter turns her head toward the light source, a rim of light appears not only on her forehead, cheek, jaw, and chin, but also along the edge of her nose and mouth. The dark side of the face consists mainly of halftones—very much like the effect in frontal lighting. A touch of background shadow is placed next to her cheek to accentuate the lighted edge.

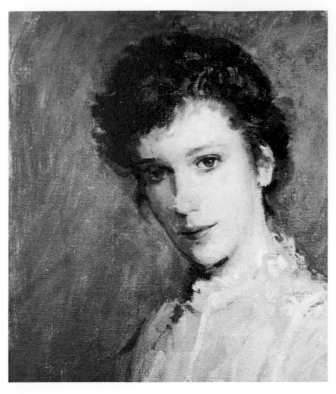

Don't place the head so far to one side that there's a huge space in front of the head and just a little space behind.

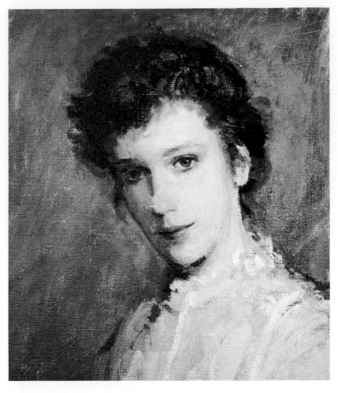

Do place the head so the space in front is just a *little* greater than the space behind. It's effective to place the head slightly off center, but not too far to one side of the canvas.

Don't push the top of the head against the top of the canvas and rest the chin against the lower edge of the canvas when you paint a close-up. Such close-ups can be handsome, but the head should never look as if it's crowding the edges of

Do allow more space beneath the chin—not hesitating to chop off a bit of hair at the top of the canvas. Now the head is just as big, but the portrait seems more spacious.

Don't crowd the canvas when you're painting a half figure. Once again, the head is too close to the top edge of the canvas and too close to the right side, allowing too much space at the front of the figure.

Do allow enough space above the head and provide a better balance of space on either side of the figure. Now the space in front of the figure is only slightly greater than the space behind.

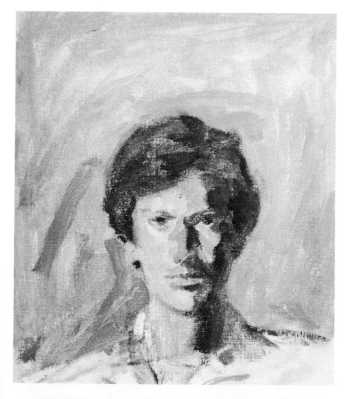

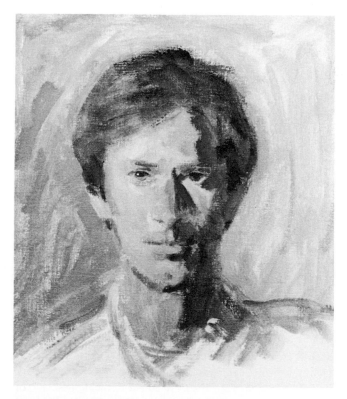

Don't drop the head too far down from the top of the canvas, allowing too much space at either side. In this portrait the space, not the head, dominates the painting.

Do make sure that the head dominates the canvas, allowing a *reasonable* amount of space at the top and the sides.

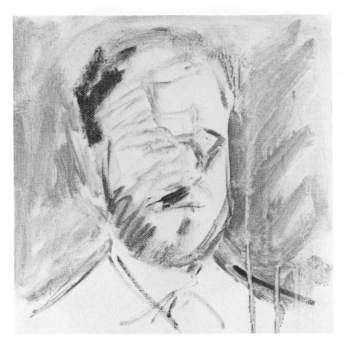

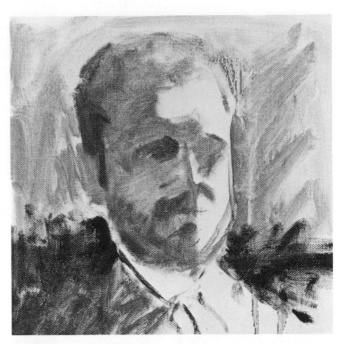

Step 1. To *paint* a preliminary sketch simply mix black and white on the palette to produce a variety of grays—diluted with turpentine. Casual strokes begin by suggesting the background; the dark patches of the hair, beard, and mustache; the shadow side of the face; and the dark eye socket on the lighted side.

Step 2. The shadow side of the face is covered with one continuous tone. On top of this tone the darker patches are scrubbed in for the hair, beard, mustache, and eye sockets. Another patch suggests the eye socket on the lighted side of the face. Scrubby strokes suggest the shoulders and a landscape background.

Step 3. A smaller bristle brush adds sharper strokes to define the hairline, ear, jaw line, brows, nostrils, and the dark line of the mouth. Halftones are added to the lighted side of the face—on the forehead, cheek, and jaw. The background is darkened to accentuate the face.

Step 4. Until now, the lights have been bare canvas. Now they're covered with thick, juicy strokes that define the lighted planes of the forehead, cheek, nose, and jaw. The brush begins to blend the brushstrokes on the shadow side of the face. Dark strokes define the features more distinctly and add texture to the beard.

Step 5. The tip of the brush adds the whites of the eyes, sharpens the lighted side of the nose and cheek, and adds details to the lighted side of the beard. Short, thick strokes suggest the texture of the hair. Compare this stage with Step 3 to see how softly the rough strokes on the shadow side of the head have been blended to produce a continuous tone. A rag wipes away some color from the dark cheek to suggest reflected light. Dark color has been scrubbed on the background next to the lighted cheek to accentuate the bright contour. The entire sketch is composed of broad areas of light and shadow, with very little attention to detail. The oil sketch may, in fact, be an excellent likeness—which proves how little detail you need to create a successful portrait, as long as the broad shapes are correct.

Step 1. The tip of a round softhair brush draws the oval contours of the face, the ragged shapes of the hair, and the first indication of the features with a fluid mixture of tube color and turpentine. Much of the work in this oil sketch will be done with this liquid mixture, which is only a bit thicker than watercolor. The painting surface is canvas-textured paper.

Step 2. A big bristle brush washes in the dark background with fluid strokes of tube color and turpentine. This fluid mixture is darker because it contains somewhat less turpentine. Now the pale tone of the hair is clearly silhouetted against the surrounding darkness.

Step 3. The artist *usually* begins by blocking in the shapes of the shadows. But this is a rough, impulsive sketch; he decides on a different approach. The face is quickly covered with a pale tone that represents the lights. A few darker dabs suggest the eye sockets. Then the brush moves swiftly around the face to suggest the shadow tone on the hair and neck.

Step 4. This same shadow is carried swiftly over the darker sides of the head and features, which are now almost complete. Smaller strokes of this tone indicate the dark upper lip, the shadow beneath the lower lip, the underside of the nose, and the lower eyelids. The eyes are placed with two quick touches. And the brush scribbles more shadow strokes over the hair.

Step 5. Having covered the entire face, neck, and hair with broad strokes of light and shadow in the shortest possible time, the artist finishes the sketch with the last few touches of detail. The tip of a round softhair brush draws the dark lines of the eyes, eyebrows, nostrils, and mouth. A few strokes of shadow darken the corner of the eye socket on the darker side of the face, the corner of the nostril, the underside of the earlobe, the hard line of the jaw, and the line of the chin. The brush scribbles more shadows into the hair that falls over the forehead, over the ear, and behind the neck. Picking up some pale color, the tip of the brush suggests some bright strands of hair that stand out against the darkness. A few rapid strokes indicate the pale color of the blouse and the dark shadow within the collar. The entire sketch is painted with tube color diluted with turpentine to a fluid consistency for rapid brushwork. Such a sketch is often used as a preliminary study for a more finished painting. But the oil sketch has a free, spontaneous quality which is satisfying in itself—and is often just as enjoyable as a more polished painting that takes many more hours of work.

Step 1. An oil sketch is like a highly simplified oil painting. The canvas is toned with a rag that carries tube color and lots of turpentine. Then the tip of a round brush quickly sketches the shapes of the figure. The sketch emphasizes proportions and visualizes the forms as simply as possible. As you can see, the artist isn't concerned with precise drawing—the shapes will be refined as the painting progresses.

Step 2. Still working with tube color, but with much less turpentine, a small bristle brush locks in the dark masses of the shadows. At this point the painting hardly looks like a human figure, but the artist knows that if he gets the shapes of the shadows right, the figure will turn out right too.

Step 3. A big bristle brush rapidly covers the lighted areas of the figure with a pale tone and brushes some of this tone into the shadows. A big brush darkens the background and the bed. Then a small bristle brush darkens the hair and adds strokes of shadow where the head and body touch the bed. The tip of a round brush adds a few strokes to suggest the features. Now all that rough brushwork begins to look like a figure.

Step 4. A flat softhair brush starts to blend the lights and shadows, making the shapes seem smoother and more lifelike. Thick touches of pale color build up the lights on the head, breast, arms, and thigh. The tip of a round brush adds some dark lines of shadow to the figure and then defines the features more sharply.

Step 5. The final touches are added with the tip of a round brush. The brush picks out a few ragged locks of hair and then sharpens the darks of the eyes, the nose, the chin, and the nipple. A single dark line of shadow sharpens the curve of the upraised shoulder. The entire oil sketch is painted with mixtures of ivory black and titanium white tube color, diluted only with turpentine. Much of the paint is as thin and washy as watercolor. The brushwork is broad and rapid. There are practically no small brushstrokes except for the few precise touches that define the features. The purpose of the oil sketch is to capture the shapes of the lights and shadows, the pose, and the mood. It's often worthwhile to make such an oil sketch as a preliminary study for a larger painting that will be executed more slowly and deliberately. It's also good experience, however, to make lots of small oil sketches in order to learn how to visualize lights and shadows as simply as possible.